GUARDIANS OF
DETROIT

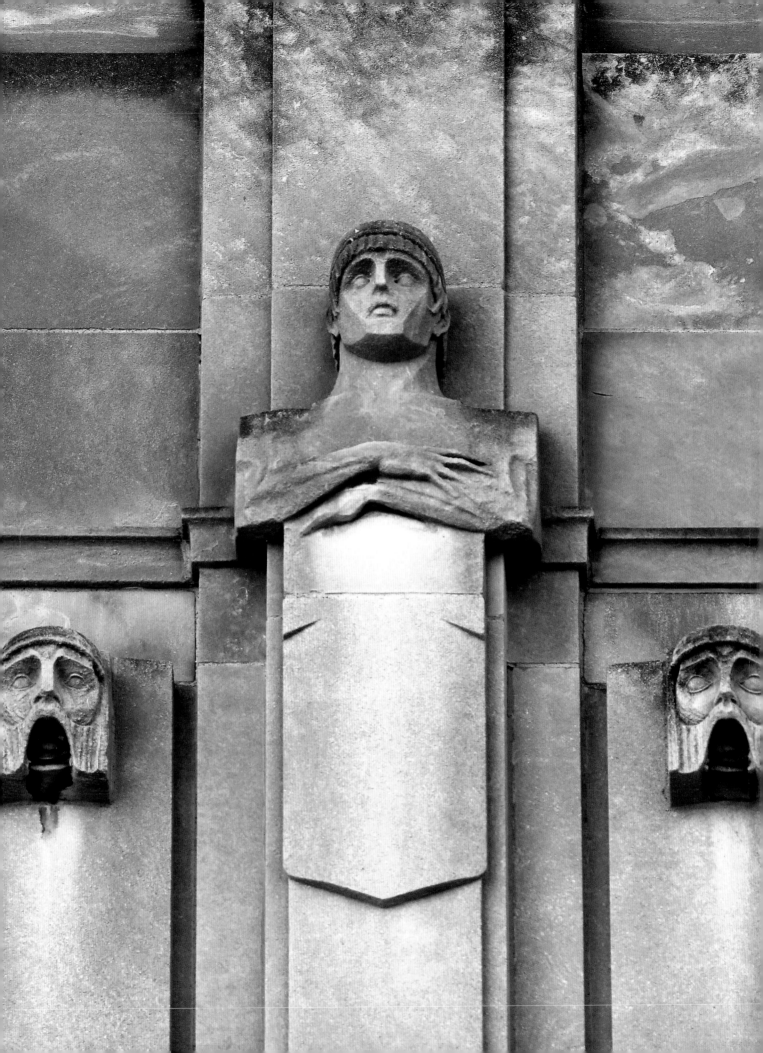

GUARDIANS OF
DETROIT

ARCHITECTURAL SCULPTURE IN THE MOTOR CITY

JEFF MORRISON

A Painted Turtle book
Detroit, Michigan

ISBN 978-0-8143-4570-2 (hardcover)

ISBN 978-0-8143-4571-9 (e-book)

Library of Congress Control Number: 2018946459

Wayne State University Press

Leonard N. Simons Building

4809 Woodward Avenue

Detroit, Michigan 48201-1309

Visit us online at wsupress.wayne.edu

To my father, Roger Elliott Morrison.
Thank you for getting me started on
this path

CONTENTS

PREFACE XI

ACKNOWLEDGMENTS XV

Fort Street Presbyterian Church and Church House 2

St. John's Episcopal Church 6

Old City Hall 12

William H. Wells House 18

First Presbyterian Church (Ecumenical Theological
 Seminary) 22

Trinity Episcopal Church (Spirit of Hope) 28

David Whitney Jr. House 38

Hurlbut Memorial Gate 40

Old Main (Detroit Central High School) 46

Hunt Street (Third Precinct) Police Station 54

Grand River Avenue Police Station and Barn 58

Wayne County Building 60

Belle Isle Aquarium 68

St. Francis D'Assisi Roman Catholic Church 72

St. Hedwig Roman Catholic Church 74

Detroit News Building 78

Detroit Main Library 84

George W. Balch School 90

Detroit Yacht Club 92

Park Avenue Building 94

Detroit Police Headquarters 98

General Motors Building 104

General Motors Corporation Laboratories 110

Archdiocese of Detroit Chancery Building 112

Book-Cadillac Hotel 114

Detroit Free Press Building 118

First State Bank Building 124

Security Trust Building 128

James Scott Memorial Fountain 134

Bankers Trust Company Building 142

Buhl Building 148

The Players Theatre 152

Detroit Masonic Temple 154

Book Building and Tower 162

Broadway Exchange Building 168

Metropolitan United Methodist Church 172

Detroit Institute of Arts 176

Maccabees Building 182

Standard Federal Savings & Loan 190

Historic Little Rock Missionary Baptist Church (Central
 Woodward Christian Church) 194

Fisher Building 198

Music Hall 208

Penobscot Building 210

S. S. Kresge Headquarters 216

David Stott Building 220

Detroit Press Building 222

Fire Department Headquarters 224

Guardian Building 228

St. Aloysius Roman Catholic Church 234

William Livingstone Memorial Light 240

Cathedral of the Most Blessed Sacrament 244

St. Cecilia Roman Catholic Church 250

Detroit Public Library, Francis Parkman Branch 254

Historic Trinity Lutheran Church 258

Detroit Public Library, Downtown (Skillman) Branch 262

Detroit Federal Building and U.S. Courthouse
 (Theodore J. Levin U.S. Courthouse) 266

D. J. Healy Shops' Neighborhood Stores 272

Nancy Brown Peace Carillon 274

Horace H. Rackham Educational Memorial 278

APPENDIX A: OTHER BUILDINGS 284

APPENDIX B: MAPS 298

APPENDIX C: SCULPTORS AND THEIR BUILDINGS 305

NOTES 309

SELECT BIBLIOGRAPHY 315

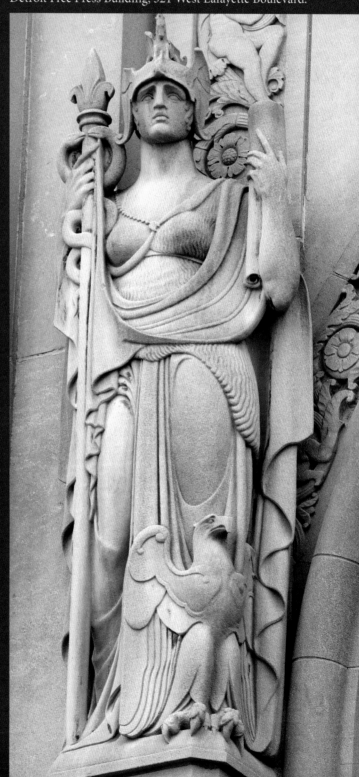

Detroit Free Press Building, 321 West Lafayette Boulevard.

Pochelon Building, 815
Bates Street.

ETROIT HAS ITS SHARE of sleek, unadorned, glass-covered buildings. While this style of building has its place in the evolution of the architectural arts, it is not my personal favorite. I prefer buildings from earlier eras—buildings with sculpted ornamentation that interact with people passing by in symbolic and meaningful ways. And because of a fortuitous confluence of geography, natural resources, and entrepreneurial spirit, Detroit is blessed with more than its share of this style of building.

When I started the *Guardians of Detroit* project, I knew there were many buildings with architectural sculpture to be seen in Detroit, but I had no idea just how many. I thought I would be lucky to fill around a hundred pages. As you can tell by the volume you have before you, nothing could be further from the truth. There was so much that, in order to keep this book to a manageable size, I had to limit it to just buildings within the city of Detroit, excluding even Highland Park and Hamtramck. So the question is, why is there so much architectural sculpture in Detroit?

By the Numbers

The first building featured in this book is Fort Street Presbyterian Church (page 2), completed in 1855. Fifty years before this church was built, Detroit had burnt to the ground. Only twenty-five years before this church was built, Detroit was still a small frontier town with a population of about twenty-two hundred people. By 1850, that number had grown by an order of magnitude to just over twenty-one thousand. During the decade in which this church was built, Detroit's population more than doubled that number, passing forty-five thousand.

By the time Old City Hall (page 12) was completed in 1871, Detroit was a booming industrial and transportation center, with over eighty thousand people. That number more than tripled by 1900, and Detroit had become

the nation's thirteenth-largest city. In those years before the automobile, raw materials such as copper, iron, and lumber flowed through Detroit, and industries including sawmills, cast-iron stoves, and locomotive production flourished. People came from around the country and all over Europe to help produce pharmaceuticals, paints and varnishes, soap, shoes, seeds, tobacco products, and steel.

Most of the buildings featured in this book were erected in the 1920s, when Detroit was the fourth-largest city in the country. That decade opened with Detroit's population at just under a million people and closed with more than one and a half million people working and living in what had become the Motor City.[1]

Building Styles

Obviously, the more the city grew and the more business thrived, the more new buildings were needed. And these new buildings were being built at a time when the most popular architectural styles included Beaux-Arts, Gothic and Romanesque Revival, and later Art Moderne and Art Deco, all of which made extensive use of sculptural ornamentation. Thus, Detroit became an incredible treasure trove of architectural sculpture, most of which is concentrated in a fairly small geographic area. *Guardians of Detroit* seeks to document this unique outdoor art gallery photographically while providing insight into its symbolism and meaning and crediting the often-anonymous artists and artisans who created it. While every attempt has been made to be comprehensive, some buildings may have been overlooked, and for this, I apologize.

A City of Giants

Another reason for Detroit's wealth of architectural wonders is that this was a time of giants, people with incredible drive and ambition and, in many cases, oversized personalities—people such as James Scripps, James Scott,

the Book brothers, and the Fisher brothers. Whether they came from humble beginnings and built huge fortunes in Michigan and/or Detroit or were born to some level of privilege and parlayed that into even greater wealth, all wanted to make their mark on the city they called home. Part of telling the stories of the buildings featured in *Guardians of Detroit* is telling the stories of these people.

Detroit was also a city of architectural giants, including George D. Mason, Wirt C. Rowland, and of course, Albert Kahn, to name only three. These men and many others brought the dreams of their wealthy patrons to reality, designing buildings that were recognized for their greatness and innovation throughout the world and putting Detroit on the architectural map. Many pages have already been written about them, and their stories are mentioned here only in passing.

A primary focus of this book is on telling the stories of the sculptors who created the architectural ornamentation featured on these pages. One of the giants in this area is Corrado Parducci. It has been said that his work adorns just about every major Detroit building erected in the 1920s and the early to mid-1930s. On the basis of research through many sources of information, Parducci is responsible for some or all of the exterior sculpture on at least twenty-five of the buildings on the following pages. Based on date of construction, known associations with Detroit architects and builders, and stylistic analysis, it is probable that he is also responsible for at least seventeen more of these buildings and possibly several more. He is also known to have worked on the interiors of even more buildings, a topic not covered in this volume.

While Parducci is the best-known figure in Detroit architectural sculpture, there are many others. Included in their ranks are Julius Melchers, Louis Sielaff, Ulysses Ricci, Géza Maróti, Charles Beaver Edwards, Marshall Fredericks, and several more. What I could find of their often-intersecting stories is told here. Keep in mind that in most cases these artists did not sign their work, and records of those often considered secondary contractors were not always kept. When a sculptor is identified herein as working on a particular building, it is because I have found documentation to support that claim, using primary sources when possible. In cases where I am reasonably sure but not 100 percent positive, I have used the words "attributed to" to describe a sculptor's contribution to a building.

Creating Architectural Sculpture

There are several ways the sculpture on these buildings was created. For some buildings, particularly those constructed in the nineteenth century, the sculptor carved stone already in place on the structure. In other cases, sculptors provided full-size plaster or clay models, based on sometimes-detailed/sometimes-loose drawings provided by the architect. These models were then used by carvers to create the finished work, under the supervision of the architect or the sculptor. The names of these tradespeople were rarely preserved, but in cases where I have found them, they have been listed in the credits, identified as "carvers." Ornamentation could also be made from terra-cotta (a type of clay), which was less expensive than carved stone. Wrought or cast iron, copper, bronze, and other metals were also used, depending on the application. Two or more of these processes could be used on a building, and I have made sure to identify who did what, when known.

Location and Preservation

While we are fortunate that so many of Detroit's amazing buildings have lasted through the years, much of the architectural heritage of this city has been lost. While interesting and certainly worthy of study, buildings such as the Detroit Museum of Art, the old Federal Building and Post Office, and the Detroit Stock Exchange, to name a few, have not been included in this book. An exception has been made for Detroit's Old City Hall. Razed in 1961, Old City Hall is featured in these pages because eight statues from the building's exterior were saved and can still be seen today. Maps showing the location of Old City Hall

and where four of its rescued statues are displayed, as well as every building included in this book, can be found in appendix B. Please note that many building names have changed over the years. In such cases, I have arbitrarily chosen the name I believe to be most recognizable today or chosen to include more than one name.

I encourage you to visit these buildings while you can. While most of the structures included in this book are still standing, and many are being restored and re-purposed and can expect to be around for years to come, some, such as the First Presbyterian Church (page 22), the Park Avenue Building (page 94), and the National Theatre (page 292), face uncertain futures. At least one building, Redeemer Presbyterian Church, has been torn down since I began working on this book, and another, the Pochelon Building, has been slated for demolition. I hope those who peruse these pages will become more aware of the architectural wonders around them and be inspired to help preserve them. Detroit organizations dedicated to this effort include Preservation Detroit (http://preservationdetroit.org) and the Belle Isle Conservancy (www.belleisleconservancy.org). This brings us to my final point.

While doing research for this book, it has occurred to me that the most important aspect of *Guardians of Detroit* and any further projects that may arise from it is documentation. It has proven to be very difficult to find close-up, detailed photos or drawings of the architectural sculpture of buildings that have been damaged, demolished, or "updated." In so many cases, such records have been lost, destroyed, or simply were never made. Pictures of entire buildings are usually available, but pictures of individual architectural details are not. If anyone out there has photos of sculpture from any of Detroit's lost buildings or knows where pieces of these building are, please contact me though my website, www.GuardiansOfDetroit.com, so photos can be made and "lost" architectural sculpture can be documented, preserved, and possibly made available through an online archive. Any help in achieving this goal will be greatly appreciated.

Creating *Guardians of Detroit* has been a labor of love. Working on this project has allowed me to meet many interesting people, from those who helped me with research and access to those who saw me taking pictures on the streets of Detroit and asked about what I was doing or shared stories of their connection to the building I was photographing. I hope you enjoy reading and looking through it as much as I enjoyed making it.

MANY PEOPLE HAVE HELPED me along on the three-and-a-half-year journey from concept to completion of this project, but first and foremost among them is my lovely wife, Susie. Thank you so much, this book never would have happened without your support.

Thanks also to the following people and institutions. Everything I got right is due at least in part to their help. Anything I got wrong is despite their help and on me alone.

The entire staff at the Burton Historical Collection and the newspaper archive at the Detroit Public Library Main Library. The staffs of the Bentley Historical Library at the University of Michigan and the Walter P. Reuther Library at Wayne State University. Sandy Schaeffer at Historic Trinity Lutheran Church for regular trips up two long flights of stairs to the third floor to provide access to the Dau Church History Library, a fantastic resource for materials on past and present Detroit parishes of all denominations. Maria R. Ketcham, director, and James E. Hanks, archivist, for access and invaluable assistance at the Research Library and Archives of the Detroit Institute of Arts. Iva Lisikewycz, manager of curatorial affairs, and Douglas Bulka, Department of Prints, Drawings and Photographs at the DIA, for access to the original plans and drawings of the First Presbyterian Church. Pamela Johnson at the Ecumenical Theological Seminary, housed in the former First Presbyterian Church, for access to the church archives. Eleanor Oakes for her time and expertise in providing scans of old negatives of photos of the First Presbyterian Church. Dawn Bilobran of Preservation Detroit and the Belle Isle Conservancy for providing access to the Preservation Detroit Archives and assistance in its use. Tracy Irwin at the Detroit Historical Society for providing access to the Old City Hall "Civic Virtues" statues. Joel Stone, senior curator, and Nathan Kelber, manager of digital projects, at the Detroit Historical Society. Catherine J. Phillips at the Lawrence Technological University Archives. Donald Bauman, director of architecture and historical preservation at Albert Kahn Associates. And Jeff Lemaux, curator, Detroit Police Museum. Tim Moran and Alison Grosch at Fort Street Presbyterian Church for access to the church house roof to view and photograph the grotesques on the east wall of the church.

Special thanks to Martin and Sharon Scott for the use of an original Smith, Hinchman & Grylls rendering of the Guardian Building's Griswold Street entrance and to Sharon Scott in her capacity as archivist for the Historical Society of Clinton. Your help with the archives and the wealth of Wirt Rowland material housed therein is greatly appreciated. Thanks also to the Clinton Township Public Library in Clinton, Michigan, which houses the archive.

Thanks also to Deacon Bob Smith at Spirit of Hope Church (Trinity Episcopal). Tom Suski, lifelong parishioner at St. Hedwig Roman Catholic Church for going above and beyond to help narrow down dates for placement of statues on the church steps. Pam York and Robert Pate of the Detroit Shriners and Steve Genther, general manager, and Rob Moore, docent, at the Detroit Masonic Temple. David Wilte, guest services manager, and Tammy Lapins, front desk, at the Westin Book-Cadillac Hotel. Barbara Cohn of the Detroit Library Friends Foundation. Kerrie Barno, clubhouse manager at the Detroit Yacht Club. Father Steven J. Kelly, rector, St. John's Episcopal Church. Matthew Morin at Macro Connect for graciously taking the time to provide access to, and information about, the Hunt Street (Third Precinct) Police Station. Roger Basmajian and Michael Allingham at Basco of Michigan for taking time to talk with me about the First State Bank Building and for providing blueprints. Aamir Farooqui of Banyan Investments for taking the time to respond to questions about the William H. Wells House. Michael Keropian, sculptor of the tiger statues at Comerica Park, and Bruce Gerlach, illustrator and sculptor, who created the replacement weather vane for the Belle Isle Aquarium for taking time to provide information about their work. Chris Meister of the Belle Isle Conservancy for telling me about the existence and location of a piece of sculp-

ture from the demolished Detroit Times Building and Jeremy Kemp, Gabby Banks, and Chance Boyer for help in arranging access to it.

Several writers have generously taken time to provide support and answer questions. Among them are Dan Austin, Amy Elliott Bragg, Deborah J. Larsen, and Barbara Krueger. Thank you all for your help.

Thanks also to my friends Barbara Downey, David Downey, Cindy Gagnier, Marty Gagnier, Cecilia Julien, Wendy Julien, Dave Prawdzik, Deb Prawdzik, and Pete Prawdzik, who sat through my preliminary *Guardians of Detroit* presentation and provided valuable commentary and advice, reviewed my first proof-of-concept booklet, and always asked how the project was going. Thank you Wayne Johnson at the Back Street Barber Shop in Oxford (best haircuts in town) and everybody at M&B Graphics in Lake Orion, especially Anthony, George, and Kat. Thank you to the Clinton Township Public Library, the Mount Clemens Public Library, and the Oxford Township Public Library for providing venues for my first public *Guardians of Detroit* presentations. Thank you Davis Clenny, William Julien, show hosts Chris Benson and Nancy Grandillo, and everybody at Celebrate Michigan and Madonna University who helped make my first *Guardians of Detroit* interview such a great experience. And thank you to my son, Noah Morrison, who guided me on my first *Guardians of Detroit* photo safaris.

Thank you to the Canon and Tamron companies for making great equipment. All photos (except historic) were shot using a Canon 5D Mark III, and most were shot using a Tamron SP 150–600mm F/5–6.3 Di VC USD lens.

And finally, thanks to Kathryn Wildfong, Rachel Ross, Emily Nowak, Carrie Downes Teefey, Andrew Katz, Emily Gauronskas, and everybody else at Wayne State University Press who helped make this book possible.

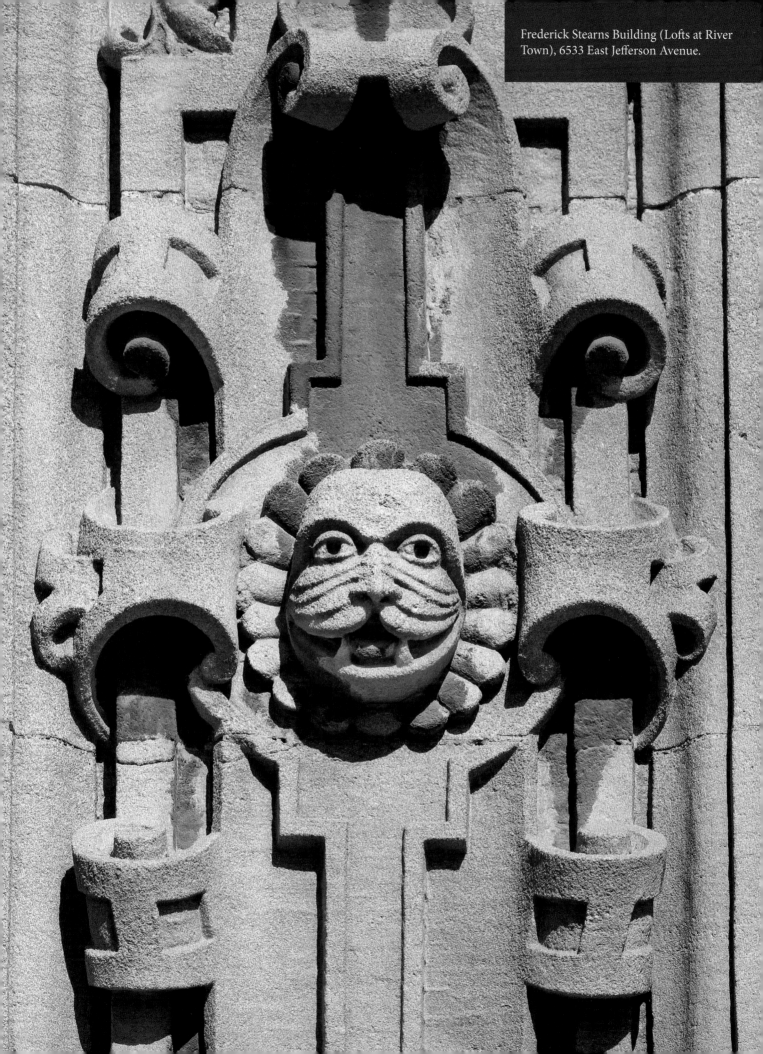

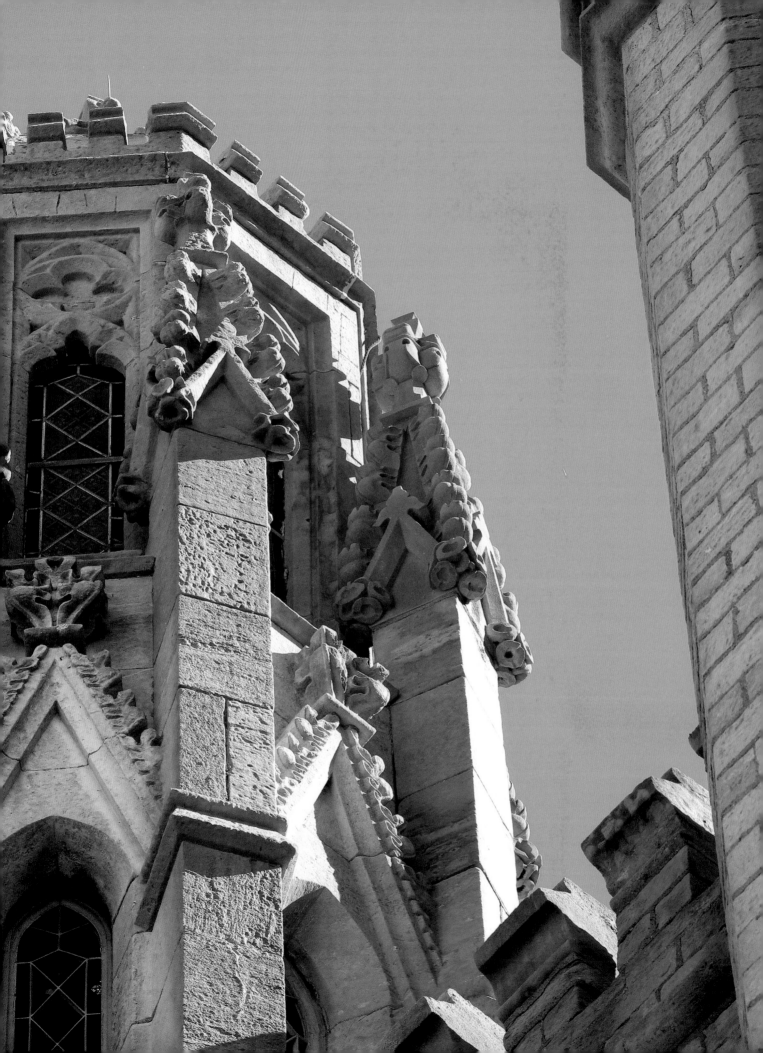

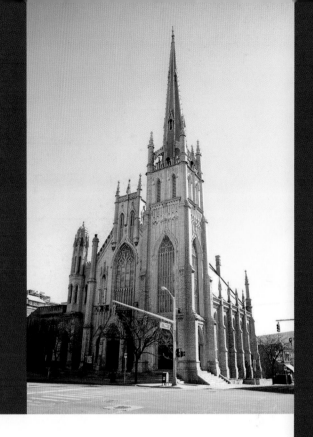

631 West Fort Street

Completed: 1855 (Church), 1908 (Church House)

Architects: Albert Jordan and James Anderson (Church), John Scott & Company (Church House)

Sculptor: Unknown

FORT STREET PRESBYTERIAN CHURCH is an apt metaphor for the city of Detroit, repeatedly rising from the ashes over the years, something Detroit has done both figuratively and literally. One of three churches established after fire destroyed the Second Presbyterian Church in 1854, Fort Street Presbyterian suffered a devastating fire in 1876 that caused the roof to collapse and sent the steeple tumbling to the street but left the exterior walls standing. The church was rebuilt to the original plans but suffered another fire in 1914, caused by workers while they were replacing gas lights with electric. It was again rebuilt to the original plans.

The church also needed repairs in 1974 when four hand-carved, five-hundred-pound stone pieces were hoisted into place on its ninety-foot-tall octagonal tower to replace those that were blown down in a storm the previous year. Even more repairs were needed in 1982 when lightning struck the narrow spire of its tall, elegant steeple. Most recently, the roof was replaced in 2013, and funds have been raised to stabilize the tower.

Located in a very fashionable neighborhood when built, the $70,000 construction cost was borne by a congregation of only 167 members. Of course, the membership roster included some of Detroit's most prominent families, among them the Buhl, Alger, Joy, Chandler, and Zug families.

The architect of record was Albert Jordan, although church tradition credits twenty-three-year-old James Anderson, a draftsman who worked for Jordan and later became his partner, with much of the design. This helps account for the youthful exuberance of the ornamentation, which includes elaborate stone tracery, multiple pinnacles with protruding crockets, and flying buttresses on the steeple, all carved with archeologically correct Gothic detail. Jordan and Anderson also designed St. John's Episcopal Church (page 6), and Anderson designed the Old City Hall (page 12).

The church features a series of unique grotesques just under the cornices on both the east and west walls. The grotesques on the east wall are more interesting and expressive than those on the west wall. Unfortunately, they have been hidden from public view for more than a hundred years, since the Church House was added in 1908. They can only be seen from windows and lower rooftops along the west side of the addition.

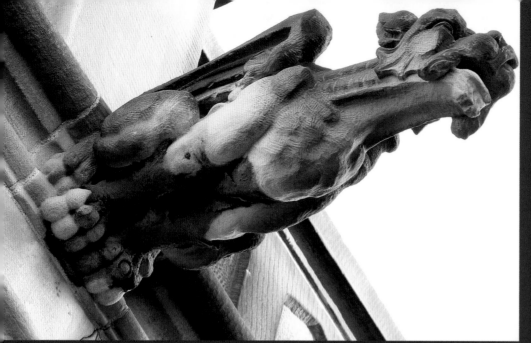

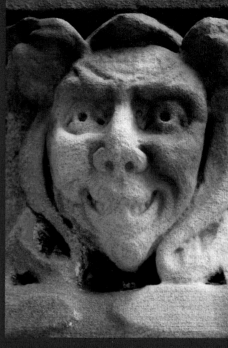

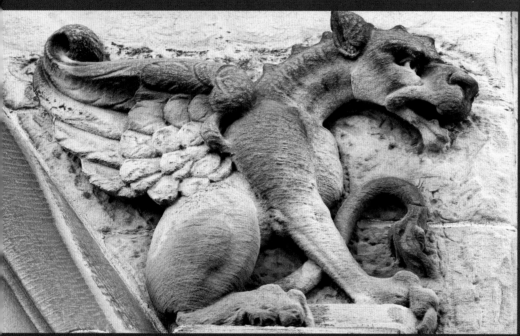

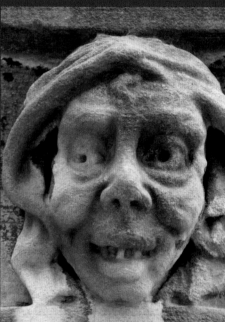

Above: Winged lions in gargoyle and relief form on the outside of the Church House, where the treasury was located. Griffins were considered guardians of treasures. While not technically griffins, these winged lions perform the same symbolic function.

Right side of page: Three fairly animated faces from the north wall of the Church House where it connects to the church appear to be engaged in lively conversation, possibly to remind worshipers entering the building that there is no place for gossip in this congregation.

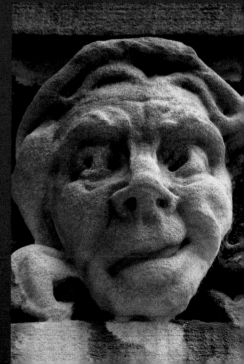

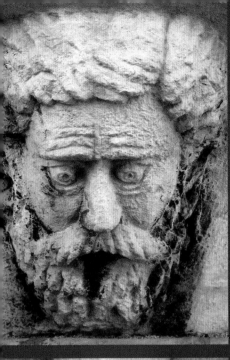
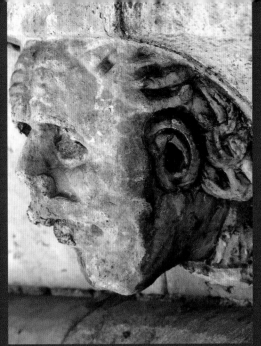
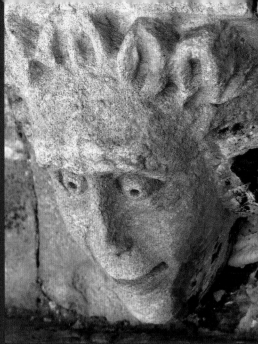
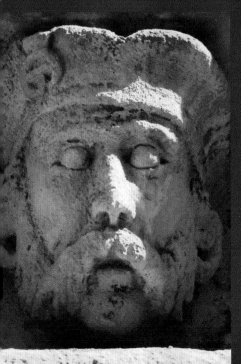
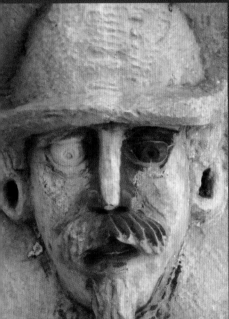

Above and left: Four unique grotesques from the east wall that have been hidden from public view for more than a hundred years.

Below left: Two of the seven grotesques from the west wall of the church. All of these carvings appear to be based on historical models rather than individual people, but documentation to confirm this has not been found.

Below right: A demon terminates a west-wall window hood molding.

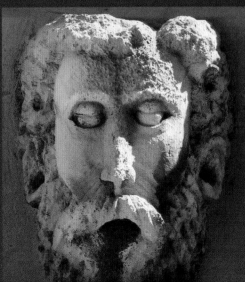
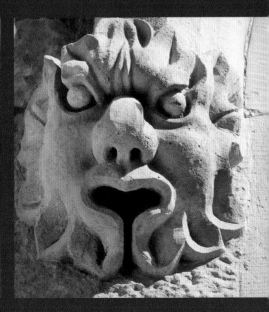

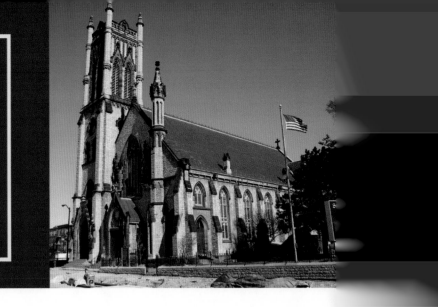

I N 1936, ST. JOHN'S Episcopal Church, built at a time when the area around the intersection of Woodward Avenue and what is now I-75 was considered rural, came very close to joining the ranks of Detroit's lost architectural treasures. The city had decided to widen Woodward Avenue, and the congregation had received a condemnation award. Rather than relocate and allow their beloved church to be torn down, they undertook the monumental task of moving the church and the chapel behind it, over forty million pounds of stone, sixty feet to the east. The award paid for the move, with enough left over to refurbish the church interior.

The Victorian Gothic church was built in 1860–61, largely due to the drive and charitable contributions of Henry P. Baldwin. Born in Coventry, Rhode Island, in 1814 and orphaned at age twelve, Baldwin went into business for himself when he was twenty and at age twenty-four came to Detroit, where he established successful shoe and chewing-tobacco businesses and later went into banking. He was also a state senator, a two-term governor, and a U.S. senator, and he was a member of the founding convention of the Republican Party.

St. John's Episcopal Church was designed by Albert H. Jordan and James Anderson, who also created Fort Street Presbyterian Church (page 2) and Detroit's 1871 City Hall (page 12). The exterior of the building consists of random-sized ashlar cut from rubble limestone quarried downriver, with yellow sandstone trim. The gray and white limestone still glows brightly in the sun, but the comparatively more porous sandstone has absorbed so much dirt and grime over the years that the church now appears to have black trim instead of the original mustard yellow.

The ornamentation is restrained compared to Jordan and Anderson's earlier work on Fort Street,

but there are many stone grotesques, located near the Woodward entrances, on the tower, and on the door and window hood moldings and along the roof line of the north wall. The south wall is more sparsely adorned, probably because it was mostly hidden by the original rectory at the time of the church's construction. It has been suggested that Henry Baldwin is represented among the grotesques, "the good-looking one with the impish smile," but according to the sculptor Walter Schweikart's granddaughter Marie Melchers, the impressive variety of animals and expressive faces are simply based on historical models. In a church booklet celebrating St. John's one hundredth anniversary, she recalled that her grandmother used to visit Schweikart every day at noon while he was working on the church, pushing a baby carriage and bringing him a hot lunch.[1]

Not much is known about Schweikart except that he owned a stone yard at the corner of Jefferson Avenue and Riopelle Street in the early 1860s[2] and a company called Novelty Marble Works in the mid-1860s.[3] According to his granddaughter Marie, the daughter of the sculptor and woodcarver Julius Melchers's son Arthur, Walter was a member of Detroit's famous east-side Schweikart family. This family included a rather colorful character, an ice cutter, saloon owner, and judge named Walter Schweikart, who lived two blocks east of the Jefferson Avenue stone yard just mentioned and died in 1904.[4] It is unclear whether the stone carver and the judge were the same person, but circumstantial evidence suggests the possibility.

Besides the work on St. John's Episcopal Church, Schweikart is credited with the Elmwood Cemetery Gate and the Lewis Cass Monument in that cemetery. In his 1861 newspaper ads, he listed as references "the most prominent builders in the city."[5]

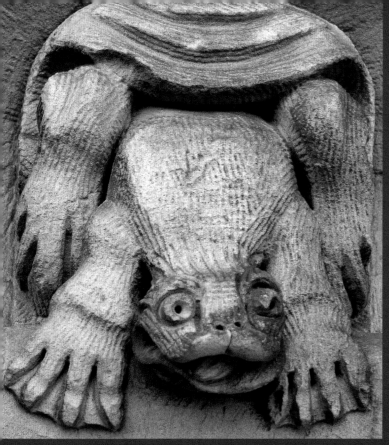

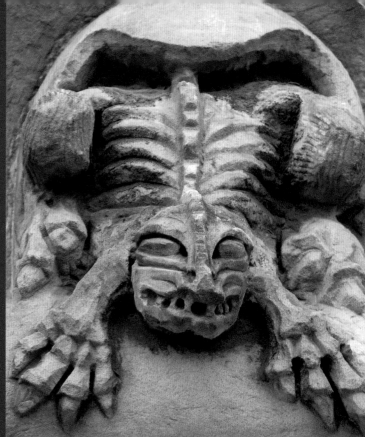

Above: Two similar creatures emerge from eggs on the north wall near the roof, one lively, the other skeletal.

Below: An old man and a young woman terminate opposite ends of a window hood molding on the west façade.

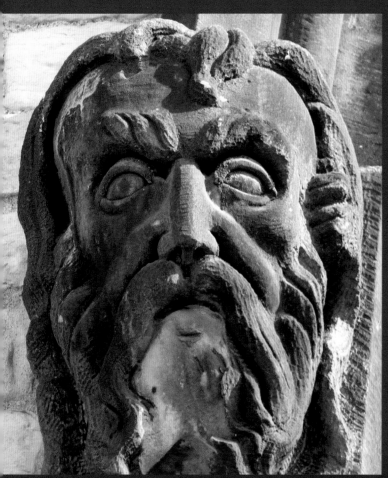

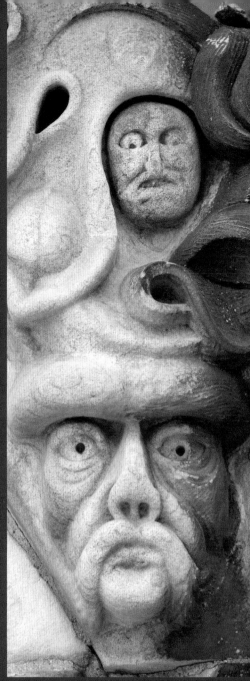

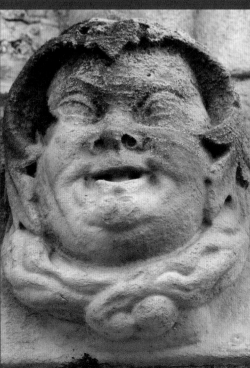

Above: A face from near the east tower entrance that has a second face peering out from within the folds of its elaborate headdress.

Left side of page: Assorted faces from the north wall of the church and the 1859 chapel, which is attached to the east end of the church. The entire chapel was picked up and moved to the east twice after it was built, once to accommodate room for a choir in the church apse and once again when both buildings were moved sixty feet so Woodward Avenue could be widened.

St. John's Episcopal Church - 9

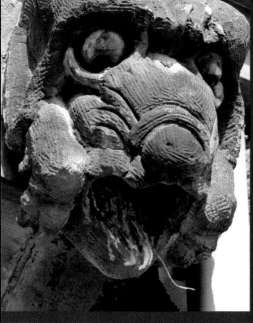

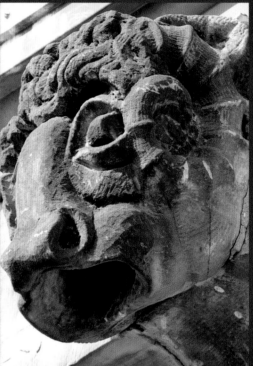

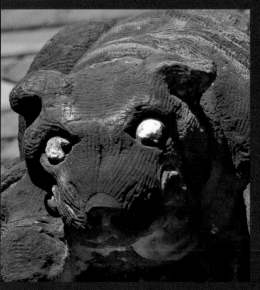

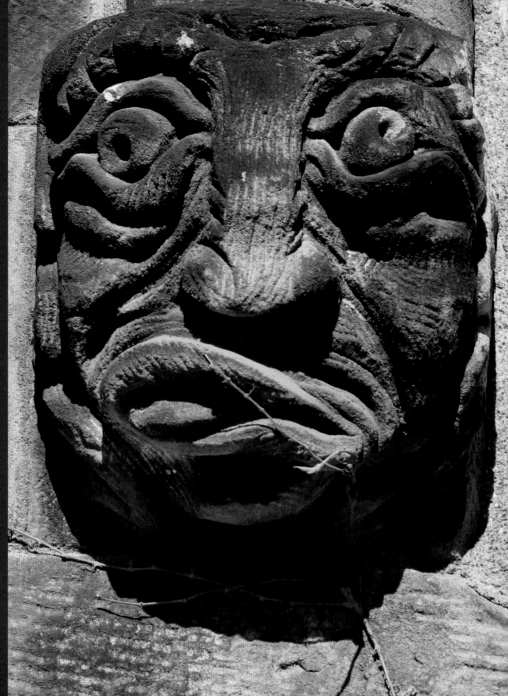

Above: This odd leering face greets churchgoers from above the main south entrance.

Left side of page: Two gargoyles and a grotesque from the south side of the church. The gargoyles are just below the cornice, and the cat-like grotesque is actually on the roof, near the east end.

Facing page: Interesting and expressive faces terminate the window hood moldings of the north transept wall. Research indicates that they are based on historical models, not real people from when the church was built.

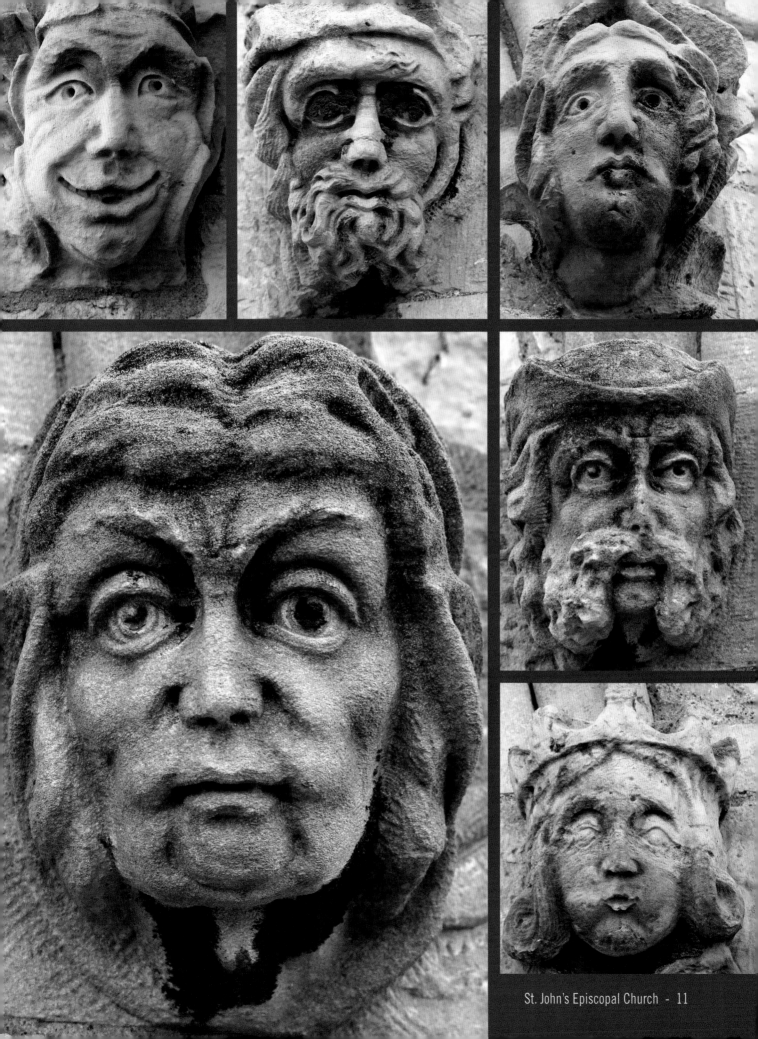

755 Woodward Avenue

Completed: 1871

Architect: James Anderson

Sculptors: John M. Donaldson,
Julius Melchers

O N July 4, 1871, the day the new City Hall was dedicated, the *Detroit Free Press* printed this description: "Outside and in, it is a building worthy of Detroit, worthy of the praise of strangers. The hand of time . . . will not dim its magnificence even when the children of our children shall stand in our places to view its massive columns, its lofty halls, and its tower pointing so boldly into the blue of noonday."[1]

But in 1894, only twenty-three years after the Old City Hall was built, Mayor Hazen Pingree advocated razing and replacing it, calling it out of style and obsolete. In 1929, the Common Council voted to tear it down and replace it, overriding mayor John C. Lodge's veto, but the Great Depression ended that plan. More plans were suggested in the mid-1930s, but none were adopted. Finally, the new City-County Building was erected at the corner of Woodward and Jefferson Avenues in 1955, and in 1961, despite the best efforts of preservationists, the Common Council voted to tear down Old City Hall. Less than ninety years after it was built, the grand old building was gone, replaced by an underground parking garage with a surface-level park and fountain. One Kennedy Square, a thirteen-story office building, was erected on the site in 2006.

Fortunately, eight statues from the old building were saved: four massive sandstone "Civic Virtues" statues from the clock tower and four limestone historical figures from niches on the Woodward Avenue and Griswold Street façades. All eight were carved by Julius Melchers, the father of architectural sculpture in Detroit.

Julius Melchers was born in Soest, Prussia, in 1829. He moved to Paris in 1848 because of involvement in the revolution against the Hohenzollerns. He had to leave Paris in 1852 due to his "political activities"[2] and eventually made it to Detroit in 1855, by way of London and New York. He worked as a wood-carver with many church commissions but also had a thriving cigar-store Indian business. Melchers's apprentice Edward Wagner claimed to have made so many Indians that he could have carved one with his eyes closed, saying, "It used to seem to me that everybody in Detroit wanted one of Melchers' wooden Indians."[3] Melchers also taught art classes, and among his students were the architectural sculptors Richard Reuther and Henry Siebert and the architect Albert Kahn.

The statues of Antoine de la Mothe Cadillac, Robert de La Salle, Father Jacques Marquette, and Father Gabriel Richard were donated to the city by the lumber baron and art patron Bela Hubbard. All four were carved by Melchers, but the statue of Marquette was based on a sculpture by the Detroit architect John M. Donaldson, whom Hubbard first approached with the commission. A 1961 City Council resolution provided for the sculptures to be moved to Belle Isle for "appropriate memorial treatment,"[4] but they were later donated to Wayne State University and have been displayed on campus since 1974. They were recently moved to make way for construction of the Anthony Wayne Apartments.

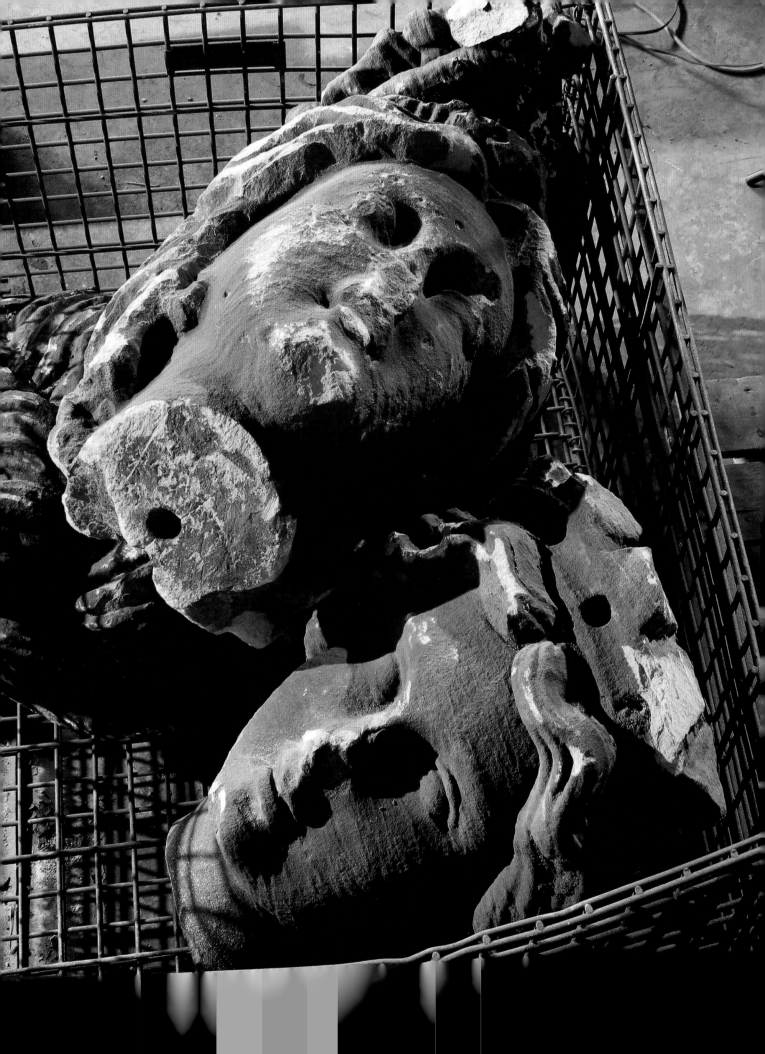

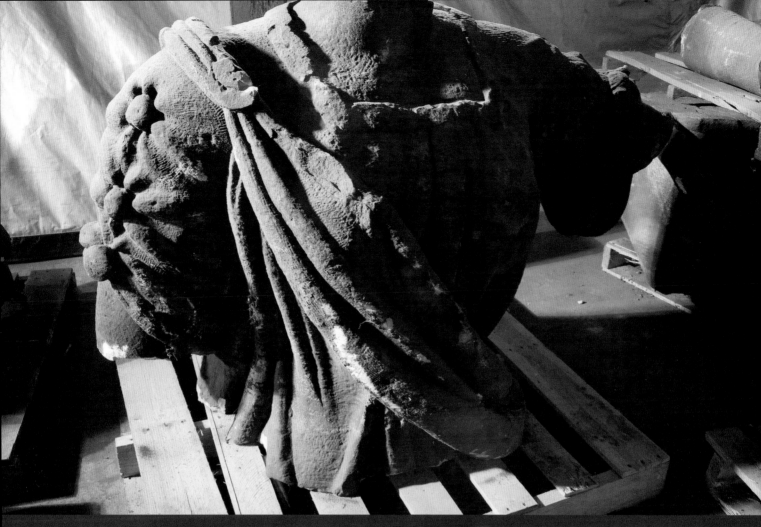

The "Civic Virtues" statues came apart when they were removed from Old City Hall. The pieces are stored in a warehouse at Historic Fort Wayne, awaiting a hoped-for restoration.

Facing page: The heads of "Industry" and "Commerce."

Above: The torso of "Justice."

Right: A bust symbolizing sculpture that stood on a pillar next to "The Arts."

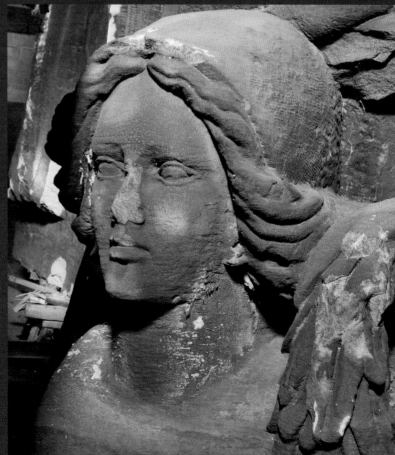

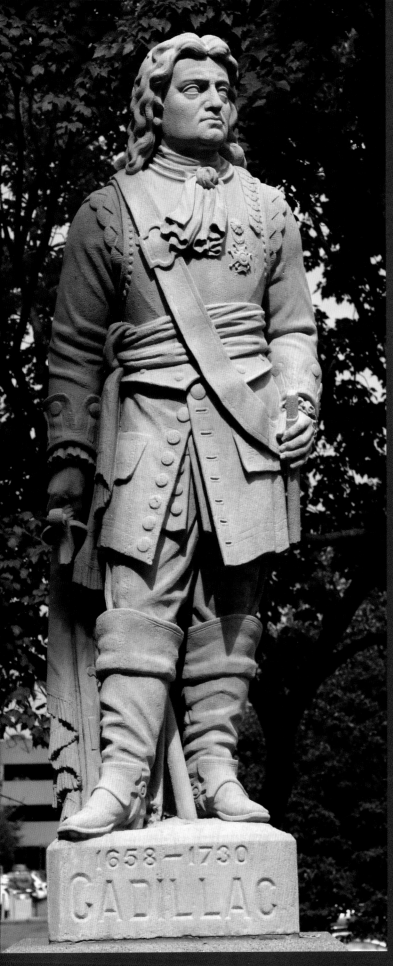

Above: Father Gabriel Richard, who, after the great fire of 1805, coined the city's Latin motto, "Speramus Meliora, Resurget Cineribus," which translates as "We hope for better things, it will rise from the ashes."

Left: Antoine de la Mothe Cadillac, founder of Detroit.

Facing page, top: The explorer and adventurer Robert de La Salle, captain of the Griffon, the first commercial sailing vessel on Lake Erie. Griffins are popular ornamental motifs on buildings throughout Detroit, possibly in recognition of La Salle's ship.

Facing page, bottom: All four of the rescued statues on their pedestals in Ludington Plaza, along Anthony Wayne Drive. Since this photo was taken, they have been moved to the south lawn of the WSU Faculty Administration building at the corner of Anthony Wayne Drive and Kirby Street, to make way for an apartment building.

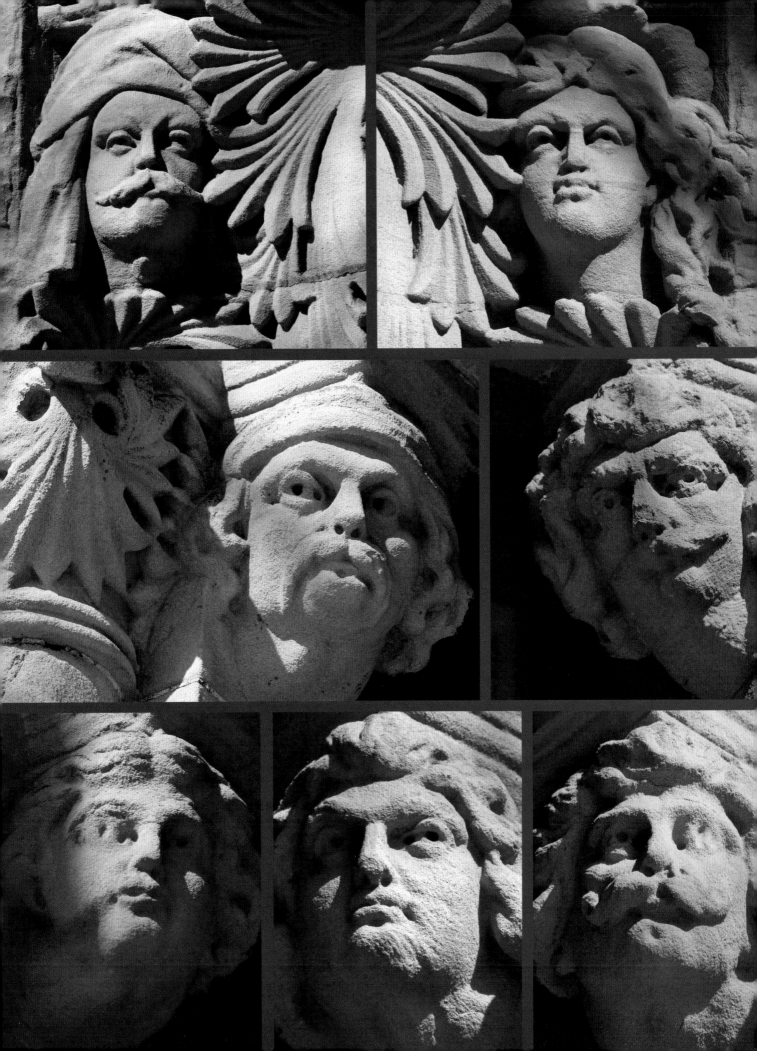

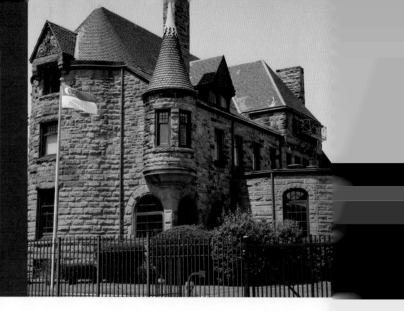

2931 East Jefferson Avenue

Completed: 1889

Architect: William H. Miller

Sculptor: Unknown

THIS ROMANESQUE REVIVAL MANSION is one of the few surviving homes from Detroit's upscale East Jefferson Avenue residential district of the late nineteenth century. It was built by the Detroit businessman William Sproul and is the only Detroit building designed by William H. Miller, who is best known for his work in and around Cornell University and Ithaca, New York.

The building is notable for its interesting asymmetrical aspect and features two areas of sculpture, in the gable over the third-story window of the large central turret and around the offset main entrance on the southwest corner. The gable has a lion surrounded by flourishes, but the work has not held up well through the years. The entrance features several heads similar in style to Joachim Jungwirth's work on the Hurlbut Gate (page 40), although no record could be found of whom they represent or who carved them. They are most likely idealized faces meant to add to the Romanesque flavor of the building, possibly based on historical models. However, it does not tax the imagination much to see the two heads over the entrance (shown at the top of the facing page) as the dashing Bela de Tuscan and his lovely wife, Joanna. More about them later.

Built by Sproul as an investment property, the mansion was occupied by William Wells soon after its construction, and Wells purchased the building in 1900. Wells was quite famous, recognized as one of the foremost lawyers in Michigan and known for his work on many important, high-profile cases. Un-

fortunately, the work took a heavy toll on him, and according to a 1904 obituary, "the strain was so heavy that he suffered a complete nervous collapse"[1] in 1900 and was sent to Oak Grove Sanitarium in Flint, where he remained until his death at age fifty-one.

Wells's widow sold the home to Ella Barbour, herself the widow of Edwin S. Barbour, the president of Detroit Stove Works. Mrs. Barbour owned the building until 1949. During this time, Wells Castle, as it is sometimes referred to, became a rental property and entered its most colorful era.

Beginning in the early to mid-1930s and continuing until 1941, the romantic stone "castle" on East Jefferson Avenue was home to the Salle de Tuscan, the fencing school of Bela and Joanna de Tuscan. The de Tuscans' competitive success, combined with their masterful showmanship and marketing, made Detroit a world-famous center of fencing. Recognizing that the esoteric and highly technical sport could not be easily appreciated by the casual spectator, Bela and Joanna held lavish, internationally themed parties at the Salle, making fencing as much a social event as a competition. Their exhibitions of fencing often included demonstration duels fought with electrified weapons on a darkened stage, creating cascades of sparks as the blades clashed.

Joanna de Tuscan was Bela's most accomplished student, dominating competition in Detroit and throughout the Midwest. She went to the 1936 Berlin Olympics as captain of the U.S. women's fencing team, was named the most beautiful female athlete at

the Olympics, and went on to win the women's professional world championship. With all the publicity generated by Joanna's success, students flocked to the school, and the Salle de Tuscan Fencing Club dominated local competition among Detroit's many high school, college, and amateur fencing clubs.

At the pinnacle of the de Tuscans' success, the dashing former Hungarian army officer and his beautiful Detroit-born bride were the toast of the town. Unfortunately, while Joanna was hospitalized, recovering from a back injury, Bela took up with a twenty-something female student. The resulting scandal led to a divorce that was a major front-page news story in 1943, the height of World War II.[2] The Salle de Tuscan moved to a new location, and the tale of Wells Castle continued on without them.

In 1941, the building became known as the Maxon Annex, housing the research and merchandising division of Maxon, Inc. This Detroit-based national advertising agency had billings over $100 million and a client list that included Gillette Safety Razor, H. J. Heinz, and General Electric. Maxon, headquartered in the nearby George Harrison Phelps Building (page 289), eventually went out of business and was absorbed by a New York agency, and the William H. Wells House went through a number of owners, including the University of Detroit, TPS Logistics (which restored much of the building's original elegance in 2000), and 400 Monroe Associates. Purchased by Banyan Investments in 2015, Wells Castle has been restored and is once again a private residence.

Facing page: Damaged but still vigilant, a lion guards the house from the gable that protrudes from the conical roof of the building's three-story-tall main turret.

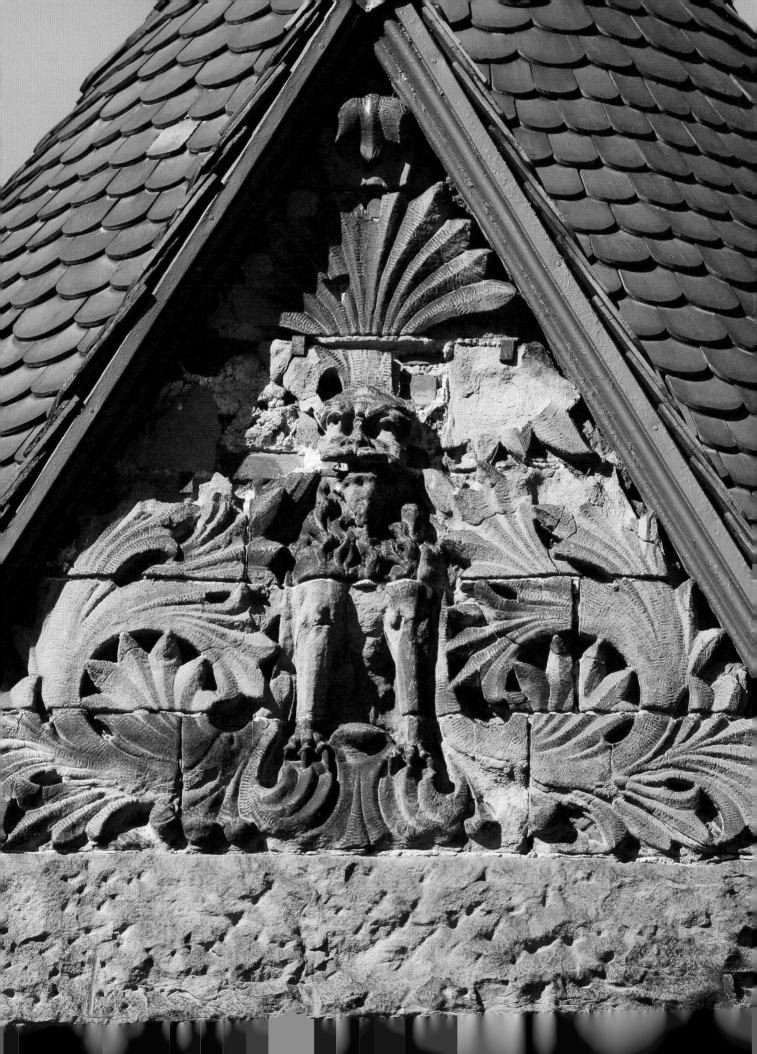

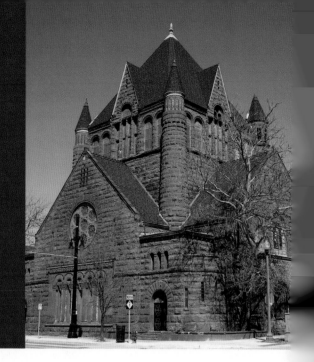

(Ecumenical Theological Seminary)

2930 Woodward Avenue

Dedicated: 1891

Architect: Mason & Rice

Sculptor: Edward Q. Wagner

THE FIRST PRESBYTERIAN CHURCH traces its roots back to 1816, when Father Gabriel Richard and Ste. Anne de Detroit Roman Catholic Church was the only game in town, religiously speaking. Governor Lewis S. Cass wrote to Princeton University to request that a Protestant minister be sent to Detroit, and Princeton sent John Montieth. Though in Detroit only five years, Montieth had an incredible impact on the city and the region. Not only did he found the First Protestant Society of Detroit and preach in its first church, but he also helped found the University of Michigan with Judge August B. Woodward and the aforementioned Father Richard.

The structure seen here is the fourth First Presbyterian Church building. The first was built in 1822 on Woodward Avenue between Larned and Congress Streets. The second burned down in 1854, and the property was sold, with 40 percent of the proceeds being used to build the third First Presbyterian Church at State and Farmer Streets. The remainder went toward building two more Presbyterian churches in the rapidly growing city, one of which was Fort Street Presbyterian Church (page 2).

In 1888, the congregation of First Presbyterian decided to leave the downtown area and move north up Woodward Avenue to the current location. The design of the building was based on Trinity Church in Boston; but this structure is more compact, and instead of granite, red sandstone from Houghton, Michigan, was used. The building looks a bit different now than when it was dedicated in 1891, due to the 1936 widening of Woodward Avenue. The massive triple-arched entrance pavilion was moved around the corner to the south side of the building, and two large circular towers that used to flank the entrance were completely removed. Two lions placed on either side of the front steps, representing the Bible and faithfulness, were moved with the porch.

The building features a wealth of sculptural detail by Edward Q. Wagner,[1] but the red sandstone from which it was carved has not held up well in the face of more than 125 years of Michigan weather. Not one of the four heads between the first-floor window arches on the Woodward Avenue façade is completely intact, and both of the large lions on the entrance pavilion steps are severely damaged. Much of the detailed carving around the upper-story windows and on the roof peaks has also disintegrated over the years.

In 1990, with the congregation's membership down to about one hundred, the main church building was closed, and members began worshiping at Westminster Presbyterian Church in northwest Detroit. However, they kept the adjacent social hall open for its community outreach programs that included Wednesday free lunches and latchkey and summer day camp. In 1992, the building got a new life when it was leased to the Ecumenical Theological Seminary. It was given to the seminary outright in 2002.

Recently, citing rising upkeep and operating expenses, the seminary board has decided to sell the property, which sits one block north of the recently completed Little Caesar's Arena and abuts the new 8.4-acre City Modern residential development in the Brush Park neighborhood.

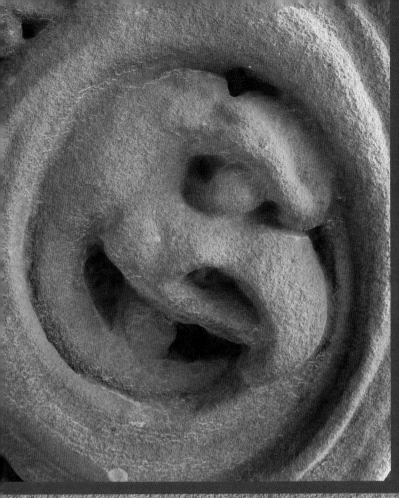

Reliefs of an eagle (*left*) and a dragon (*below*) from inside the entrance arch are hidden within a band of intricately carved foliage. The eagle faces toward the door and represents the human spirit entering the church seeking enlightenment. The dragon faces away from the door and shows that there is no place for evil within these walls.

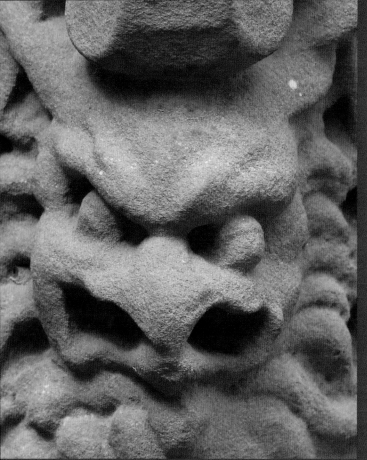

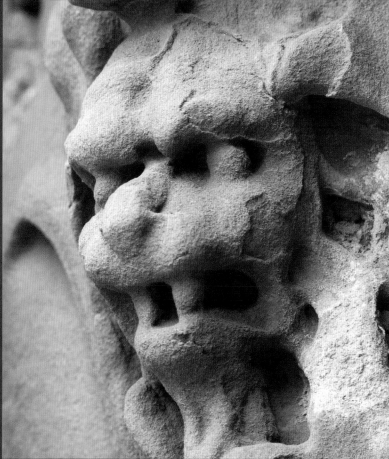

Pillar capital ornaments from the south façade include several demonic creatures.

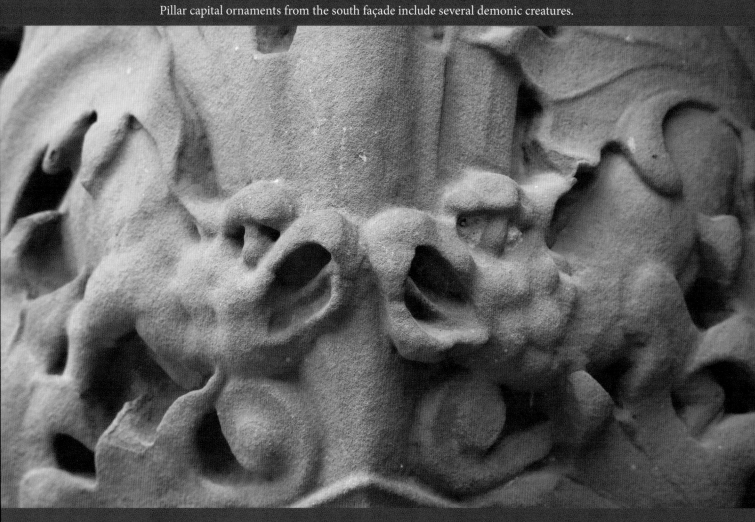

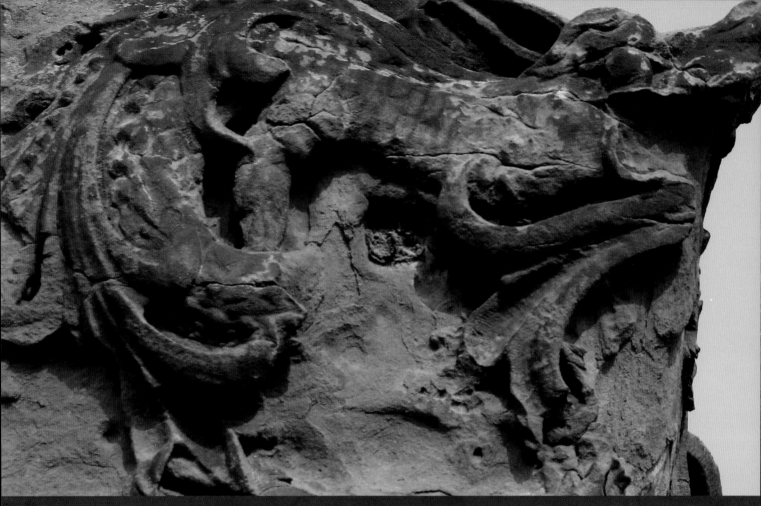

Above: A weathered demon from the corner of a south façade cornice.

Right: One of the four damaged heads over the west façade windows. The inset shows the head before it was damaged. These windows and ornaments were added when the entrance was moved in 1936.

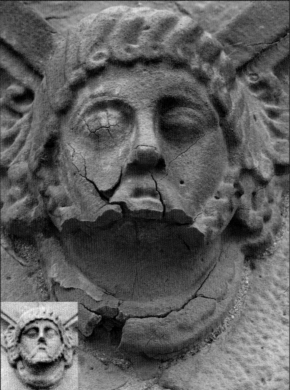

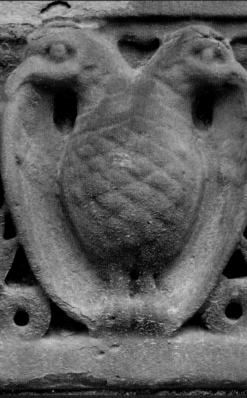

Above: One of a series of two-headed doves from the south façade.

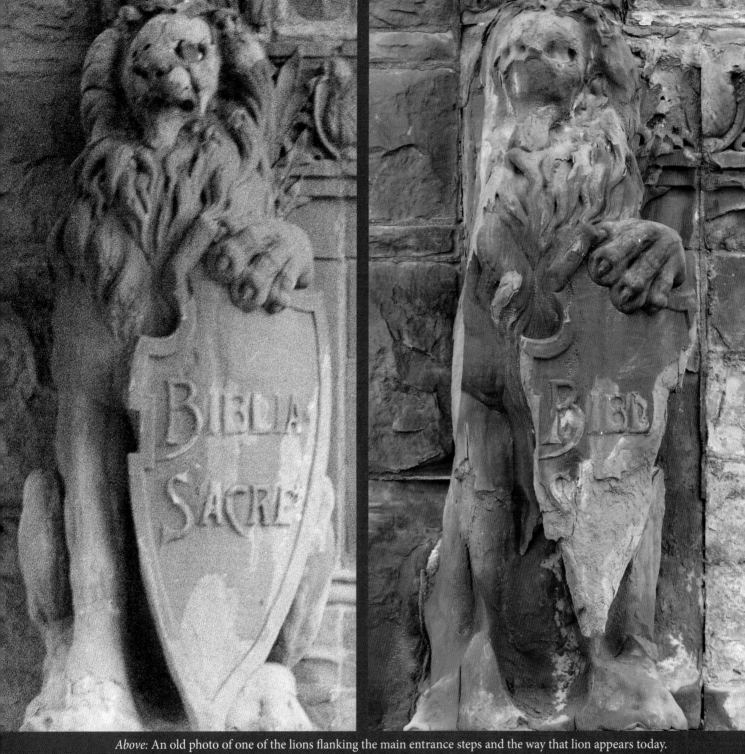

Above: An old photo of one of the lions flanking the main entrance steps and the way that lion appears today.

Below: Reliefs from the west wall that replaced the lion statues when they were moved.

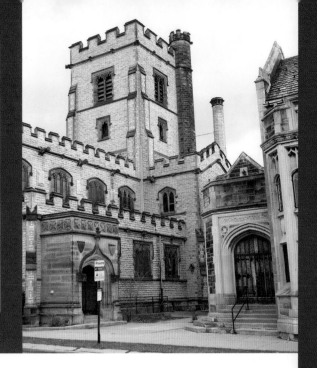

(Spirit of Hope)

1519 Martin Luther King Jr. Boulevard

Dedicated: 1892

Architect: George D. Mason (Mason & Rice)

Sculptors: Edward Q. Wagner, Richard G.
 Reuther, Hubert Cull

AT THE END OF the nineteenth century, a church that could have been built in the fourteenth century was erected at the corner of Myrtle Street (now Martin Luther King Jr. Boulevard) and Trumbull Avenue. With a unique design based on extensive historical research, Trinity Episcopal is one of the first and finest Gothic Revival churches built in the United States.

James Scripps made his fortune as the publisher of the *Detroit News.* He built a Tudor mansion on Trumbull near Grand River Avenue, and he and his wife, Harriet, joined a Reformed Episcopal congregation housed in a wood-frame church across the street. They donated money for a new church, and finding contemporary Victorian styles frivolous and decadent, Scripps took great pains to make sure this new church would be authentically Gothic and, as he put it, "stimulate, if possible, a return to the older and more truly artistic forms."[1]

An English architect was hired to research Gothic churches in southern England, and he provided the firm of Mason & Rice with drawings and historical evidence on which to base its designs. The resulting building, with its gargoyles and crenellations, brought a truly medieval character to this particular corner of Detroit.

Few buildings in Detroit rival Trinity Episcopal Church for the quantity, quality, and variety of its exterior adornments. Scripps felt "the genius of Gothic architecture is life, and the whole building should properly teem with animal and vegetable life executed in stone."[2] To this end, 172 stone carvings were planned for the outside of the church, carved in the shapes of people, animals, devils, demons, and vegetation, all based on historical models. It is interesting to note that for each of the ten gargoyles above the clerestory windows, there is a corresponding stone angel inside the church.

The carvings on the east side of the church were designed and cut by Edward Q. Wagner, and those on the west side by Richard G. Reuther.[3] Wagner was born in Bitburg, Germany, in 1855 and immigrated to Detroit with his family around age ten. Here he studied art under Julius Melchers and later became his apprentice for four years. He also studied in New York and did some work in Chicago and Grand Rapids before returning to Detroit to start his own company. At the time Trinity Episcopal was built, he had formed a partnership with Reuther, who was born in Detroit in 1859 and also studied art with Melchers. Wagner worked in Detroit with several different partners until his death in 1913.

There are about a dozen blank stone blocks on the outside of the church that were intended for sculptures but never carved, three of which can be seen in the lower left corner of the picture on the facing page. There are also some barely started ornaments on the hood molding terminations on the east-side windows.

Church benefactor James Scripps was a staunch supporter of the Episcopal Reform movement. When Trinity's congregation voted to join the Episcopal Diocese of Michigan in 1896, a non-Reform diocese, Scripps got so angry that, according to Bob Smith, the deacon of the building's current congregation, "he took his ball and went home."[4] He pulled his financial support from the church, leaving some of the stonework unfinished. It is said that Scripps's ghost returned to the building after his death and haunts the bell tower.

The building is still in use today as Spirit of Hope, a combined Episcopal and Lutheran congregation that provides important social services to the surrounding community.

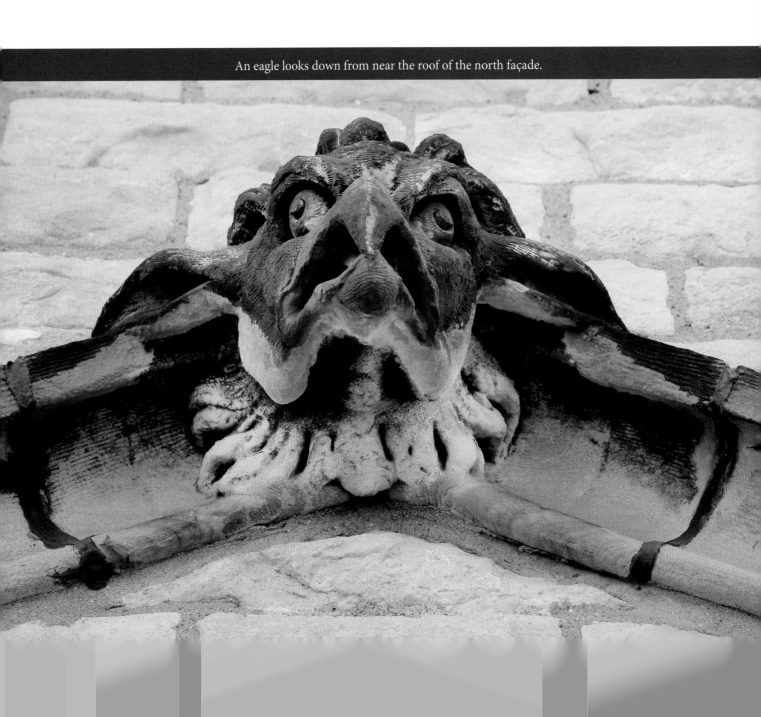

An eagle looks down from near the roof of the north façade.

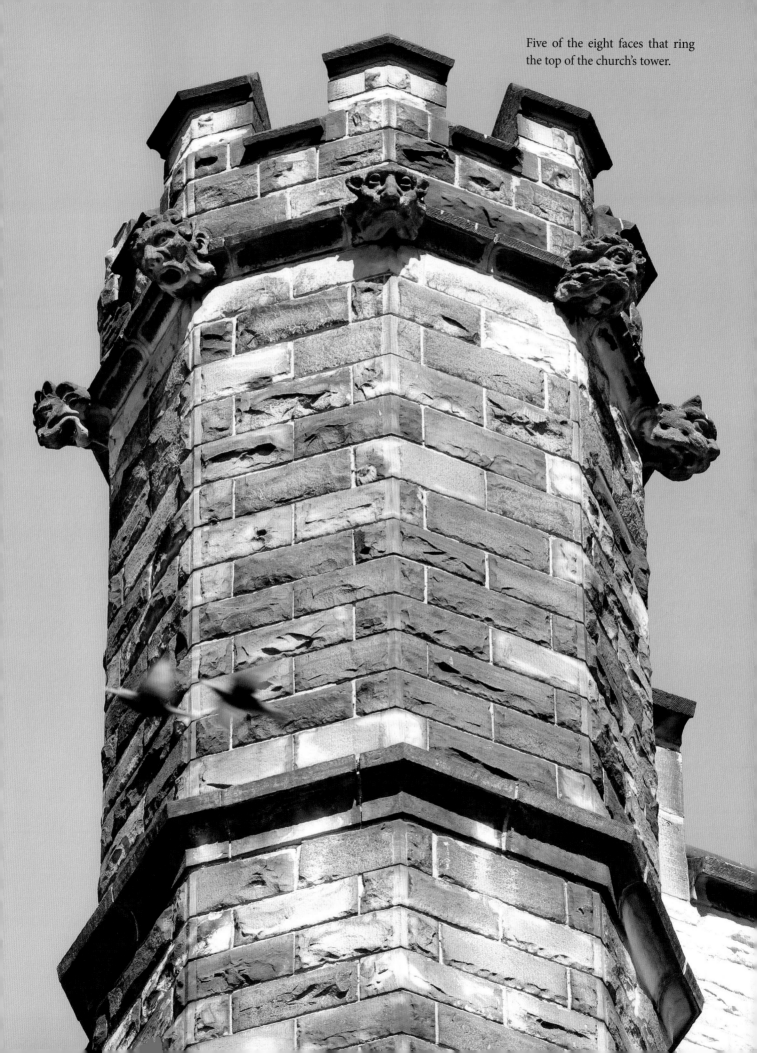

Five of the eight faces that ring the top of the church's tower.

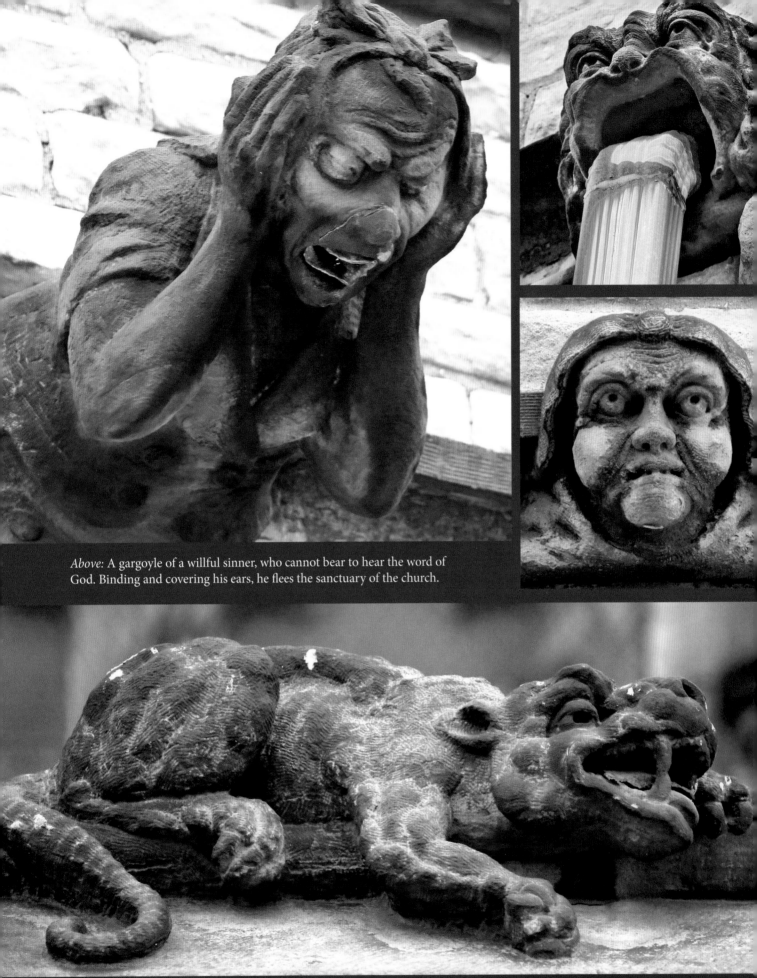

Above: A gargoyle of a willful sinner, who cannot bear to hear the word of God. Binding and covering his ears, he flees the sanctuary of the church.

This small church has an incredible variety of faces and figures, featuring more than 150 exterior

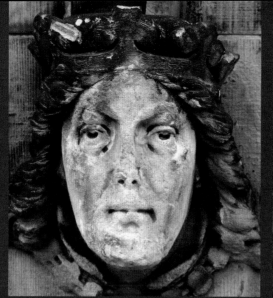
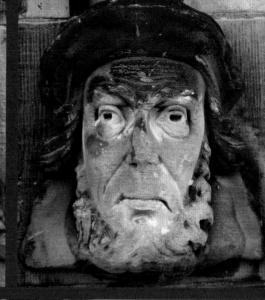

Right: Portraits of King Richard II and John Wycliffe flank the east entrance. Richard II ruled England from 1377 to 1399, the time period that Trinity Episcopal Church is meant to evoke. John Wycliffe is recognized as the first person to translate the Bible into English. Both carvings were made by Edward Wagner, working from old engravings. Corresponding portraits of Geoffrey Chaucer and William of Wykeham intended for the west entrance porch were never carved.

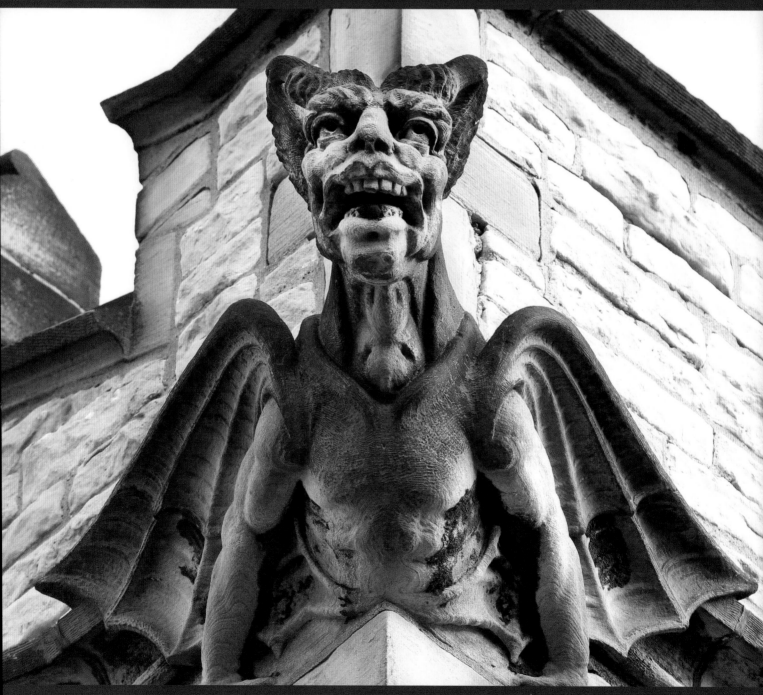

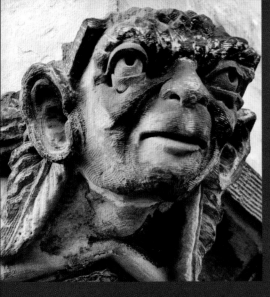

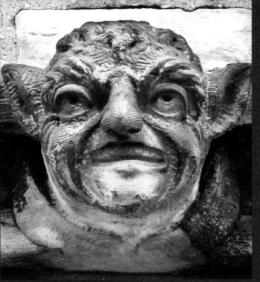

The stone gargoyles and grotesques show the effects of more than a century of exposure to air pollution, birds, and the harsh extremes of Michigan's weather. Note that most of them appear to be leaving the church, showing that there is no room inside the house of God for demons and evil spirits.

Below: This damaged gargoyle represents a wolf in clerical robes, warning against misuse of authority by the clergy, one of the causes of the reform movement.

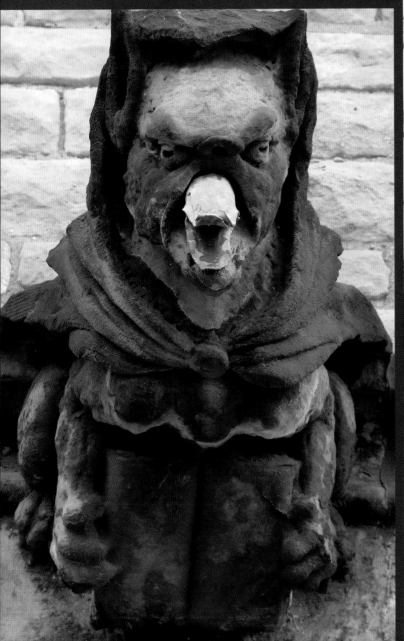

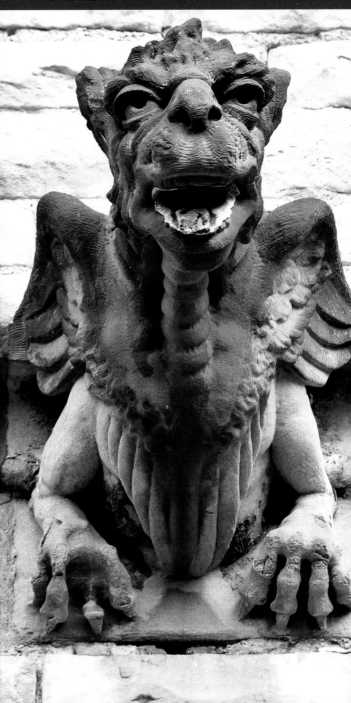

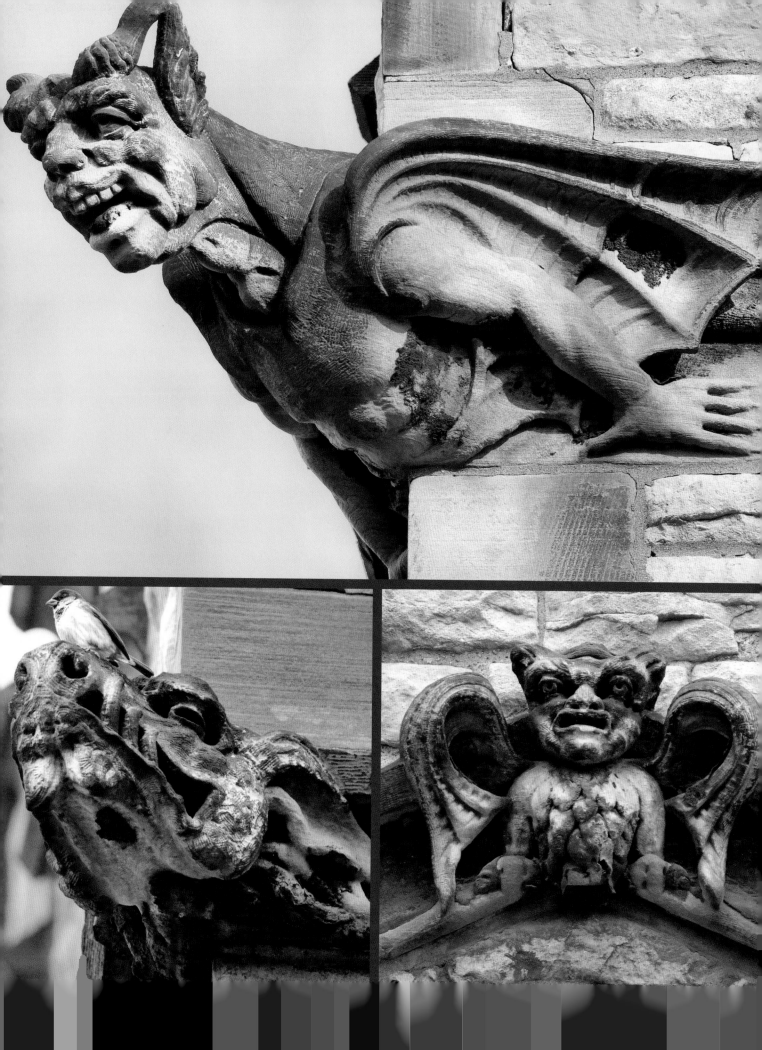

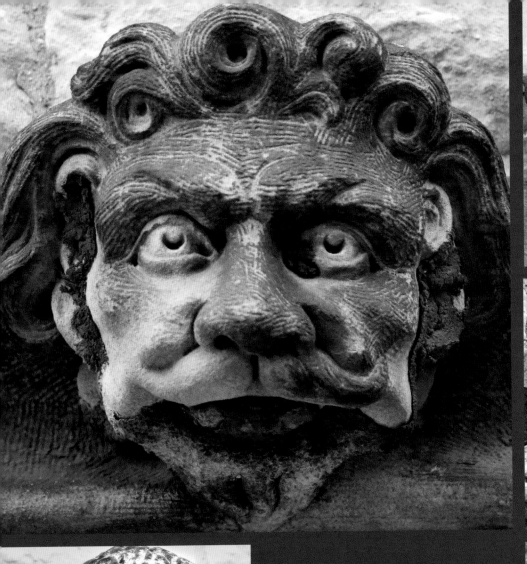

Left: Most of Trinity's carvings are based on historic fourteenth- and fifteenth-century English models, but this gargoyle is believed to be a portrait of the building foreman.

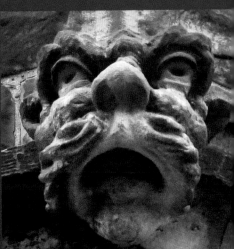

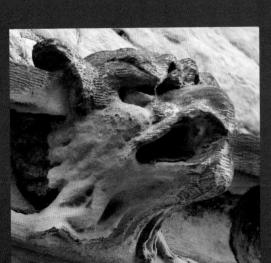

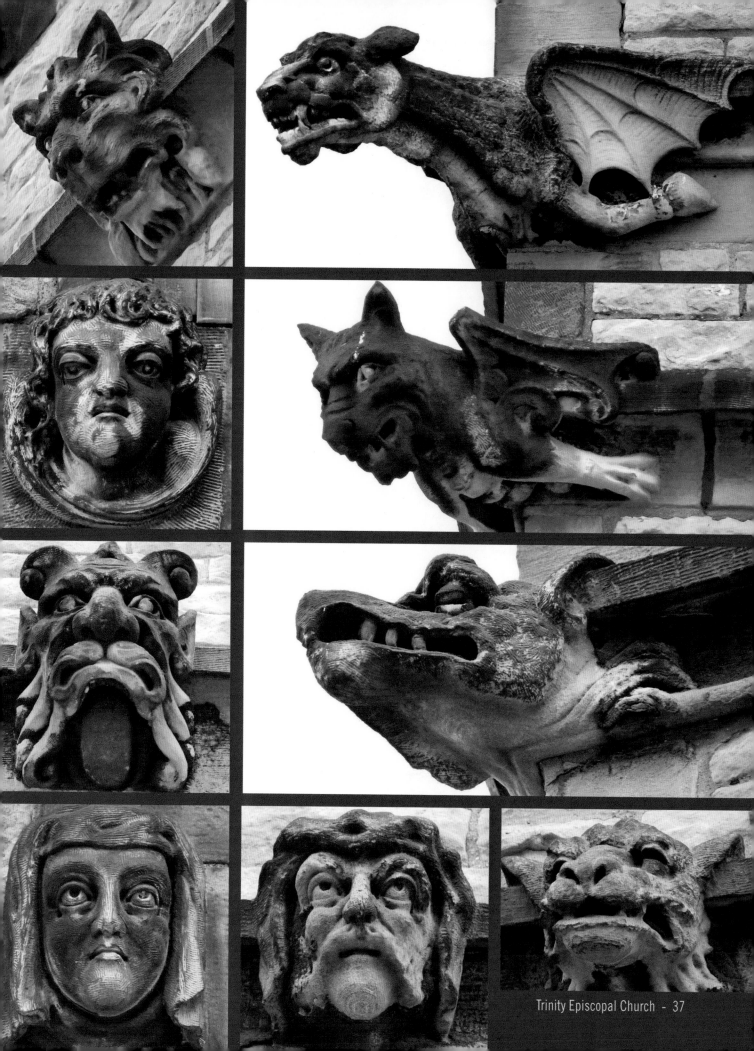

Trinity Episcopal Church - 37

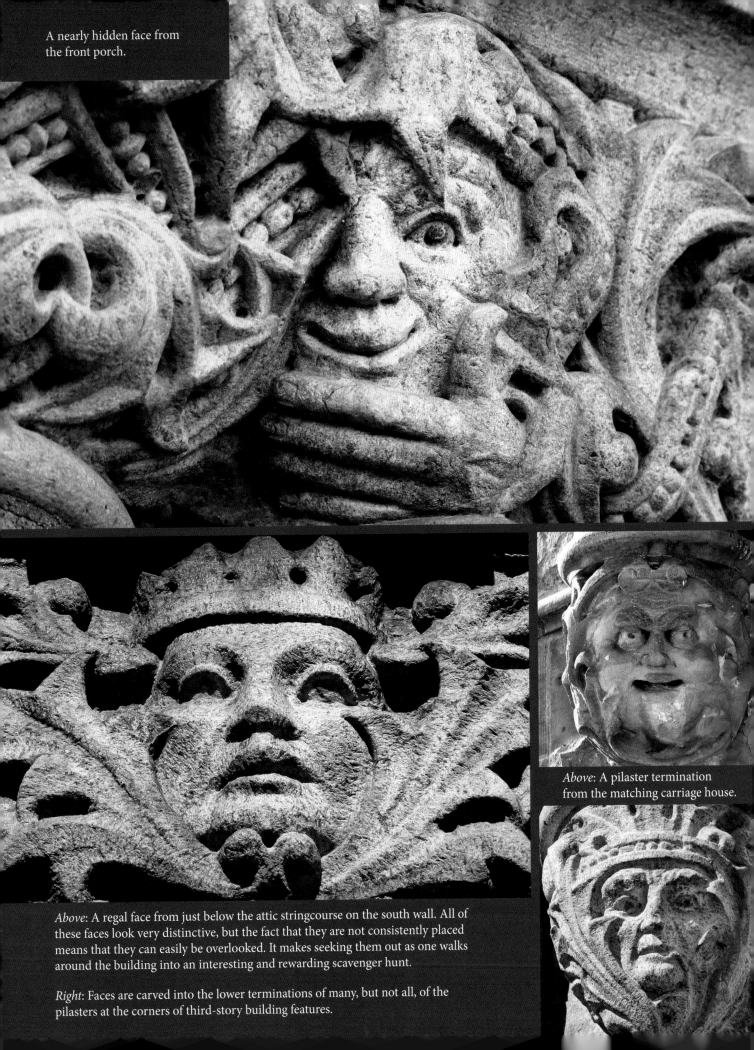

A nearly hidden face from the front porch.

Above: A pilaster termination from the matching carriage house.

Above: A regal face from just below the attic stringcourse on the south wall. All of these faces look very distinctive, but the fact that they are not consistently placed means that they can easily be overlooked. It makes seeking them out as one walks around the building into an interesting and rewarding scavenger hunt.

Right: Faces are carved into the lower terminations of many, but not all, of the pilasters at the corners of third-story building features.

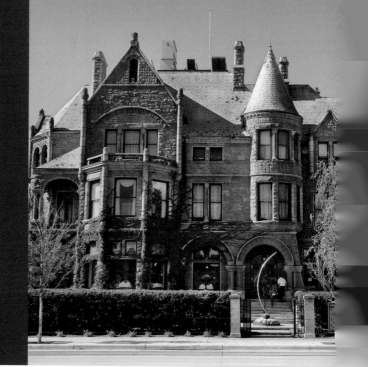

4424 Woodward Avenue

Completed: 1894

Architect: Gordon W. Lloyd

Sculptor: Unknown

REGARDING DAVID WHITNEY JR.'s palatial new residence being built at the corner of Woodward and Canfield Avenues, "Whitney disclaim[ed] any lot or part in the affair, saying the whole project [was] Mrs. Whitney's," according to the *Detroit Free Press* a week after the groundbreaking in June 1889.[1] Apparently, Sarah Whitney felt that the richest man in Detroit should have "the most pretentious modern home in the state and one of the most elaborate houses in the west."[2]

The three-story Romanesque mansion was noted for its style, size, and construction materials. The exterior walls are built almost entirely of jasper, a type of pink granite noted for its hardness and endurance, brought to Detroit from Sioux Falls, South Dakota. The stone was so hard that it was necessary to have a blacksmith shop on site because the best chisel would lose its edge after as little as ten minutes of work.[3] The quality of the stone is further seen in the fact that the many faces hidden among the ornamental scrollwork and carved vegetation still look as if they could have been carved yesterday. It is not known who did the carving, but the style is very similar to that of Alfred F. Nygard, who did the sculpture on Wayne State University's Old Main.

The home, which took a bit more than four years to build, was even more elaborate on the inside. It featured oak, mahogany, and maple molding, wainscoting, and floors; pillars and mosaic floors of imported marble; and several large Tiffany stained-glass windows. The more than fifty rooms included a twenty-four-by-fifty-foot grand hall, library, conservatory, and music room and a third-floor art gallery.

David Whitney Jr. was born in 1830, the son of a farmer in Westford, Massachusetts. He got into the lumber business in 1854 and came to Detroit in 1857, investing heavily in Michigan's pine timberlands, buying from the government for as little as $1.25 an acre and seeing the value increase up to a hundredfold.[4] He then invested in Detroit real estate, Great Lakes shipping, and many of Detroit's banks and industries. After his death in 1900, Whitney was lauded by associates for his generous but private acts of charity, usually provided on the condition that no one was to know they came from him.[5]

Sarah Whitney stayed in the home after her husband's death, until her own death in 1917. The building then housed the Wayne County Medical Society, the Visiting Nurses Association, and, since 1979, an upscale restaurant called The Whitney, under two different owners.

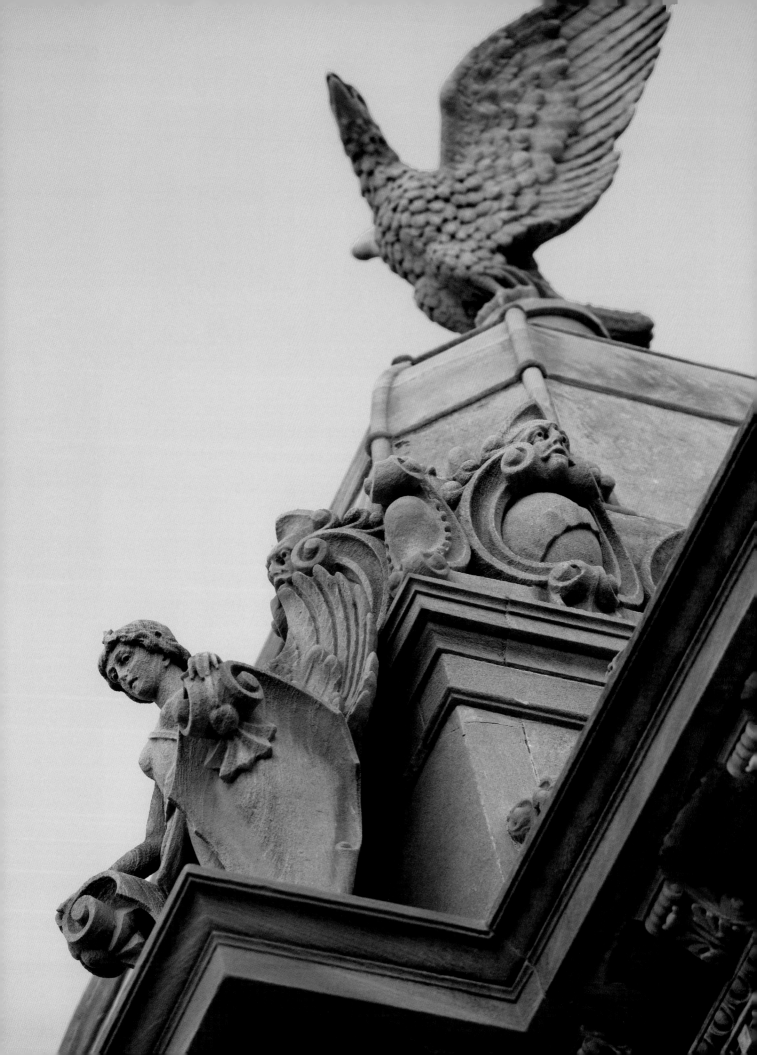

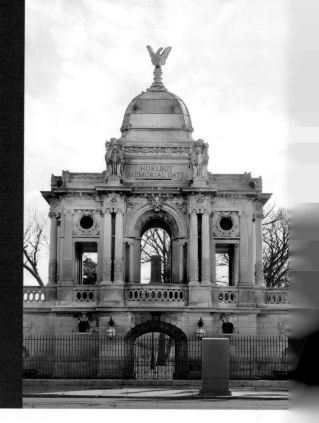

East Jefferson Avenue at Cadillac Boulevard

Completed: 1894

Architects: Herman A. Brede and Gustave Miller

Sculptors: Joachim Jungwirth, Richard G. Reuther, Richard H. Krakow Sr.

THE HURLBUT MEMORIAL GATE marks the entrance to Waterworks Park, which rivaled Belle Isle in its heyday but has since been mostly forgotten. The gate was built to honor Chauncey Hurlbut, a man who owned a thriving grocery business in the city and was also known for his strong sense of civic duty. He served on the board of the fire department, was a city alderman, was a director of the board of trade, and was a sewer commissioner. He was also a member of the board of water commissioners, serving as its president from 1871 until his death in 1885. When he died, he left $50,000 to be used for the beautification of Waterworks Park. Another $250,000 was added to the bequest when his wife, Philindra, passed away a year later.

Waterworks Park was one of the most beautiful and popular parks of its day. It featured elaborate floral displays, a winding canal that could be reached by canoe from the Detroit River, and a chance to enjoy a spectacular view of the city from the standpipe, a type of water tower. It was also the home of a group of a dozen enormous (six hundred foot tall) mission pear trees, planted by French settlers in the early eighteenth century and named for the twelve apostles. The last of these trees, Judas, finally succumbed to old age in the 1940s.

The elaborate gate was built to symbolically separate the peaceful confines of the park from the hustle and bustle of the city. It is 132 feet wide, 40 feet deep, and 50 feet tall. It included watering troughs for horses, an ornate iron gate for vehicle traffic, and a brass bust of Chauncey Hurlbut on a second-floor pedestal. The bust was created by Richard Reuther.

The contract for the sculpture was awarded to Richard Reuther & Company,[1] and Joachim Jungwirth was a partner in that firm. Jungwirth had immigrated to America from Austria in 1882, settling first in Wisconsin, then in Grand Rapids, and finally in Detroit. He partnered with Richard Reuther and also with Henry A. Siebert, before forming his own firm, J. Jungwirth & Company. He had made a living carving ships' figureheads in Europe.

Jungwirth is credited with the oak carving from the Brass Rail Restaurant on Grand Circus Park that now graces the front of the Kruse and Muer restaurant in downtown Rochester, Michigan (page 286). The exterior stone work on the Belle Isle Aquarium (page 68) is also attributed to Jungwirth, but he mostly did interior wood carving for churches and buildings such as the Detroit News Building (page 78), and the General Motors Building (page 104).

In 1893, Jungwirth helped create "the World's Largest Stove," which was placed near the Belle Isle

Bridge from 1903 to 1963, after it was brought back from the Chicago world's fair. It was displayed at the Michigan State Fairgrounds until it was heavily damaged by fire in 2011, and the remains have been put in storage by the Detroit Historical Museum. Jungwirth's son, Leonard, created a statue of Father Gabriel Richard that was placed near the stove on Jefferson Avenue at Sheridan. Leonard joked with Jungwirth that Father Richard could cross the boulevard and get warm at the stove when it got cold.[2]

Waterworks Park was closed to protect Detroit's water supply from saboteurs during World Wars I and II. It was closed again during the Korean War, partially opened in 1957, and closed for good in the early 1970s. The bust of Chauncey Hurlbut was stolen in 1975, and the gate fell into disrepair. The structure was restored in 2007 and now stands behind a wrought-iron fence, a closed gateway to an empty field, a beautiful Beaux-Arts reminder of Detroit's second most popular riverine park.

One of two youthful celestial figures near the top of the gate.

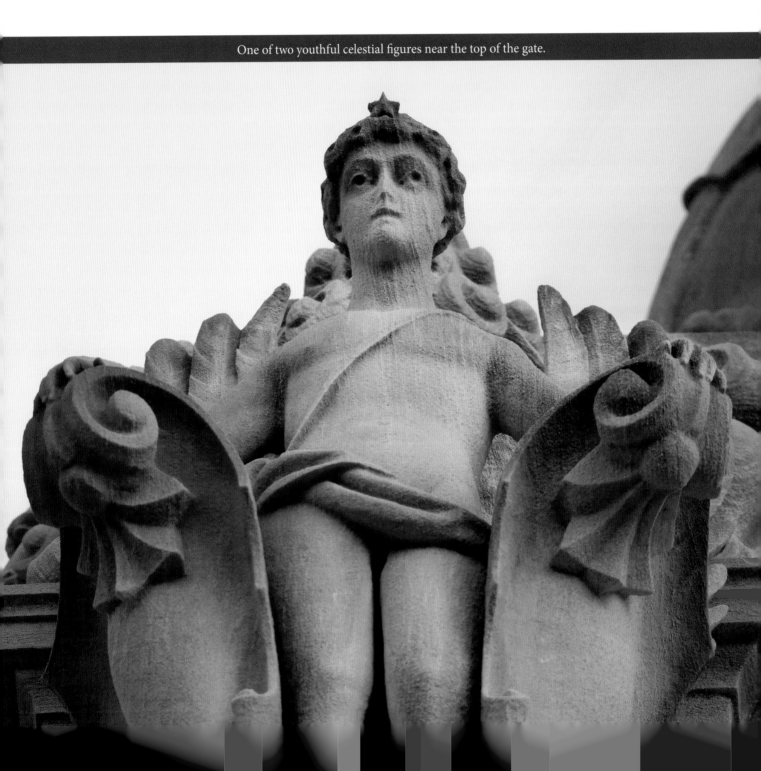

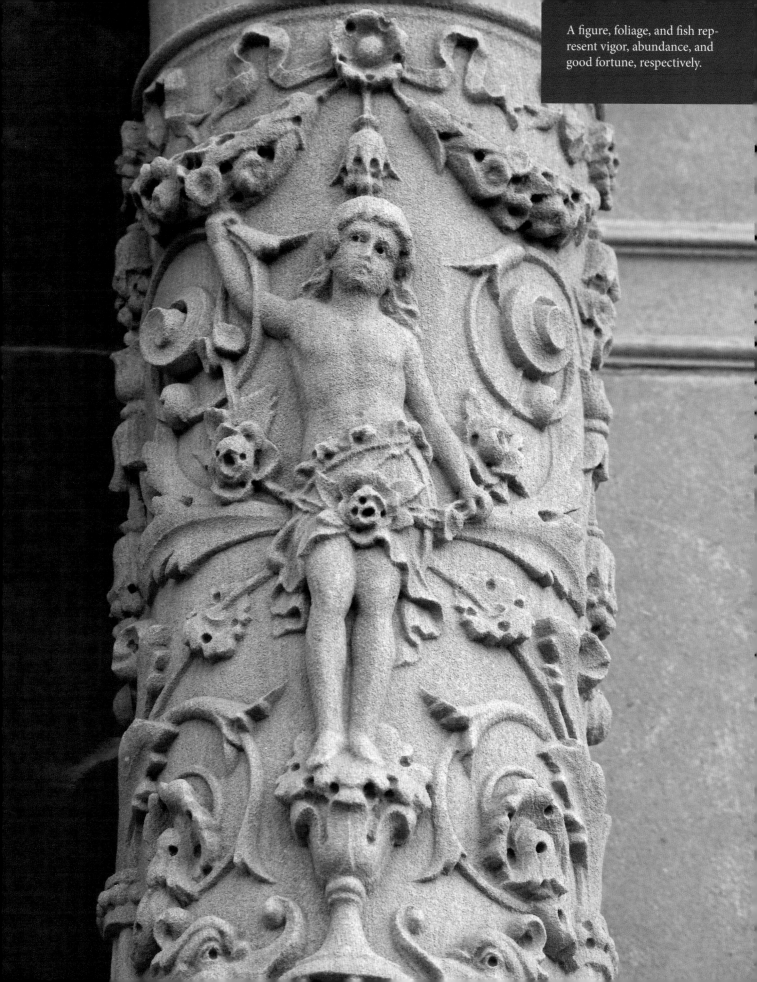

A figure, foliage, and fish represent vigor, abundance, and good fortune, respectively.

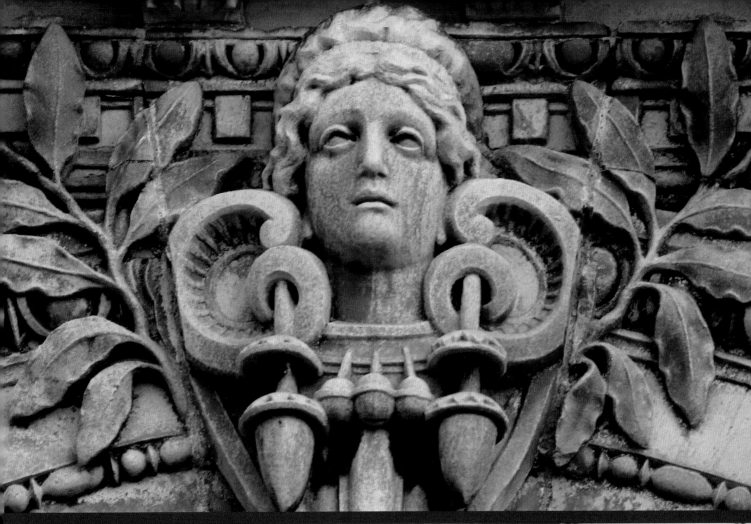

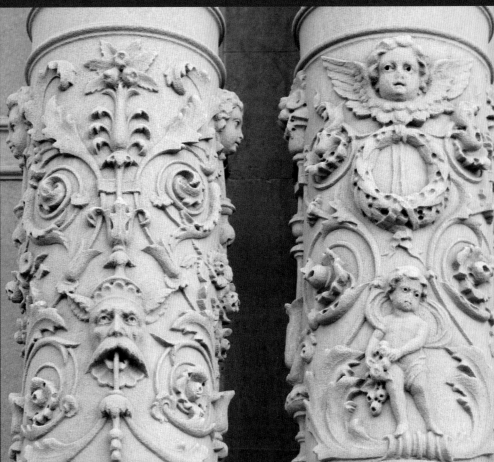

Above: This woman is carved into the keystone of the main arch. The acorns suspended from her elaborate necklace represent fertility and abundance, and the olive branches on either side represent peace.

Right: Paired pillars carved with intricate designs based on Italian Renaissance motifs support the central arch that once protected a bust of the gate's namesake, Chauncey Hurlbut.

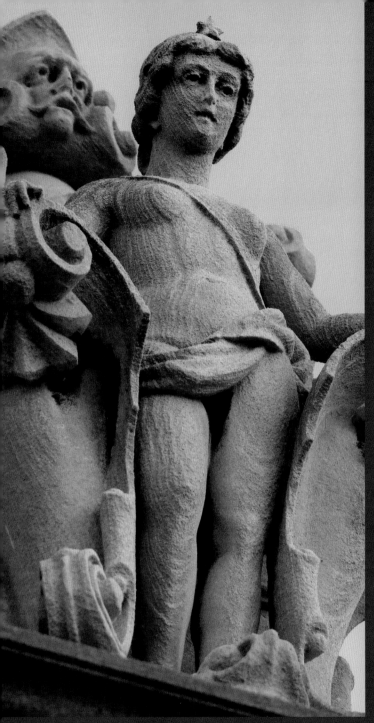

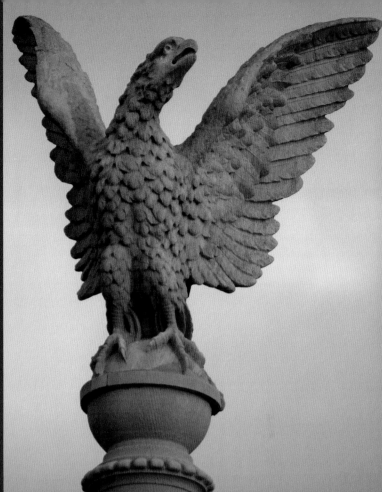

Above: A victory eagle tops off the central dome.

Below: At one time, this lion fountain spewed water into a horse trough.

Above: A young celestial figure with a star in her hair greets all who enter the park.

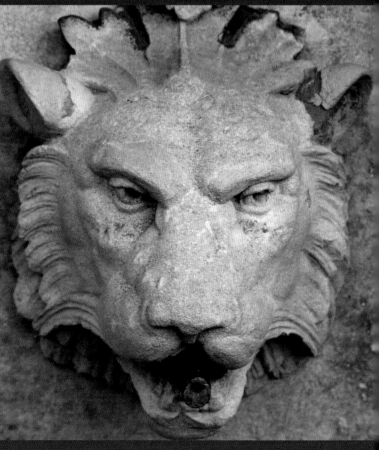

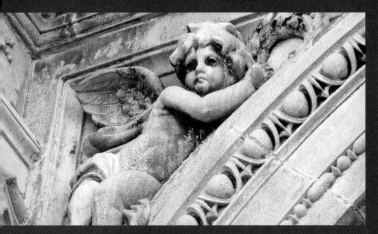

Above: A guardian cherub from a central arch spandrel holds a lau-

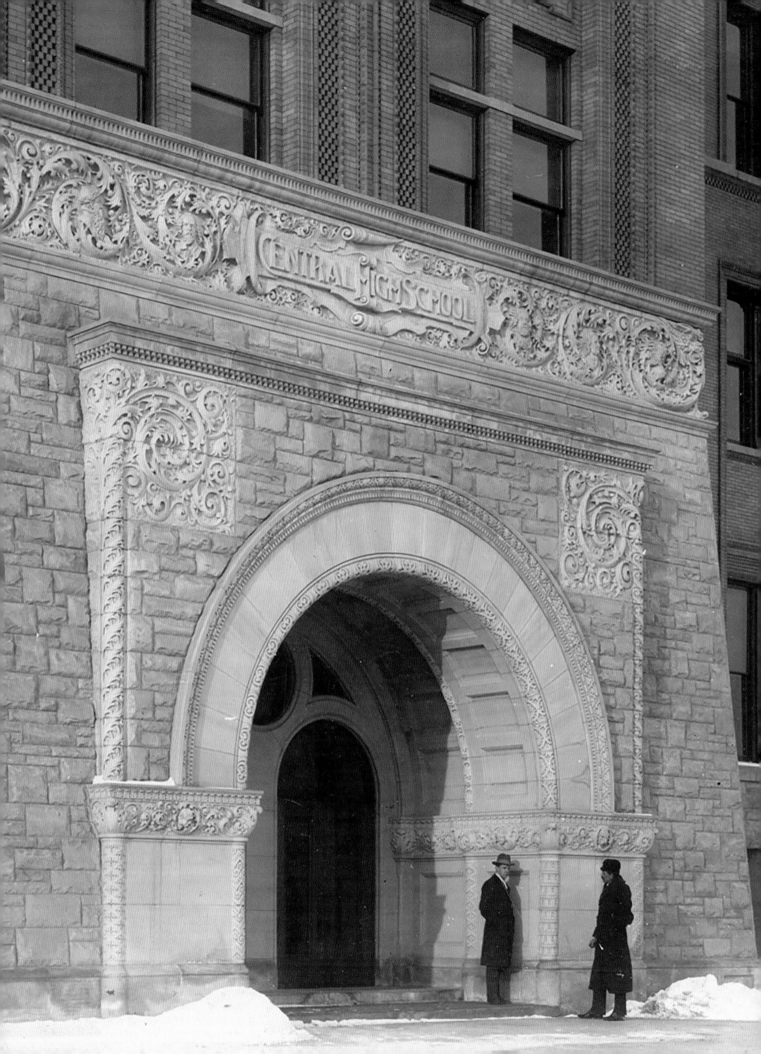

(Detroit Central High School)

4841 Cass Avenue

Completed: 1896

Architect: Malcomson & Higginbotham

Sculptor: Alfred F. Nygard

In 1858, the high school system of the city of Detroit consisted of one teacher, one class of twenty-three boys, and a single room in a wood-frame building on Miami Street (now Broadway).[1] It was opened over the protests of those who felt "higher education should not be tax supported and that it only bred discontent."[2] When the new Central High School opened just thirty-eight years later, it housed forty-nine teachers,[3] over sixteen hundred students, and had more than one hundred rooms.[4] During this same period, the population of Detroit had skyrocketed from roughly 45,000 to approximately 240,000.

The building opened for classes in September 1896, but it was not dedicated until January 13, 1897. The ceremony consisted mainly of long-winded speeches, and apparently people knew what was coming ahead of time, as the crowd was smaller than expected. The building's architect, W. G. Malcomson, made a speech and handed a large gold key to the Building Committee chairman, Thomas Craig, who made a speech and handed the key to the school board president, Caleb C. Pitkin, who made a speech and handed the key to the principal, Frederick C. Bliss, who also made a speech.

Bliss spoke of how well the building reflected the character of "this old French city," and Pitkin spoke of the importance of education in training each student "to think, to reason, to use the keen-est element of his nature—the mind." This followed the words of Thomas Craig, who assured everyone that for good luck, "nearly every important step in connection with the work had been considered and decided on by thirteen members of the board of education on the thirteenth of the month."[5]

Detroit's population grew even more rapidly during the early twentieth century, and despite a 1908 addition, the school, a building rated for eighteen hundred students, was soon housing over three thousand, about 12 percent of whom were Detroit Junior College students.[6] A new Central High School was built in 1926, and this building became the College of the City of Detroit Main Building. The structure's name was officially changed to Old Main after a 1950 addition and renovation.

The exterior of the building is mostly unchanged since its construction, except that the original tile roof has been replaced with aluminum. Unfortunately, the interior has been remodeled and modernized over the years, with little attention paid to historical preservation, and much of its original character has been lost. But the fact is, it is still in use after more than 120 years, and for many alumni, it remains an abiding symbol of the school they love.

Old Main features an intricately carved belt course above the main entrance with portraits of eight historical figures. For many years, people had

no idea of the existence of these carvings, as they were covered with ivy shortly after the school was built. It was not until a 1995 exterior cleaning that the ivy was removed and the portraits were once again exposed to view. Originally, there were twelve, but the faces of Johannes Gutenberg, William Shakespeare, Homer, and Isaac Newton[7] were chiseled off the front panel, along with the words "Central High School," to make room for "College of the City of Detroit" lettering, which was eventually changed to "Wayne University" and then "Wayne State University." The photo on page 46, from the Burton Historical Collection at the Detroit Public Library, shows how the main entrance looked when the school first opened. The people in the picture give an idea of the monumental scale of the entrance arch.

The sculpture on this building was created by Alfred F. Nygard, a Detroit sculptor of Danish origin, who worked on many Detroit homes and commercial buildings, including the original Hotel Ponchartrain. He created the bronze sculpture *Yet* in front of the Metropolitan United Methodist Church (page 172) and was one of the founding instructors at the Detroit School of Design, known today as the College for Creative Studies.

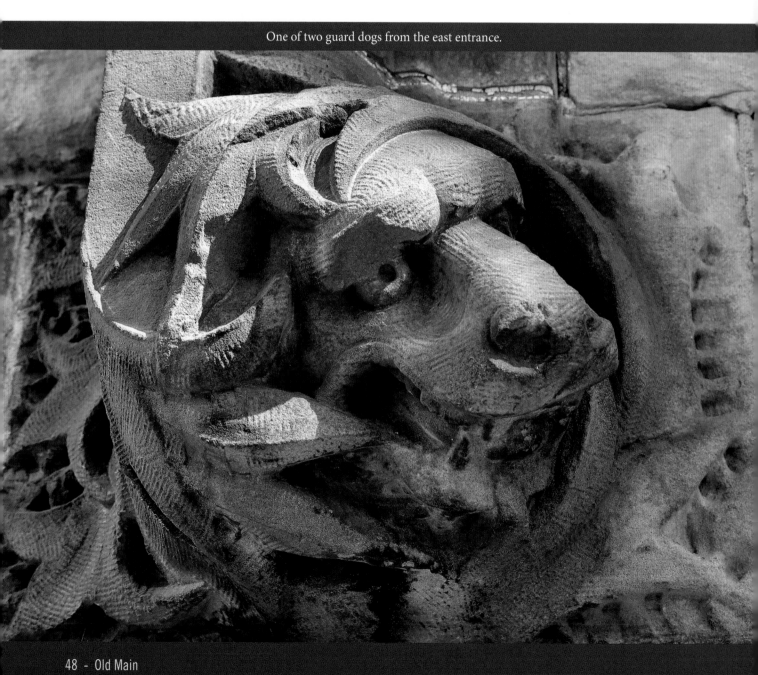

One of two guard dogs from the east entrance.

A portrait of Louis Pasteur from the south wall of the main entrance pavilion.

Above: A wise owl welcomes students from a corner of the entrance pavilion.

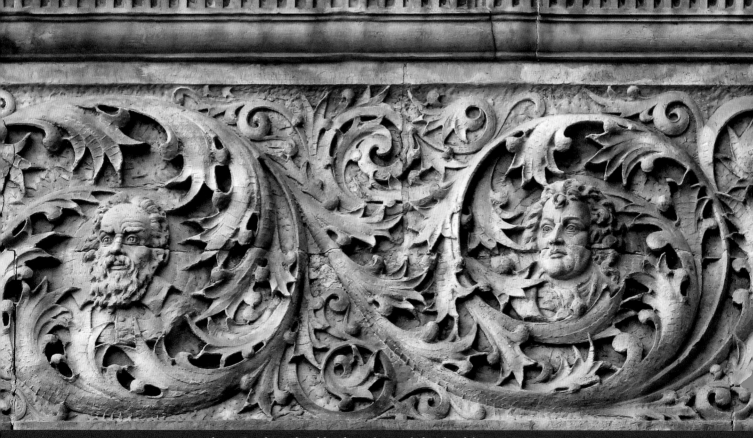

Above: Goethe and Galileo from the north façade of the main entrance pavilion in a view that

4150 Grand River Avenue

Completed: 1901

Architect: Louis Kamper

Sculptor: Unknown

JUST AS TRINITY EPISCOPAL Church (page 28) recalls England in the fourteenth century, the Eighth Precinct Police Station is a taste of the French Renaissance brought to Detroit. The chateau style was popular in Detroit at the turn of the century, and this building and the Woodward Avenue mansion that the architect Louis Kamper designed for Col. Frank J. Hecker are two of the finest examples of this style left in the city.

This fancifully elegant building features gables, arched windows, steeply peaked roofs, and round turrets with conical caps. The barn is connected to the main building with a triple-arched arcade that echoes the arches of the main entrance. The main entrance arches are supported by columns with Corinthian capitals topped with portrait heads similar to those on the Hunt Street Police Station (page 54). The difference is that instead of representing the rank and file, these are portraits of the mayor, the governor, and the members of the police commission when the building was erected. There is no record of who created them, but they are similar in style to those on the Book-Cadillac Hotel (page 114), another Kamper-designed building, whose sculpture is the work of Thomas Tibble and Louis Sielaff.

It has been suggested that the heads of the governor and the mayor are side-by-side, which would be ironic considering their shared history and mutual dislike, but comparison of the faces to period photographs suggests the portraits can be identified as follows, moving from north to south: commission secretary J. Edward DuPont; commissioners

George W. Fowle, Homer Warren, and Marvin M. Stanton; mayor William C. Maybury; commissioner Ralph Phelps; and a rather unflattering portrait of Maybury's political rival, governor Hazen S. Pingree.

Pingree was a reform-minded mayor and a foe of big business but left office when he was elected governor of Michigan in 1897. Captain Albert E. Stewart, chosen by Pingree to succeed him and continue his policies, lost by only five hundred votes (of thirty-six thousand cast)[1] to Maybury, a man popular with business interests. It is therefore not surprising that Maybury would see to it that Pingree's portrait got the position of least prominence on a building constructed under the auspices of his administration. And of course, Maybury got the plum position, to the right of the central arch.

Serving as Eighth Precinct Headquarters until 1954, the building then housed the Detroit Police Youth Bureau and was later used by the personnel division and the bomb squad. Abandoned by the Detroit Police Department in 1993, it was owned for some time by a property-management company. In 2013, the building was renamed Castle Lofts, and it now has multiple rental units split between both buildings, with a gymnasium and heated indoor parking on the ground floor of the converted barn.

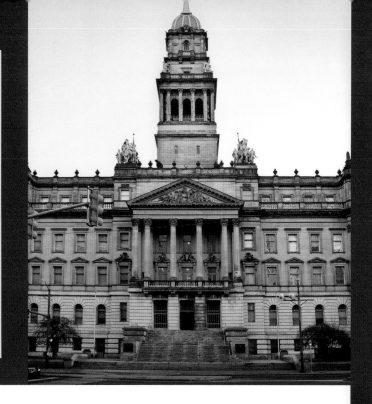

600 Randolph Street

Completed: 1902

Architects: John and Arthur Scott

Sculptors (stone): Richard G. Reuther, Edward Q. Wagner, Richard H. Krakow Sr.

Sculptor (quadrigae and tower allegories): John Massey Rhind

ONE LOOK AT THIS century-old Beaux-Arts palace in downtown Detroit, and it is easy to see why it has been a popular backdrop for movie production companies filming in the Motor City over the past few years. Scenes from *True Romance* and *Conviction* as well as big-money blockbusters such as *Transformers: Dark of the Moon* and *Batman v. Superman: Dawn of Justice* have been set in and around this historic reminder of the Age of Elegance.

The Wayne County Courthouse took six years to build, with ground being broken in 1896 and the building opening in 1902. A stunning example of Beaux-Arts architecture, it contains 44,625 square feet of space and housed 18 courtrooms and 145 other rooms. It is quite ornate, a hallmark of Beaux-Arts classicism, and features a wealth of stone carving in deep relief over and around many of the windows and all four entrances.

High above the main entrance and supported by six Corinthian pillars is the Anthony Wayne Pediment, featuring General "Mad" Anthony Wayne on horseback, conferring with Native Americans. Acting on orders from President Washington, Wayne defeated a Shawnee/Miami confederacy loosely allied with the British, compelling the British to surrender the entire region, known then as the North-west Territory, to the United States in 1796. Wayne County and Wayne State University are both named for General Wayne, as are the cities of Wayne, Michigan, and Fort Wayne, Indiana.

The pediment was considered one of the most important works of the sculptor Edward Q. Wagner and was often mentioned in connection with him. It represents the establishment of U.S. authority over the Northwest Territory, the introduction of agriculture and commerce to the area, and the "civilization" of the area's Native American population.

The structure also boasts two dynamic quadrigae and four tower allegories. A quadriga is a Roman chariot pulled by four horses, but sharp-eyed observers will notice that for some reason, these quadrigae have only three horses. The sculptural groups represent victory and progress and are the work of John Massey Rhind.

Rhind was born in Edinburgh, Scotland, where his grandfather, father, and all of his brothers save one (an architect) were ornamental sculptors. When he announced his intention to emigrate to America in 1889, his father advocated against it, saying, "There is no sculptural art in America, you'll starve."[1] Fortunately for Rhind, he arrived as the Beaux-Arts school of architecture was making its influence felt in the United States. He quickly

became one of the most prolific sculptors in New York, with many highly praised works throughout the East and the near Midwest.

Having visited Detroit in 1902 to discuss specifications for the competition to create the Hazen Pingree monument,[2] Rhind returned in 1903 to create models for the two quadrigae for the base of the tower and four personifications, of agriculture, commerce, law, and mechanics, for above the tower colonnade, after "studying the problem for nearly a year."[3] The statues were originally conceived to be cast in bronze, but economic considerations caused them to be fabricated of pressed copper sheeting over an iron frame, similar to how the Statue of Liberty was made. They were put in place in 1904.

The quadrigae have been at turns neglected and protected through the years. They survived a 1942 attempt by the Wayne County auditor Ray Hafell to turn them over to the war effort for scrap.[4] He apparently believed them to be cast bronze. A public outcry led by the Art Institute secretary Clyde H. Burroughs and the city planner Frank Barcus saved them. The roof below them was shored up in 1973 when it appeared they might fall through to the offices below. Wind and weather damaged the arm of one

of the charioteers in 1979, and Marshall Fredericks, the sculptor who created the iconic *Spirit of Detroit* and the reliefs on the Rackham Educational Memorial (page 278), stepped forward to perform the repairs at no charge to the county.[5] In the winter of 2006–7, the quadrigae were removed from the building for two years and taken to Venus Bronze Works in Detroit, where the original armatures were replaced with stainless steel.

The building was home to the Wayne County Hall of Justice and county offices until the City County Building (now the Coleman A. Young Municipal Center) opened in 1955. After that, it housed the Detroit Traffic Court and the Wayne County Friend of the Court. Over the years, it was allowed to become run down and shabby; but a $25 million renovation restored it to its original glory in 1987, and the county consolidated several large departments there at that time. Unfortunately, Wayne County later abandoned "Old County" for good when it purchased the Guardian Building (page 228) for its offices in 2010. The Wayne County Building has been empty since; but it was announced in May 2017 that another interior and exterior renovation was in the works, and a single-occupancy tenant was actively being sought.

Facing page: The central tower has an allegorical sculpture on each corner. The three visible here are "Mechanics," "Agriculture," and "Commerce."

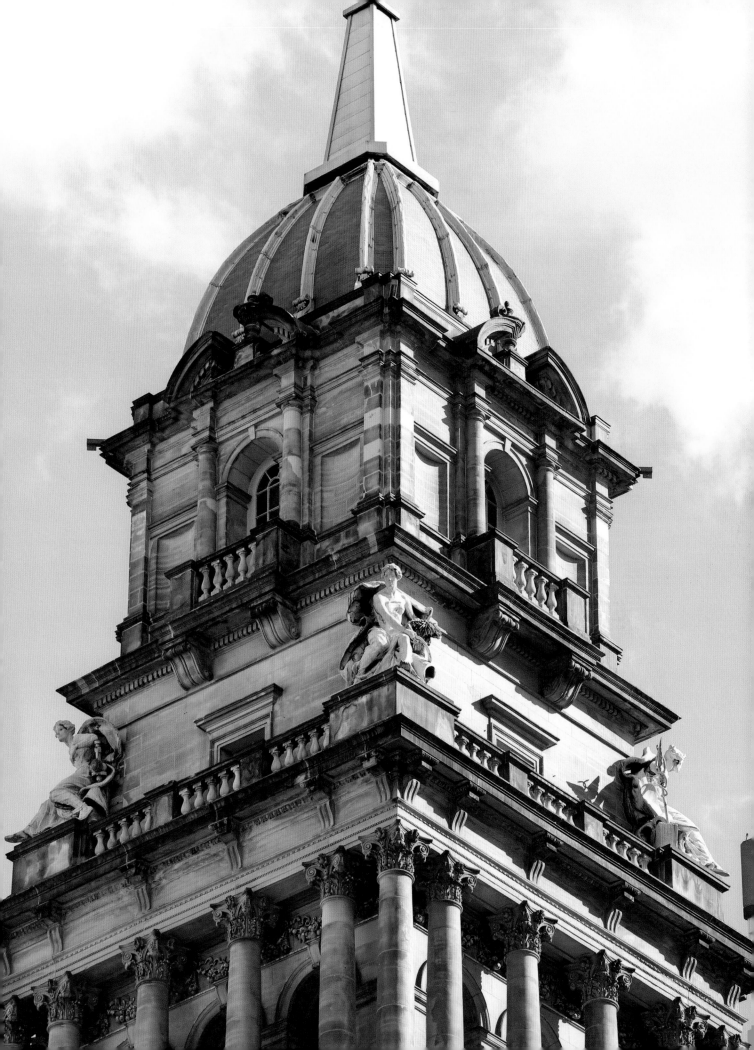

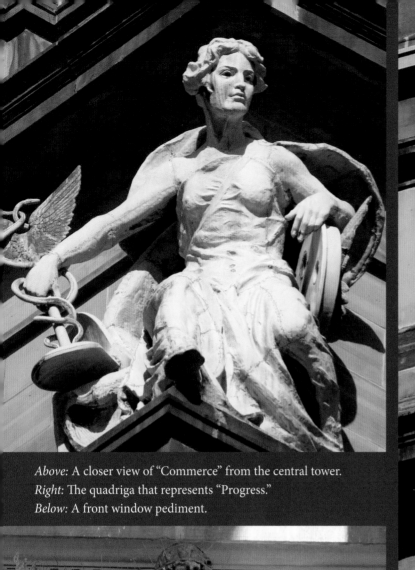

Above: A closer view of "Commerce" from the central tower.
Right: The quadriga that represents "Progress."
Below: A front window pediment.

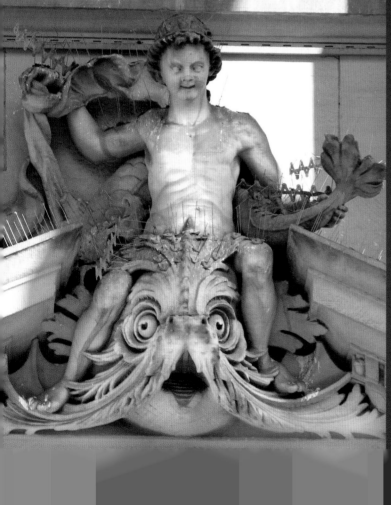

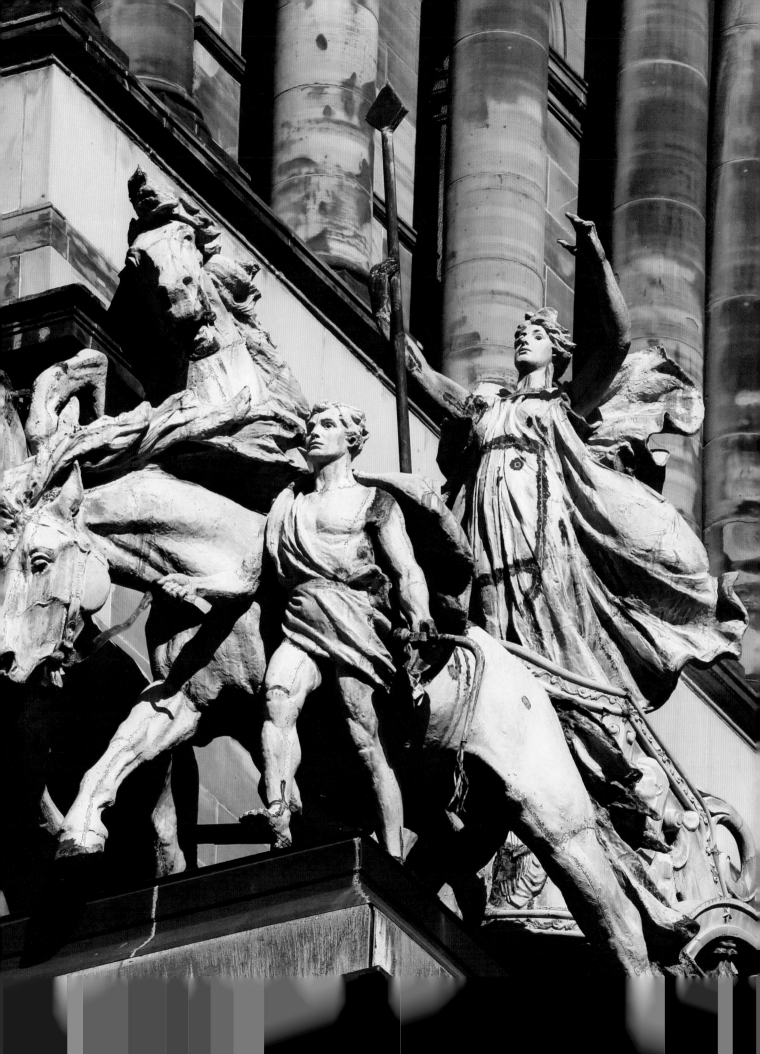

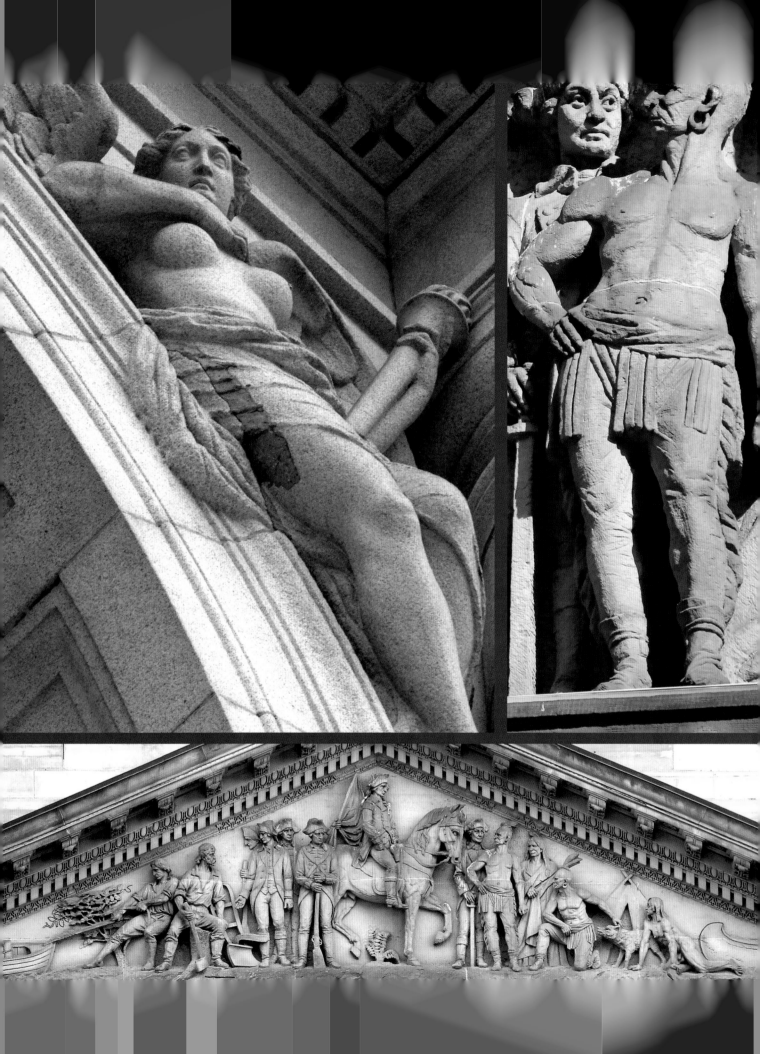

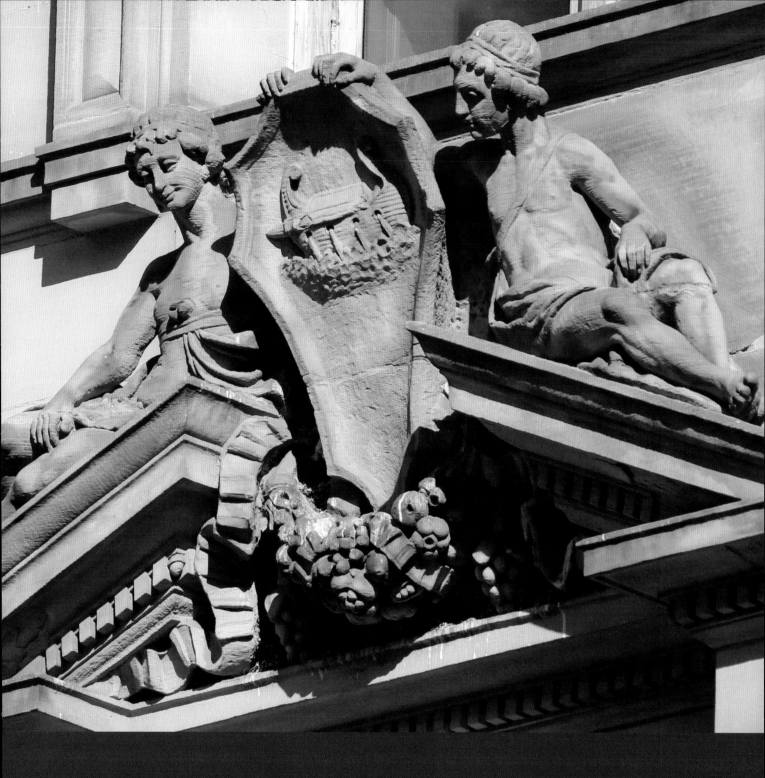

Above: A window pediment with a shield showing the ship of humanity passing safely over a sea of worldly temptation.

Facing page, bottom: The entire Anthony Wayne Pediment. Note the aggressive poses of the settlers on the left and the submissive postures of the Native Americans on the right.

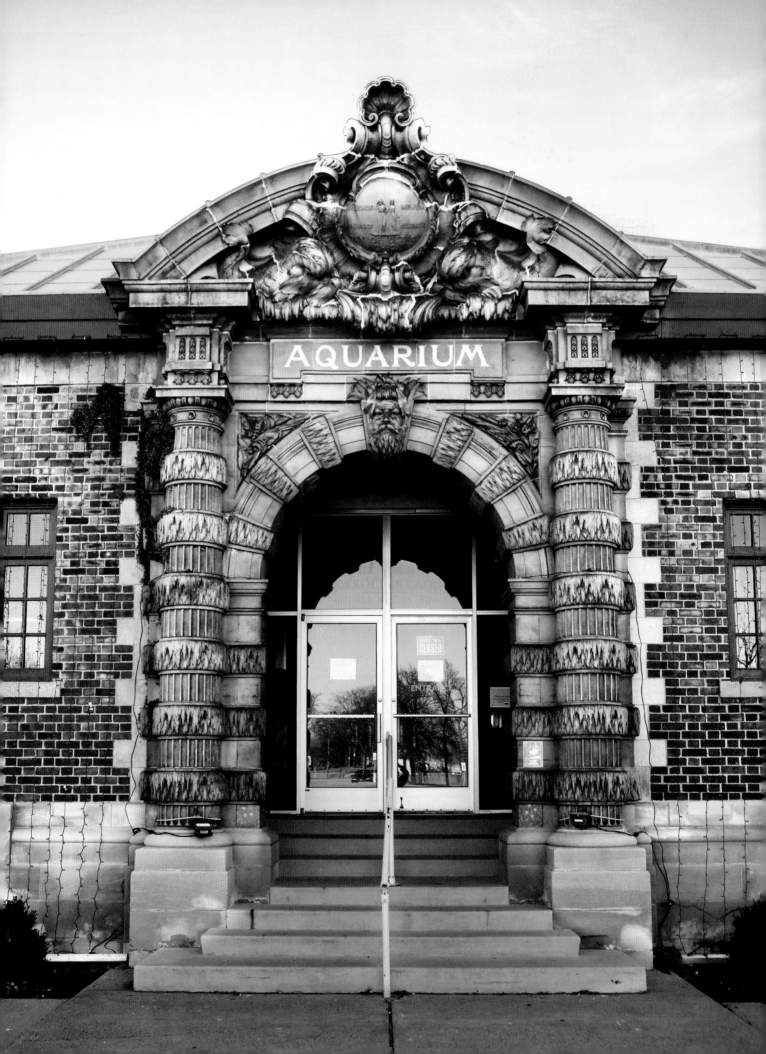

AQUARIUM

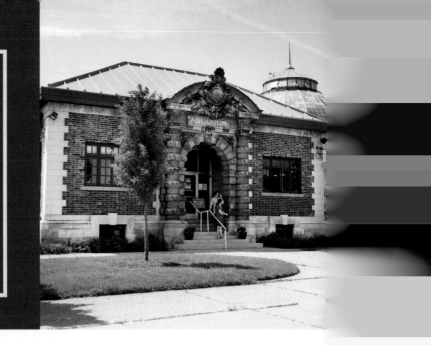

900 Inselruhe Avenue

Completed: 1904

Architect: Albert Kahn

Sculptors: Attributed to Joachim Jungwirth (stone), Bruce Gerlach (weather vane)

O N AUGUST 1, 1900, the Parks and Boulevards Commission invited Detroit architects to submit plans for a new aquarium and horticultural building to be erected on Belle Isle. Fifteen architects and architectural firms, two draftsmen, and an artist announced that they would enter the competition.[1] By the time the October 15 deadline rolled around, only five or six proposals were submitted. The design created by a young architect named Albert Kahn was selected. It was the biggest project yet in the early career of a man who was to become world famous as a revolutionary designer of industrial and commercial buildings in Detroit and around the world. This is the first of several Kahn designs featured in this book.

Before Kahn completed his design, he studied aquariums in New York, Washington, DC, and Hamburg, Germany. He created a facility that was widely hailed as the finest aquarium in the world and that served as an inspiration for later aquarium designers in Boston, Chicago, and other cities.

Ornamentation on the building is concentrated around the classically inspired entrance and features intricate work attributed to the dean of Detroit architectural sculptors, Joachim Jungwirth. Pillars on either side of the door are adorned with carved bands of seaweed, and the keystone of the entrance arch features Neptune with a crown of cattails. Above that is an elaborate cartouche displaying the seal of the City of Detroit and a pair of dolphins playfully spitting water at all who enter.

The new aquarium proved to be immensely popular with Detroiters. It first opened its doors in July 1904, and the two Sundays before the official dedication on August 18 saw crowds of 10,371 and 14,670 visitors. By the end of October, more than 315,000 people had toured the facility. They saw freshwater and saltwater creatures in forty-four wall tanks and several large pools. According to a 1911 catalog, the aquarium featured fifty species of freshwater fish, six species of freshwater crustaceans, amphibians, reptiles, forty-two species of saltwater fish, six species of saltwater crustaceans, four species of sea turtles, and a variety of starfish, sea urchins, and sea anemonies.[2]

The Belle Isle Aquarium maintained its popularity through good times and bad, surviving everything from the sale for soup of Pete the loggerhead turtle in 1932, when the aquarium could no longer afford to maintain saltwater exhibits,[3] to the 1972 theft of an alligator by pranksters, who hoped to deposit it in a pool in front of Cobo Hall before a Rolling Stones concert. The pranksters were thwarted by larger-than-expected crowds and a substantial police presence and returned the gator to Belle Isle, releasing it in the James Scott Memorial Fountain (page 134).[4] The aquarium even survived a 1972

threat of closure due to budget cutbacks, thanks in part to an unexpected sewer-bill refund of $13,339.

The aquarium was also honored three times with the coveted Edward H. Bean Award, the highest honor presented by the American Zoo and Aquarium Association. It won in 1975 and 1984 for breeding programs involving oscillating stingrays and checkerboard stingrays and in 1984 for saving the golden skiffia, a Mexican fish discovered in 1970 that had become extinct in the wild.[5]

Unfortunately, time, finances, and politics finally caught up with the then-101-year-old institution in 2005. The combination of a $230 million city budget deficit, the need for extensive building repairs and maintenance, and the belief among some zoo officials and others that the aging 10,000-square-foot building should be replaced with a new, state-of-the-art 150,000-square-foot riverfront facility led to the closure of the oldest continuously operating aquarium in the world. But that was not the end of the story.

Through the efforts of the Belle Isle Conservancy, the aquarium was reopened in 2012 as the only all-volunteer-run aquarium in the United States, with twelve operating tanks. Over four thousand people visited that day, with the doors staying open past closing time to accommodate the crowd. The aquarium now has forty-two tanks with over 175 species of Great Lakes and saltwater marine life and an average of twenty-five hundred visitors per weekend. In 2014, the aquarium held a contest to replace the long-lost fish weather vane that is visible in old postcards. The winning entry features a spotted gar surrounded by four electric eels, created by the Eastpointe sculptor/illustrator Bruce Gerlach. The Conservancy continues to promote further restoration of the building, which is open every Friday through Sunday. Admission is free.

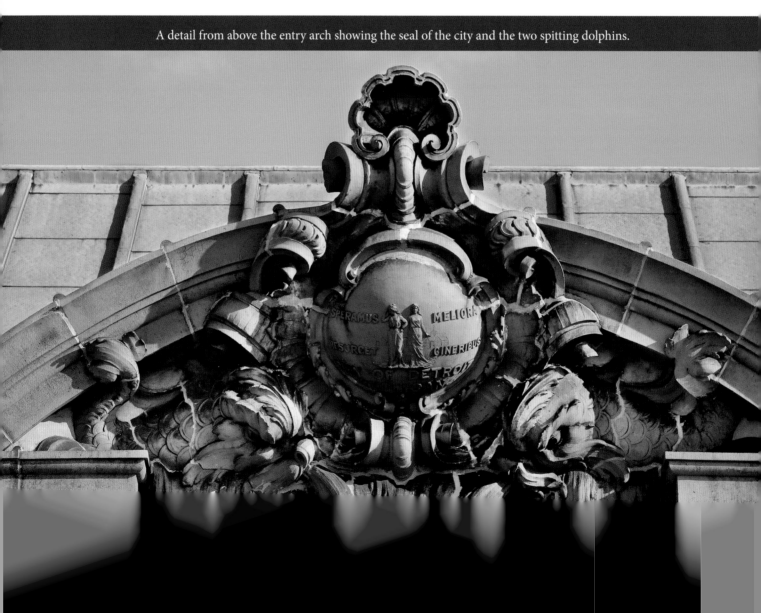

A detail from above the entry arch showing the seal of the city and the two spitting dolphins.

Above: Detail of "Neptune" from the entrance arch keystone.

Below: The spotted gar weather vane.

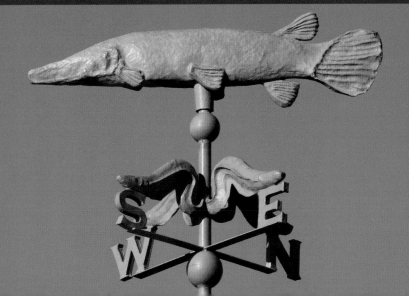

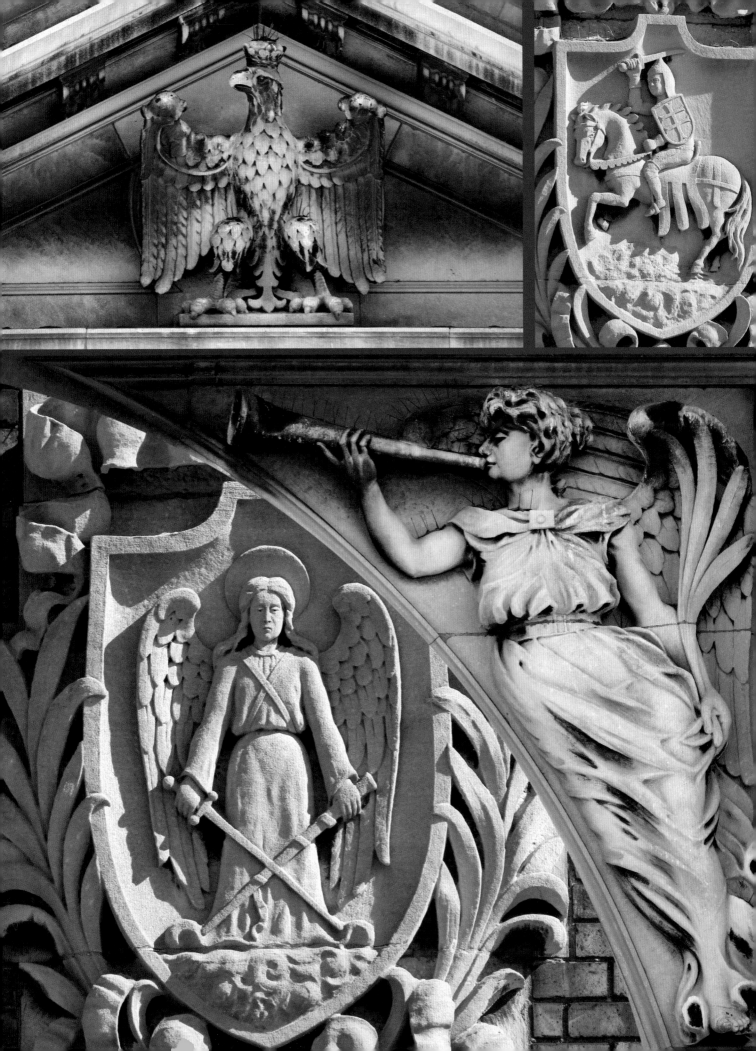

4500 Wesson Street

Completed: 1905

Architects: Joseph Kastler,
William Hunter

Sculptor: Unknown

Due to many factors, including lack of economic opportunity, political unrest, and growing Russian and German power in Europe, Detroit saw a huge influx of Polish immigrants during the second half of the nineteenth century. Many settled along the western border of Detroit, north of Michigan Avenue, which was a thirty-foot-wide plank road at the time. As that population grew, the need for a new Polish Catholic church in the area became apparent, and this led to the founding of St. Francis D'Assisi Parish in 1889, the fifth Polish parish in Detroit.

The façade of St. Francis D'Assisi Church is unique among Detroit's Polish Catholic churches in that it is the only one to prominently feature symbols of Polish nationalism. Poland of that time had been partitioned by the great powers of Europe and was mostly under Russian rule. These powerful symbols were a reflection of the parishioners' fervent hope for the restoration of a strong, unified, and independent Poland.

The main entrance is enclosed in a triumphal arch that features angels in the spandrels holding palm leaves and blowing trumpets. Directly above the entrance is the White Eagle of Poland, a symbol of Polish sovereignty since the eighth century.

Legend has it that Lech, the founder of Poland, found a white eagle's nest, and as he gazed upon it, a bright ray of sunshine fell on the eagle. He decided to settle that area and made the white eagle his symbol.

To the left of the arch is a shield featuring the Archangel Michael, leader of the heavenly army and a symbol of protection from civil war, like the failed January Insurrection of 1863–64 against Russian rule, which many church members had fled. To the right of the arch is a Pogonia, a knight on horseback that was originally seen as leaping to the defense of the people, but after the 1569 union of Poland and Lithuania, it became a knight pursuing the enemy. The double cross on the knight's shield dates to the twelfth-century baptism of King Jogaila of Poland.

In the 1920s, St. Francis was among the largest and most vibrant parishes in Detroit. As the neighborhood changed, membership declined, and in the late 1980s, it looked as if the parish might be closed. Fortunately, it was determined that St. Francis Parish was still viable, and it remained open. The parish has most recently seen an influx of Hispanic members and has been combined with St. Hedwig Parish. Together, they offer mass in Polish, Spanish, and English.

3245 Junction Street

Completed: 1916

Architect: Harry J. Rill

Sculptor: Unknown

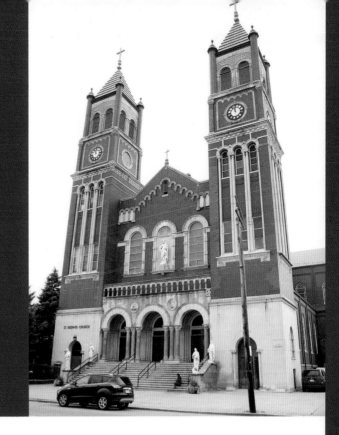

THE FIRST MASS IN this beautiful red-brick and limestone Italianate church was held in the basement on November 12, 1911. The service was held in the basement because the parish did not have enough money to build more than the basement until 1915, when work to complete the rest of the building began.

St. Hedwig Parish was formed in 1903 to serve the growing Polish community on what was then the far west side of Detroit. In fact, this area had only recently been annexed to the city. The village of Grand Junction was founded in 1859 along Junction Street south of Chicago Road (now Michigan Avenue). In 1874, it was renamed Detroit Junction, and in 1885, it became part of Detroit. It was an area composed of old brickyards, small frame houses, and unpaved streets.

The new church was needed because the parish had run out of room in its first building, a two-story structure with a community center in the basement, four classrooms plus teacher living quarters on the ground floor, and a second-story chapel with room to seat twelve hundred people. When the basement chapel opened in 1911, it had room for eighteen hundred. When the church was finally completed five years later, three thousand people attended the first service as the church was blessed by Bishop Edward Kelly.

The front façade features relief carvings of a lamb with a banner representing the church triumphant and a pelican with chicks, representing the atonement. A niche above the center door holds an icon of Saint Hedwig, the patron saint of Silesia, a central European region located mostly in southwestern Poland. The icon appears to be based on a statue that stands in Wrocław, the historic capital of Silesia.

One of the most interesting features of the church is the four expressive statues of the Evangelists that stand on each side of the wide front stairway. Based on the recollections of lifelong parishioner Tom Suski and review of historical photos, the statues were most likely placed in their current positions at some time between 1942 and 1949.

In 2013, St. Hedwig Parish and St. Francis D'Assisi Parish (page 72) were merged. The combined parish serves the area's remaining Polish residents as well as the growing Hispanic population.

Above: The weather-worn face of Saint Matthew looks over the scroll of his Gospel.

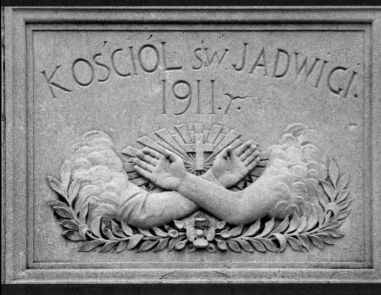

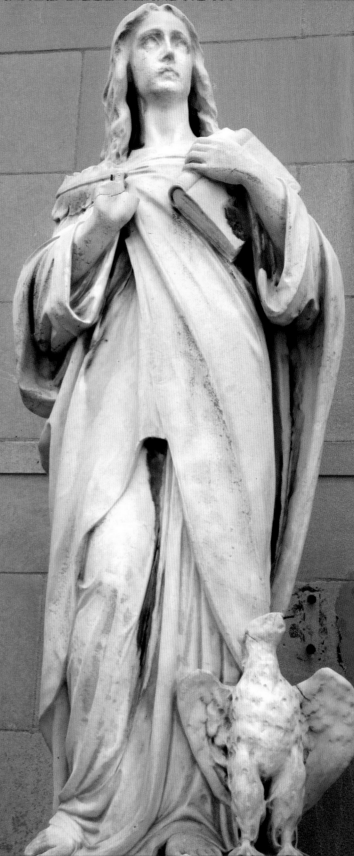

Above: Saint John gazes heavenward. His symbol, an eagle, does likewise at his feet.

Left: The building's cornerstone includes a relief of the crossed arms of Jesus and Saint Anthony, a traditional symbol of the Franciscan Order. The Franciscans were brought in to run the parish in 1905 after a dispute between the congregation and the pastor appointed by Bishop Foley.

Above: A somewhat-judgmental-looking Saint Luke sternly eyes all who enter the church.

Below: The Lion of Saint Mark from the feet of his statue.

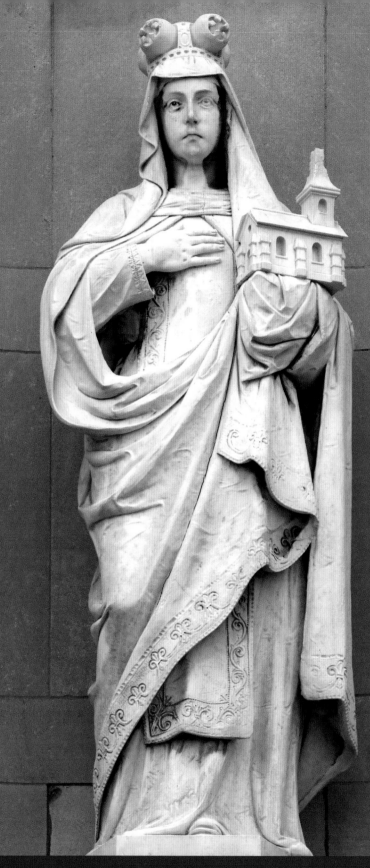

Above: Saint Hedwig stands in a niche over the main entrance, holding a building representing Trzebnica Abbey, which was built at her request by her husband, Duke Henry of Silesia.

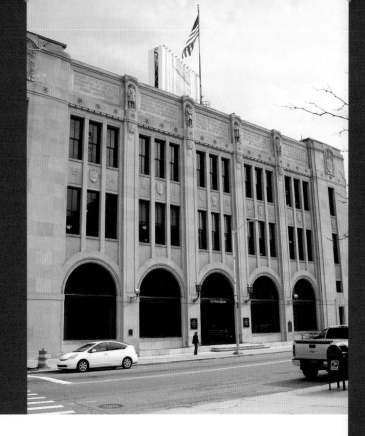

615 West Lafayette Boulevard

Completed: 1917

Architect: Albert Kahn

Sculptor: Attributed to
Joachim Jungwirth

IN 1917, AFTER YEARS of analysis, planning, and delays, the *Detroit News* publisher George Gough Booth presided over the construction of what was then the largest exclusively-for-newspaper building in the world. Offices and a thoroughly modern printing plant were both housed in the 144,484-square-foot building.[1]

Booth was the son-in-law of the *Detroit News* founder, James E. Scripps, and, like Scripps, a talented amateur architect. He wanted his newspaper's new home to have "dignity of style, chastity of spirit and substantiality."[2] He worked closely with the Detroit architect Albert Kahn's firm to design a building that ignored the ornate Beaux-Arts style that was popular at the time. Together, they created a solid Gothic Revival block of a building with strong vertical lines offset by welcoming ground-floor arches that befit Booth's view of the newspaper as a semipublic institution. Another expression of this view was the use of architectural sculpture, something unusual on a commercial structure at that time. As you may have noticed, this is the first building presented in this chronologically arranged book that is not of an institutional, religious, or residential nature.

The walls of the Detroit News Building, for those who know how to read them, are an open book, a history of publishing. The parapet of the Lafayette Boulevard side is adorned with sculptures of four pioneering printers. These figures are accompanied by five statements written by Professor F. N. Scott of the University of Michigan describing the societal role of the *Detroit News*, such as "Bearer of Intelligence—Dispeller of Ignorance and Prejudice—A Light Shining into All Dark Places." There are no statues on the Fort Street side, but there are five more inscribed statements.

Fluted spandrels below the third-floor windows feature thirty cryptic symbols, emblems of early printers and publishers. Included among these are the colophons of John Siberch, Philippe Pigouchet, J. Besicken, and John Byddell.[3]

In one emblem, a child rides a frog beneath a palm tree while two smaller frogs look on. This is the colophon of Christopher Froschover, publisher of the first English-language Bible on the European continent. *Froschover* is German for "frog over." Upon Christopher's death, his two sons continued the business but removed the larger frog from their colophon. The colophon of Aldus Manutius features

a dolphin, symbolizing speed, and an anchor, for stability, to represent his motto "Make haste slowly." Manutius created italic type and produced small, pocket-sized books, making scholarship portable.[4]

The exterior sculpture on this building is attributed to Joachim Jungwirth and he is definitely known to have done the interior wood carving. It is also possible that the sculpture is the work of Ulysses Ricci, as he may have been working with Albert Kahn by this time and was known for his figural work.

In 1930, there was a plan to greatly expand this building, with room for even more expected growth. According to the March 7, 1930, edition of the *Detroit News*, the expansion would more than double the building's size, and the foundations "will be such as to provide ultimately for 10 stories."[5] A rendering accompanying the article shows the building extending westward to the other end of the block. It is interesting to speculate who else among the famous printers of the past would have been immortalized on the addition. Apparently, the Depression kept this plan from ever being realized.

In 1998, following a joint operating agreement, the *Detroit News* was joined in this building by the *Detroit Free Press*. Both moved to new quarters in 2014, and the building was purchased by the billionaire Detroit businessman Dan Gilbert's Bedrock real estate firm. Molina Healthcare and Gilbert's Quicken Loans took up residence in the building in early 2017.[6]

Right: William Caxton is credited with bringing the first printing presses to England and being the first to print books in English.

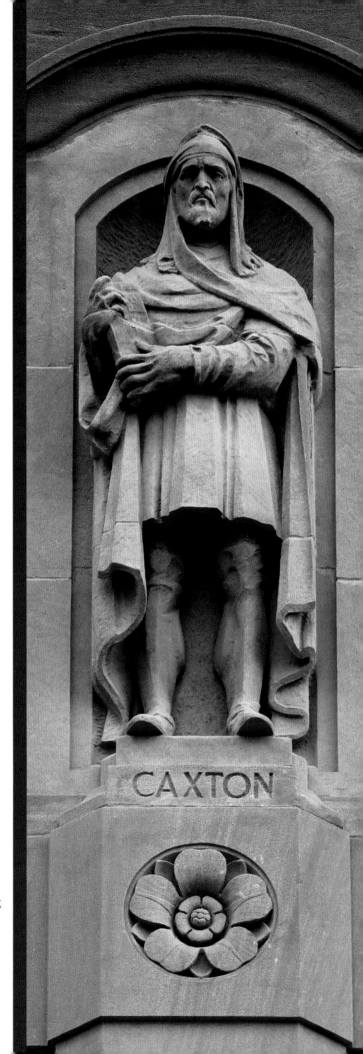

A light fixture from the
Lafayette Street façade.

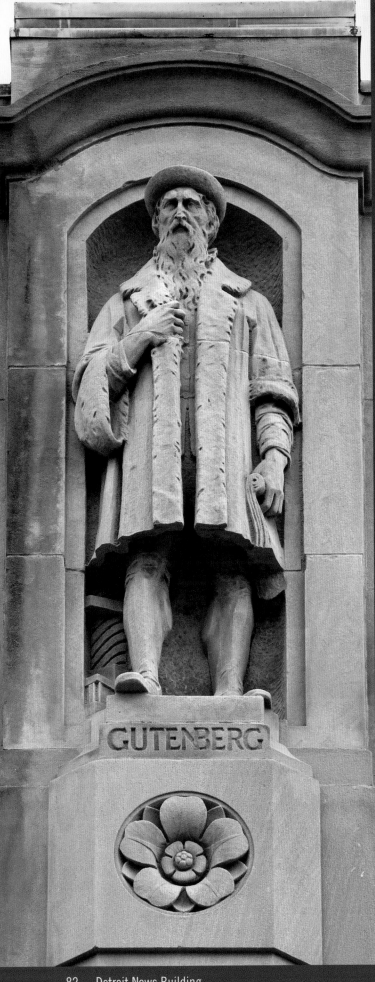

The Lafayette Boulevard and Fort Street façades are similar except that the parapet on the Lafayette Boulevard side features four portrait sculptures, which include Johannes Gutenberg, the inventor of moveable type, and Benjamin Franklin, the colonial American printer.

Left: One of several identical parapet shields placed at both upper corners of all but the west façade, representing the newspaper and its mission.

Above: Emblem of Christopher Froschover, publisher of the first English-language Bible printed on the European continent.

Below: Emblem of Aldus Manutius, creator of italic type and pocket-sized books.

5201 Woodward Avenue

Completed: 1921

Architect: Cass Gilbert

Sculptors: Oswald Hoepfner, C. Grandelis, John Donnelly (carver)

I N THE OPENING PARAGRAPH of his 1925 book *The House That Love Built*, W. Francklyn Paris declares of the Detroit Main Library, "it is both a joy and an encouragement to behold such a center of commercialism as is Detroit turning long enough from the manufacture of automobiles to buy hyacinths for its soul."[1] He continues in this vein with rapturous descriptions of the harmonious architectural perfection of the structure and its exterior and interior ornamentation. As a principal of the firm commissioned to design the interior of the building, his flowery words are somewhat self-serving but arguably true.

In 1910, with funding provided by the philanthropist Andrew Carnegie, Detroit moved ahead with plans for a new library. Conceived to be the first building of a new cultural center in the rapidly growing area north of downtown, it was built to replace the beautiful but obsolete old library, which the city had outgrown.

A design competition was held, and from a field of twenty firms, the Library Commission selected Cass Gilbert, the foremost architect of his time and designer of the much-admired St. Louis Public Library. Over the course of his career, Gilbert designed many major buildings including New York's Woolworth Building, the U.S. Supreme Court Building, and three state capitols. Land was purchased in 1913, construction began in 1915, and the library opened to the public on March 29, 1921.

In preparation for designing the library's early Italian Renaissance façade, Gilbert toured Italy. With the inspiration from his travels in mind, he created an elegant design that features a gold and ivory terra-cotta cornice, a parapet with low-relief carvings of the zodiac (a very popular Italian Renaissance theme), window-arch tympana with twenty-nine elaborate medallions of historic authors, and intricate bronze doors inspired by the work of Donatello. Each door features five panels depicting the phases of Greek (left door) and Roman (right door) literature: Epic, Tragic, Lyric Poetry, Philosophy, and Comedy.

Looking up into the second-floor loggia from just outside the main entrance, one can see ceiling mosaics based on Shakespeare's "Seven Ages of Man" soliloquy from *As You Like It*. They were designed by Frederick J. Wiley and executed by Mary Chase Perry Stratton and Horace James Caulkins of Pewabic Pottery. The Cass Avenue entrance that was part of the 1963 addition is adorned with Millard Sheets's mosaic *The River of Knowledge*.

The interior of the building is stunningly decorated throughout with numerous murals, mosaics, painted glass windows, and much more and is well worth a visit. Docent-guided tours are available.

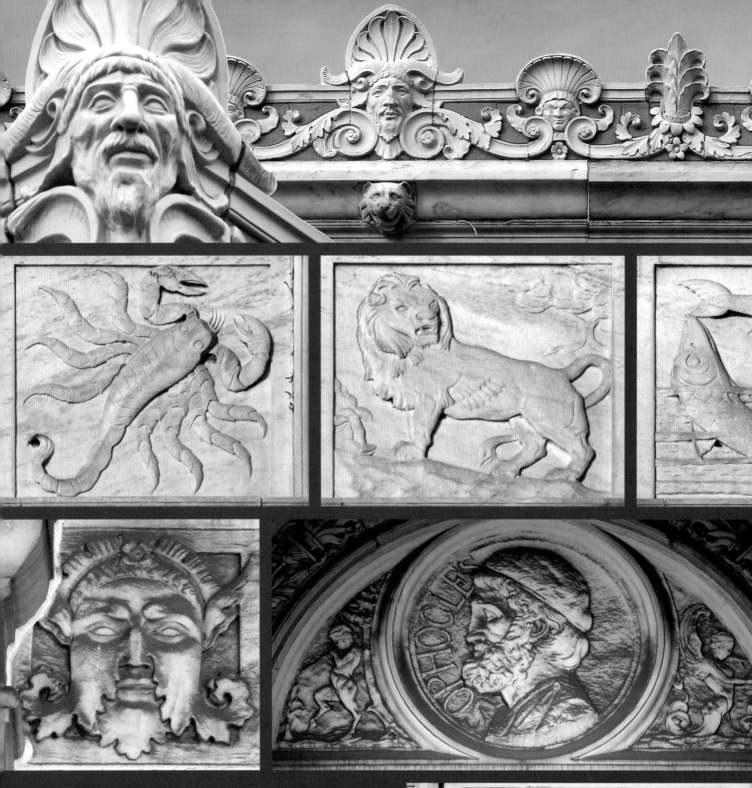

Right: "Moses" and "Sappho" from the east wall and a chimera from the north wall.

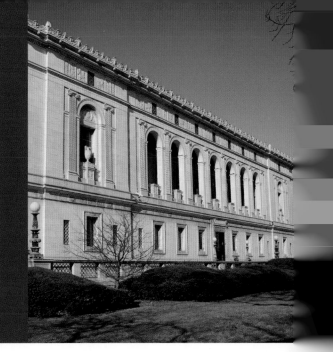

5201 Woodward Avenue

Completed: 1921

Architect: Cass Gilbert

Sculptors: Oswald Hoepfner, C. Grandelis, John Donnelly (carver)

I N THE OPENING PARAGRAPH of his 1925 book *The House That Love Built*, W. Francklyn Paris declares of the Detroit Main Library, "it is both a joy and an encouragement to behold such a center of commercialism as is Detroit turning long enough from the manufacture of automobiles to buy hyacinths for its soul."[1] He continues in this vein with rapturous descriptions of the harmonious architectural perfection of the structure and its exterior and interior ornamentation. As a principal of the firm commissioned to design the interior of the building, his flowery words are somewhat self-serving but arguably true.

In 1910, with funding provided by the philanthropist Andrew Carnegie, Detroit moved ahead with plans for a new library. Conceived to be the first building of a new cultural center in the rapidly growing area north of downtown, it was built to replace the beautiful but obsolete old library, which the city had outgrown.

A design competition was held, and from a field of twenty firms, the Library Commission selected Cass Gilbert, the foremost architect of his time and designer of the much-admired St. Louis Public Library. Over the course of his career, Gilbert designed many major buildings including New York's Woolworth Building, the U.S. Supreme Court Building, and three state capitols. Land was purchased in 1913, construction began in 1915, and the library opened to the public on March 29, 1921.

In preparation for designing the library's early Italian Renaissance façade, Gilbert toured Italy. With the inspiration from his travels in mind, he created an elegant design that features a gold and ivory terra-cotta cornice, a parapet with low-relief carvings of the zodiac (a very popular Italian Renaissance theme), window-arch tympana with twenty-nine elaborate medallions of historic authors, and intricate bronze doors inspired by the work of Donatello. Each door features five panels depicting the phases of Greek (left door) and Roman (right door) literature: Epic, Tragic, Lyric Poetry, Philosophy, and Comedy.

Looking up into the second-floor loggia from just outside the main entrance, one can see ceiling mosaics based on Shakespeare's "Seven Ages of Man" soliloquy from *As You Like It*. They were designed by Frederick J. Wiley and executed by Mary Chase Perry Stratton and Horace James Caulkins of Pewabic Pottery. The Cass Avenue entrance that was part of the 1963 addition is adorned with Millard Sheets's mosaic *The River of Knowledge*.

The interior of the building is stunningly decorated throughout with numerous murals, mosaics, painted glass windows, and much more and is well worth a visit. Docent-guided tours are available.

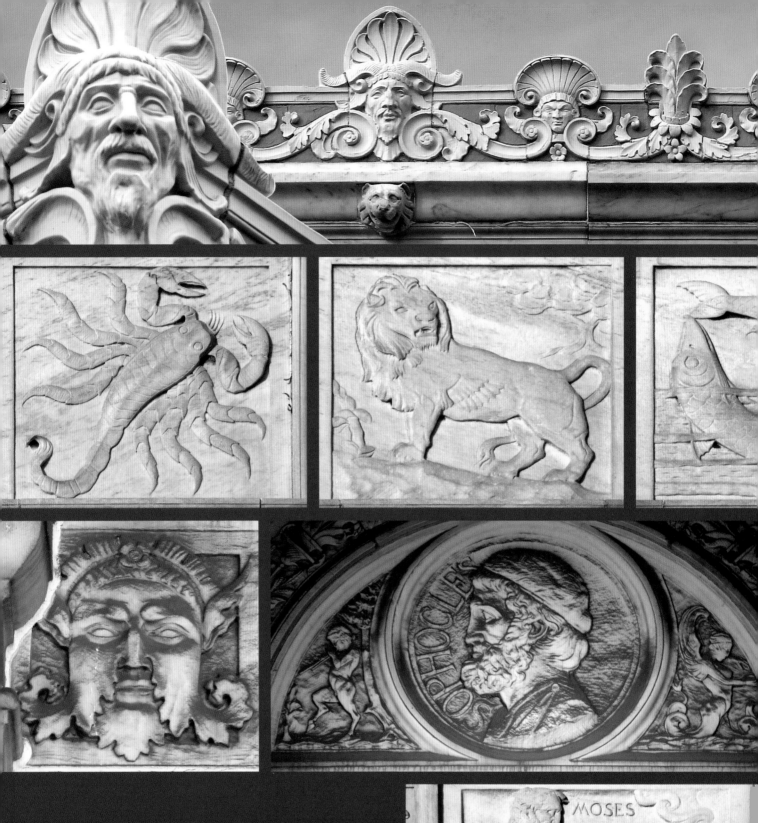

Right: "Moses" and "Sappho" from the east wall and a chimera from the north wall.

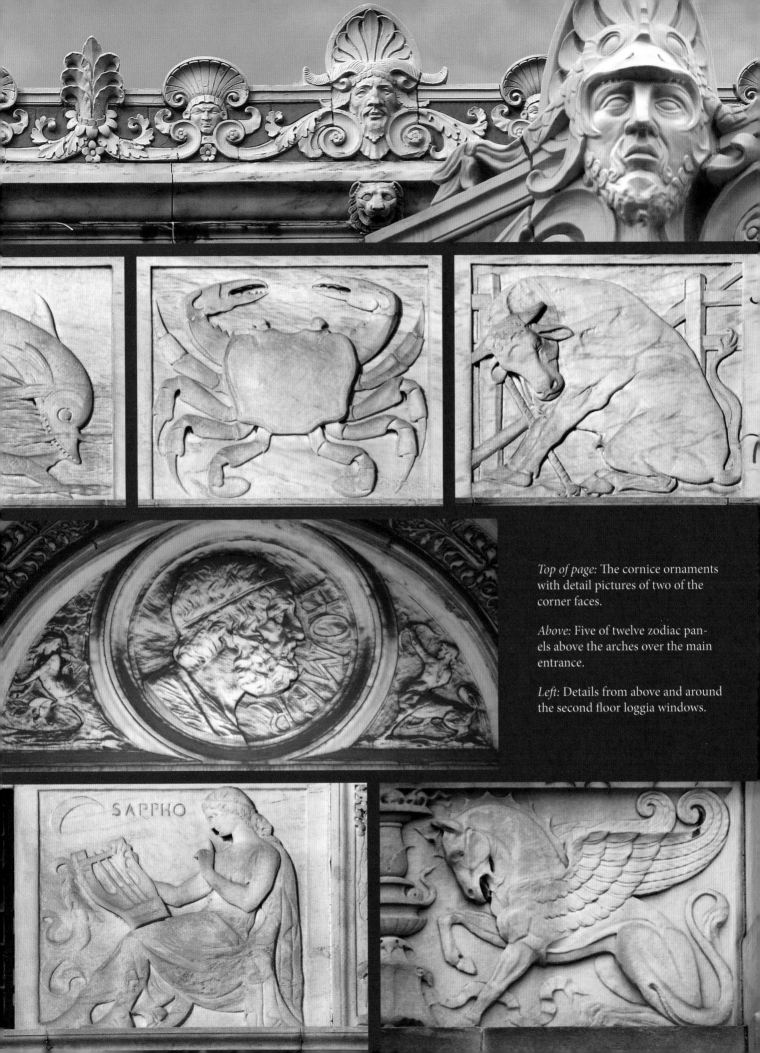

Top of page: The cornice ornaments with detail pictures of two of the corner faces.

Above: Five of twelve zodiac panels above the arches over the main entrance.

Left: Details from above and around the second floor loggia windows.

SAPPHO

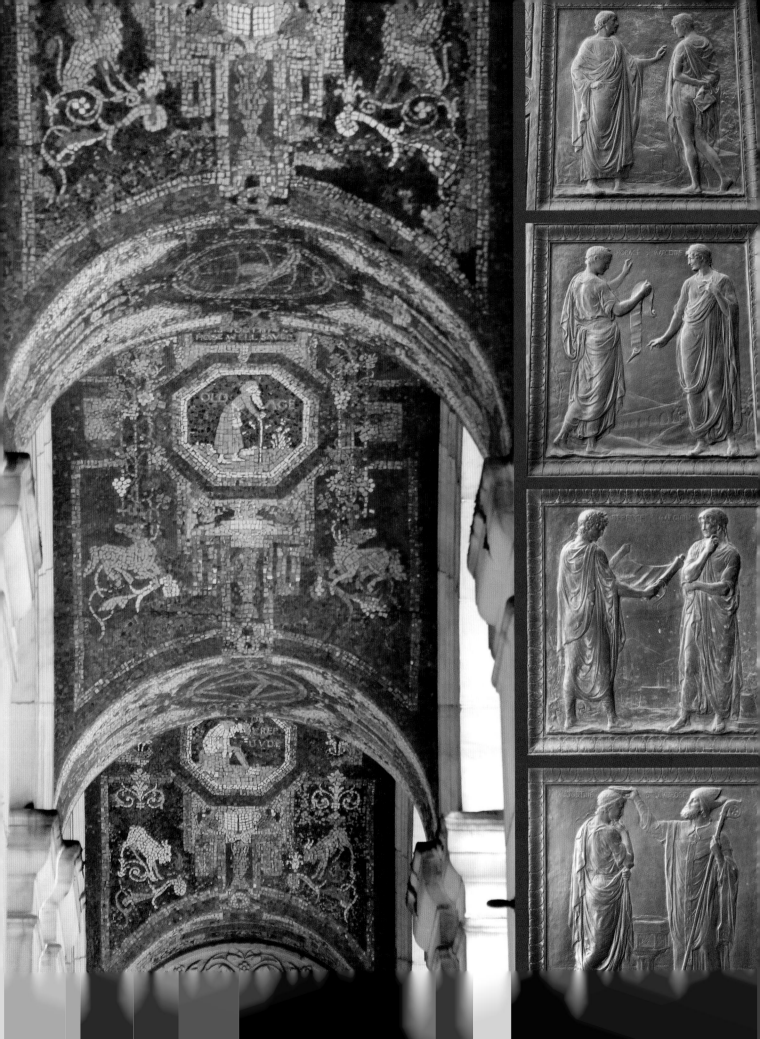

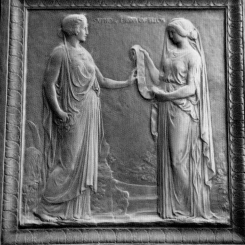
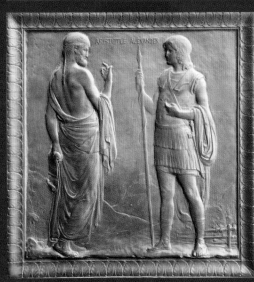
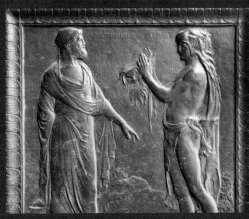

Left and above: Two details from *The River of Knowledge* mosaic over the Cass Avenue entrance.

Facing page and right: Eight panels from the main entrance's bronze doors.

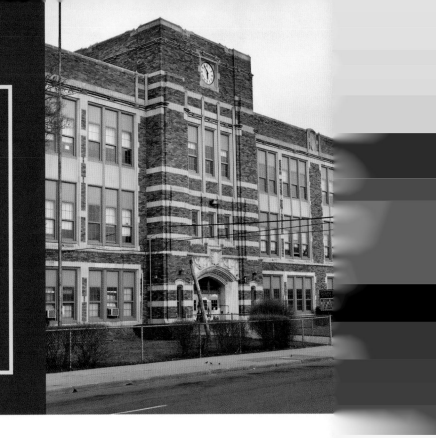

5536 St. Antoine Street

Completed: 1922

Architect: Malcomson, Higginbotham & Palmer

Sculptor: Unknown

TODAY, FEW PEOPLE REMEMBER George W. Balch and his place in Detroit history, but he was once hailed as the man who brought the telephone to Detroit. In 1877, Balch, along with several other men, organized the Telegraph and Telephone Construction Company.

The first practical contract and installation of the telephone anywhere in the world was made by Balch's company, followed by the world's first telephone exchange, with about forty customers using four to five lines. A year later, the first use of the telephone as a means to communicate between towns was successfully tried when a line was run from Detroit to Port Huron.[1]

George W. Balch also had a strong sense of civic responsibility and "took a warm interest in the affairs of the municipality, holding many positions of trust."[2] He was a member of the City Council in 1870 and was president of the council when Old City Hall (page 12) was occupied in 1871. Balch also served on the school board in the 1870s and was president of that organization when Central High School (page 46) opened in 1896. He died in 1908 at age seventy-six, and it was no surprise that Detroit Public Schools chose to honor him by naming a new school building after him in 1922.

Balch School was designed by the firm of Malcomson, Higginbotham & Palmer, which designed more than 75 percent of the many public schools built in response to Detroit's rapid population growth between 1894 to 1923.[3] It was one of three new buildings and eight additions begun in 1920.[4]

This building features some interesting sculpture, some of which appears to have been influenced by the fact that it was built in a neighborhood with many families of Russian descent. As a matter of fact, more than half of the students enrolled in this school in 1922 came from Russian families.[5]

The arch over the main entrance has shields with reliefs depicting educational and recreational activities, and the entrance is flanked with sculptures of a female and a male student. However, the most unique aspect of the school's sculptural ornamentation seems to be reflective of the neighborhood's eastern European heritage. Three hooded gnome-like figures are depicted reading from a scroll, playing basketball, and perusing a book.

Today, this ninety-five-year-old building is home to the Golightly Education Center.

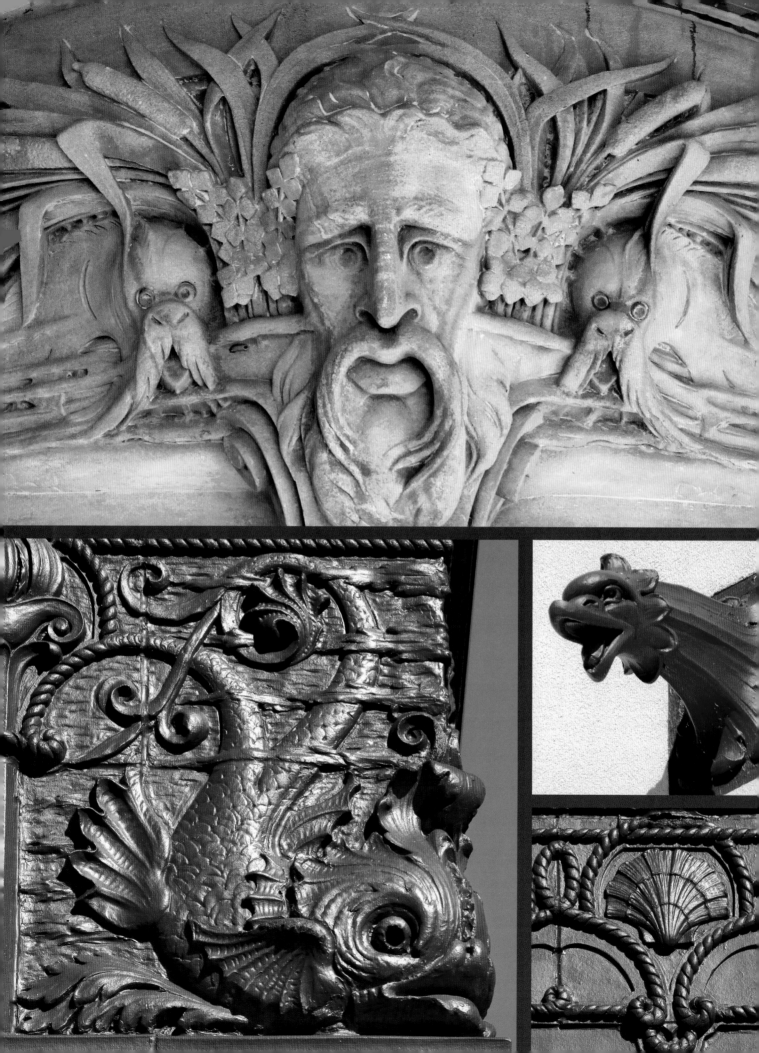

1 Riverbank Drive

Completed: 1923

Architect: George D. Mason

Sculptor: Unknown

THE DETROIT YACHT CLUB, founded in 1868, is one of the oldest private clubs in North America. Although its early years were marked by internal strife and a split that led to the formation of the Michigan Yacht Club, by 1895, the club was unified, growing in membership, and on a firm financial footing. It also had finally acquired the long-sought rights to an anchorage on Belle Isle, having purchased the defunct Michigan Yacht Club's building, located across the river from its own anchorage on the mainland, and having received an extension of the Michigan Yacht Club's franchise from the Parks Commission.

Unfortunately, that clubhouse, designed by Donaldson & Meier and erected in 1891, burnt down in 1904. A replacement, designed by Field, Hinchman & Smith and built on a man-made island ninety feet from shore, was completed in time for the 1905 yachting season. The club flourished in its new home and by 1912 was said to have the third-largest fleet on the Great Lakes, behind Toronto and Chicago.[1]

The rest of that decade saw continued growth for the Detroit Yacht Club, and as Detroit entered the boom years of the 1920s, plans were made to build an even bigger and better clubhouse. In November 1921, the international speedboat champion and club commodore Gar Woods christened the first of over two thousand cedar piles to be driven into the riverbed for the new building.

Built about one thousand feet upriver from the old clubhouse, the new building was likewise constructed on a man-made island and connected to Belle Isle by a private bridge. Designed by the Detroit architect George D. Mason, who also designed the Grand Hotel on Mackinac Island and the Detroit Masonic Temple (page 154), the Detroit Yacht Club's new home was declared by the *Detroit Free Press* to be "the costliest, largest and most complete club house of its kind in the world today."[2] At ninety-three thousand square feet, it remains the largest yacht club clubhouse in the Americas.

The clubhouse is designed in a Mediterranean Revival style, with ground-floor brick, creamy stucco above, and a red tile roof. The asymmetrical and somewhat rambling layout is reflective of the relaxing feel of life on the water. Sculpture on the building, as seen on the facing page, also reflects the nautical theme. Cornices feature ropes and knots around sea shells with cavorting dolphins wrapping around the corners. There are also several sea-serpent gargoyles. The most interesting work is the tympanum over the main entrance. Recently cleaned and restored, it features Neptune with a pair of fancifully mustachioed fish peering out from a mass of cattails and other aquatic vegetation.

The club thrived in the 1920s, survived the Depression-era 1930s, and continues strong today. It is perhaps best known as a host and sponsor of the APBA Gold Cup hydroplane races since 1921. The prestigious Gold Cup, first awarded in 1904, is the oldest active trophy in motorsports.

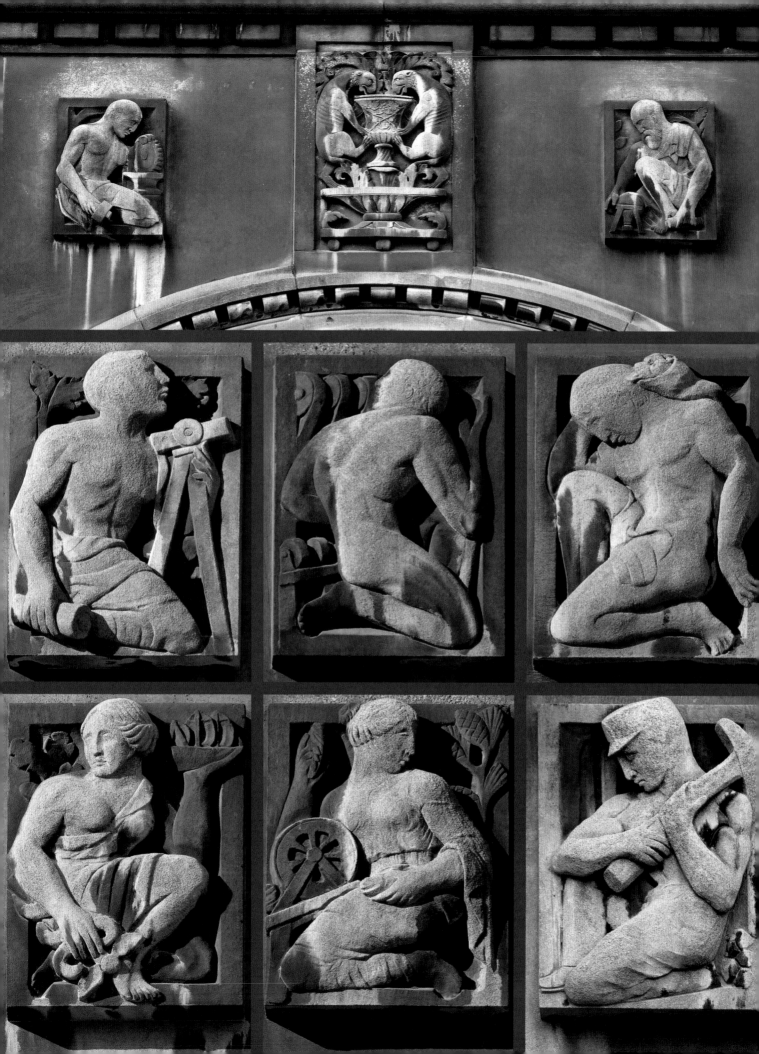

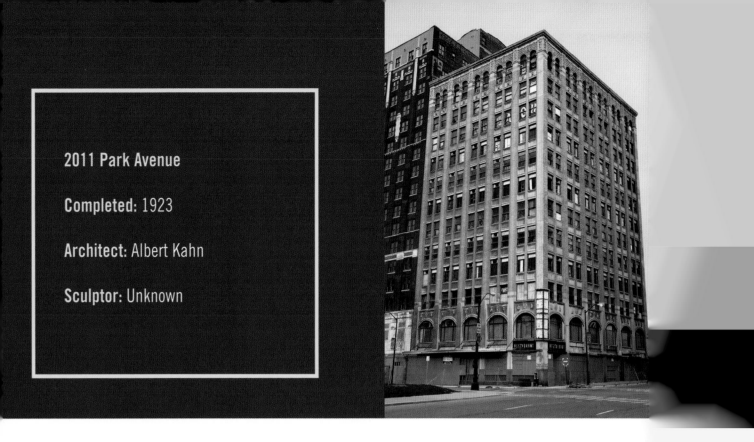

2011 Park Avenue

Completed: 1923

Architect: Albert Kahn

Sculptor: Unknown

WHEN THIS BUILDING OPENED in 1923, it was home to the General Necessities Corporation, and there was a large sign, about three or four stories tall, on the roof with the words "General Necessities" on it. There was also a very familiar brand name on the top of the sign that we will get to later.

The definition of what constitutes a necessity has changed over the years. The General Necessities Corporation was formed in 1916, mainly as a distributor of coal and ice. It was a time when most furnaces burned coal and most homes had an ice box instead of a refrigerator, necessitating regular deliveries of coal and ice. It also sold ice cream and water and managed properties, including Arena Gardens, a coliseum for grand opera, auto shows, skating, and dancing, located on Woodward Avenue between Campus Martius and Grand Circus Park. Arena Gardens was converted into the huge Cass-Woodward Market in 1920 with seventy thousand square feet of floor space. It provided room for eighty meat and produce stalls on the ground floor and thirty shops on the second floor.[1]

The General Necessities Building, as it was then known, was designed in a Beaux-Arts style with or-nate arches over large second-story windows. The space above the arches features carved allegorical ornaments that represent the many industries and pursuits in which the company was involved. It is not known for sure who created these ornaments, but given the year, the style, and the fact that this was an Albert Kahn–designed building, chances are it was Corrado Parducci or Ulysses Ricci.

Above the keystone of each arch, two lions drink the water of life from an ornate urn, as shown at the top of the facing page. Above one arch, the two reliefs on each side of the lions represent mechanics and chemistry. A figure above another arch holds a deed in his right hand and uses a surveying tool, an allegory for property management. Another figure is in front of machinery, representing manufacturing, and a third carries a bag of produce over his shoulder, symbolizing agriculture.

In other reliefs, a female figure is holding a caduceus and a ship, familiar symbols of commerce. Another figure represents textiles, with a woman holding a spindle and spinning wheel in front of a flax plant. One more relief features a coal miner.

As the 1920s ended, natural gas replaced coal for home heating, and electric refrigerators

replaced ice boxes. Home delivery of coal and ice was no longer needed, and the General Necessities Corporation was dissolved in 1932. Its assets were sold, among them the Absopure Distilled Aerated Water Company, whose familiar chunky script logo was the top line on the rooftop sign.

After General Necessities went out of business, the building was refreshed and renamed the Park Avenue Building. It was consistently occupied into the 1990s, but its last tenant, a ground-floor restaurant, left in 2000. The building was not secured by its owners and was left unattended for almost fifteen years, becoming a run-down, scrapped-out eyesore. Things got so bad that the city filed suit to tear the building down, and it became a focal point in the discussion over historical preservation.

A group called Preservation Detroit[2] opposed the move to tear it down, arguing that the building is historically and architecturally significant and that demolishing the building would reward the owner, who would retain ownership of the land, for his years of neglect. In the end, an agreement was reached, and the property was mothballed to prevent further damage.

As of this writing, the Park Avenue Building's future remains uncertain. It is in a prime location near the new Arena District and has been put on the market, hopefully to be bought and restored. However, it is located in one of the district's planned neighborhoods, described as a "fresh, modern neighborhood anchored by a new public green space,"[3] so it could yet be demolished in the name of progress.

Allegories representing "Construction" and "Agriculture."

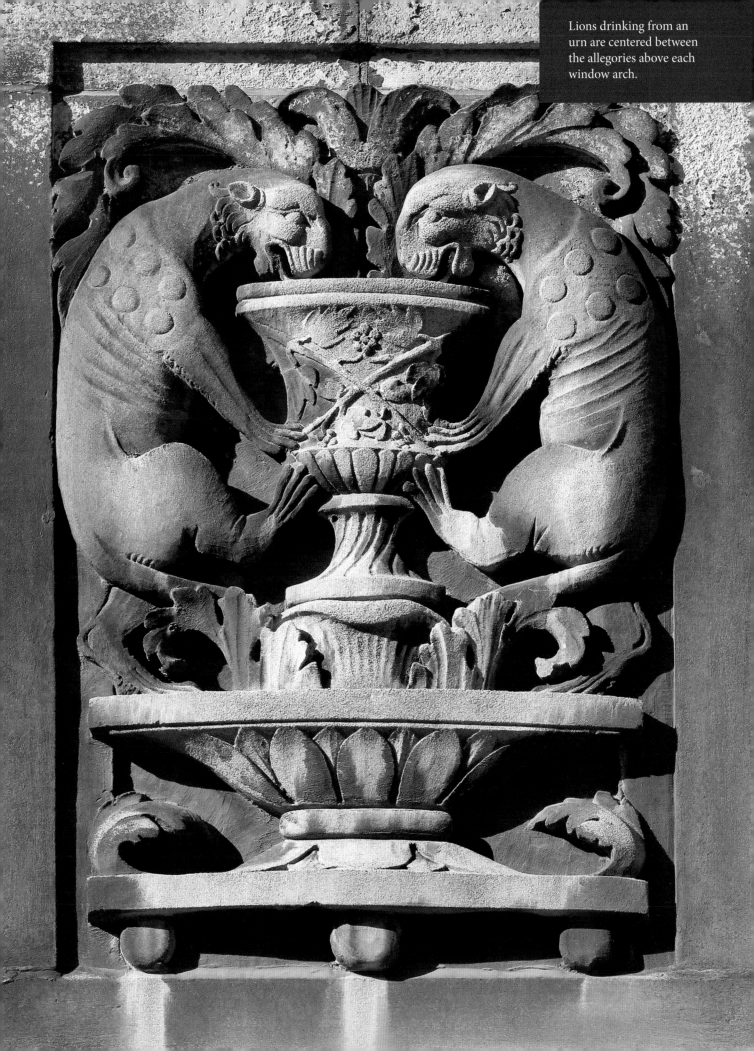

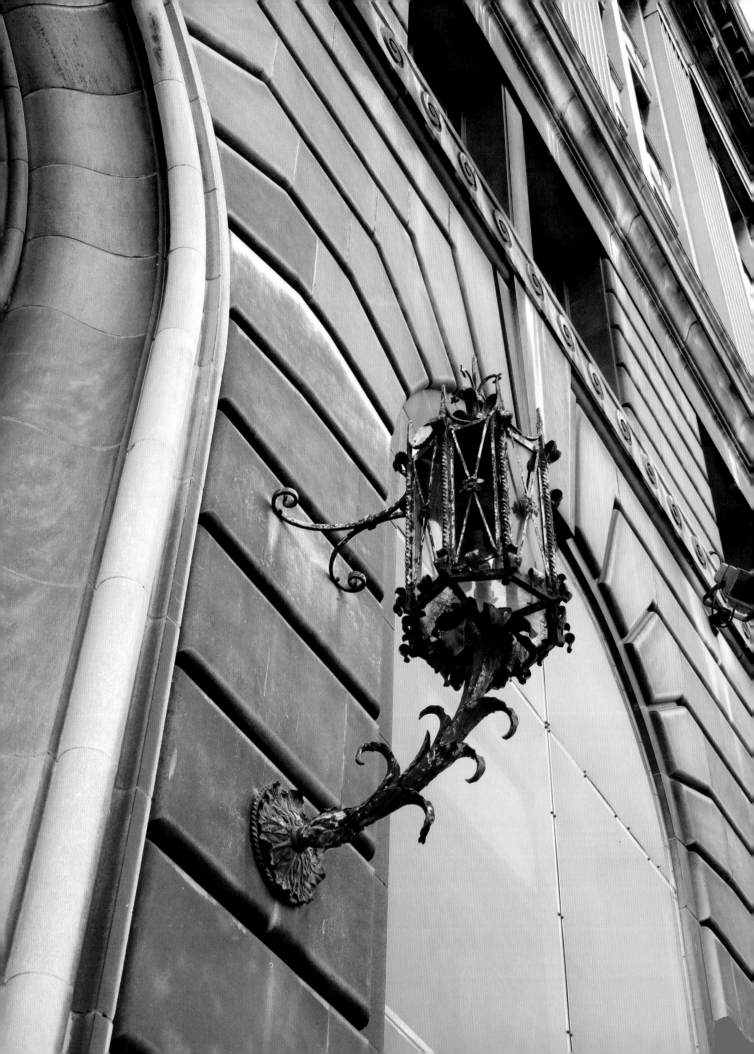

1300 Beaubien Street

Completed: 1923

Architect: Albert Kahn

Sculptor: Unknown

POLICE COMMISSIONER JAMES INCHES worked closely with the architect Albert Kahn to ensure the new Police Headquarters would be the finest building of its type in the world. Inches and Kahn toured the East Coast, inspecting police departments and their buildings. When they returned from the tour, Inches said, "We didn't get any tips that particularly struck me, but we saw lots of things to keep away from. . . . We don't want a lot of heavy iron bars sticking out like a lot of sore thumbs. We're going to have the building strong enough, but we'll camouflage the 'forbidding exterior' features."[1] The intent was to create a building that appeared strong and secure but was still welcoming to the average citizen.

With this in mind, Kahn blended contemporary pier-and-spandrel construction with details he borrowed from Italian palaces. Among these are a series of eight expressive figures carved in deep relief on the spandrels between the fourth- and fifth-floor windows that tell the tale of the legal system.

The first panel, "Shame," shows a woman gazing sadly at a mirror, unhappy that she has done the bidding of an untrustworthy serpent. The next panel, "Defiance," shows an unrepentant lawbreaker in chains, shaking his fist at his captors. This is followed by "Vengeance," in which a man with clenched fist and club glares at the lawbreaker. That impulse is tempered by the figure in the fourth panel, a woman who holds the sword of justice while pointing to a passage in the book of law. In the fifth relief, a woman holds the torch of knowledge and enlightenment, which leads to the man in the sixth relief, a thinker who reflects on his misdeeds. The seventh panel, "Penance," shows a man with a hammer working at hard, honest labor, perhaps learning a trade, and the eighth panel shows a man reaping the rewards of rehabilitation.

It is hard to be sure who created these sculptures because documentation could not be found. They bear some resemblance to Ulysses Ricci's work on the General Motors Corporation Laboratory building (page 110), but it seems likely they were done by Corrado Parducci. Kahn is known to have used Parducci during the time that he was still in New York, an employee of Anthony DiLorenzo & Company. According to an oral-history interview with Parducci,[2] Kahn liked working with Parducci because Kahn could provide a rough idea of what he wanted, similar to what is sketched in the plans for the building,[3] and Parducci would produce a clay "sketch" for Kahn's approval. Working this way,

instead of the old way of producing detailed scale drawings of each sculpture needed, saved a lot of time and money.

As is typical of Kahn designs, the interior usage of the building is clearly defined on the outside with cornices dividing it into three sections. The first three floors were for everyday police business, including a large drill and assembly hall that doubled as a gymnasium. The middle four floors were for offices, with the relatively new fingerprint department and identification bureau on the fourth floor and the detective bureau and prosecutors' offices in close proximity on the fifth floor. The top two floors were for detention, with the women's cells on the eighth floor and the men's cells on the ninth. This was quite innovative for the time, as city lockups were typically located in dungeon-like basements. The carvings below the tenth-floor cornice relate to use of the rooms within, showing repentant men in chains.

This structure still stands, but it has been in danger of being taken down for several years. At the ribbon-cutting ceremony for the new Public Safety Headquarters in 2013, then-mayor Dave Bing stated that the building would probably have to be demolished.[4] It has been empty since January 2014, when it was closed due to hazardous conditions. Remaining police staff were reassigned, and the doorways and windows were covered with Plexiglas shielding. The building is currently owned by the bond insurer Syncora Guarantee, part of Detroit's 2014 bankruptcy settlement. It has recently gained new life when it was announced in February 2018 that Dan Gilbert's Bedrock real estate firm will be working in partnership with Syncora to redevelop this historic landmark.[5]

Facing page: A cartouche over the main entrance shows the seal of Detroit flanked by two children, representing how the innocent are protected by the police force. The ram above the seal symbolizes strength, while the lion below stands for power and unceasing vigilance.

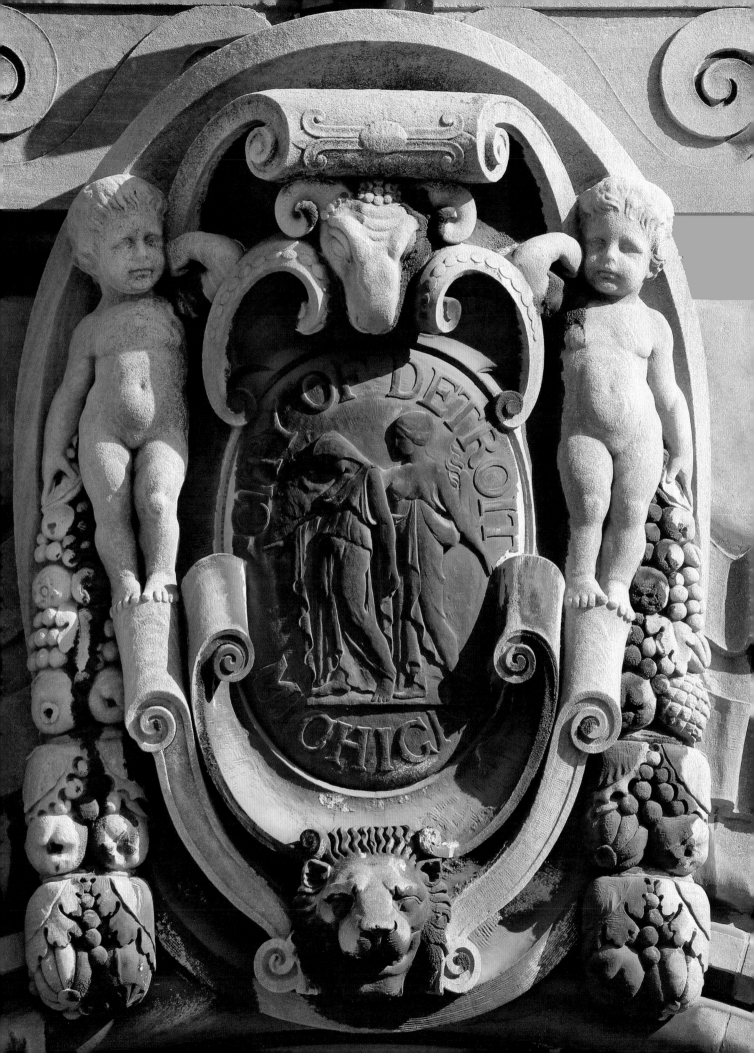

Above: Sign over the Clinton Street entrance.

Above: Just below the detention-level cornice, humbled prisoners on either side of a leering gorgon hide their faces.

Below: A cornice ornament featuring griffins.

Five of eight reliefs from the window spandrels between the fourth and fifth floors, representing enlightenment, temptation, justice, captivity, and aggression.

3044 West Grand Boulevard

Completed: 1923

Architect: Albert Kahn

Sculptors: Ulysses Ricci (entrance figures and clock), Anthony DiLorenzo, John Donnelly, Oswald Hoepfner, Corrado Parducci

T HIS BUILDING WAS SUPPOSED to be called the Durant Building. The stonemasons were on their scaffolding in front of the Grand Boulevard entrance, about to carve the word "DURANT." It was at this moment that Jake Zimmerman, the building manager, received an urgent telegram, informing him that William C. Durant had been ousted from control of General Motors. He rushed down to the entry and had the stonemasons stop their work. Eventually, "General Motors Building" was carved over the entrance instead. Durant's imprint lingers on in the form of stone shields with the letter "D" near the fifteenth-floor cornices, which were already in place when Durant was sent packing.[1]

The General Motors Building was the second-largest office building in the world when it was built. Placed at the geographical center of Detroit, away from the congestion of downtown and near the most desirable residential areas of the city, it was the first major development in what became known as the New Center Area. The availability of land at Grand Boulevard and Cass Avenue allowed Albert Kahn to create a building that spread out instead of up, with four fifteen-story wings extending from a central

spine and separated by ninety-five-foot-wide light courts. Expressing Kahn's belief that "more buildings suffer from over-ornamentation than lack of it,"[2] most of the Italian Renaissance–inspired decoration is clustered around the entrance, on the window arches for the seven ground-level automobile showrooms, and up near the colonnaded cornices.

The main entrance on Grand Boulevard features a three-arch loggia with elaborately carved stone vaulting. The doorways at the rear of the loggia are based on an old Roman design and are highlighted by intricately carved Tennessee marble. The central arch is adorned with a monumental clock created by Ulysses Ricci. It has a zodiac around its face and is flanked by allegorical figures representing chemistry and mechanics. The clock is topped with a winged wheel, a motif adopted by the Detroit hockey team when it changed its name from the Cougars to the Red Wings.

The building housed General Motors until 1999, when the company moved to the Renaissance Center in downtown Detroit. After a two-year renovation, the building reopened as Cadillac Place, providing offices for the State of Michigan.

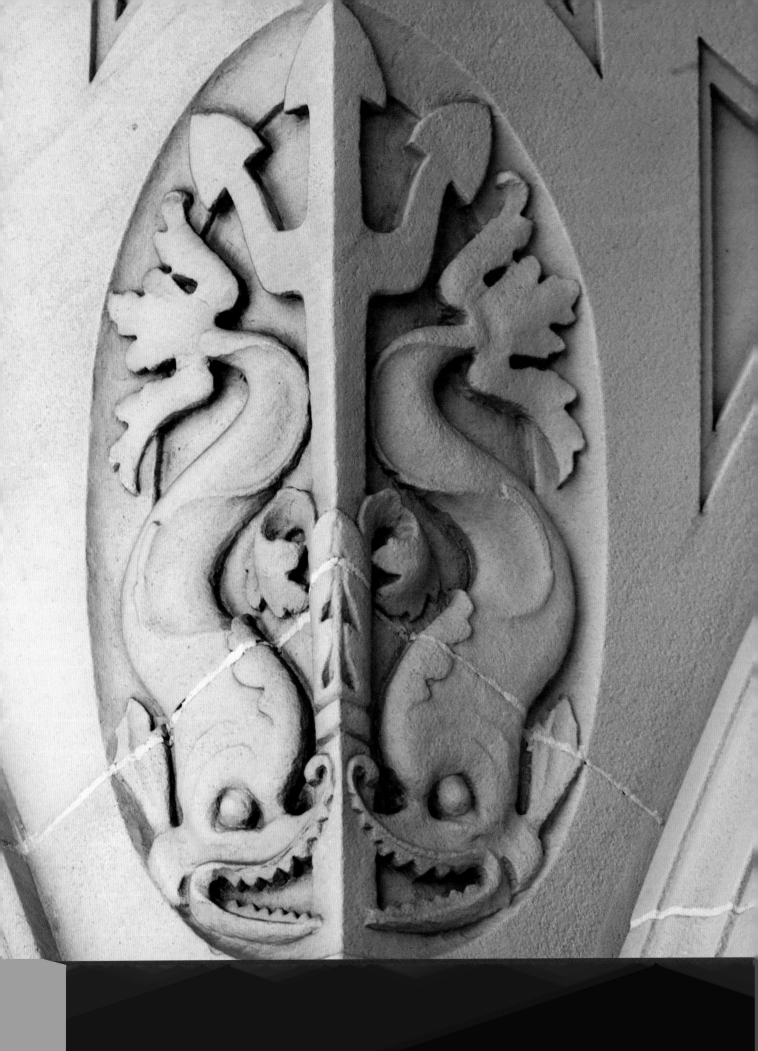

Above, left: A green man, symbol of fertility and abundance, flanked by griffins, guardians of treasure.
Above, right: Detail of the winged wheel from atop the zodiac clock over the main entrance loggia.

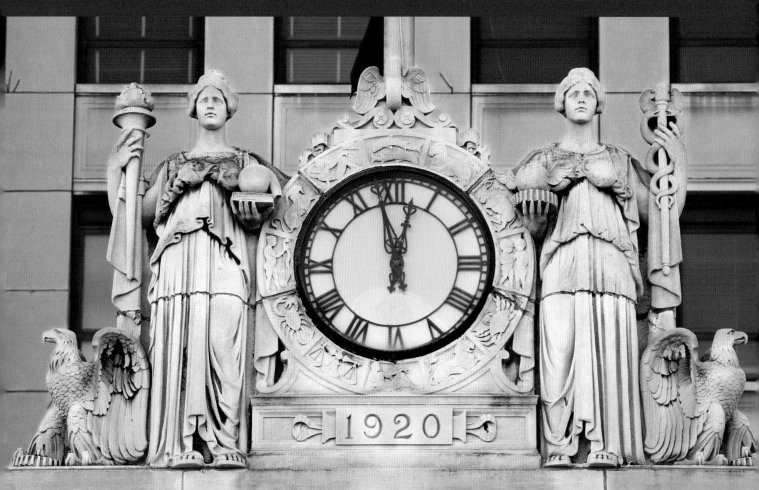

Above: The clock over the main entrance loggia, created by Ulysses Ricci. The figure on the left represents chemistry, and the one on the right represents mechanics. Note the year "1920" below the clock; the building was opened in stages, and that is the year this part was completed.

Above: Grotesque creatures taken from Italian Renaissance designs.

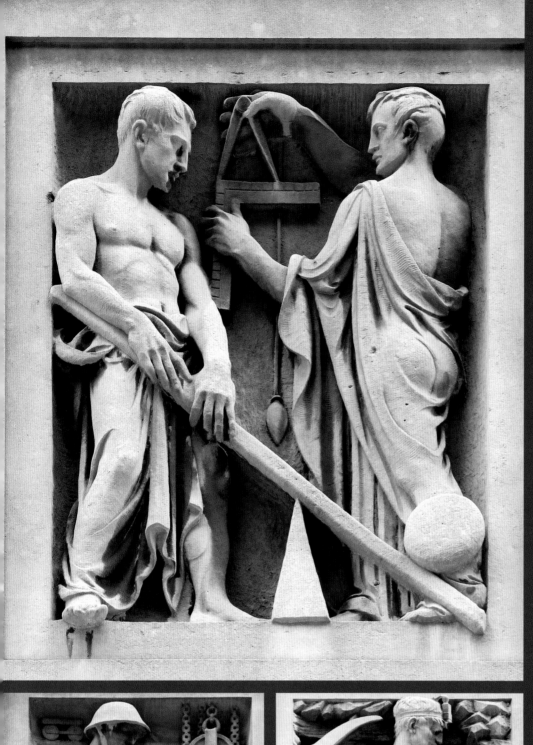

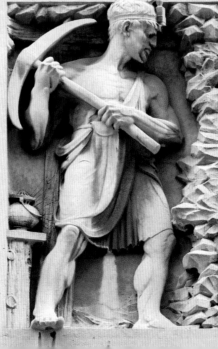
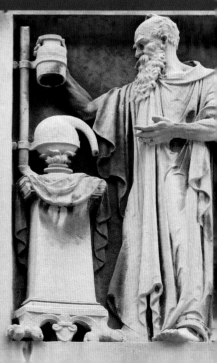

Milwaukee Avenue (behind General Motors Building)

Completed: 1923

Architect: Albert Kahn

Sculptor: Ulysses Ricci

THE GENERAL MOTORS CORPORATION Laboratories building is actually an integral portion of the General Motors Building and was built at the same time, even though it is referred to as an annex. The apparent separation is called for by its function. As the name implies, it was a research facility, not a business and retail structure, so the building's architect, Albert Kahn, in his style of expressing the inside of a structure on the outside, designed it to appear to be a freestanding entity.

The five-story building runs the length of the block and is dominated by a central four-story portico with six massive Ionic columns. Along with the piered wings on either side of the entrance, this gives the laboratory structure a heavier classical look that contrasts sharply with the lighter Italian Renaissance look of the headquarters building, creating the appearance of a totally separate building.

This building was also notable for its fourth-floor exhibition space. It featured a five-hundred-by-sixty-foot area with no column supports, providing thirty thousand square feet of unbroken floor space. This area was often used by other industries for exhibitions and conventions. It was broken up for use as offices when General Motors Corporation Laboratories moved across West Milwaukee Avenue to the Argonaut Building in 1928.

The attic area above the central portico features eight relief panels by Ulysses Ricci, who also created the monumental clock and figures over the central arch of the Grand Boulevard entrance to the headquarters building (page 104). Each panel in the entablature features a different subject, expressing an aspect of the work taking place inside the building. Six of the panels are shown on the facing page.

Starting with the upper left panel and proceeding clockwise, they represent physics, agriculture, mechanics, chemistry, mining, and metallurgy. The panels representing astronomy and navigation are not shown. An interesting aspect of the panels is that, in keeping with the classically styled architecture of the building, the figures are wearing clothing common to ancient Greece, even though they are using tools and placed in backgrounds from more modern times, making for an intriguing juxtaposition.

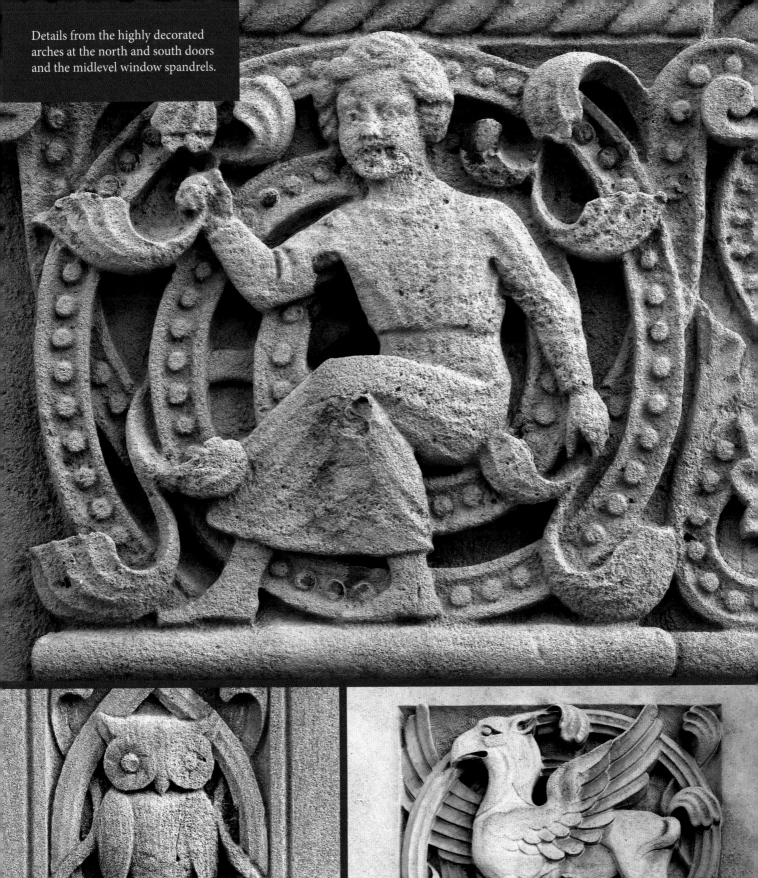

Details from the highly decorated arches at the north and south doors and the midlevel window spandrels.

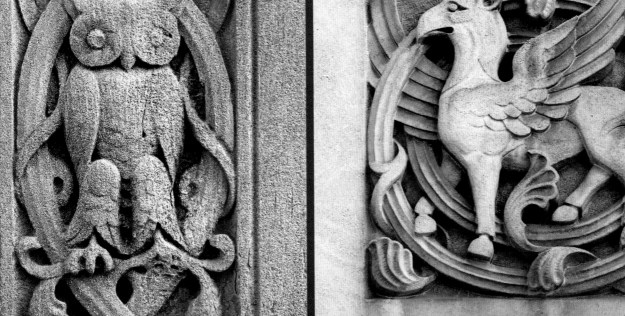

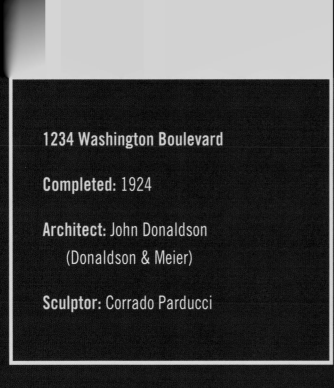

1234 Washington Boulevard

Completed: 1924

Architect: John Donaldson
(Donaldson & Meier)

Sculptor: Corrado Parducci

According to then-chancellor John M. Doyle in 1923, "Detroit [was] the first Catholic diocese in America to have a modern office building for its chancellery house."[1] John Donaldson's design for the building is a successfully creative combination of early twentieth-century modern and classical elements. The modestly peaked roof and open two-story loggia on the seventh and eighth floors are especially attractive.

The chancery was built on land once occupied by the home of Col. John Winder, who came to the Michigan Territory at the age of nineteen in 1824 and lived to the ripe old age of ninety-three. During his lifetime, he saw Detroit grow from a frontier village of less than 2,000 people to a thriving metropolis of more than 250,000 and become a major commercial and industrial center.

Winder built a mansion at the corner of Woodward Avenue and Winder Street, and his first home on Washington Boulevard became the rectory for St. Aloysius Church next door, when the archdiocese bought both from the Presbyterians in 1873. At that time, Father Ernest Van Dyke, rector of St. Aloysius, "could sit on the front porch of the cottage rectory and watch the sail boats come down the Detroit River, his view unobstructed the entire way."[2]

The chancery building that replaced the old rectory coincided with the Book brothers' commercial redevelopment of Washington Boulevard, and the first two floors were meant to be used as retail space. The next five stories were designated for the offices of the archdiocese and other Catholic organizations, and the top floor was the new St. Aloysius rectory.[3] The chancery was also built with an eye to the future. The foundation and frame were constructed to allow for the addition of four more floors, although that option was never acted on.[4]

The carved ornamentation on the building is especially profuse on the arches around the north and south entrances, which led to the chancery offices and the rectory. The window spandrels of the office stories feature alternating griffins, paired birds, and urns with flowering plants, and the area above the loggia is quite interesting, with its checkerboard pattern and archdiocesan seal.

The chancery offices moved to the refurbished Detroit Savings Bank Building on State Street at Griswold Street in 2015, and this building now houses the offices of St. Aloysius Parish as well as some ground-floor retail space.

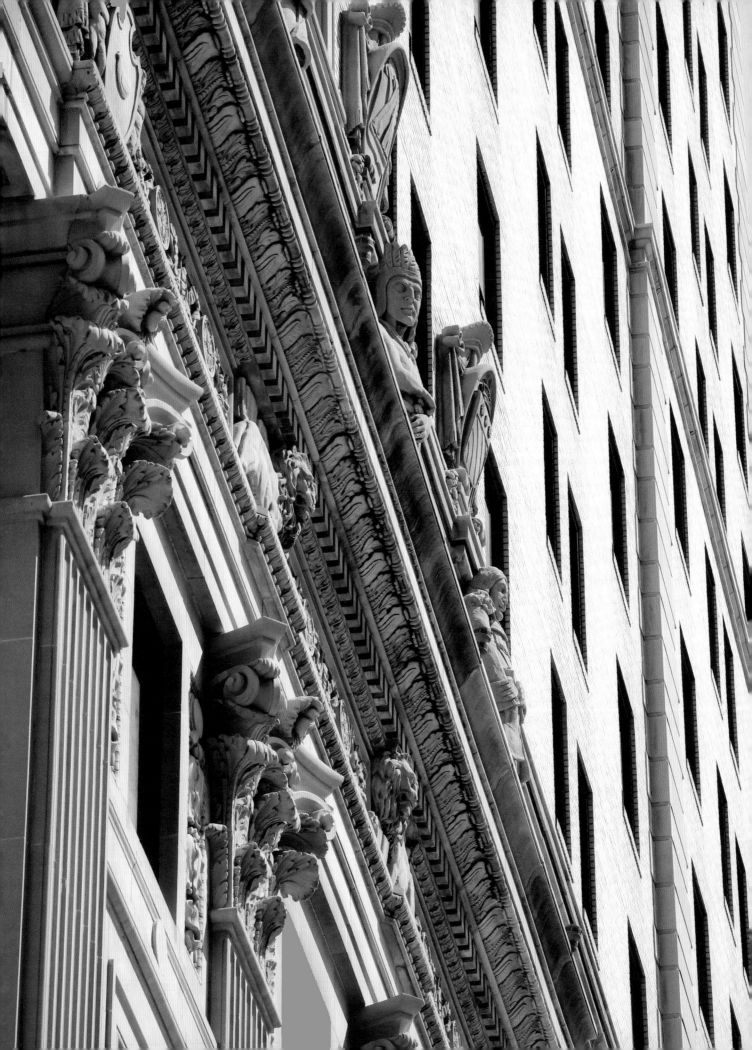

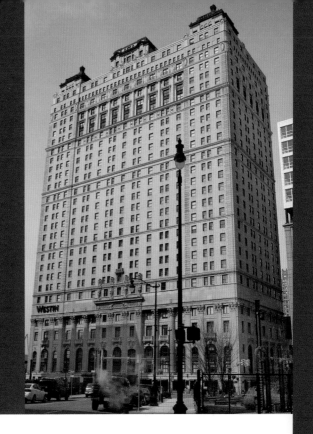

1114 Washington Boulevard

Completed: 1924

Architect: Louis Kamper

Sculptors: Thomas Tibble and Louis Sielaff

B UILT ON THE SITE of the Cadillac Hotel, where the Book brothers (Herbert, Frank, and J. Burgess Book Jr.) were born and raised, the Book-Cadillac Hotel was the third building in their plan to revitalize Washington Boulevard and turn it into a high-class rival to New York's Fifth Avenue. They spared no expense, creating the tallest hotel in the world, the largest hotel outside of New York, and, until the Buhl Building opened in 1925, the tallest building in Michigan.

Louis Kamper's Italian Renaissance design for the Book-Cadillac reaches twenty-nine floors above street level and includes twelve hundred rooms, each with the unprecedented luxury (at least among Detroit hotels) of its own bathroom. Originally, a beautiful ground-level arcade ran from Washington Boulevard to Shelby Street with nineteen shops, each of which also had street entrances. The building also had three elegant ballrooms, an ornate Italian garden, and luxurious appointments and amenities throughout.

The Book-Cadillac became well known as the best hotel in the city. Many famous guests have stayed there, including at least seven presidents, entertainers and movie stars such as Frank Sinatra and Errol Flynn, and sports heroes such as Joe Louis and Babe Ruth. Lou Gehrig was staying at the Book-Cadillac in 1939 when he became too ill to play and his record 2,130 consecutive games streak came to an end.

The top floor of the hotel was home to the radio station WCX, which billed itself as the highest broadcasting station in the world. WCX became WCX/WJR and later moved to the Fisher Building.

One of the Book-Cadillac's most prominent exterior features is the set of four portrait figures high above the Michigan Avenue entrance. They include General "Mad" Anthony Wayne, hero of the Northwest Indian War; Antoine de la Mothe Cadillac, founder of Detroit; Chief Pontiac, leader of the Pontiac Conspiracy; and Robert Navarre, Cadillac's lieutenant and a direct ancestor of the Book brothers. There are also finely carved portrait cartouches in the keystones of the arches over the third-story windows. Nobody knows for sure whom they represent, but legend has it that they are portraits of friends and family of the sculptors who worked on the building, Thomas Tibble and Louis Sielaff.[1]

Tibble was a Detroit sculptor who studied in his youth with Julius Melchers and apprenticed with

Richard Reuther. He formed a partnership with Louis Sielaff in 1903 that lasted until 1923, just before this building was completed.

Sielaff was born in Detroit in 1877. He studied under Joseph Gries, a student of Julius Melchers, at the new Detroit Art Academy and apprenticed with George W. Cope Pattern Works. One of the earliest commissions of Tibble and Sielaff's partnership was the wood carving for the public rooms of the *City of Detroit III*, one of the largest ships from the era of luxurious Great Lakes passenger steamers. The ship itself is long gone, but the elaborately carved gentlemen's lounge was saved and can be seen at the Dossin Great Lakes Museum on Belle Isle. This work made the reputation of the Tibble & Sielaff firm, which worked on and in many buildings throughout Detroit.

Tibble left the firm in 1923, and its name was changed to L. A. Sielaff & Company. Sielaff's best-known work during this time was the interior of the Michigan Theatre and the large heads on the Macomb County Building in Mount Clemens. He also did a lot of church and cemetery work. Louis Sielaff continued to work until his death in 1950. At that time, he and Corrado Parducci were just about the last active sculptors from Detroit's great building boom of the 1920s.

The Book brothers lost the Book-Cadillac to the Great Depression, and it went through a series of owners with varying degrees of success until it was closed in 1984. It became the victim of scavengers, and the run-down, vandalized building was slated to be razed in 1993. It survived simply because Detroit did not have funds to pay for its demolition.

Purchased from the city in 2006, the building underwent two years of renovations and reopened as the Westin Book Cadillac. It remains open today, an early forerunner of Detroit's ongoing revitalization.

Right: A portrait of Antoine de la Mothe Cadillac, the founder of Detroit.

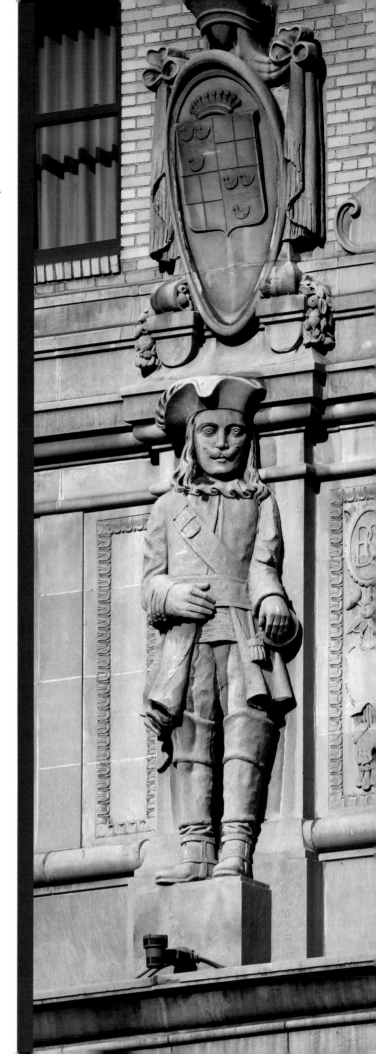

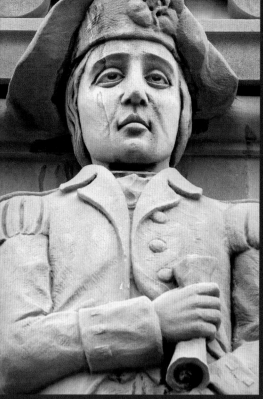
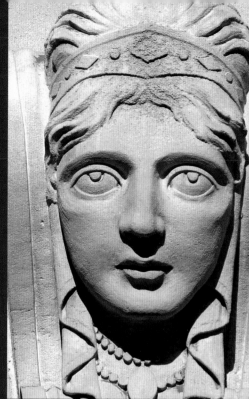

Above, left to right: A whimsical "coat of arms" above the figure of General "Mad" Anthony Wayne, featuring three mittens and a moose; General Wayne holding the treaty in which the British ceded all the territory from the Ohio to the Mississippi Rivers to the United States; and portrait busts from the keystones of the arches above the third-floor windows.

Below: The lion represents majesty and protection, and the open book symbolizes peace and wisdom. Taken together, they express the concept that a wise person knows that he or she can find safe, peaceful rest within the walls of the Book-Cadillac Hotel.

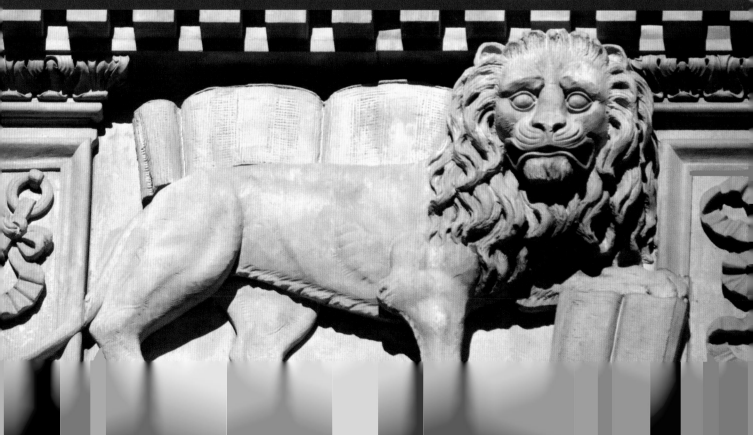

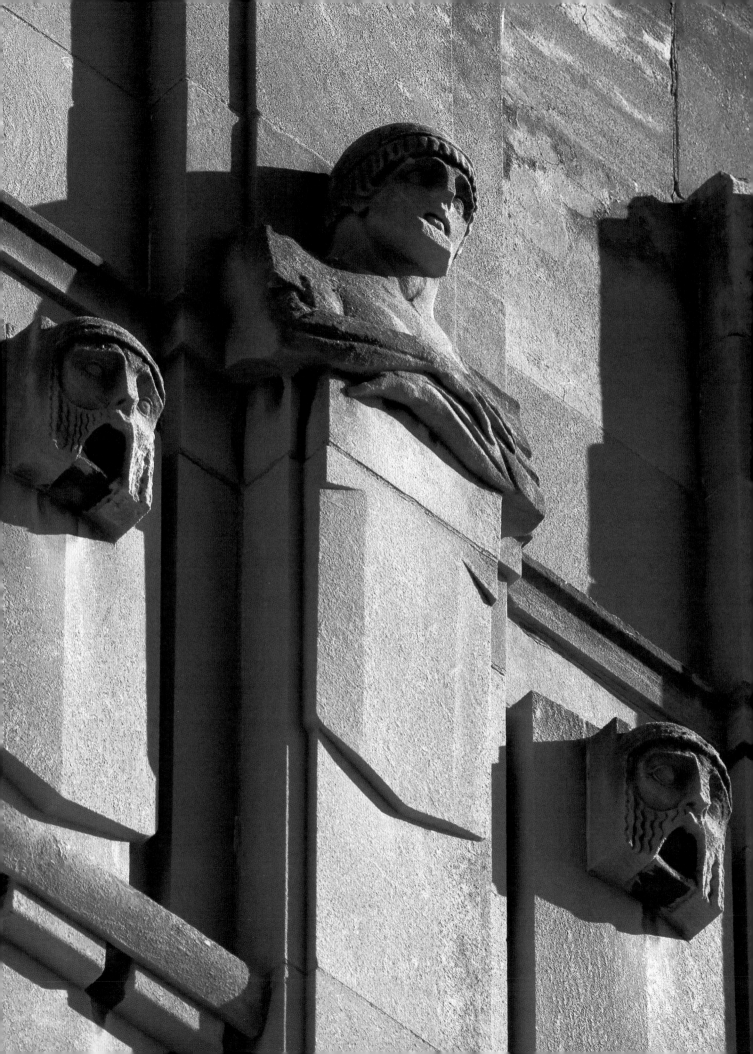

321 West Lafayette Boulevard

Completed: 1925

Architect: Albert Kahn

Sculptor: Ulysses A. Ricci

WITH A THIRTEEN-STORY CENTRAL tower that rises above two six-story wings, Albert Kahn's design for the Detroit Free Press Building is echoed in his later commercial work, most notably the Maccabees Building (page 182) and the Fisher Building (page 198). However, this building had some unique features all its own, including a basement-housed printing plant and a subbasement for storage of paper rolls, as well as a third-floor walkway connecting it to the nearby Detroit Club. It was built substantially larger than the nearby Detroit News Building to accommodate revenue-generating retail and commercial office space.

The building featured ground-level shops on the front and both sides, with the back devoted to a mailing room with a twenty-foot covered drive and loading docks. Newspaper business offices occupied the entire second floor, and editorial offices and composing rooms occupied the third. Owner E. D. Stairs's office was high above, on the thirteenth floor of the tower.

The building is also a monument to Detroit's rapid growth during the early twentieth century, as it was built to replace a structure meant to be the *Free Press*'s "all-time newspaper home" just twelve years before, which the paper quickly outgrew. During that period, daily circulation of 66,162 and Sunday circulation of 77,159 rose to 161,242 and 214,042, respectively.[1]

A two-story-tall, ornately decorated main entrance features carvings created by Ulysses A. Ricci. They include monumental female figures on either side, goddesses of commerce and communications. Just below each goddess is a relief figure of a man working a printing press. Below them on each side of the entrance are allegorical figures representing communication technology, wealth, and the authority of wisdom on the left and entertainment arts, commerce, and agriculture on the right. In between these are panels featuring a variety of birds and animals that appear to be passing news along from one to another.

The front façade is also adorned with eight bas-relief medallion portraits featuring famous newspapermen and Michiganders. The upper reaches of the central tower are dominated by an enormous guardian figure representing the *Detroit Free Press* as the guardian of liberty. There are also profile portraits of Mercury, god of commerce, and Athena, goddess of wisdom, and multiple protective gargoyles in the shape of warriors and lions.

The sculptor, Ulysses A. Ricci, was born in New York City in 1888. He partnered with Anthony DiLorenzo and later with Angelo Zari. Ricci was known for his figural work, and his partners usually

did the ornamental work in their commissions. Corrado Parducci worked with Ricci and stayed with DiLorenzo after Ricci left, because he knew he would get to do a lot of figural work with Ricci gone. Ricci worked mainly in New York, Washington, DC, and along the East Coast. His Detroit work includes the Fisher Building (page 198), the General Motors Building (page 104), and the State Savings Bank (page x).

The Detroit Free Press Building served as the home to the newspaper for seventy-three years, until the staff moved down the street to share the Detroit News Building in 1988, following a joint operating agreement. Empty for many years, the building was purchased by the Bedrock real estate firm in 2016. A mixed-use retail/office/residential renovation is expected, with a projected 2019 completion date.[2]

Right, top to bottom: Medallions from the Lafayette Boulevard façade, which include portraits of pioneering newspaperman and publisher Ben Franklin, journalist Charles Dana, University of Michigan president James Angell, and Monroe native General George Custer.

Left column: Medallions on the east and west façades show modes of transportation.

Top and center right: Mermen repeated at all four corners of the building represent the arts and commerce.

Bottom right: Sentinel figures and lion-head gargoyles are featured along the cornices and are repeated on all four sides of the building.

Detroit Free Press Building - 121

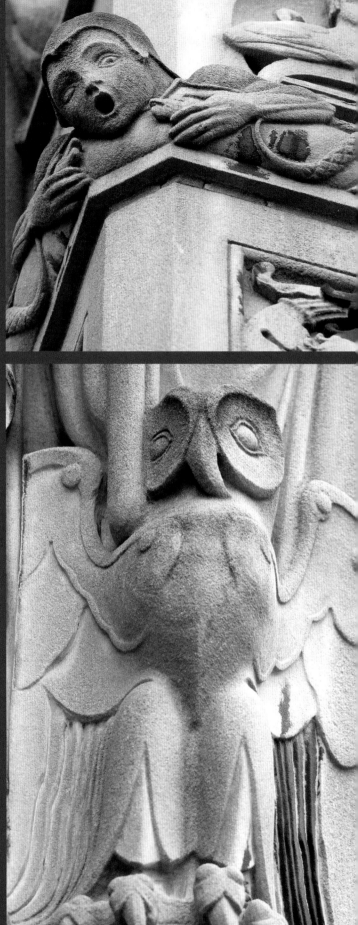

Below: The eagle near the feet of the figure of "Commerce" on the left side of the entrance, and a seahorse symbolizing power and good fortune.

Below: An allegory representing the authority of wisdom.

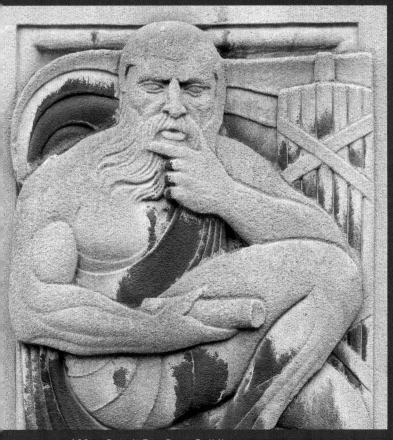

Above: Detail of an owl from the base of the figure of "Communication."

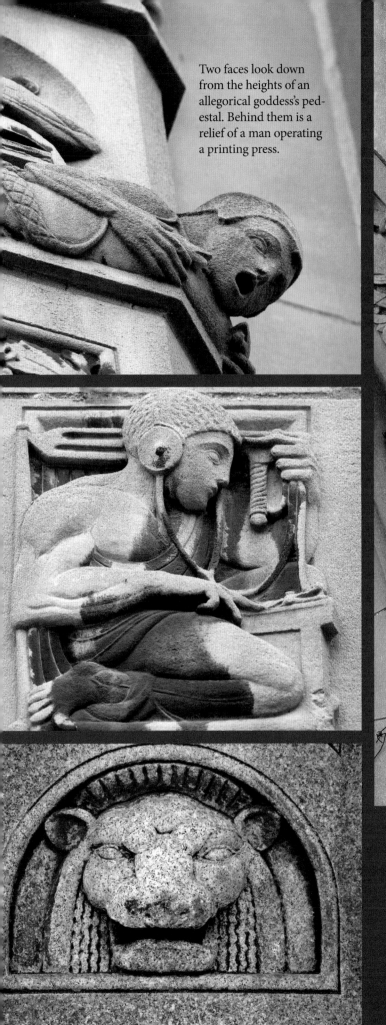

Two faces look down from the heights of an allegorical goddess's pedestal. Behind them is a relief of a man operating a printing press.

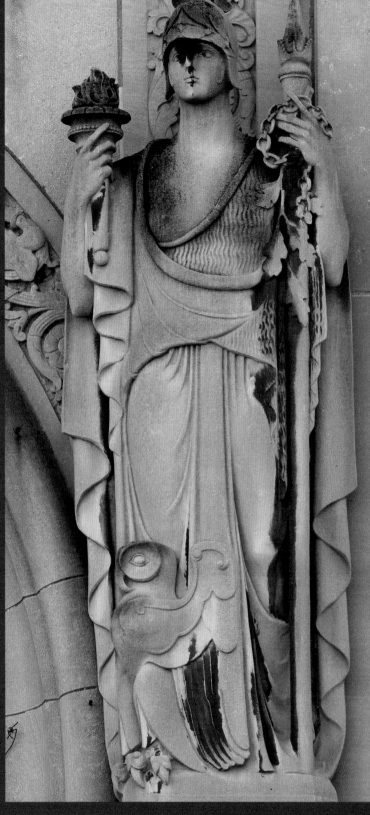

Above: On the right side of the entrance, a figure representing "Communication" holds the torch of knowledge in her right hand and the spear of destiny and the broken chains of ignorance in her left.

Center left: An allegory relief representing communication technology.

Bottom left: When a lion is placed at the base of a column, as it is here, it symbolizes Satan rendered powerless, subject to the service of humankind.

Detroit Free Press Building - 123

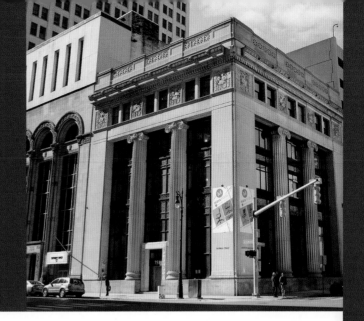

751 Griswold Street

Completed: 1925

Architect: Albert Kahn

Sculptor: Corrado Parducci

Working on the First State Bank Building marked a major turning point in the life of the sculptor Corrado Parducci that resonated throughout the city of Detroit. Parducci was working for DiLorenzo & Company in New York City at that time and had created the plaster models for the sculpture on the First State Bank Building. The carving work was proceeding in the wintertime, and according to Parducci, "Kahn didn't want to climb the scaffold to inspect the work so he had me do it for him."[1]

Parducci came to Detroit planning to stay a couple of months, but as Parducci told it, "while I was here, George D. Mason and Donaldson and Meier and Smith Hinchman & Grylls and Albert Kahn just showered me with so much work and I couldn't get away."[2] He sent for his wife and bought out his contract with DiLorenzo. For the next ten years, during the building boom of the 1920s and continuing into the 1930s, just about every major building erected in Detroit had Corrado Parducci's work on it or in it or both.

Corrado Joseph Parducci was born in Buti, a small Italian village about ten miles north of Pisa. In 1904, at the age of four, he immigrated with his father to New York City. While his father worked to earn enough to bring the rest of the family to America, young Corrado was placed in an orphanage. When his mother and twelve siblings arrived in New York a year and a half later, he needed a translator to talk with them, as he no longer spoke Italian.[3]

The young man's artistic abilities were recognized early on, and he received top-notch academic training, including admittance to the Beaux-Arts School of New York. After years of apprenticeship, he ended up working for Anthony DiLorenzo.

Parducci's work on the First State Bank Building is concentrated in two areas, around the doorway and up near the top, with large intricate panels between the windows of the attic level and a lot of detail work on the cornice.

This building was the home to the First State Bank and its successor companies until the Guardian National Bank of Commerce was dissolved in 1935. It was bought by First Federal Savings and Loan in 1942 and served as its headquarters until 1965. It was then successively owned by Burton Abstract & Title (1969), Peoples Federal Savings and Loan (1972), the Church of Scientology (1979), and Olde Discount Brokers (1987). The building had been vacant since 1999 when it was purchased by Roger Basmajian's development company, Basco of Michigan, in 2013.

Now known as "the 751," the First State Bank Building has undergone a $7 million remodeling and restoration. The ground floor, with its ornate twenty-foot ceilings and gallery, has become the showroom for the office furniture company MarxModa, and the remaining floors now house MarxModa's headquarters. The grand opening was celebrated in April 2018.

Left and below: Reliefs around the Griswold Street entrance include reproductions of ancient coins and childlike figures representing industry and commerce.

Top: This jolly-looking lion on the cornice represents security and vigilance.

Above: Allegorical reliefs of wealth and security from between the attic windows. Note how smoke billows from the factory chimneys in the background of the wealth panel, at that time considered a positive image of thriving industry.

Facing page: Mercury, the Roman god of commerce. This image was made after the exterior of the building was cleaned; the others are from before the cleaning.

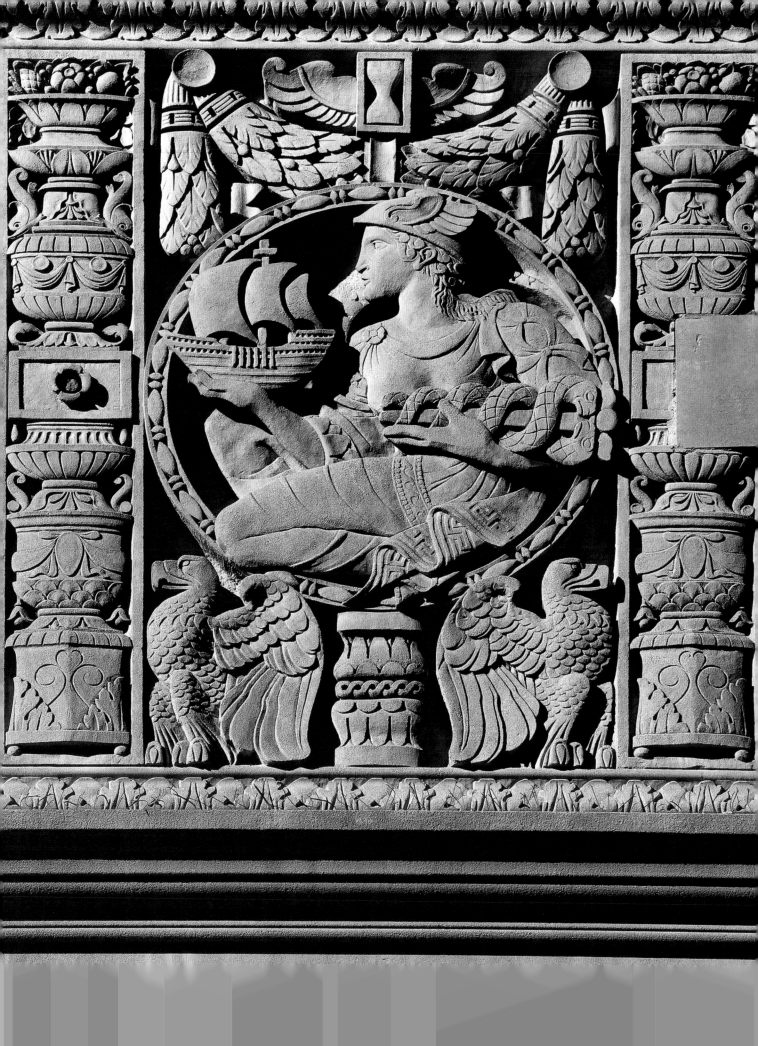

735 Griswold Street

Completed: 1925, 1961 (addition)

Architect: Albert Kahn

Sculptor: Corrado Parducci

THE SECURITY TRUST BUILDING is an example of what happened when 1960s-style urban renewal met a classic Romanesque Revival structure. Built in 1925 at the same time as the neighboring First State Bank Building (page 124), this was the home of the Security Trust Company and then the First Detroit Company until 1936, when the stockbroker J. S. Bache & Company moved in. The Federal Reserve Bank of Chicago occupied the building during World War II, and it was followed by the Abstract and Title Guaranty Company, which was eventually absorbed by the Lawyers Title Insurance Corporation.

When Lawyers Title needed more room in 1961, it replaced the original shallow-gable roof with a plain two-story box clad with cast concrete panels. The main entrance was replaced with a window and two new entrances on either side, but fortunately the intricate carving of the center door frame was saved. Window spandrels and their ornamental brass panels were replaced with modern windows, but the original windows and ornaments were left on the south façade and can still be seen from the alley between this building and Chrysler House (formerly the Dime Bank Building) immediately to the south. The architectural update was lauded at the time for showing how an old-fashioned

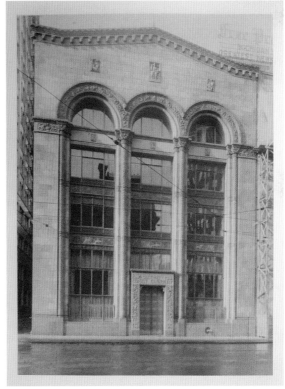

Historical photo: Thomas Ellison, Photographs of Completed Buildings in Leather Portfolios, 1907–1941, vol. 61, Albert Kahn Associates Records, Bentley Historical Library, University of Michigan, Ann Arbor, MI.

building could be adapted for "modern" sensibilities.[1] The original appearance of the building can be compared with its updated look in the photographs on this page.

To place this discordant "update" in context, Detroit in the 1960s was in the mood for modern.

The diaspora to the suburbs had begun, and many businessmen and city leaders felt that a major cause was the old-fashioned look of Detroit's downtown. They believed that urban renewal to create a fresh, modern-looking city was needed, and historical preservation was not a consideration.

It was during this time that Old City Hall (page 12) was torn down and several downtown buildings, such as the Detroit & Northern Building and the Burroughs Boulevard Building, were given new metal and glass façades. The eight-story Manufacturers National Bank of Detroit at Griswold Street and Michigan Avenue had the top six floors removed and was "drastically remodeled—turning it into a handsomely modern two-story branch office."[2]

An unfortunate result of the Security Trust Building's update was the loss of the three reliefs over the window arches and the twenty-eight carved heads from the base of the ornate cornice. However, much of sculptor Corrado Parducci's intricate work was preserved, including the spiral designs on the pillars and the menagerie of symbolic and fanciful creatures on the capitals and lining the arches that the pillars support.

After Lawyers Title left, the Security Trust Building was home to the Burger Chef chain's largest restaurant and was then known as the Olde Building, until the discount brokerage moved next door in 1987. Hardee's had a restaurant in the building until 1994, after which it was home to the Detroit Public Schools Jessie Carter Kennedy Adult Education Center.

The building was purchased by the attorney Joseph Kalladat circa 2008. Kalladat, with the help of the historical preservationist Rebecca Binno Savage, got the Detroit Financial District added to the National Register of Historic Places in 2009. This made thirty-two "conforming buildings" within the district eligible for a 20 percent historic tax credit on renovation work, if they followed certain guidelines. The building was taken down to its bare exterior walls and concrete floors and converted to apartments.[3] Security Lofts opened for occupancy in 2013 and features nineteen apartments and a ground-floor fitness center.

Facing page, top: Details from two of the intricately carved pillars of the east façade.

Facing page, bottom: Detail image of one of the figures from the relief panels on either side of the original doorway, which is now a window.

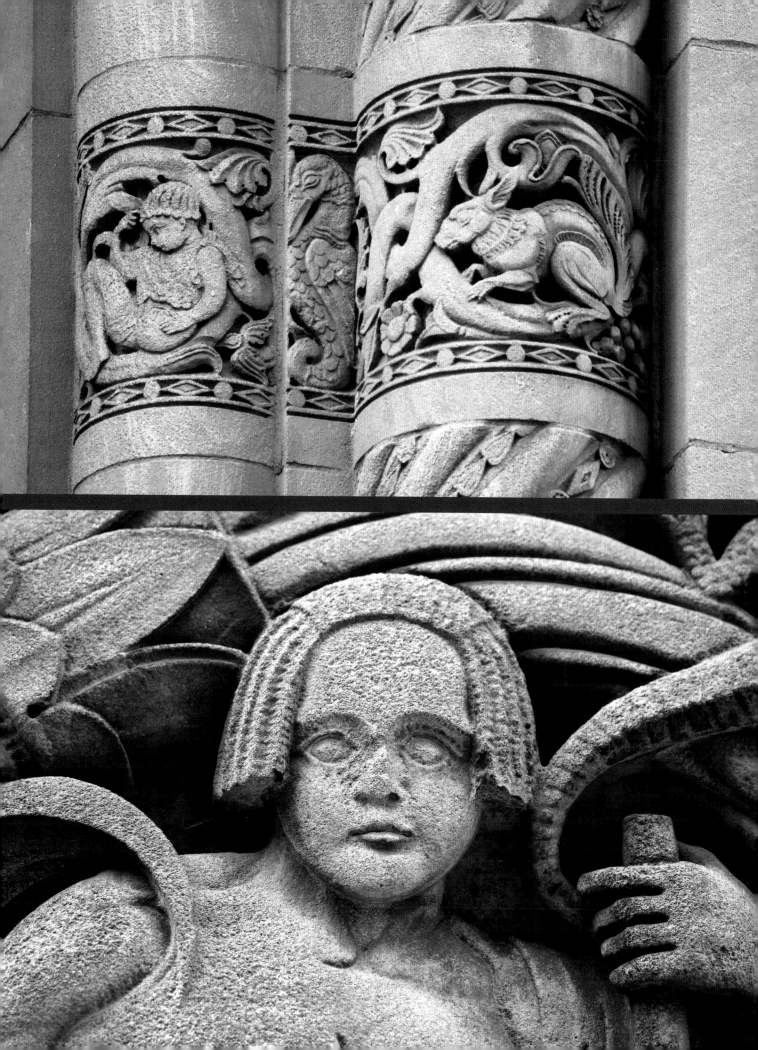

Above: A treasure-protecting griffin and a caduceus, symbol of commerce, from the old main-entrance lintel.

Left: One of the relief panels that flank the old main entrance.

Above: A guardian lion surrounded by putti (figures of naked children) from the juncture of two of the window arches.

Left: A loyal guard dog adorns a window spandrel.

Below, center: The capital from one of the three-part pillars features sphinxes and owls for wisdom, a pair of merlions for international commerce, and a duck representing abundance.

Bottom: An ornamental grille from a window spandrel. These were removed from the front of the building when the windows were updated in 1961, but some were left on the south façade and can be seen from the alley.

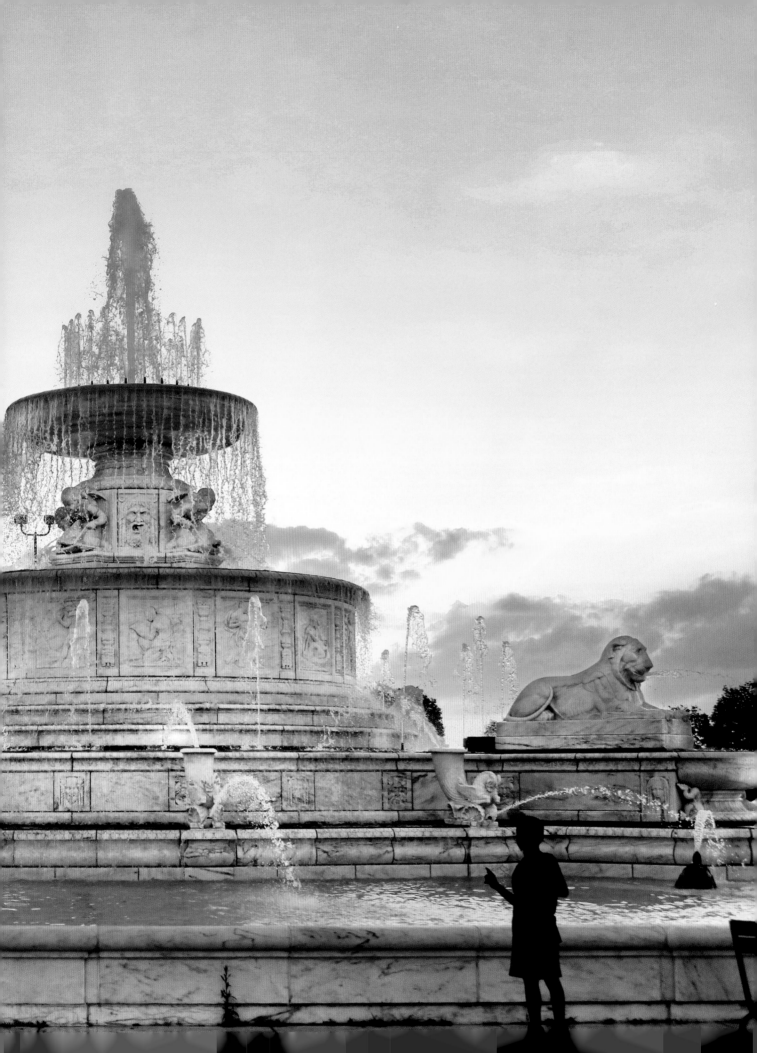

Sunset Drive, western end of Belle Isle

Completed: 1925

Architect: Cass Gilbert

Sculptors: Oswald Hoepfner, Louis Sielaff (fountain), Herbert Adams (James Scott statue)

WHEN JAMES SCOTT DIED, it was not front-page news. Although he was a well-known and wealthy Detroiter, all the story of his passing rated was a three-line death notice on page 24 of the *Detroit Free Press*.[1] The funeral arrangements made it all the way up to page 4. It was not until Scott's will was read that the story made it to the front page. It turned out that Scott had left most of his estate (money and income-earning properties valued at over $500,000) to the city of Detroit, for the purpose of building a fountain on Belle Isle. There was, however, one controversial condition: "There shall be placed on the fountain a life-sized statue of myself, made in accordance with my executors."[2]

James Scott was known to his contemporaries as a cantankerous, litigious businessman and unrepentant scalawag, a drinker and gambler who liked to loudly recount profanely humorous stories about his youthful adventures along the Mississippi River. He was also known as a world-class practical joker, but his jokes usually had a vengeful edge to them.

The Parke-Davis company wanted to buy some property from him but would not meet his price. When he was told that the company expected that he would not be alive much longer and that it would

soon be able to get the property for less, he changed his will so the parcel could not be sold for ten years after his death. When a neighbor wanted to plant a hedge to replace a dilapidated fence along a shared property line, Scott was offended and erected a twelve-foot-tall billboard fence in its place, blocking the neighbor's view down Woodward Avenue. Leaving $500,000 to beautify the city, but only if it erected a statue in his honor, was Scott's final practical joke, a thumb in the eye to those who found him and his antics offensive.

As Scott had probably hoped, many of the "respectable" citizens of Detroit were scandalized. At a council meeting to discuss whether to accept the gift and build the fountain, preachers and prominent businessmen spoke out against accepting the gift. Three Presbyterian ministers said that allowing Scott to buy the honor of a public memorial "would be a sad and demoralizing object lesson for the children of today and the future."[3] J. L. Hudson proclaimed that the fountain would be "a monument to nastiness and filthy stories."[4]

But others spoke in Scott's defense. They said his fortune was made through wise real estate investments, not gambling, and that because of a deathbed promise to his father, he had not touched

liquor in years. Clarence Burton said he regularly dined with James Scott and his wife and "never knew him to tell an impure story," adding, "I heard he did tell them, but only to people who wanted to hear them."[5] Others told of his generous nature and acts of charity, which he went to great lengths to keep hidden from the public eye.

In the end, the Common Council decided it would be a disservice to the people of Detroit not to accept Scott's gift and voted to build the fountain and statue. A national design competition was won by Cass Gilbert, the designer of the Detroit Main Library (page 84) and the U.S. Supreme Court Building. The fountain, a reflecting pool, and a statue of James Scott were built on two hundred acres added to the west end of Belle Isle through landfill. Scott finally had his last laugh, to the joy of generations of Detroiters.

The fountain is constructed of white Vermont marble and has 109 water outlets. The central jet can shoot water 125 feet in the air to cascade down the fountain into a circular basin 150 feet in circumference. From there, it travels down two sets of terraced marble steps to a 500-foot lagoon. The basin featured Pewabic tiles until they were destroyed during a 2010 restoration effort. The Belle Isle Conservancy is leading a fund-raising effort to replace them, and efforts are also under way to update the plumbing and controls housed in a hidden room beneath the fountain. The water is turned on each year from Memorial Day to Labor Day, as are the fountain's many colored lights, which create a beautiful evening extravaganza for park visitors.

The sculptural ornamentation on the fountain is the work of Oswald Hoepfner, who signed one of the panels on the upper portion, and Louis Sielaff. Hoepfner also worked on the Detroit Main Library, while Sielaff and his partner, Thomas Tibble, also worked on the Book-Cadillac Hotel (page 114). There are three portraits, apparently of Hoepfner, Sielaff, and Gilbert, on the upper part of the fountain, along with relief panels depicting frontier living and Native American life from the early days of Detroit.

The larger-than-life statue of James Scott was created by Herbert Adams, a nationally known sculptor of monumental works. It portrays Scott sitting in an ornate chair at the edge of the raised plaza, gazing contentedly at his fountain and the city beyond. Despite the controversy that accompanied the creation of the Scott Fountain, it has been very popular with the people of Detroit since it was built, proving the last line of the dedication on the back of the chair: "From the good deed of one comes benefit to many."

Facing page: To the west of the main fountain, water travels down two sections of terraced marble steps to a five-hundred-foot lagoon. The upper section features water shooting from the mouths of Neptunes in sea shells. The lower section features water flowing from the mouths of sea gods and fish at the top and several lions on the lower levels. This section of the fountain can best be seen from a canoe or kayak on the lagoon.

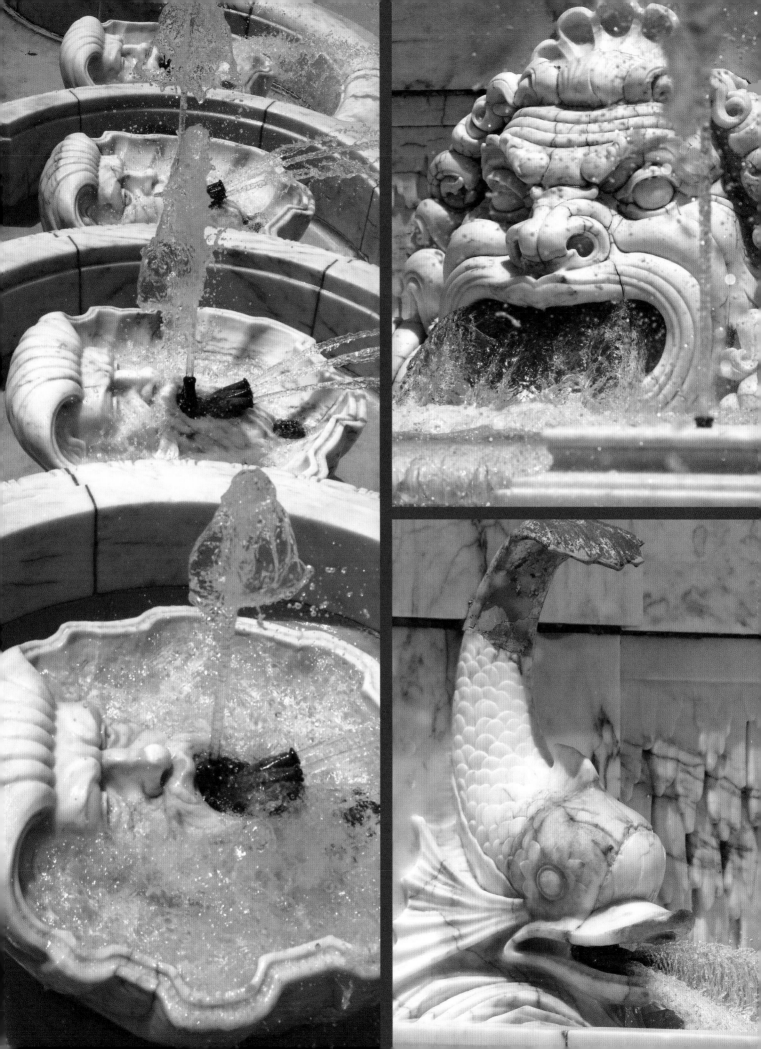

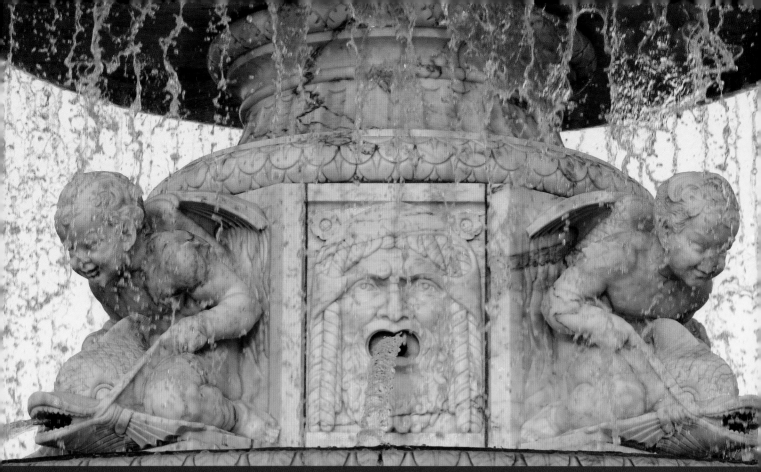

Water shoots from the mouths of an assortment of lions, fish, faces, frogs, and turtles. Some are carved from marble and located on the fountain's various levels. The turtles and most of the frogs are cast bronze and sit within the basin.

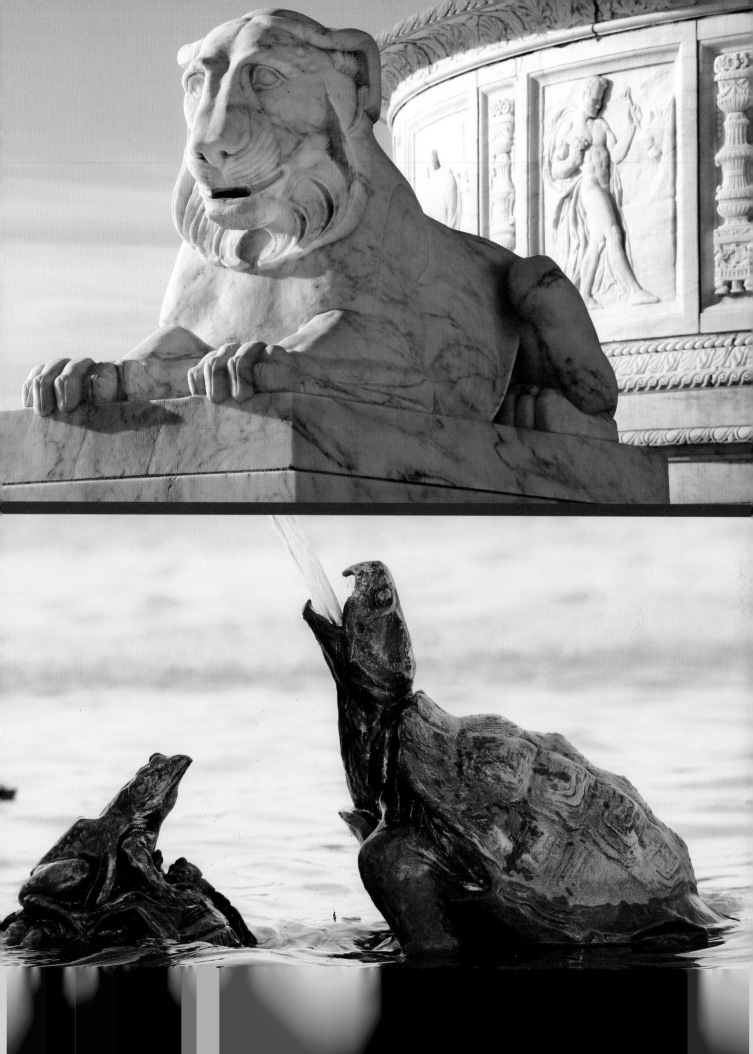

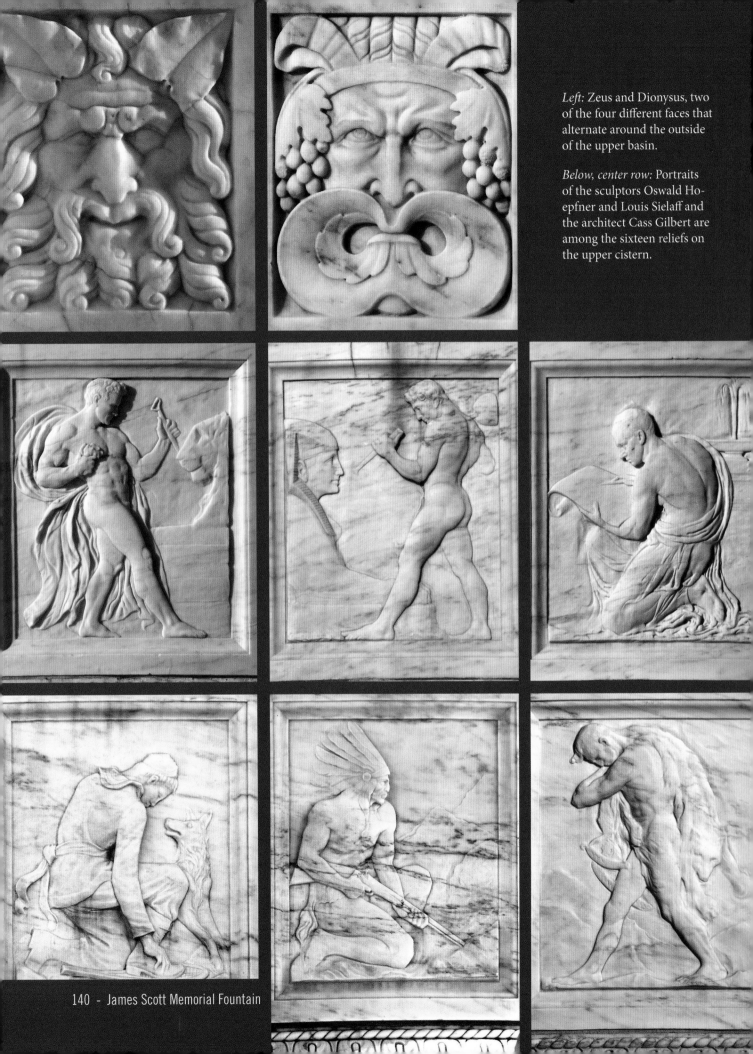

Left: Zeus and Dionysus, two of the four different faces that alternate around the outside of the upper basin.

Below, center row: Portraits of the sculptors Oswald Hoepfner and Louis Sielaff and the architect Cass Gilbert are among the sixteen reliefs on the upper cistern.

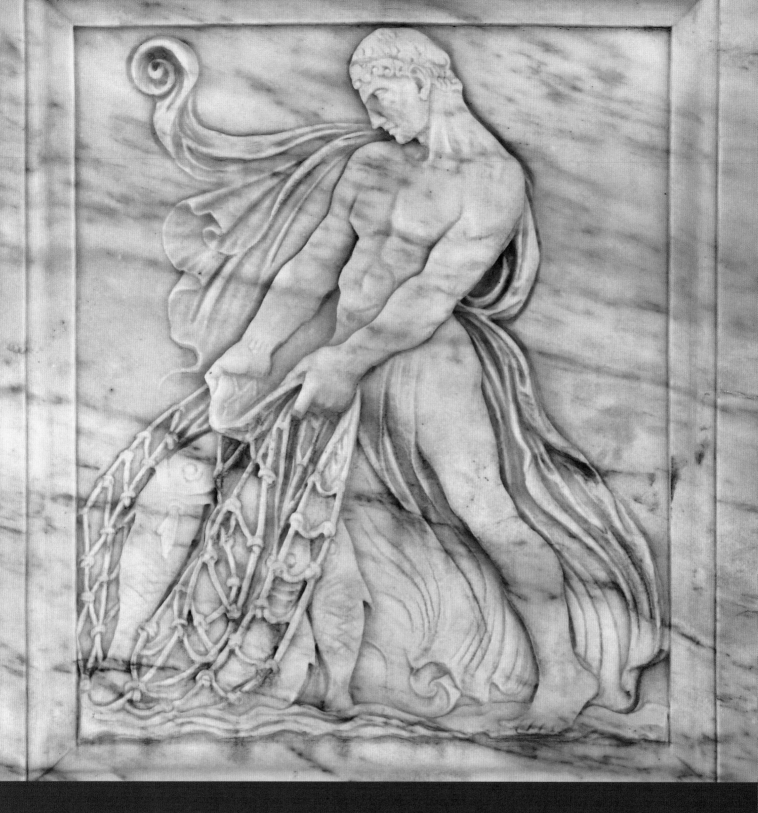

Bottom row of facing page and above: Four of the thirteen panels on the upper cistern featuring scenes of Native American and frontier life.

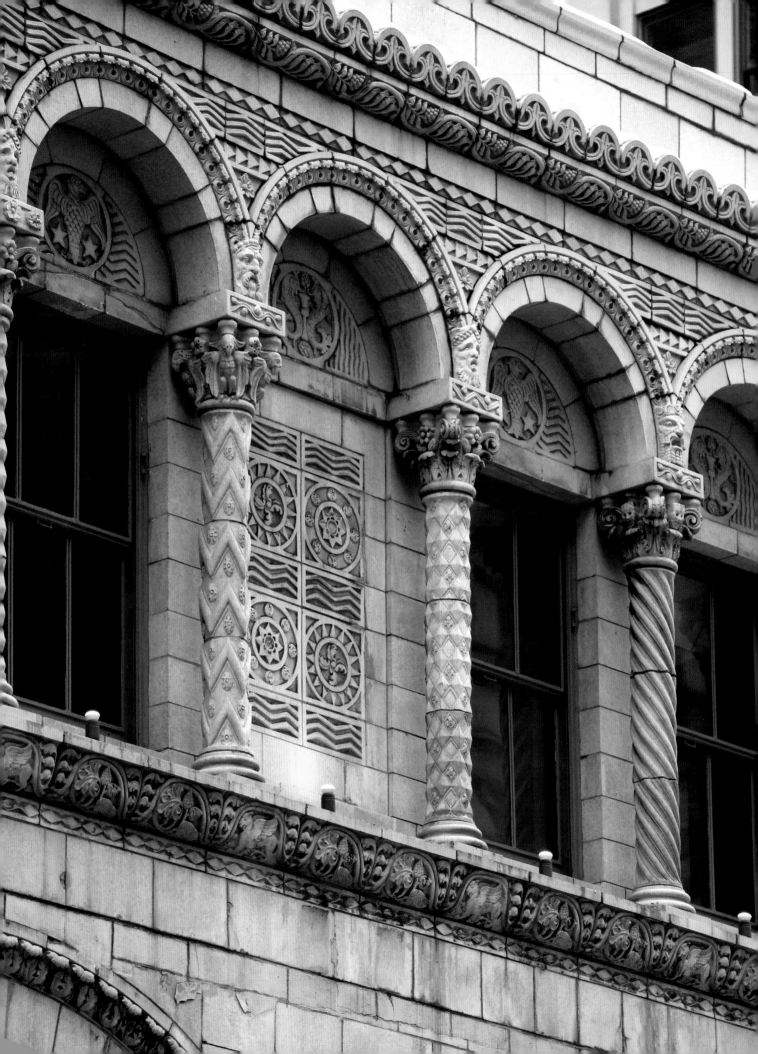

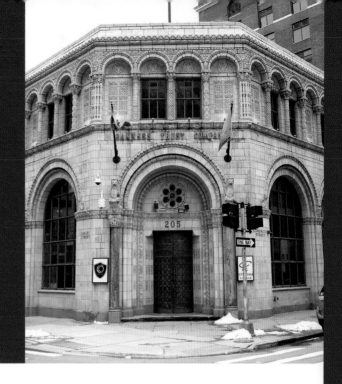

205 West Congress Street

Completed: 1925

Architect: Wirt C. Rowland (Smith, Hinchman & Grylls)

Sculptor: Corrado Parducci

O NE BLOCK WEST OF the skyscrapers in the heart of the financial district, there is an Italian Renaissance–influenced Romanesque wonder, standing out from its stodgy neighbors with massive arches and exuberant terra-cotta ornamentation. It is the Bankers Trust Company Building, the culmination of the architect Wirt C. Rowland's fascination with European architectural forms.

Rowland was born and raised thirty miles west of Detroit in the village of Clinton. He was drawn to architecture as a child when he happened across a June 1883 *Harper's* magazine article on Lambert Palace in London. The pictures and plans in the magazine inspired him to create page after page of drawings of his own palaces and castles. There were few opportunities for an aspiring architect in small-town Clinton, and in 1901, Rowland decided to seek his fortune in Detroit.

Rowland first found a position as an office boy at the offices of Rogers & MacFarlane and moved on to work at some of Detroit's most important architectural firms, including George D. Mason, Albert Kahn, and Malcomson & Higginbotham. During this time, he also attended the Harvard Graduate School of Architecture (1910–11) and then traveled extensively in Europe to study its historic structures and building styles. In 1922, Rowland became head

designer at Smith, Hinchman & Grylls, the oldest, largest, and most prestigious architectural firm in the city.

The opulent two-tone terra-cotta ornamentation and multiple highly decorated pilasters and arches make the Bankers Trust Company Building feel like a banking palace. The symbolism of the many decorative carvings speaks to wealth and the power to protect and nurture it. Lions represent power, and several hold shields with keys on them, representing security. Eagles provide sharp-eyed vigilance, while guard dogs over the unique rounded bronze doors represent how well the contents of this building are protected.

Squirrels with acorns show the wise foresight of stored savings, while multiple grotesques ward off those who mean harm. A row of griffins, guardians of treasure, assure investors and customers that this is a place of utmost security. Everything combines to tell passersby that there is no safer place for their money and investments than the Bankers Trust Company.

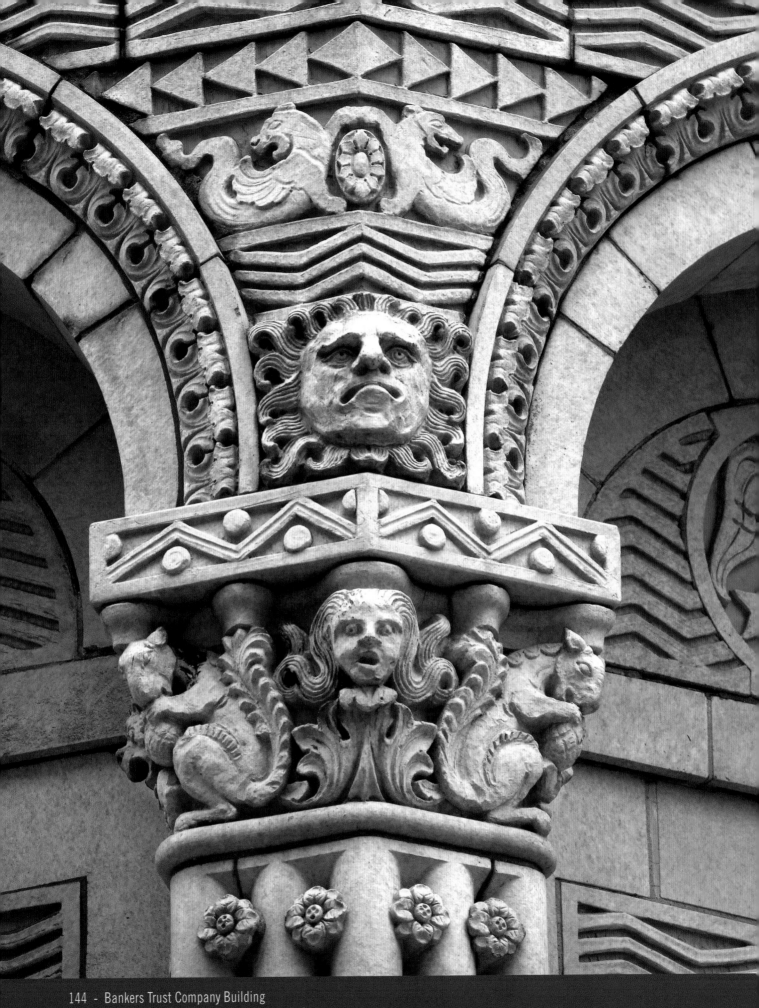

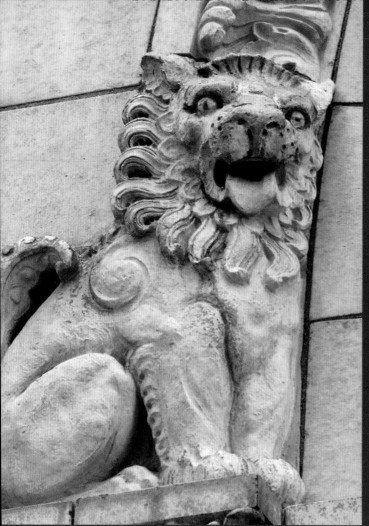

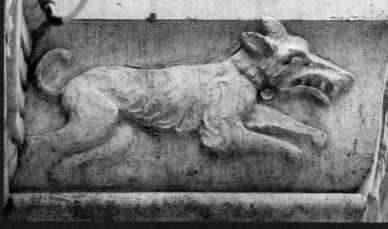

Facing page: Two-tone geometric patterns, combined with rich figural detail representing abundance, growth, and planning, provide a sense of opulence at this palace of banking.

This page: Deposits at the Bankers Trust Company are protected by guard dogs, lions, and basilisks. The basilisk is a creature so horrible that it can kill with a glance.

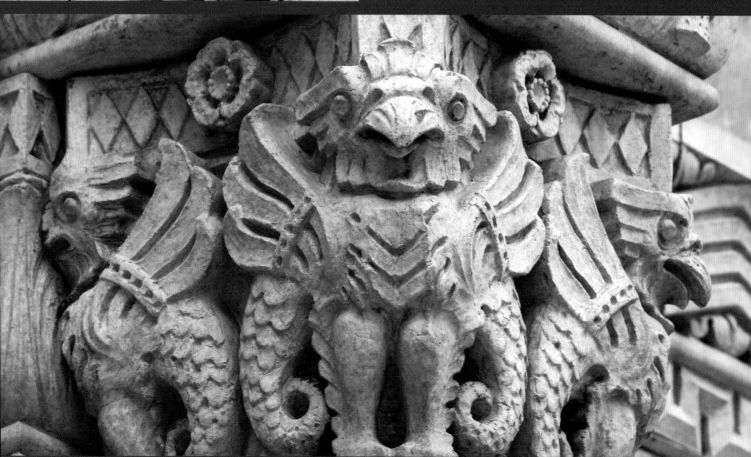

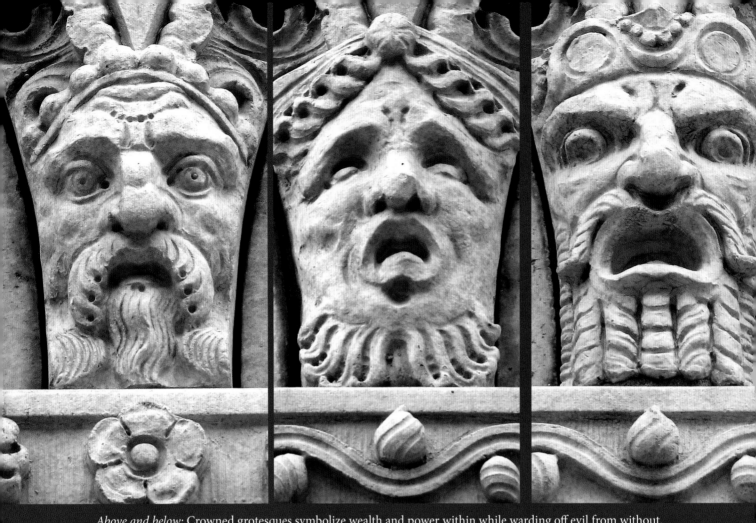

Above and below: Crowned grotesques symbolize wealth and power within while warding off evil from without.

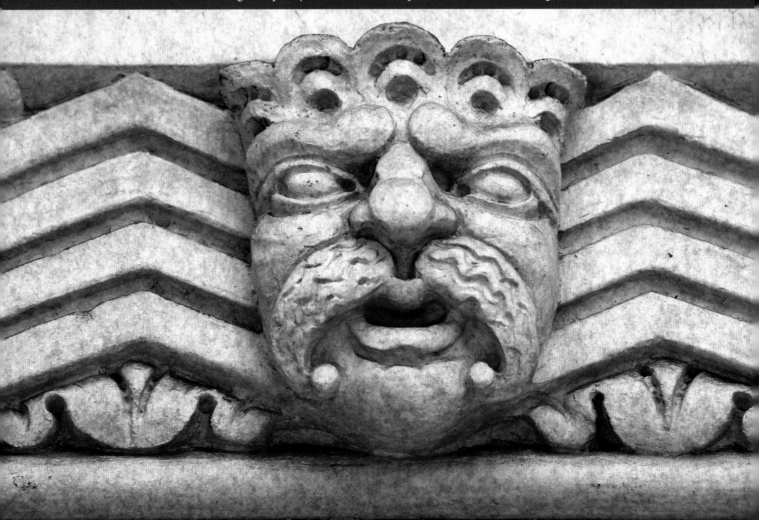

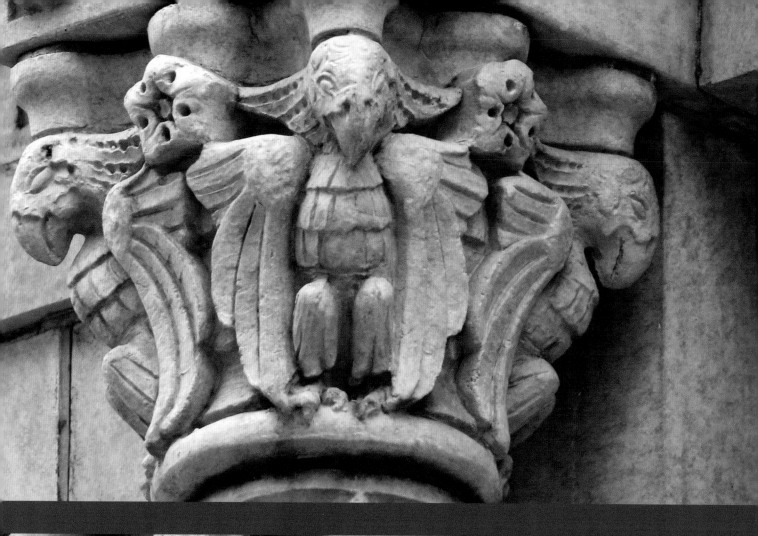

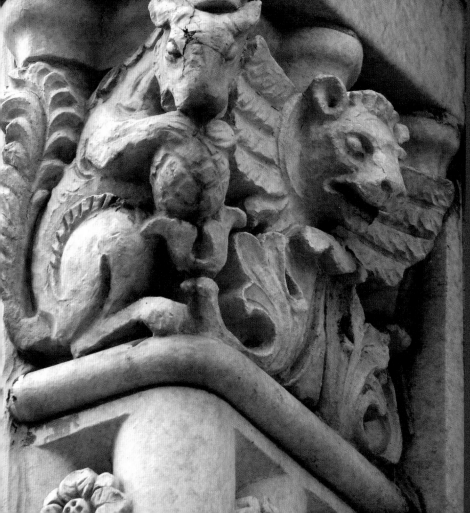

Above: Eagles provide ever-vigilant protection.

Left: A squirrel with a nut represents foresight, and the winged bull represents strength and power. The terra-cotta decoration has aged well over the past ninety years, with this squirrel being one of the few ornaments to show damage.

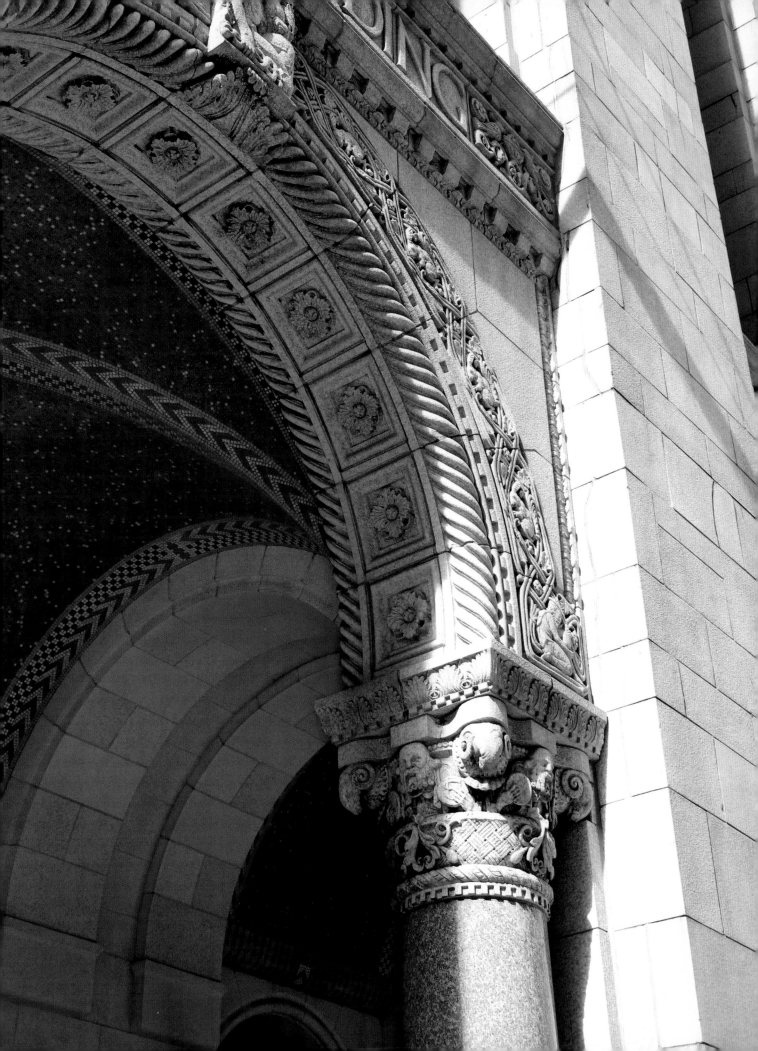

533 Griswold Street

Completed: 1925

Architect: Wirt C. Rowland (Smith, Hinchman & Grylls)

Sculptor: Corrado Parducci

THE BUHL BROTHERS, CHRISTIAN and Frederick, came to Detroit in the early 1800s. They started out in the fur trade and hat business and later moved on to retail, heavy industry, and property development and management. They founded the Detroit Locomotive Works, the precursor company to Detroit Copper and Brass. Each served as mayor of Detroit, Frederick in 1848 and Christian in 1860–61. Their children built the original Buhl Building, a small office building that was razed by a third generation of the Buhl family to make way for this skyscraper.

The Buhl Building is a transitional building, both for its architect, Wirt C. Rowland, and for the city of Detroit. This was the first of Rowland's three financial-district skyscrapers and one of the first true skyscrapers in Detroit. At that time, the city skyline was being transformed by tall buildings, maximizing use of increasingly valuable downtown property by stacking as many offices as possible onto a small footprint.

A student and admirer of Gothic architectural forms, Rowland created an office building in a Latin cross shape extruded to twenty-six stories tall. He eliminated cornices to emphasize the height of the building but also used large, randomly sized blocks on the lower façade to recall medieval building styles, emphasizing the building's solidity. Most architectural critics agree that Rowland's fusion of Old World stylistic idioms with the American skyscraper was much more successful and elegant than Louis Kamper's attempt at the same thing with his Book Tower (page 162).

The Buhl was the tallest building in Detroit until it was surpassed by the Book Tower only a year later. The Buhl was unique because of its cruciform shape, which allowed natural light to reach every office and provided eight higher-rent corner offices on each floor instead of the usual four.

The Buhl was also lauded for its elegance, as noted in the May 3, 1925, edition of the *Detroit Free Press*, which suggested, "when visiting the Buhl building, do not hurry through as one viewing the commonplace, but stop and study the many details of ornamentation."[1]

The lower façade features Romanesque details that represent the history of the building site and the ideals of the Buhl family. Sculptures of Native Americans placed on either side of the entry represent the original masters of the land on which the tower is built. Lions symbolize the strength and watchfulness of the businesses within, and the Roman god Mercury represents commerce.

Right: One of two Native American figures that stand solemn guard above the main entrance, flanked by animals representing the figure's wealth and status.

Below: A lion with a shield provides strong security.

Bottom right: A king holds golden plates. Ram's heads on either side of him are symbols of power.

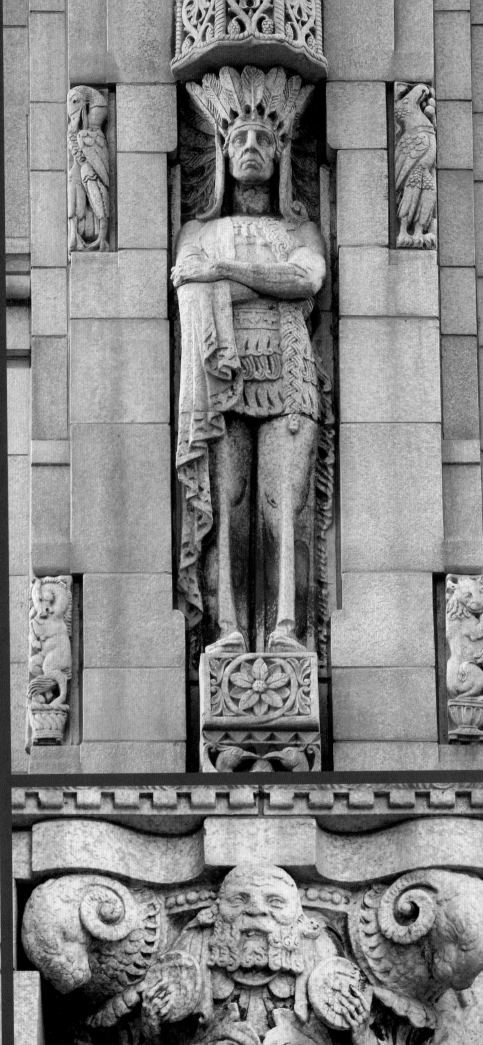

Top: The smiling visage of a demigod welcomes visitors from over the Congress Street entrance.

Left: A pair of fish with a rooted plant represent fertility and growth.

Bottom: This winged lion is a symbol of Babylon, an ancient city of great wealth and power.

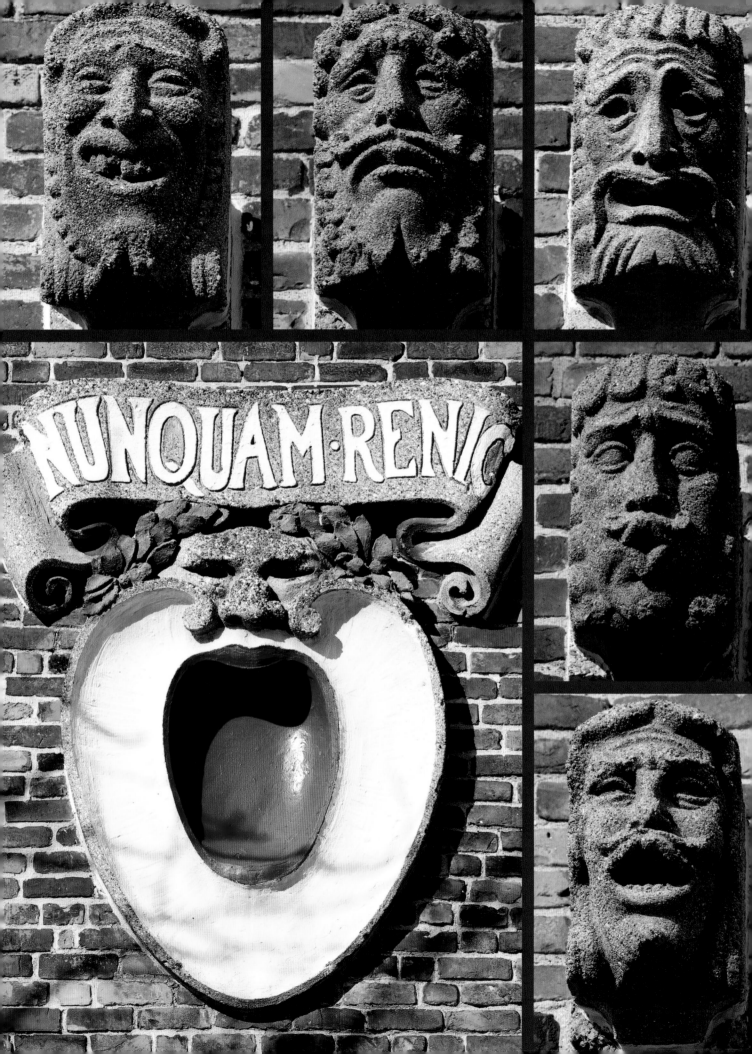

NUNQUAM·RENI

3321 East Jefferson Avenue

Completed: 1925

Architect: William E. Kapp
(Smith, Hinchman &
Grylls)

Sculptor: Corrado Parducci

THE PLAYERS CLUB DATES back to 1910, when it was formed by a group of prominent Detroit businessmen for the purpose of encouraging the production and enjoyment of amateur theater. Membership is male only, and although the club has had its ups and downs through the years, it remains active today, observing traditions that were mostly established in the first thirty years of its existence, including donning formal attire for all performances. The club presents members-only "Frolics" on the first Saturday of the month during a season that lasts from October to April, followed by an "Invitational Frolic" in May, to which guests may be invited.

During The Players Club's early years, performances were staged in various rented facilities. It was not until the mid-1920s that the club felt strong enough financially to build and run its own theater. William E. Kapp of Smith, Hinchman & Grylls supervised design and construction, and club members were so impressed with his work that they asked him to become a member. He became a prolific set designer, responsible for 198 sets over the years.[1] Other buildings designed by Kapp include the Detroit Historical Museum (page 287) and the Dossin Great Lakes Museum on Belle Isle.

The building was erected near the site of the Battle of Bloody Run, in which Chief Pontiac and his men ambushed and overwhelmed British soldiers on their way to attempt a surprise attack on Pontiac's encampment. So many soldiers were killed that Parent's Creek, which once flowed under a corner of the theater, ran red with blood and was known thereafter as Bloody Run.[2]

The Players Theatre was built in a sixteenth-century English Renaissance style and features a row of ten grotesques carved out of cinderblock, a revolutionary new construction material at the time that was used in place of stone on many interior and exterior features. These expressive theatrical masks were created by Corrado Parducci. He is probably responsible for The Players Club seal over the door as well. It is made up of a brightly painted Dionysus beneath a banner featuring the club's motto, "Nunquam Renig." Translated as "None shall refuse," it expresses the idea that an active club member will always accept and complete any assignment offered to him.

The Players Club has evolved over the years, with membership becoming less exclusive, but all members are still considered gentlemen and expected to behave as such at all times. Information on membership and events can be found at www.playersdetroit.org.

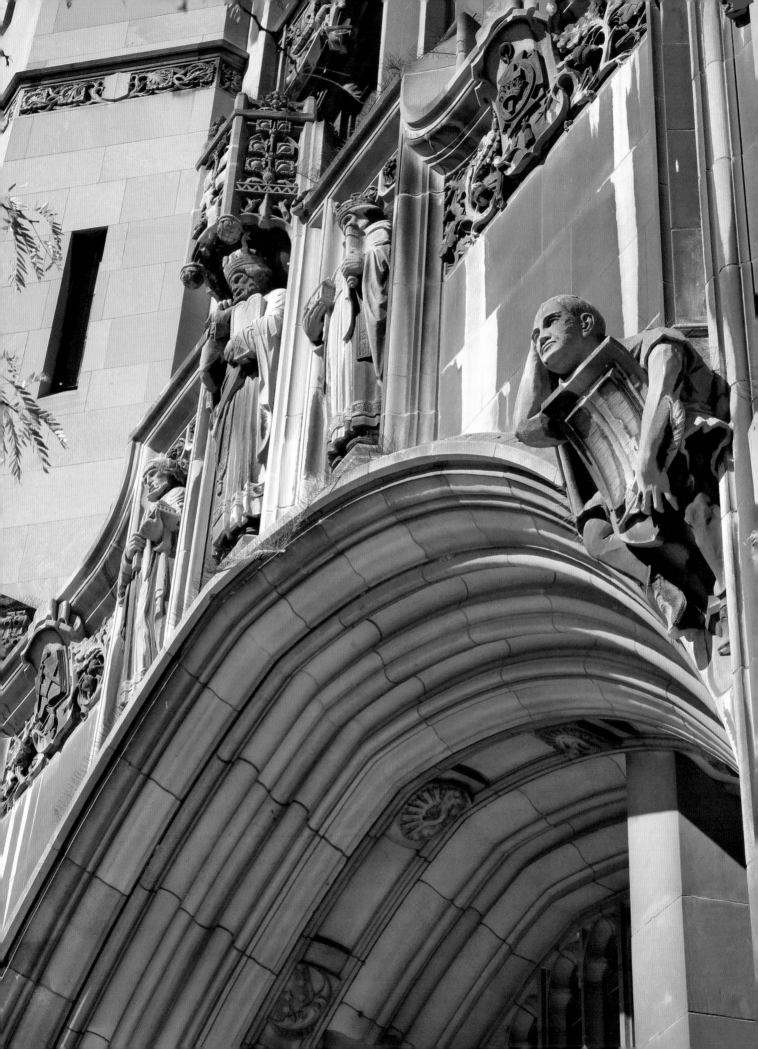

500 Temple Street

Completed: 1926

Architect: George D. Mason

Sculptors: Leo Friedlander, Bill Gehrke, Henry Steinman

WHEN THE DETROIT MASONIC Temple was built, a contemporary writer described it as a poem in stone.[1] It was the architect George D. Mason's masterpiece, the largest Masonic temple in the world. Its Gothic design creates an impression of massive strength and stability and is profusely ornamented with sculpture representing the history and traditions of Masonry. The building is composed of three sections: the ritual building of the Scottish Rite Cathedral (Masons) to the west; the Moslem Temple, Ancient Arabic Order, Nobles of the Mystic Shrine (home of the Shriners) to the east; and the main auditorium (Masonic Temple Theater) in the middle.

The cornerstone for the massive structure was laid April 18, 1922, in a ceremony attended by over forty thousand Masons from all over Michigan. Secretary of State Edwin Denby was there to read a speech prepared by President Warren Harding, who bowed out at the last minute due to his wife's illness. Secretary Denby and Clarke W. McKenzie, Grand Master of the Grand Lodge of Michigan, spread mortar for the cornerstone with the trowel used by George Washington when the cornerstone of the Capitol Building in Washington, DC, was laid. Almost four years later, on February 22, 1926, the building was completed.

The entrance to the main temple features life-size sculptures of three men. The central figure, King Solomon, builder of the First Temple in Jerusalem, represents wisdom and knowledge. This figure, carved holding his finger to his lips, also personifies the old Masonic slogan "Aude, Vide, Tace," which means "Hear, see, be silent."

The figure on the left is Hiram Abiff, known as "The Widow's Son." King Solomon appointed him Master of Works of the temple, and he holds a model of the temple as well as a square and a compass, the central symbols of Masonry. Abiff was slain when he refused to divulge secret Masonic passwords to ruffians. He symbolizes Masonic commitment to building the best possible life and ignoring the base desires and failure of the spirit, represented by his attackers.

The third figure is King Hiram of Tyre, a Phoenician monarch who provided architects, workmen, and gold for the temple's construction. In one hand, he holds a scepter, symbol of his earthly power, and in the other, he holds a treasure chest, symbol of his freely given wealth. The figures were created by the renowned New York sculptor Leo Friedlander, who also created the colossal equestrian statues on Washington, DC's Memorial Bridge and the thirty-three-foot-tall figures of the *Four Freedoms* for the 1939 New York world's fair. Friedlander was born in New York City in 1888 and studied in New York, Brussels, and Paris. He taught at the American Academy in Rome and was head of the sculpture department at New York University. He died in 1966. This is believed to be Friedlander's only Detroit work.

Below these figures, at the bases of the entry arch, are Gothic-style portraits of the architect

George D. Mason and Frank E. Fisher, first secretary and onetime president of the Masonic Temple Association. Fisher, inventor of an electric self-starter for automobiles, sold his factory and retired from business so he could supervise the building of the temple and work to raise the $7 million needed for its construction full-time.[2]

The towers are guarded by massive Knights Templar and crusaders, symbols of faith and sacrifice. They are the largest stone figures in the city. Two knights from the 32nd Degree Scottish Rite guard the west entrance to the cathedral, along with a two-headed eagle, a symbol of eternal vigilance.

The auditorium entrances feature comedy and tragedy masks as well as Shriners with acanthus leaves, symbols of enduring life. The wall between the theater and the Shriners' clubhouse is decorated with Egyptian pharaohs and camels, representing the Shriners' use of Eastern symbolism, and scrolls featuring open and closed thistle buds, symbols of Scotland.

Built to replace an 1892 building that was meant to last fifty years but was outgrown in only twelve, the Detroit Masonic Temple turned out to be much larger than would ever be needed. For a variety of reasons, including the economic downturn of the 1930s and the post–World War II rise of the suburbs, Detroit's population never met 1920s projections of three million plus. Add to this a shift in lifestyles away from membership in fraternal orders and competition from new types of entertainment, and by the early 2000s, it had become difficult to pay for maintenance and other expenses. The problem was further exacerbated when the Shriners moved to Southfield in 2003.

By 2013, it looked as if the building would be foreclosed on for nonpayment of taxes. The Detroit musician Jack White came to the rescue, paying the $142,000 tax bill. This, along with contributions from suburban Masonic lodges, has helped to put the Detroit Masonic Temple Association on a more solid financial footing. It is hoped that this will allow the venerable Masonic monument to continue to serve Detroit citizens as a concert, meeting, and party venue for years to come.

Above: Detail of a light fixture near the main entrance to the Scottish Rite Cathedral.

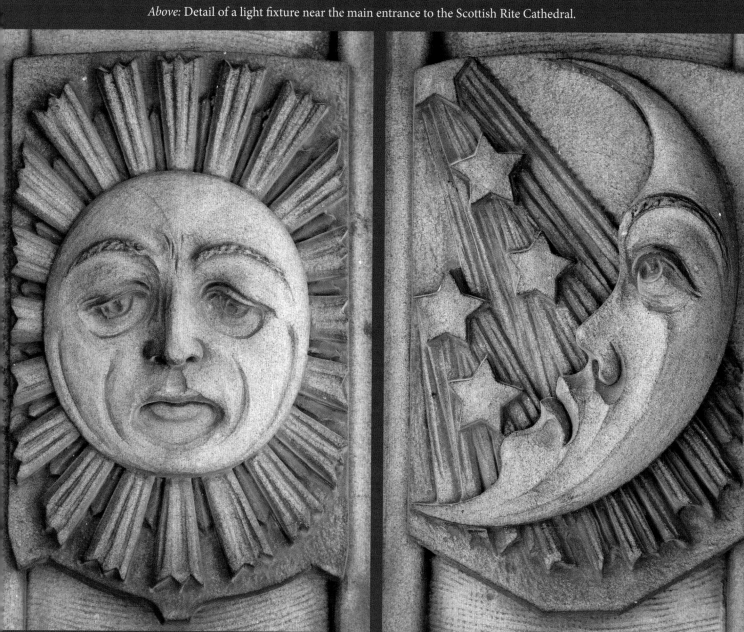

Above: The sun and the moon watch over all who enter the Scottish Rite Cathedral from inside the main entrance arch.

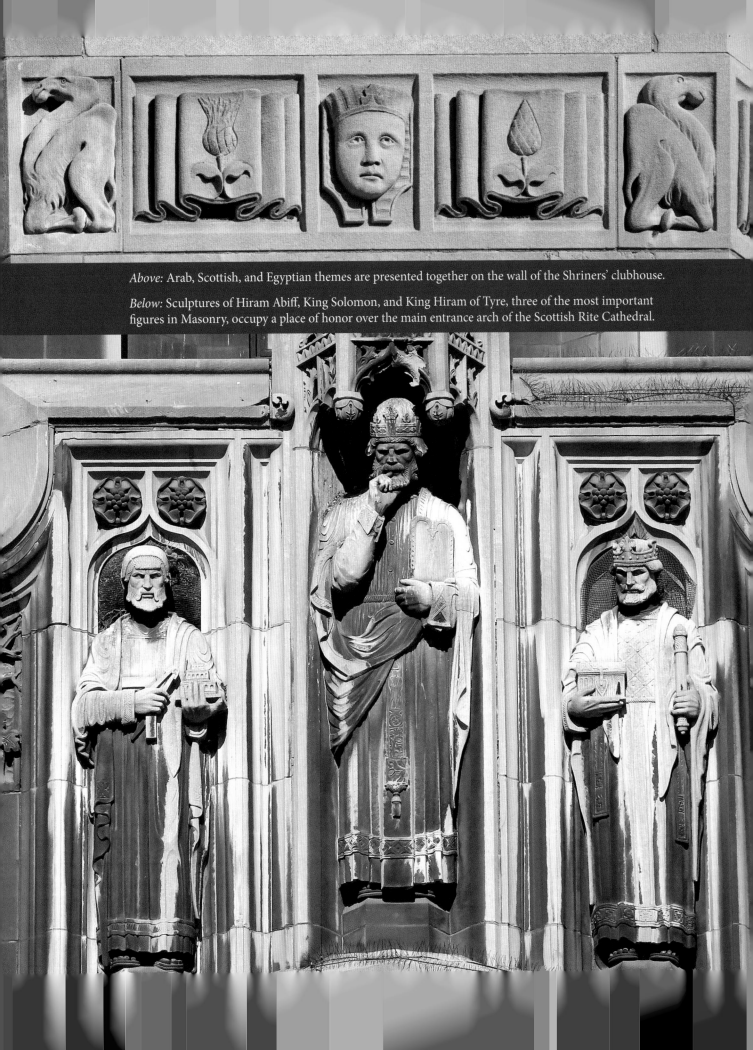

Above: Arab, Scottish, and Egyptian themes are presented together on the wall of the Shriners' clubhouse.

Below: Sculptures of Hiram Abiff, King Solomon, and King Hiram of Tyre, three of the most important figures in Masonry, occupy a place of honor over the main entrance arch of the Scottish Rite Cathedral.

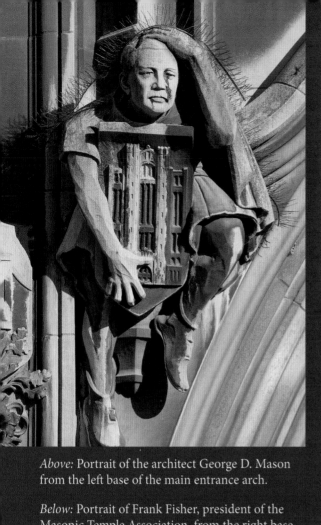

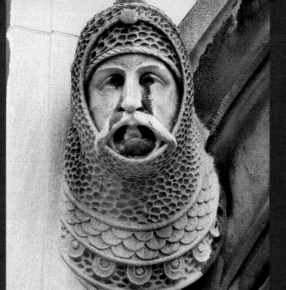

Left: An armored knight watches over each side of the Second Avenue entrance to the ritual tower.

Below: A large Knight Templar stands guard near the top of the main tower.

Above: Portrait of the architect George D. Mason from the left base of the main entrance arch.

Below: Portrait of Frank Fisher, president of the Masonic Temple Association, from the right base of the main entrance arch.

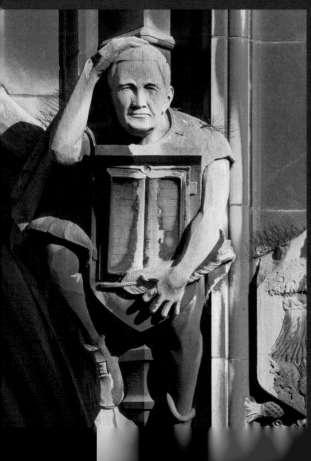

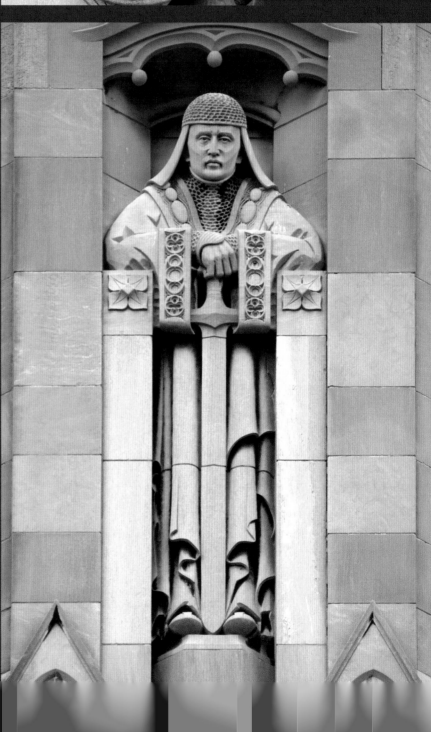

Below, left: A knight of the Crusades stands sentry, high above Second Avenue, on one of the ritual building towers.

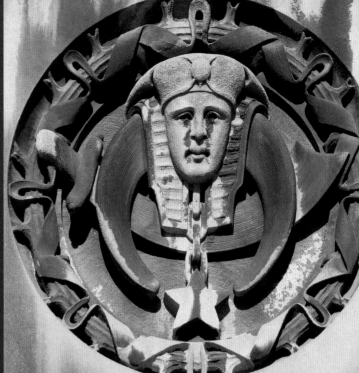

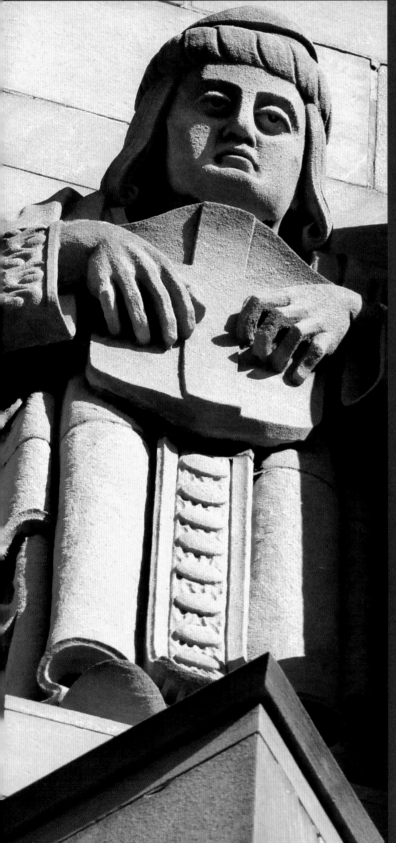

Above: The symbol of the Moslem Temple, Ancient Arabic Order, Nobles of the Mystic Shrine (Shriners).

Below, right: An "Entered Apprentice," a first-degree Mason. He holds a trowel and points to a book, indicating he has much to learn.

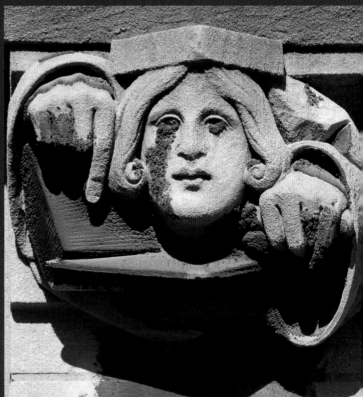

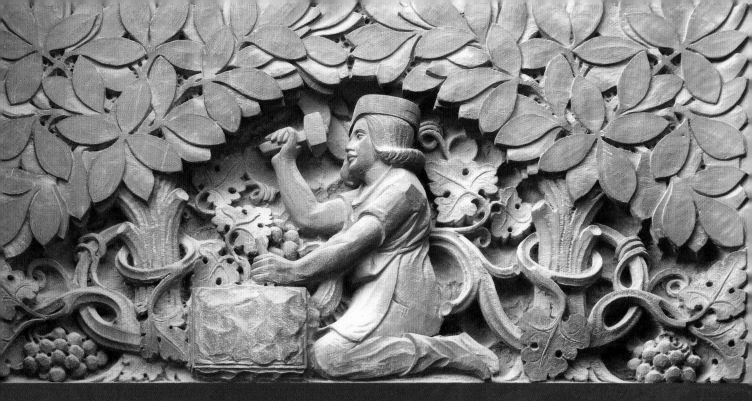

Above: An Apprentice Mason uses a mason's gavel to begin smoothing a rough ashlar (building stone). The stone must be perfectly smooth and the edges perfectly straight and square before it can be used in a building. This is an allegory for the work that an uninitiated Freemason must undertake, chipping vice and excess away from his heart, using Masonic education to build an upstanding life and achieve enlightenment.

Below: A sublime Master Mason has achieved enlightenment. He wears the spotless white lambskin apron of the Master Mason, showing that he has been cleansed of all impurities of body and soul. He stands amid acanthus trees, representing eternal life, and grape vines, symbolizing the blood of Christ and the need for personal sacrifice. The beavers are symbols of industry and persistence as well as a reminder to separate oneself from the temptations of the flesh. Ancient Greeks believed that beaver testicles contained an extremely valuable healing substance and that when hunted, the beaver would bite off its testicles, rolling on its back to show the hunter they were gone. This relief and the one of the Apprentice Mason can both be found near the entrance of the Scottish Rite Cathedral.

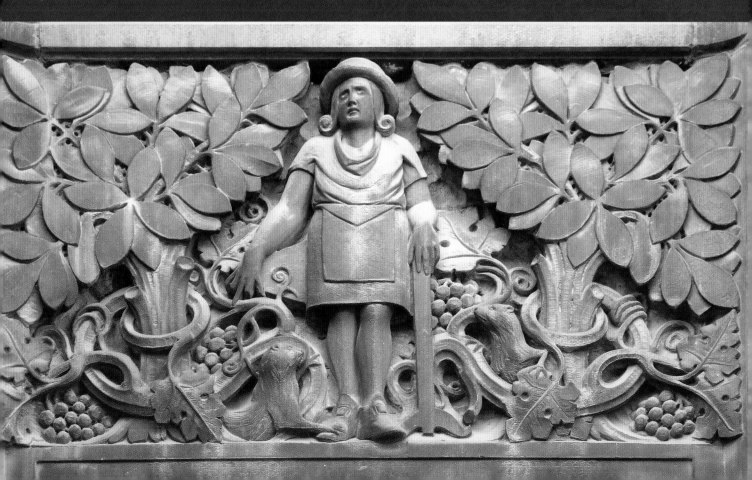

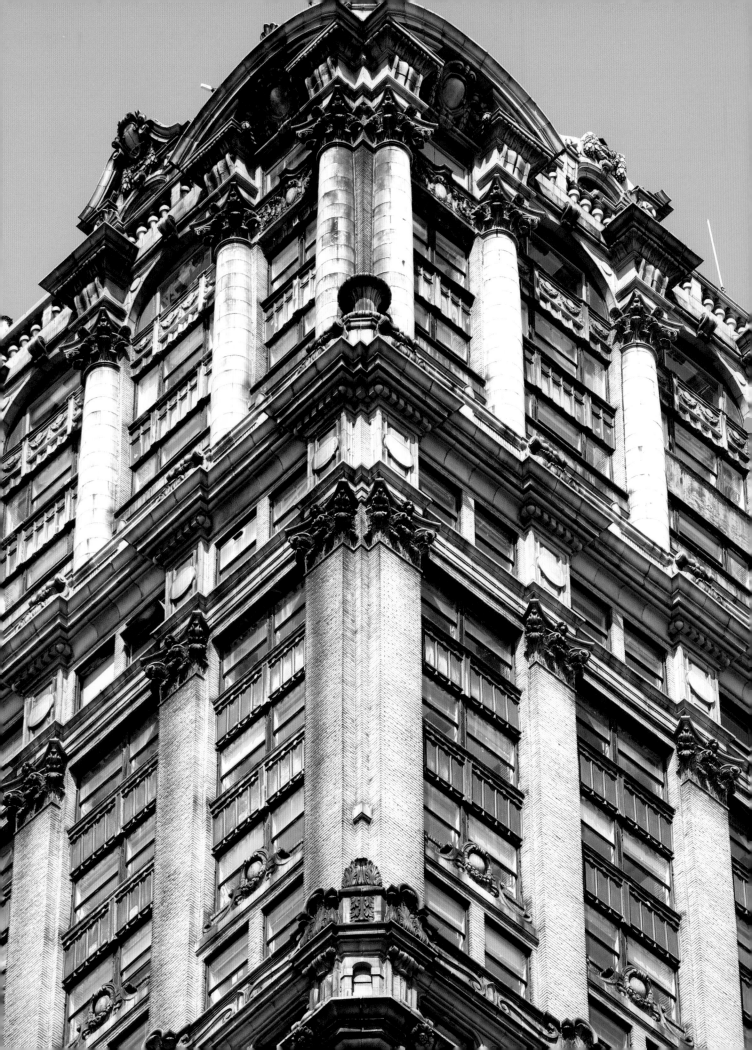

1249 Washington Boulevard

Completed: 1917 (building), 1926 (tower)

Architect: Louis Kamper

Sculptor: Unknown (building), attributed to Corrado Parducci (tower)

THE THIRTEEN-STORY BOOK BUILDING and the adjoining thirty-six-story Book Tower are part of the vision that J. Burgess Book Jr. and his brothers, Herbert and Frank, had for transforming Washington Boulevard, of which they eventually owned about 60 percent. They took a crumbling residential area and turned it into an exclusive shopping district, hoping to rival New York's Fifth Avenue.

The architect Louis Kamper was their partner in bringing this vision to reality. The German-born Kamper had traveled Europe studying its historic architectural monuments. Working with the Book brothers in Detroit was his chance to bring the artistry of European architecture to a new American building form—the skyscraper. With the Book Building, he created a unique structure with a front façade befitting a high-class shopping district.

The Book Building was one of Detroit's first modern office buildings. The Book Tower, built as an addition to the Book Building nine years later, was one of Detroit's first true skyscrapers, the tallest building in Detroit until it was surpassed by the Penobscot Building (page 210) only two years later.

The Book Building's quirky design includes layers of heavy ornamentation at the lower levels and twelve nude female figures on the consoles supporting the cornice. St. Aloysius Roman Catholic Church (page 234), built directly across the street in 1930, features twelve statues of the apostles. In the 1970s, the priests of St. Aloysius Church jokingly referred to the Book Building nudes as "the wives of the twelve apostles."[1] Unconfirmed legend has it that the nude figures were placed on the building, in full view of anyone exiting the church, because of a feud between J. Burgess Book Jr. and Archdiocese of Detroit Bishop Michael Gallagher.

The first thirteen floors of the Book Tower were designed to match the Book Building. After that, however, Kamper let his love of European-style design run loose. He adapted his personal vision of academic classicism to the skyscraper, adding a belt of oversized nude female figures at the thirteenth floor and festooning the top ten floors with large-scale Italian Renaissance ornamentation. Critics feel that Kamper missed the basic premise of the skyscraper, the emphasis on verticality. The huge horizontal bands of cake-like decorations seem to be a crushing bonnet, making one of the tallest buildings in the world when built look squat and somewhat top-heavy.

However, the Book Tower can be viewed as a unique historical bridge between the architecture of the Old World and that of the New. After the Book

163

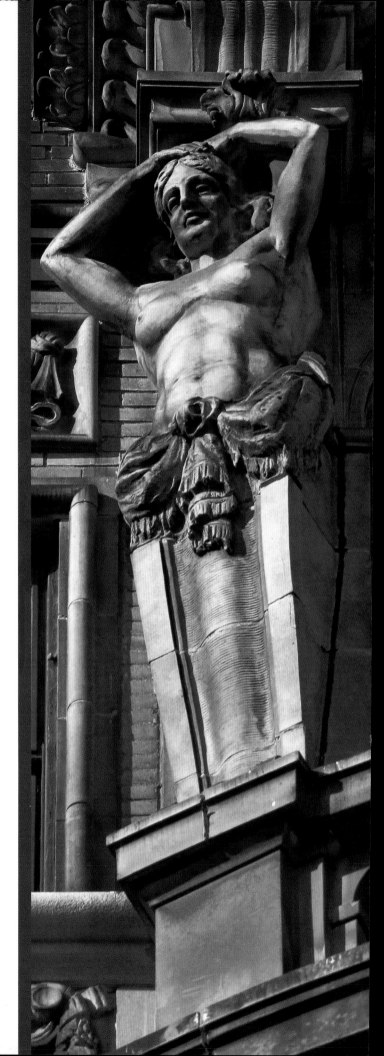

Tower, Kamper modified his approach. His nearby Industrial Bank Building of 1928 was much more restrained, and his design for the planned but never built eighty-one-story second Book tower was the epitome of the modern 1920s skyscraper.

The Book Building and Tower fell on hard times in the 1970s and limped along under various owners until it was finally closed in late 2009. Fortunately, the Detroit businessman Dan Gilbert announced in August 2015 that his Bedrock real estate firm had purchased the building and tower and promised to "bring this world-class iconic landmark back to life in a manner that will make all Detroiters and visitors proud."[2]

Right: One of the nude figures from the tower's thirteenth-floor "belt," before restoration.

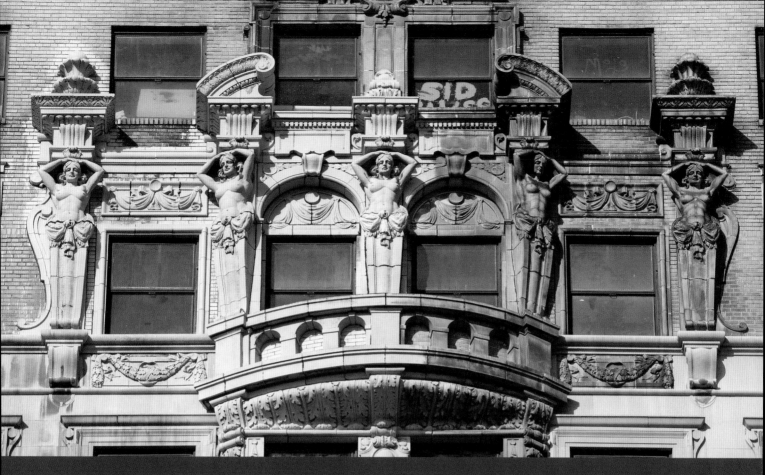

Above: A partially cleaned section of the tower's thirteenth-story "belt" of nude figures.
Below, left: Printer's mark of John Grafton, publisher of the first English-language Bible and the first critical history of England.

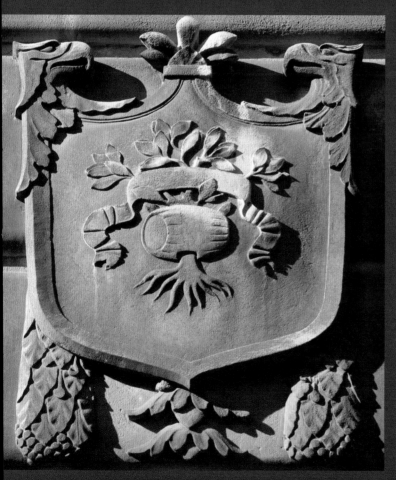

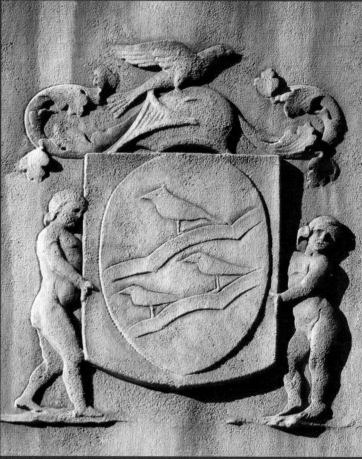

Above, right: A family crest from the Washington Boulevard façade. The three birds in the center oval represent the three Book brothers: J. Burgess Jr., Herbert, and Frank.

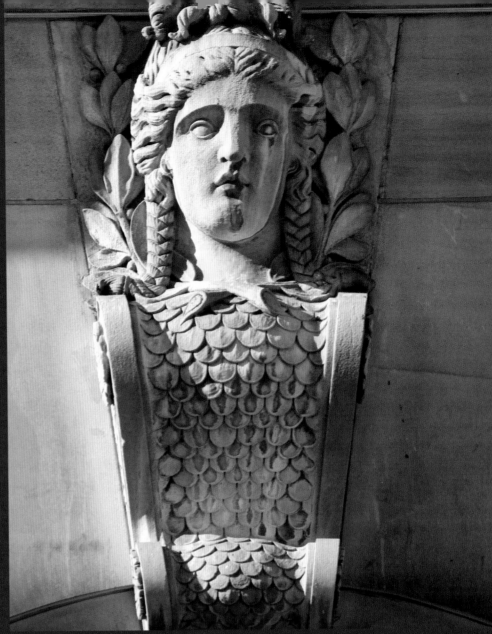

Left: Several of the twelve nude figures adorning the consoles that support the cornice. These are the original terra-cotta figures, before they were replaced with fiberglass replicas during the recent renovation.

Above and below: The keystone bust and a griffin over the Washington Boulevard entrance.

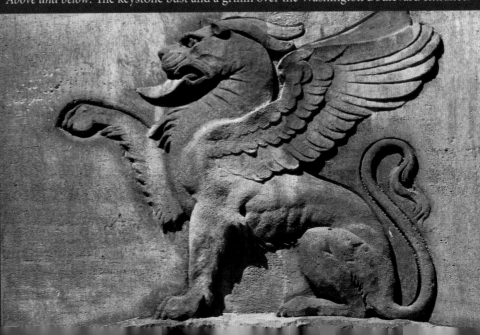

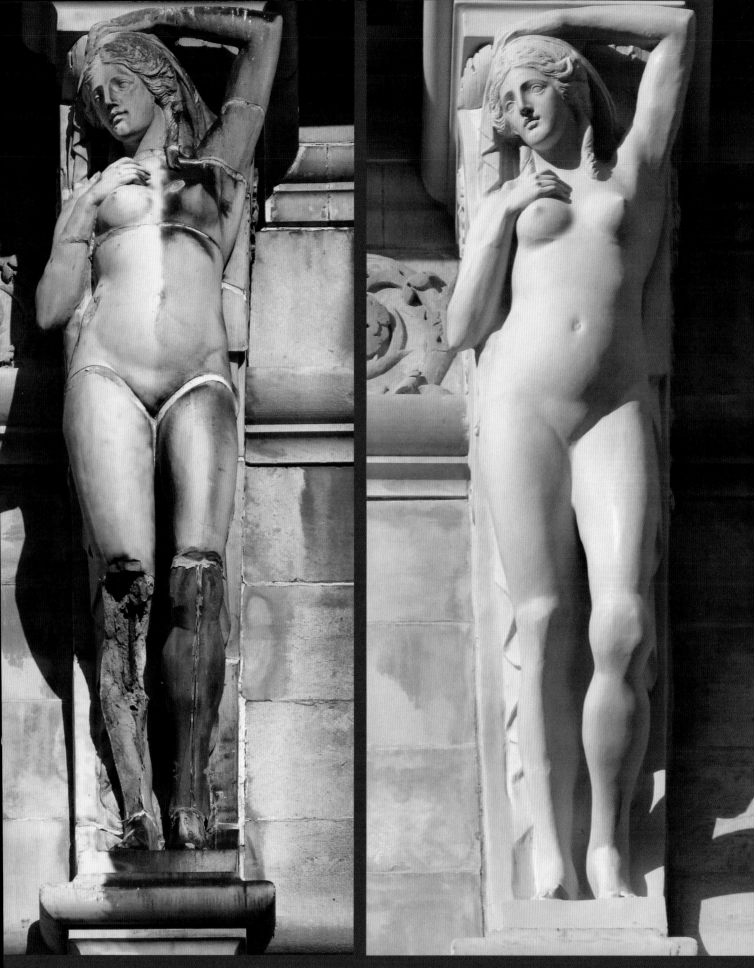

Over the years, the steel frames inside the figures rusted and expanded, damaging the terra-cotta sculptures from within. During renovation, they were deemed to be too far gone to repair. Shown here for comparison are one of the originals (*left*) and its fiberglass replacement (*right*).

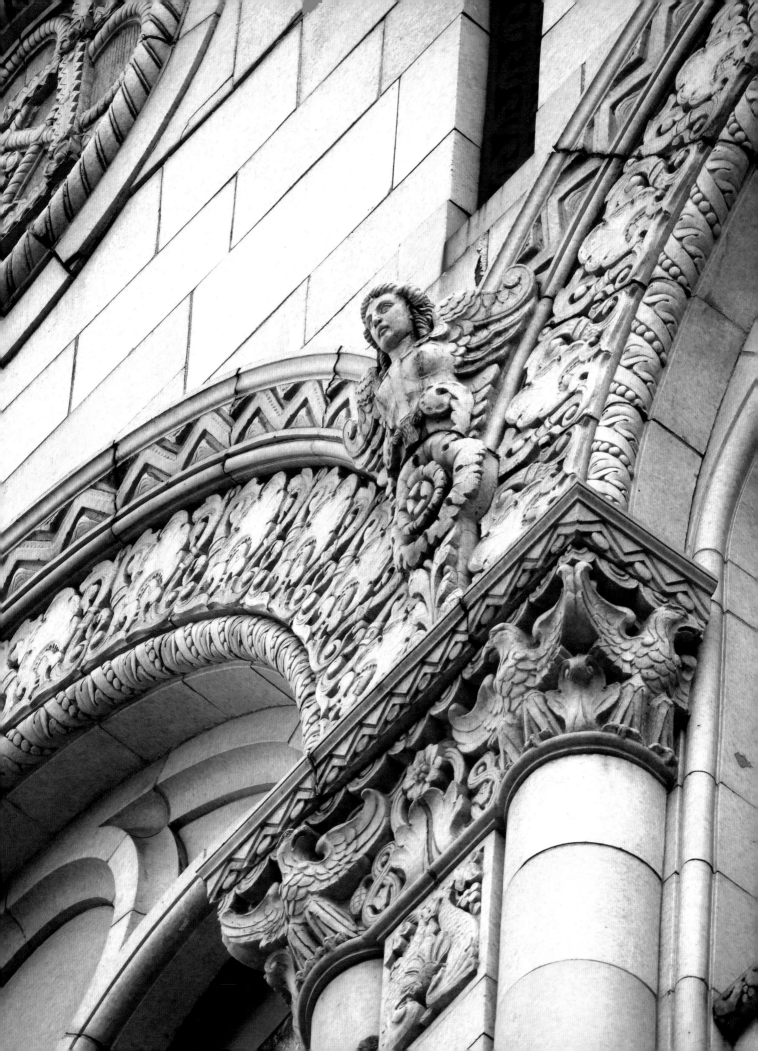

1342–46 Broadway

Completed: 1926

Architect: George D. Mason

Sculptor: Unknown

THE BROADWAY EXCHANGE BUILDING has been known by several names over the years, including the American Radiator Building, the Phillips Building, and most recently, Harvard Square Centre. It was built in 1926 as an investment property by Clara Scherer, the widow of Hugo Scherer. Hugo had become rich as a manufacturer of automotive parts, bodies, and engines as well as small boats. He invested some of his profits in property, and when he died in 1923, he left an estate valued at $5 million.

The first two floors were for retail tenants, and the remaining nine floors were for offices. Unlike some buildings that specialized in renting to a specific type of business, the Broadway Exchange Building leased offices to a wide variety of tenants. Among them were tailors, architects, and glass companies. In 1927, the basement was leased to the YWCA for use as a cafeteria. After the building was purchased by the American Radiator Company, unused space was rented to the Detroit Board of Education and others, including a vacuum cleaner sales office, silk stocking repair company, modeling agency, and even an operatic voice teacher.

The retail space has also seen many different tenants, including Merchant's Salvage Company Mortgage Liquidators, Federated Clothes, the Broadway Market (which featured the very popular Lefkofsky's Delicatessen and Kreger's Drink Shoppe), and most recently, the Paris Bar. The building has been vacant since the bar closed in 2005. It was purchased in 2017 by Dan Gilbert's Bedrock LLC. Redevelopment is expected but plans have not yet been announced.

This Romanesque Revival building features a wealth of terra-cotta ornamentation on the third floor, on the three arches above the eleventh-floor windows, and on the window spandrels. There are even a couple of gargoyles near the roof on the otherwise plain south façade. On the basis of style, the date of construction, and the fact that Corrado Parducci regularly worked with the architect George Mason during this period (among others), the building's sculpture was probably provided by the prolific Parducci, although no documentation could be found to confirm this assumption.

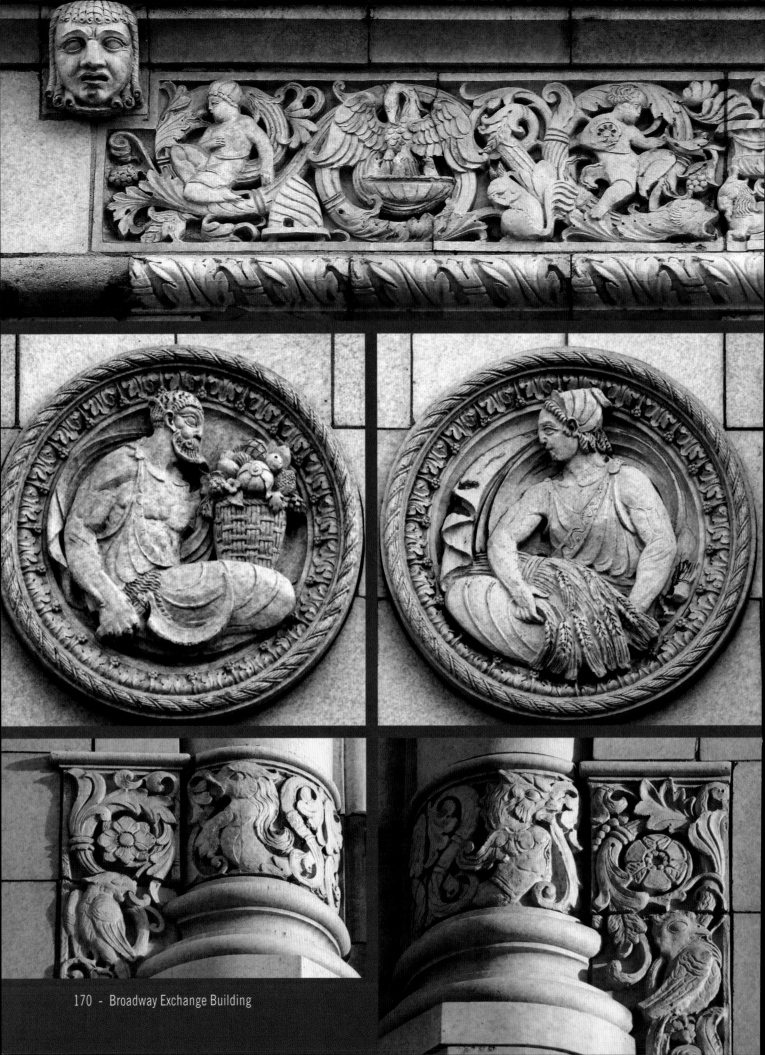

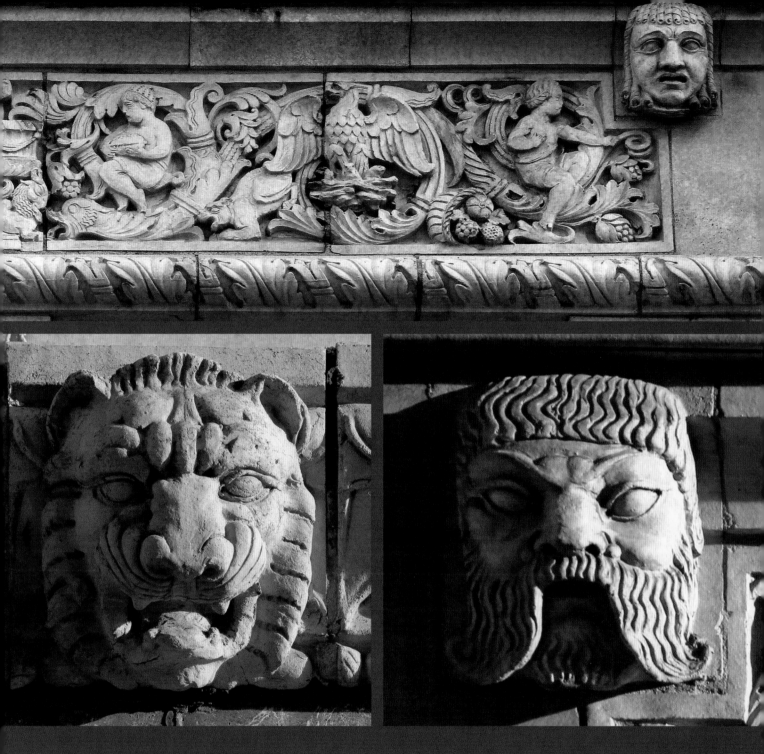

Top, this page and facing: One of three elaborate reliefs that separate the third and fourth floors.

Above, this page: A lion and a face from the belt course between the third and fourth stories.

Facing page, center: Male and female agricultural allegories from the left and right ends of the third story façade.

Facing page, bottom: Carvings from the bases of the eight-story-tall pilasters that begin at the fourth floor.

8000 Woodward Avenue

Completed: 1926

Architect: William E. N. Hunter

Sculptor: Unknown

THE $175,000 COST OF the land for this beautiful building was paid for by Sebastian S. Kresge, a member of the congregation and founder of the dime-store chain that bore his name. However, the $1.6 million building was paid for with over thirteen thousand individual donations. It was said that pastor Merton S. Rice's brilliant oratory built the congregation but that copastor C. B. Allen built the church.

It was Allen's idea to sell the individual Plymouth-granite ashlar blocks used in the church's construction for a dollar each, raising $52,000. It was also said that "a large portion of the budget was raised on the golf course and that if C. B. invited you for a few holes, you'd better bring your checkbook!"[1]

At the time the church was built, it ranked as the third most valuable church building in the country. By the mid-1930s, on the strength of Pastor Rice's preaching and national reputation, it was the largest local congregation in World Methodism.

The building's architect, William E. N. Hunter, was a church member and well recognized for his expertise in ecclesiastical architecture. He designed many Detroit-area and Ontario churches, including Historic Trinity Lutheran Church (page 258). The identity of the sculptor is not definitely known, but it was most likely Corrado Parducci, who was very active in Detroit during this time and worked with Hunter on Historic Trinity Lutheran in 1931.

The main entrance to the church is on Chandler Street, but there are two doors on Woodward Avenue that feature carved reliefs in their tympana. The north door has an Old Testament theme, with David playing the harp and singing for King Saul and also playing a flute to his sheep. The south door shows Jesus preaching from the deck of a boat on one side and a pastor preaching to a congregation on the other.

There are three large windows on the north, west, and south façades, each with its own theme. The most prominent is on the west wall and features the intricately carved words, "Thy Kingdom Come," along with an hourglass, symbolizing time; a brazen serpent on a cross and a crown on a cross, symbolizing eternal life through faith in Jesus; and a peacock, a symbol of renewal. The theme of the north window is the Eucharist and the saints, and the theme of the south window is the Methodist church and its history in America.

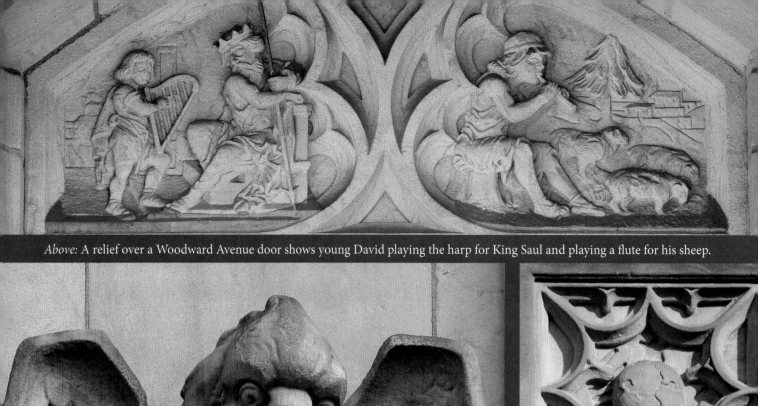

Above: A relief over a Woodward Avenue door shows young David playing the harp for King Saul and playing a flute for his sheep.

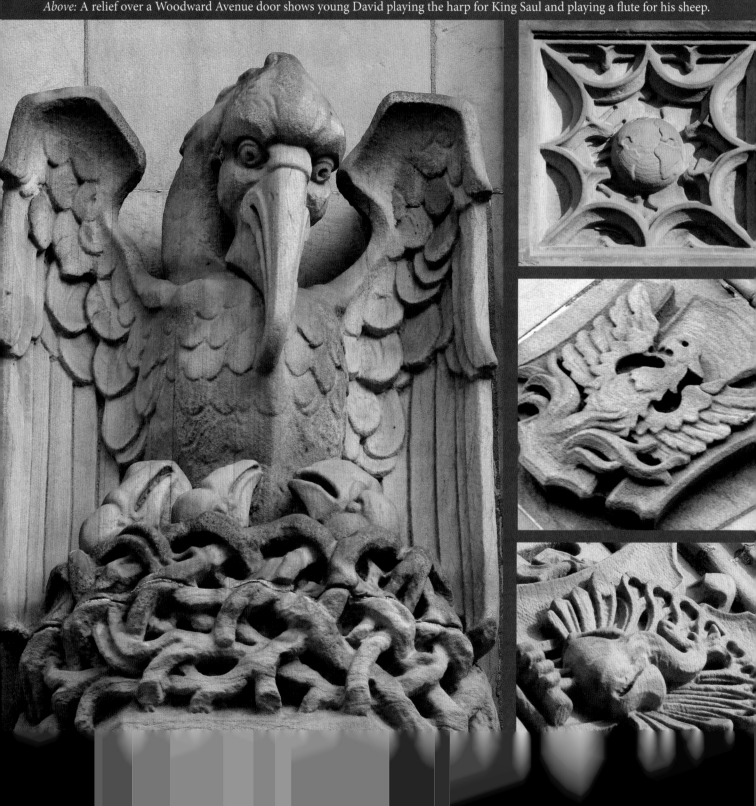

Facing page, bottom left: A pelican with its young, very similar to the one carved by Corrado Parducci on the tower of Historic Trinity Lutheran Church (page 258).

Facing page, right (top to bottom): The creation of the world, a phoenix (an obvious symbol of the resurrection), and a peacock, a symbol of renewal.

Right: An owl on the north wall probably marks where the original church library was.

Below: Part of the coat of arms of New York City. The windmill vanes and flour barrels honor the original Dutch settlers of New Amsterdam, and the beavers represent the fur trade, the basis for the founding of the city.

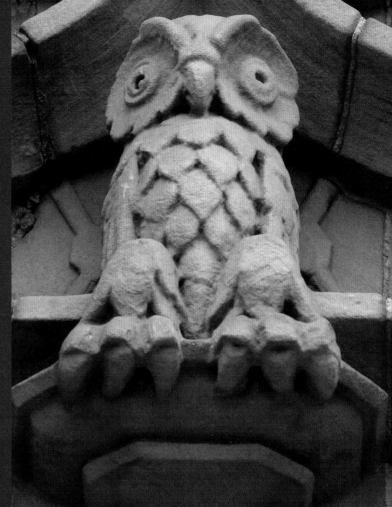

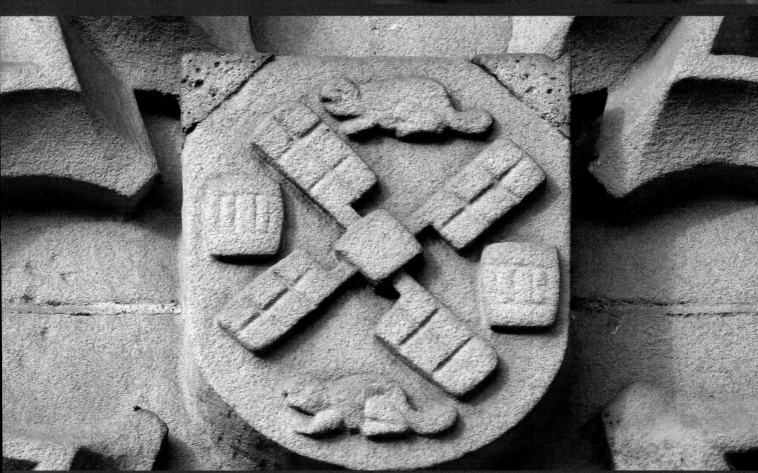

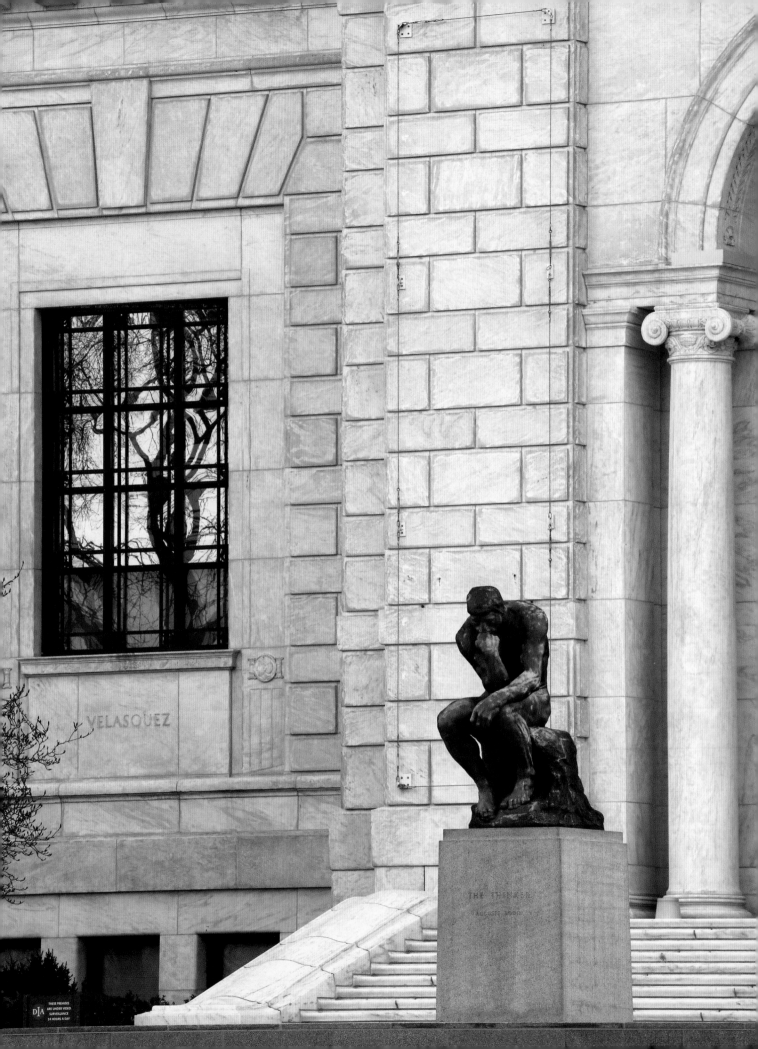

VELASQUEZ

THE THINKER
AUGUSTE RODIN

5200 Woodward Avenue

Completed: 1927

Architect: Paul P. Cret with Zantzinger, Borie & Medary

Sculptors, Architectural: Leon Hermant, Carl Beil (carver)

Bronzes: Antoine Coysevox, Donatello, Philippe Magnier, Michelangelo, Auguste Rodin

"THE MARBLE BOOK WHERE Detroiters may keep now and forever the reminders from ages long dead that beauty is everlasting and the hunger for it is eternal." That is how the *Detroit Free Press* described the Detroit Institute of Arts (DIA) the day after it opened in 1927.[1] It was created by Paul Cret, a French architect who studied at the École des Beaux-Arts in Lyon and Paris and was professor of design at the University of Pennsylvania. Designing it is said to have meant more to Cret than any other building in his career.[2] And he almost did not get the job.

The city had asked Albert Kahn to design the DIA's new home; but he did not think it would be proper since he was a member of the Arts Commission, and he recommended Paul Cret. This proved to be a wise decision, as Cret's design was widely praised. It won a Gold Medal of Honor from the Architectural League of New York, and its floor plan was recognized as an example of "ideal museum arrangement" in the 1929 *Encyclopedia Britannica*.[3]

The building features restrained ornamentation, the work of Leon Hermant, a French-born-and-educated sculptor based in Chicago. Hermant closely followed Cret's sketches, even relocating with his partner, Carl Beil, to Philadelphia for the duration of the project so they could work directly under Cret.[4]

Niches at the north and south ends of the front façade are occupied by bronze castings of historic marble sculptures, Michelangelo's *Dying Slave* to the north and Donatello's *St. George* to the south. The bronze statues in the north and south niches of the front façade and on either side of the steps were chosen to be representative of European masters, symbolizing "the inspiration of the arts to be found within,"[5] although the Arts Commission secretary Clyde Burroughs said the commission intended to replace them one day with the works of American sculptors.[6] The approach features reproductions of large bronzes from the gardens at Versailles and is dominated by *The Thinker*, by Auguste Rodin.

Ironically, *The Thinker*, the epitome of immobility, has led a very peripatetic existence since it was purchased by Horace H. Rackham in 1922 and placed outside the original art museum. It was moved from there into the DIA in 1927, the only piece of art in the Great Hall. It was moved back outdoors sometime around 1930–34, placed close to the Woodward Avenue sidewalk. Moved closer to the building sometime in the late 1950s or early 1960s, *The Thinker* was repositioned when the stair-step fountain was added in 1981, spending part of that year on the east side of the building before making its way back to the west side. It even got to enjoy the Michigan tradition of going up north for the summer in 2007, when it was loaned to Frederik Meijer Gardens in Grand Rapids.

Above, left: A tragedy mask from the building's south façade, where the museum's theater is located. *Facing page, top:* Nike carries the lamp of knowledge, a merlion represents the institute's international reach, and a comedy mask, also from the south façade.

Above: Athena, goddess of war, wisdom, and art and the basis for the DIA's onetime logo, which was used until a recent update.

Right, this page and facing: Four playful window-grate ornaments that closely follow Cret's original sketches.

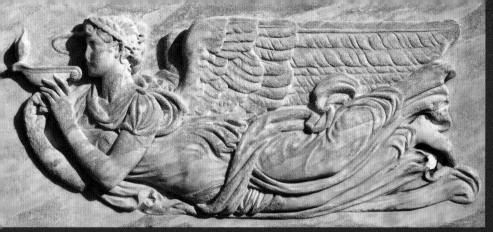

Above: Dionysus and revelers above the east entrance to the theater.

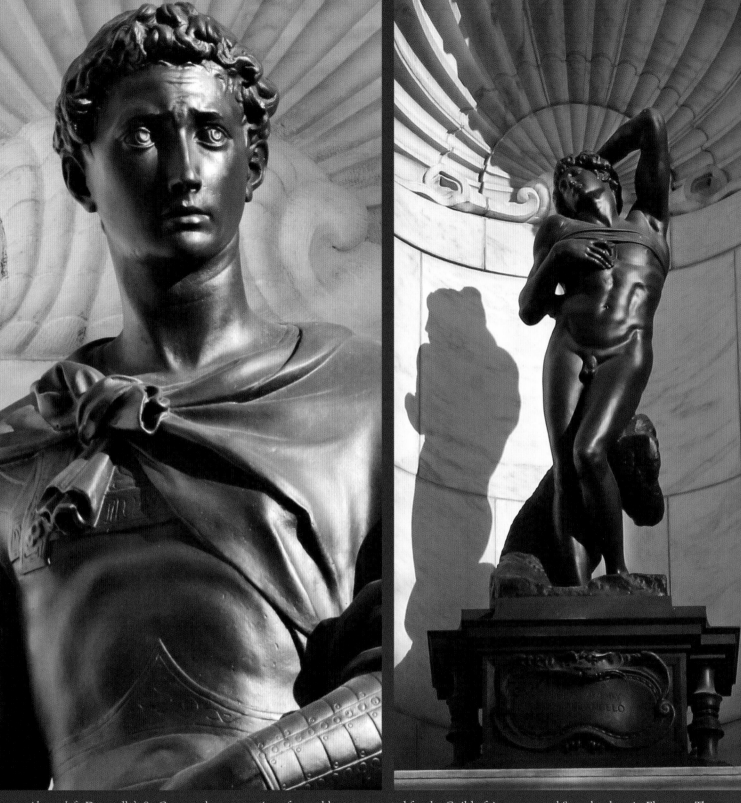

Above, left: Donatello's *St. George*, a bronze casting of a marble statue created for the Guild of Armorers and Swordmakers in Florence. The heroic saint was chosen by the guild to represent the Florentine spirit and to provide an example to the city's young men, who had a reputation for being wild troublemakers. The saint provided a similar example to the young men and gangs of Detroit during Prohibition, when more than 90 percent of the bootleg liquor entering the United States came through this city.

Above, right: Michelangelo's *Dying Slave*, a casting of a marble sculpture in the Louvre, created to adorn the tomb of Pope Julius II, one of the most influential art patrons of the Italian Renaissance.

Facing page, top: Phillipe Magnier's *Nymph and Cupid*.

Facing page, bottom: Garonne River God by Antoine Coysevox. Both of these bronzes are copies of statues created for the gardens of Versailles.

5057 Woodward Avenue

Completed: 1927

Architect: Albert Kahn

Sculptor: Corrado Parducci

S EATED AT THE CONTROLS of a large steam shovel, Supreme Commander A. W. Frye scooped up two tons of dirt, breaking ground for the new Maccabees Building two days before New Year's Eve 1925.[1] At the building's dedication nineteen months later, Frye said that its "wonderful architecture exemplifies a God-given genius, personified in the painstaking development of the human mind, reminding us that infinite wisdom has placed in our hands the opportunity of improving the happiness of humanity."[2] However, about halfway through construction, it seemed that none of the "God-given genius" he mentioned went toward making sure the building was properly positioned.

The decision of the Maccabees to build their new headquarters in Detroit was greeted with a flurry of publicity, and almost every newspaper story about the planned building mentioned how it would be set twenty-three feet back from the current building line to accommodate the new "Wider Woodward" plan approved by the voters in October 1925.[3]

However, in May 1926, five months into construction, the City Plan Commission reported to the City Council that the building was in fact nine to fourteen feet over the new lot line. In June, the council voted to condemn the part of the building that extended over the lot line, declaring that either the building had to be moved back or the portion of the building that was over the line must be removed. The Maccabees claimed it was an honest mistake, and the building's architect, Albert Kahn, estimated that the cost to comply with the council's demands would be between $200,000 and $300,000.[4] The attorney and City Plan Commission member Louis J. Colombo was all for condemnation, saying that Kahn and the Maccabees were trying to "put something through contrary to the wishes of the people of Detroit."[5] Colombo also claimed that the Maccabees would be solely responsible for the extra costs.

Fortunately for Kahn and the Maccabees, within a few months, an agreement was reached with the city that would allow them to keep the building as it was. Woodward Avenue would be jogged a bit to the east, and the width of the sidewalks on either side would be reduced from fifteen feet to eight.[6] Walk or drive past the building today, and you will notice that it is much closer to the street than its neighbors are. But that is not quite the end of the story.

It was never revealed at the time, but it turned out that Colombo's suspicions regarding Kahn's intentions were correct. According to records of a

building planning meeting that took place in July 1925, Kahn wanted to ignore the boundaries drawn by the City Plan Commission, which would cause the Maccabees' lot to be an irregular shape and instead "square out [the] building," which "would naturally save the owners considerable money."[7] Kahn stated that he thought he could get the commission to agree because it would improve on its original plan, saying, "we will be able to square our building without detriment, but I believe with benefit."[8] Whether or not this belief was correct can be debated, but that is eventually what happened.

Although the Maccabees got their squared-off lot and building at no additional cost, the issue came back to haunt Kahn a couple of years later. In January 1929, the Common Council voted Kahn a $1 million contract to build a hangar at City Airport. Within forty-eight hours, the council rescinded the award "for reasons never fully explained," instead giving the job to Louis Kamper, who had provided plans for a smaller structure at a cost $1.5 million higher than Kahn's proposal.[9]

The Maccabees were formed in 1878 as a mutual-aid society in which members were assessed 10¢ each so that $1,000 could be provided to a member's family upon his death. The group's name and rituals came from the story of Judah Maccabee, who led a Judean revolt against the Selucid Empire in 167 BCE. Maccabee is said to be the first military leader to require soldiers to set aside a portion of their spoils to provide for the families of their fallen comrades.

Much of the elaborately carved iconography on the outside of the structure relates to the Maccabees' origins. Images of protective lions, eagles, and fanciful creatures are also prominent. The sculpture, especially that which is around and near the entrance, provides examples of some of Corrado Parducci's finest and most intricately detailed work.

The Maccabees evolved into an insurance company, spinning off their fraternal aspects in 1958. They sold their downtown headquarters to Detroit Public Schools, moving to Troy in 1960. The building was acquired by Wayne State University in 2002.

Detail from one of the ornate copper grilles found within the three-story-tall main entrance arch on Woodward Avenue.

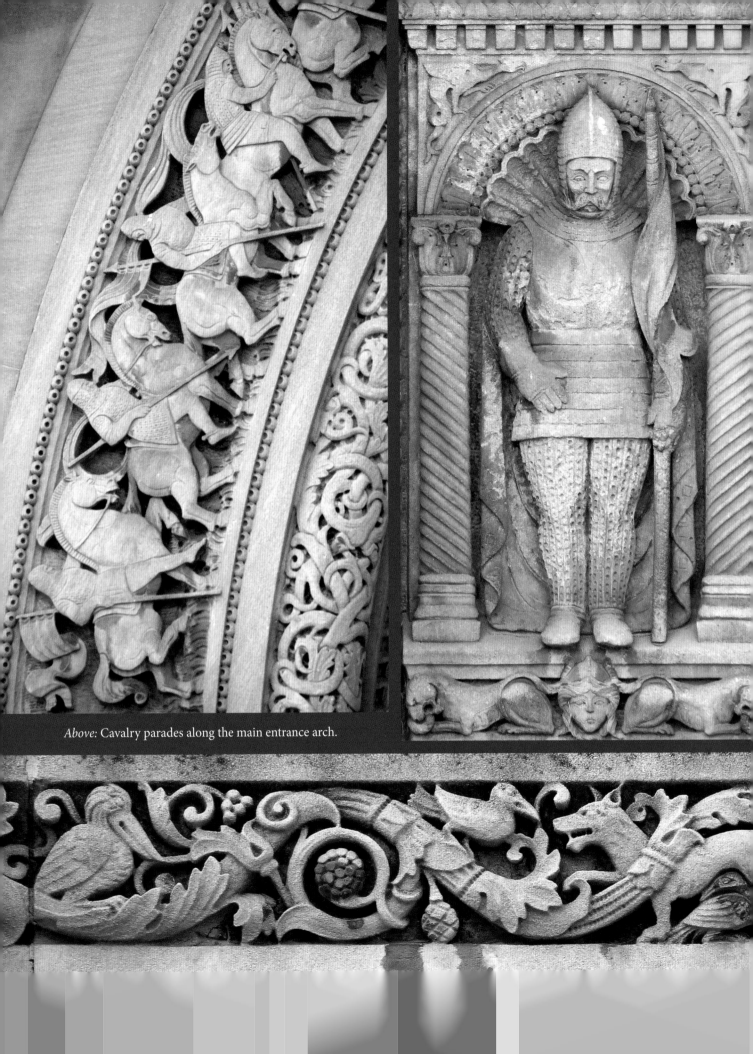

Above: Cavalry parades along the main entrance arch.

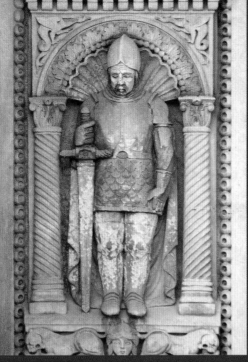

Facing page, right: One of the figures representing Judah Maccabee, his father, and his brothers from either side of the main entrance.

Left, top: Two more of the figures representing Judah Maccabee and his family.

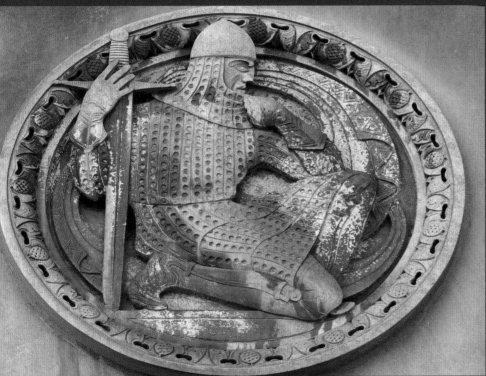

Left, center: One of the two medallions featuring guardian knights found on either side of the main entrance arch.

Below: Window-ledge ornamentation above the colonnade over the main entrance arch. The acanthus leaves represent enduring life, and the pomegranates symbolize the unity of many parts. The wolf represents temptation, and the pair of turtledoves is a symbol of marital fidelity.

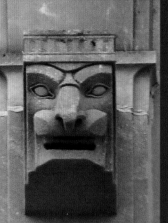

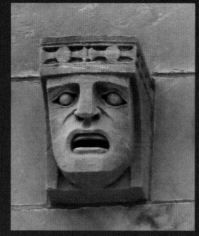

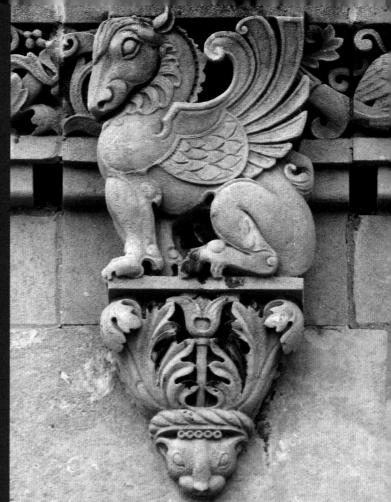

Above: Four of the gargoyle heads from the cornices.

Above: Three different lions on the building. The first is from the granite pilasters on either side of the

Left: Two reliefs illustrating protection for business and home.

Facing page, top right: A combination griffin/Pegasus from the window ledge above the third-story colonnade.

Below: Hamlet contemplates life and mortality, from inside the entrance arch.

1 Griswold Street

Completed: 1927

Architect: George D. Mason

Sculptor: Corrado Parducci

STANDARD FEDERAL SAVINGS & Loan liked to call the land at Griswold Street and Jefferson Avenue where it built its new headquarters, "the Cornerstone of Detroit." It was on this spot that Antoine de la Mothe Cadillac erected Ste. Anne de Detroit Church, "the first building built by civilized man in Detroit,"[1] in July 1701, one day after staking out Fort Ponchartrain. Ste. Anne Parish is one of the oldest Roman Catholic parishes in the United States, with continuous records dating back to 1704.[2] The current church (page 295), dedicated in 1887, is the parish's eighth home and is located at the corner of Ste. Anne (Nineteenth) and Howard Streets.

At first glance, the Standard Federal Building appears to be fairly plain, but closer inspection shows many fine examples of Corrado Parducci's work. The sculpture is based on Persian motifs, a style that carried over to the original interior ornamentation.

Due to a conservative banking philosophy, Standard Federal survived the Great Depression and even stayed open through the "Bank Holiday" of 1933. Its headquarters stayed at this location until 1973, when it moved to a new building in Troy. Standard Federal kept a branch office here for many years, but eventually the building became home to the Roney & Co. brokerage, which was purchased by Raymond James Financial in 1999. The company put a large Raymond James sign on the roof with a ticker showing stock prices for the day, and the structure came to be known as the Raymond James Building.

In 2007, the Church of Scientology bought this building for $3.5 million but did nothing with it for ten years. They eventually got around to restoring and remodeling the building, and on Sunday, October 14, 2018, the church held a members-only grand opening and ribbon-cutting ceremony. This marks the second time the Church of Scientology has been housed in a downtown former bank building, having occupied the First State Bank Building (page 124) in the 1980s.

Left: An American eagle wraps around the southeast corner, just below the cornice.

Center: Allegorical panels representing wealth and security from upper-story window spandrels.

Bottom: A representation of an ancient coin and a guardian eagle above the Griswold entrance.

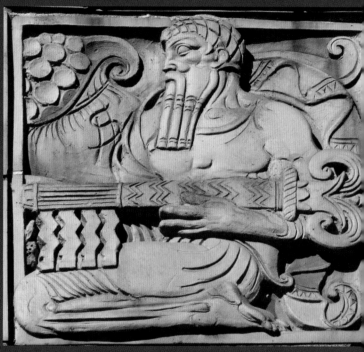

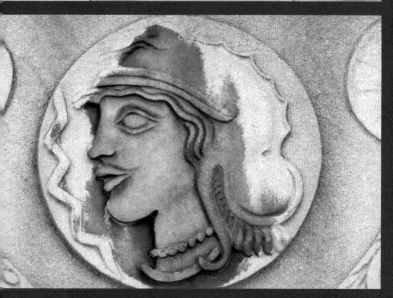

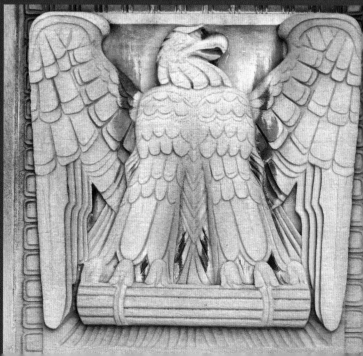

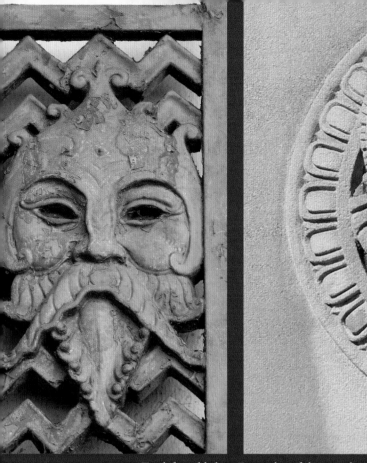

Top left and below: Examples of the metal grill work near the Griswold Street entrance.

Top right: One of the lions over the main-floor windows on the Jefferson Avenue side.

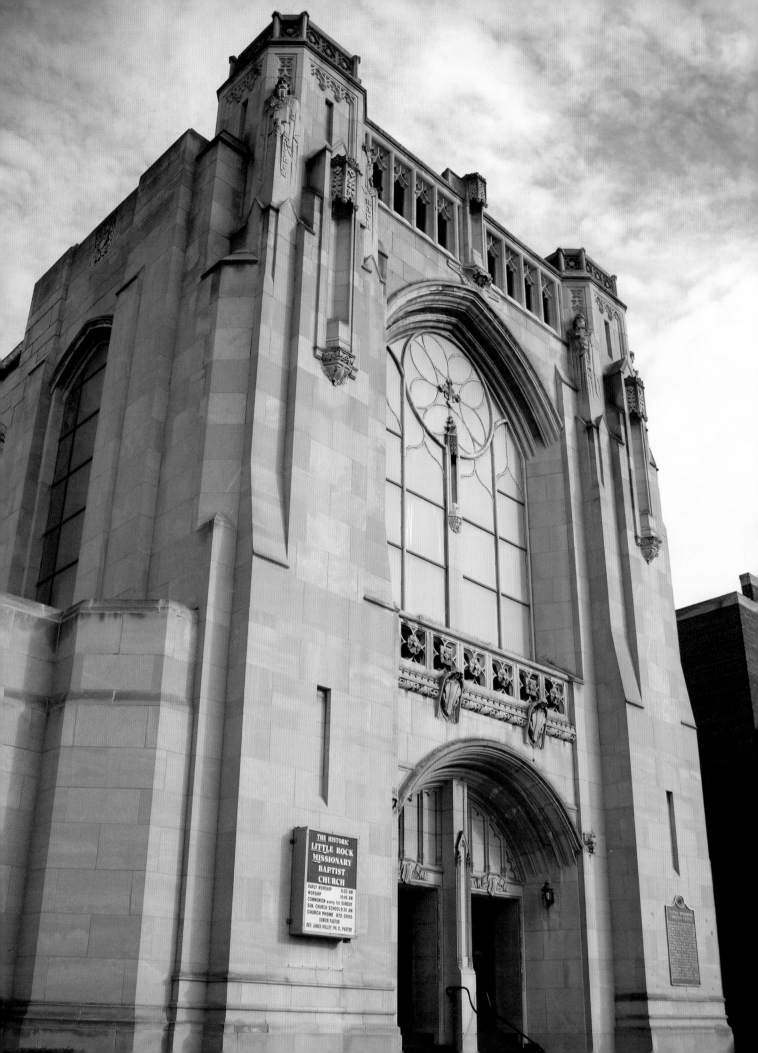

THE HISTORIC
LITTLE ROCK
MISSIONARY
BAPTIST
CHURCH

EARLY WORSHIP 8:00 AM
WORSHIP 10:45 AM
COMMUNION every 1st SUNDAY
SUN. CHURCH SCHOOL 9:30 AM
CHURCH PHONE 872-2900
SENIOR PASTOR
REV. JAMES HOLLEY, PH. D, PASTOR

(Central Woodward Christian Church)

9000 Woodward Avenue

Completed: 1928

Architect: George D. Mason

Sculptor: Unknown

THIS BEAUTIFUL STRUCTURE HAS been the home of two dynamic congregations over the years. The first one had its roots in the Disciples of Christ, organized in 1846.[1] Members worshiped at several locations around Detroit, eventually moving northward to the Central Christian Church in the Cass Park area in 1890. In 1927, with the new building on Woodward Avenue already in progress, this congregation combined with Woodward Christian Church, wrote a new constitution, and elected new officers.[2] Central Woodward Christian Church was dedicated on October 14, 1928.[3]

The style of the building is a step away from Gothic Revival, toward Neo-Gothic, combining traditional forms with a sleeker, more modern look. It won the building's architect, George Mason, an award for design excellence from the Detroit chapter of the American Institute of Architects.[4]

The church thrived through the 1950s and into the 1960s, even with a membership that was "scattered to the remote outskirts of the city and the suburbs."[5] However, as conditions in the northern Woodward neighborhood changed, the congregation was unable to adapt and moved to Troy in 1978, selling the building to the Little Rock Missionary Baptist Church, a congregation with a history in many ways similar to its own.

Begun in 1936 in a basement on Russell Street, the congregation at first worshiped in members' homes and then at several locations around the city. Rev. Dr. James Holley became head minister in 1972, and the church entered a period of rapid expansion. It has become very influential in the northern Woodward neighborhood, providing many important community services.

There is no clear record of who did the external architectural sculpture on this structure. Frank Maslen, the founder of Detroit Decorative Supply Company, said in a 1960 newspaper interview that he worked on this church,[6] but he was known for interiors. The work was probably done by the ubiquitous Corrado Parducci.

The style is similar to much of Parducci's other work, especially his carvings on Historic Trinity Lutheran Church (page 258), finished three years later. Unfortunately, Parducci never signed his work, claiming there was no point in doing so as only the birds would ever see his signature.[7]

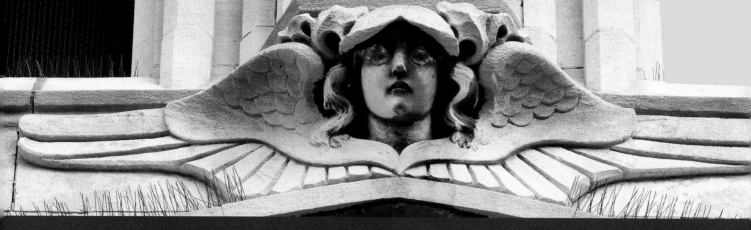

Above: An angel watches over the entrance from above the arch of the large window on the front of the church.

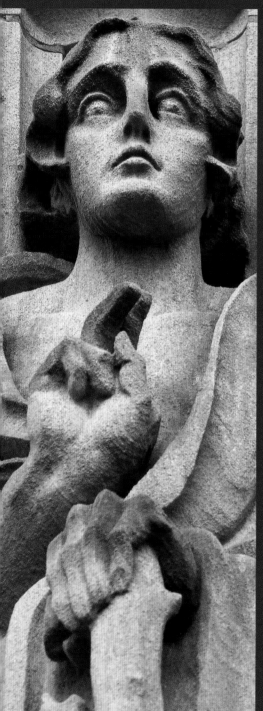
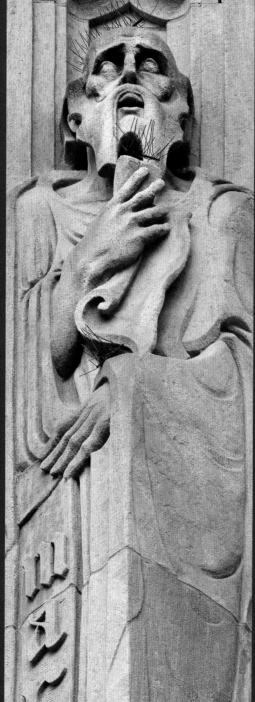
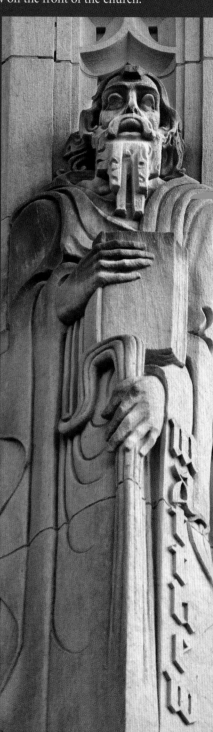

Above: A gargoyle from the 110-foot-tall central tower.

Facing page, bottom: Portraits of the Gospel writers are carved into the corners of the pylons on either side of the front façade. John raises his hand in benediction, Mark clasps the scroll of his Gospel close to his heart, and Matthew holds the record book of a tax collector.

Top left: A cherub from the window's center column, representing the children of the church.

Left: One of two angels over the doorway arch, holding a three-part shield that represents the protection of the Triune God.

Above: The ship in this image represents the church bringing the word of God to all parts of the world. The figures on either side are missionaries.

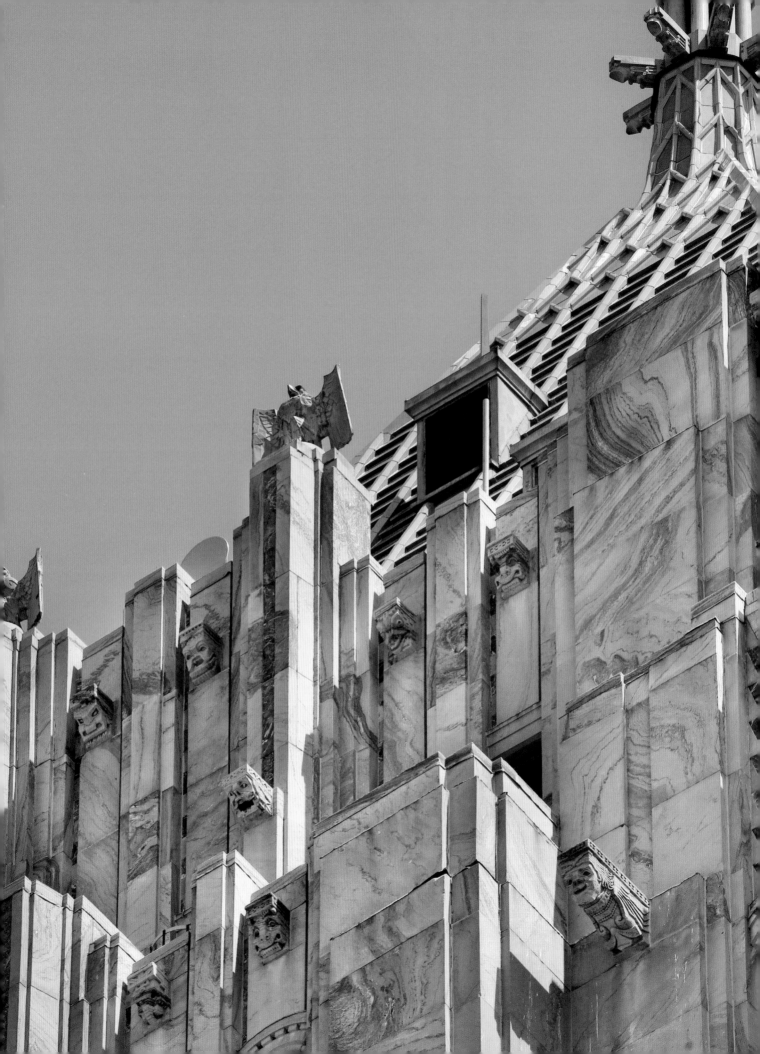

3011 West Grand Boulevard

Completed: 1928

Architect: Albert Kahn

Sculptors: Anthony DiLorenzo, Géza Maróti,
Corrado Parducci, Ulysses Ricci

"Detroit's largest art object." "The building of the century." "Albert Kahn's masterpiece." All of these phrases aptly apply to the Fisher Building. The Fisher brothers wanted their namesake building to be the most beautiful commercial structure in the world, in order to, in Frederick J. Fisher's words, "record for future generations the tremendous energy and massive solidarity of American business by translating these in the enduring terms of monumental architecture."[1]

As Albert Kahn put it, "In their insistence that the new Fisher Building be a thing of beauty as well as a thing of utility, the Fisher Brothers have done more for Detroit than Detroit probably realizes,"[2] even though the Fisher Building we know represents less than one-third of the planned development. The original plan included a twin twenty-six-story building at the other end of the block with a massive sixty-story tower between the two smaller structures. That dream was derailed by the stock-market crash of 1929 and the onset of the Great Depression.

A visitor to the Fisher Building is greeted with an incredibly ornamented five-story-tall entrance dominated by a Romanesque arch that reaches all the way to the fourth floor. The portal is strategically placed at the head of Second Boulevard so the viewer has enough room to see and grasp it visually. The intricate ground-level brass ornamentation was made by Anthony DiLorenzo, and the inside of the arch is decorated with multiple granite reliefs designed by the Hungarian sculptor Géza Maróti in a conscious effort to create a new and absolutely modern style.[3] Maróti also designed eagles for the entrance and upper reaches of the tower to reflect American power, culture, ideals, and commercial activity.[4] The building went up so quickly (fifteen months) that Maróti could not keep up, so his designs were modeled by the quick-working Corrado Parducci, who also created sculpture for the interior of the building.[5]

The first three levels are clad in pink Minnesota granite, while the rest of the building is covered in Beaver Dam Marvilla marble from a quarry in Maryland. The quarry was so small, and this was by far its largest order ever, that the Fisher brothers invested considerable capital and equipment in it to make sure that marble was always available on site as needed.[6] This unique marble is richly veined in

shades of beige, pink, and brown, and the many fanciful animal-themed carvings of the upper reaches, created by Ulysses Ricci, use the texture of the marble to great effect. It is difficult to appreciate these beautiful and intricate carvings from ground level without the aid of binoculars or telephoto photography. There are more than 150 different carvings on the exterior of the building.

The sloping roof of the building was originally covered with tiles faced with gold leaf and lit at night, a monument to wealth and excellence that could be seen for miles. The building's longtime tenant, the radio station WJR, moved in shortly after the building opened. It had a deal that gave it studio space in the building as long as it always announced during station breaks that it was broadcasting from the "golden tower of the Fisher Building," a phrase that resonates with anyone who grew up within WJR's substantial listening area. The tiles were coated with asphalt during World War II to prevent one of the tallest buildings in the "Arsenal of Democracy" from becoming a target for bombers. The coating proved impossible to remove after the war, and the original tiles were covered with green ones. The tower is now lit with golden light at night, providing a similar effect.

The Fisher Building is also home to the Fisher Theatre, the last of the opulent movie palaces built in Detroit, the only true rival to the Fox Theatre (page 289), which had opened just a couple of months earlier. The interior, designed by the Chicago firm of Graven & Mayger, played off the public's fascination with recent archeological discoveries in Central America and was decorated as if the movie theater had been built by the ancient Mayans. Everything in the theater was based on original Mayan artifacts, and the authenticity of the effort was such that the *Detroit Free Press* claimed that it was "officially recognized by archaeologists, the Mexican government and others interested in early American art, as the finest example of Mayan architecture in the world."[7] The theater was dedicated to showing first-run movies and occasional stage shows. With the advent of television, movie attendance declined throughout the 1950s, and in 1961, the Fisher brothers totally remodeled the theater as a home to Broadway-style plays and musicals.

Unlike so many buildings in the downtown area, the Fisher Building did not struggle to maintain occupancy through the later decades of the twentieth century, mostly due to its location in the New Center Area, across from General Motors headquarters (page 104). However, when GM moved to the Renaissance Center in 1999, occupancy began to fall. The building has changed hands a couple of times since then and was purchased in 2016 by a consortium that includes HFZ Capital Group, Rheal Capital Investment, and Platform Investment Group. This consortium has announced plans to return the building to its former glory and is currently in the midst of a $100 million restoration program.

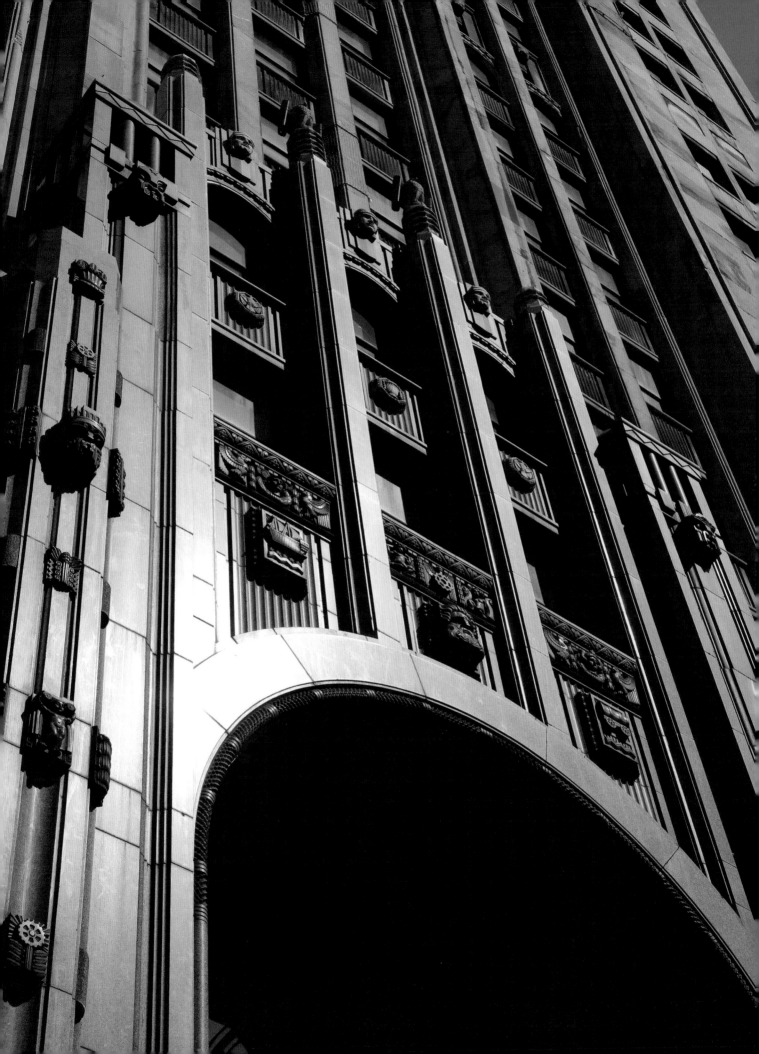

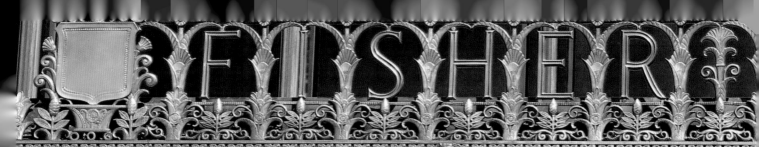

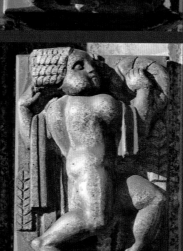

Facing page and top: Details of the ornate brass grilles above the entrance, designed by Géza Maróti and executed by Anthony DiLorenzo & Company.

Above and left: Allegories designed by Géza Maróti and carved from models created by Corrado Parducci. These six examples represent peace, construction, automobile manufacturing, agriculture, parts manufacturing, and flight.

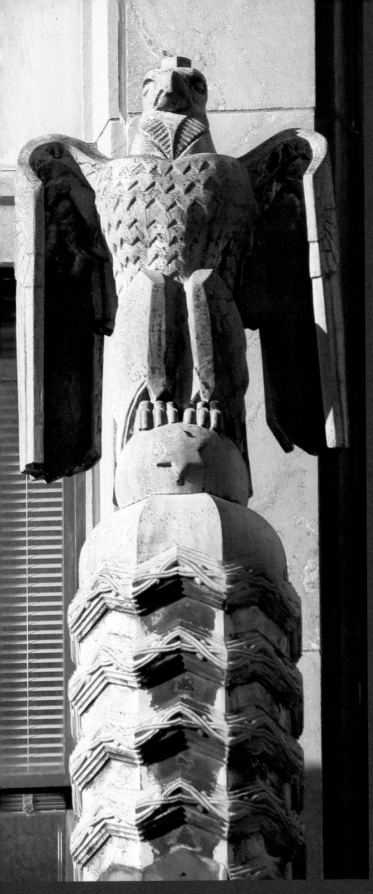

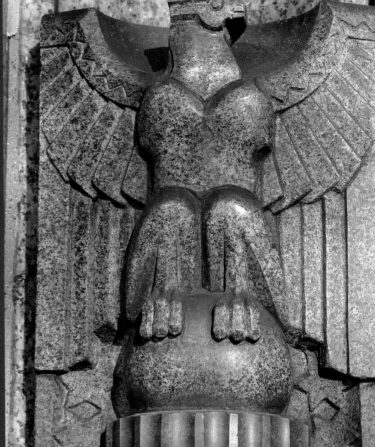

Above: A once-gilded granite eagle from one of the columns framing the main entrance. It is a conventional symbol of American power and capitalism, placed at eye level for pedestrians.

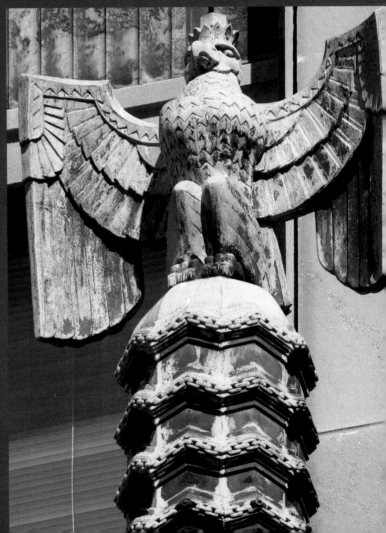

Above: One of the eagles from atop a pylon over the main entrance arch. Its wings are open but curved forward in a sheltering gesture, symbolizing an America that nurtures genius and innovation.

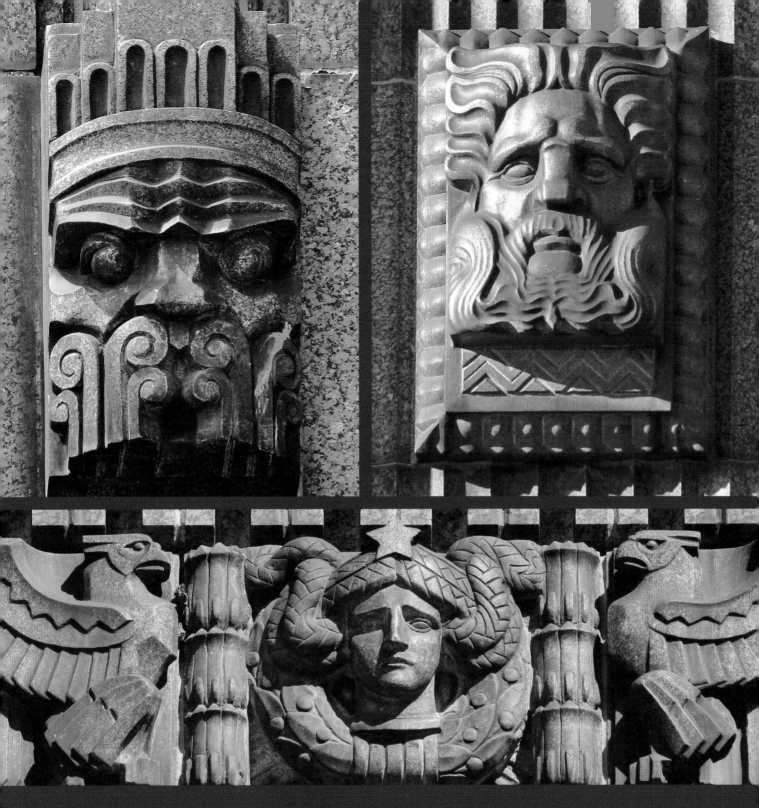

Top left: A head from one of the columns on either side of the arch, an Art Moderne version of an ancient Assyrian designs.

Top right and above: Godlike and heroic heads over the main entrance. Although carved in granite, these were originally gilded, but most of the gilding has tarnished and worn away over the years.

Left, facing page: Another of the eagles from a main-entrance pylon. Dynamically spreading its wings to take flight, it represents the progressive and entrepreneurial spirit of America, always moving forward to bigger and better things.

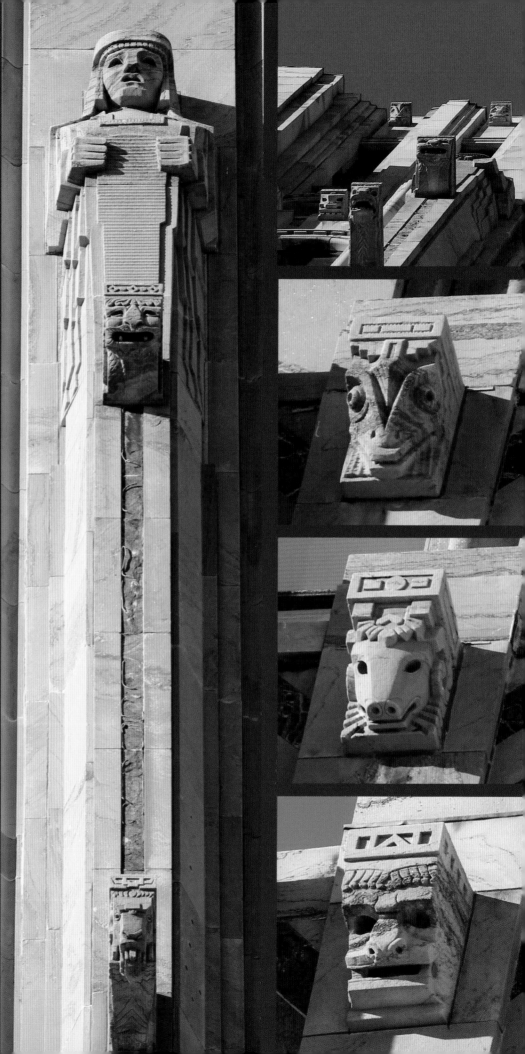

The upper reaches of the Fisher Building are covered with fanciful gargoyles and grotesques. According to an oral history interview that Corrado Parducci did for the Smithsonian Institution (by Dennis Barrie, March 17, 1975, Archives of American Art), these were carved by Ulysses Ricci.

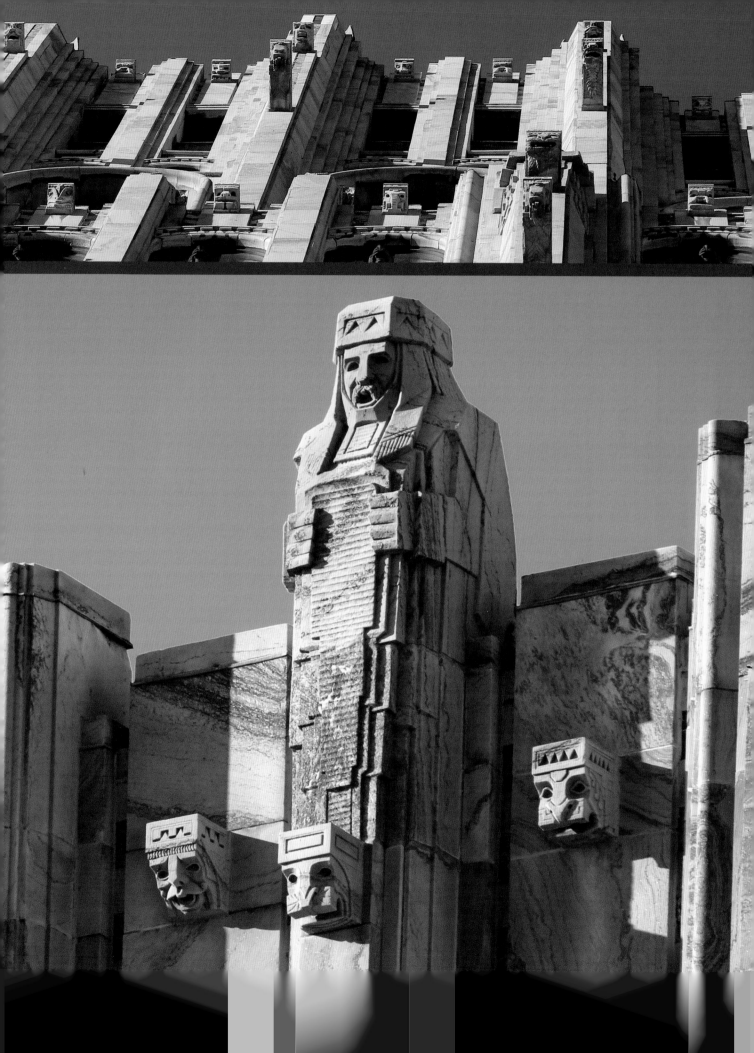

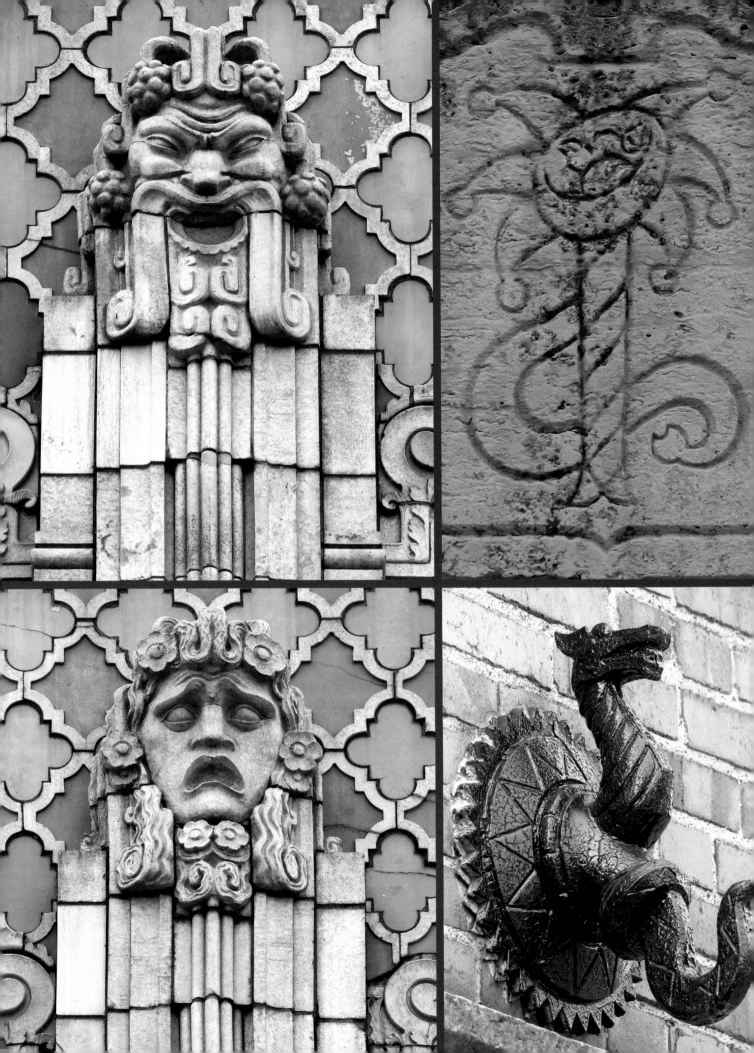

350 Madison Street

Completed: 1928

Architect: William E. Kapp (Smith, Hinchman & Grylls)

Sculptor: Corrado Parducci

"THE THEATER THAT REFUSED to Die," one of the longest-running shows in the history of Detroit, continues today at Music Hall Center for the Performing Arts. The saga began in 1883 when the German immigrants George and Margaret Rausch moved to Detroit from Ontario with their daughter, Matilda.

The Rausches owned and operated a saloon and a boarding house. Their daughter, Matilda, got a secretarial position with the Dodge brothers and married John Dodge in December 1907. John died in 1920, making Matilda one of the richest women in the United States. She got remarried in 1925 to Alfred G. Wilson and in 1928 built the Wilson Theater.

Mrs. Wilson and the architect William E. Kapp built a theater in Detroit to rival those of London. It had the second-largest stage in Detroit, outstanding sight lines and acoustics, and intimacy. The furthest seat in the house was only sixty-five feet from the footlights.[1]

In 1944, the Wilson Theater was sold to Henry Reichold, who changed the name to Music Hall. It became the home of the Detroit Symphony Orchestra, until the orchestra disbanded in 1949 and the building was closed. In 1953 the building was purchased by the steel magnate Mervyn Gaskin.

Gaskin adapted Music Hall for Cinerama, a new movie process shot with three cameras using one shutter and projected on a curved screen using three projectors. The ultrawide screen, combined with seven-speaker stereophonic sound, stunned movie audiences, putting them smack in the middle of the action. Music Hall was only the second Cinerama theater in the world and remained popular in Detroit for years. But its popularity eventually waned, and in 1966 Music Hall was converted into a conventional movie theater. It showed second-run features until it closed again in 1970. However, it did not stay closed for long.

In 1971, Music Hall became the first home of the Michigan Opera Theatre. The building was almost razed in 1973, but it was reborn as the nonprofit Music Hall Center for the Performing Arts. Mervyn Gaskin donated half the building's value to the new organization, with the Kresge Foundation providing a grant for the rest. Detroit Renaissance agreed to finance operating deficits for the next two years.[2]

Michigan Opera Theatre stayed until 1985. The theater also became known as the home of the Paul Taylor Dance Company, the number-one dance presenter in Detroit.[3] In 1995, the building underwent a $6.5 million renovation/restoration. New jazz performance spaces have been added and the story of "The Theater That Refused to Die" continues, with Music Hall Center for the Performing Arts known as one of the finest jazz, theater, and dance venues in Detroit.

MUSIC HALL

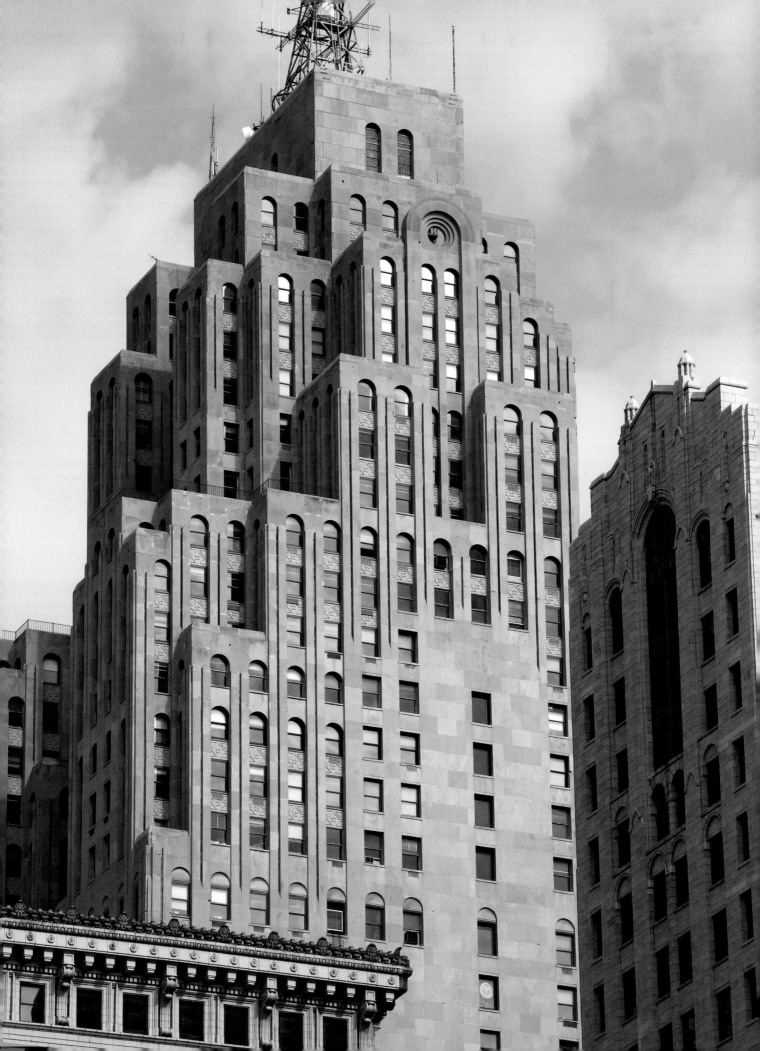

645 Griswold Street

Completed: 1928

Architect: Wirt C. Rowland (Smith, Hinchman & Grylls)

Sculptor: Corrado Parducci

REACHING A TOWERING FORTY-SEVEN-STORIES, the Penobscot Building was the tallest building in Detroit, the "chief" of the city's skyscrapers for almost fifty years, until it was surpassed by the Renaissance Center in 1977. It was also a stunning departure from classic European forms for its architect, Wirt Rowland: an H-shaped shaft rising for thirty stories until it is broken into seventeen stories of unique cubist shapes set back from the main mass of the tower and emphasizing the increasing altitude of the top floors. The roof is topped with a one-hundred-foot metal tower that supports a twelve-foot-diameter blinking aviation beacon lit with 960 feet of red neon tubing and visible for forty miles. Penobscot's iconic shape and dramatic lighting made it an architectural symbol of Detroit for generations.

The Penobscot Building takes its name from the river in Maine where the lumber baron Simon J. Murphy got his start before moving to Michigan and amassing a fortune. He built the first Penobscot Building in 1902, a thirteen-story office building with a one-hundred-foot frontage on Fort Street. Murphy died shortly before it was completed, and his children followed this up in 1916 with the New Penobscot Building, a twenty-four-story annex with an eighty-foot frontage on West Congress Street. The Greater Penobscot Building, as the tower is actually named, was built on the former site of Fort Shelby and replaced the Moffat Building, which was torn down to make way for it.

The building underwent a name change in 1972 when its major tenant, City National Bank, signed a new lease and got naming rights as part of the deal. Detroiters refused to accept the change, and after ten years, the "City National Bank" lettering over the entrance was taken down and replaced with a new "Penobscot Building" sign.

The four-story entry arch is dominated by a three-story-tall carving of a chieftain meant to represent all Native Americans. The inside of the arch features something truly unique, a Native American–themed zodiac carved in Art Deco style, a nod to Italian Renaissance motifs and contemporary mania for astrology. The stonework is carved into the building, and the brass work is flush mounted, in keeping with the building's overall sleek look. Corrado Parducci created sculpture to match his impression of the building, rather than working to a preconceived style.

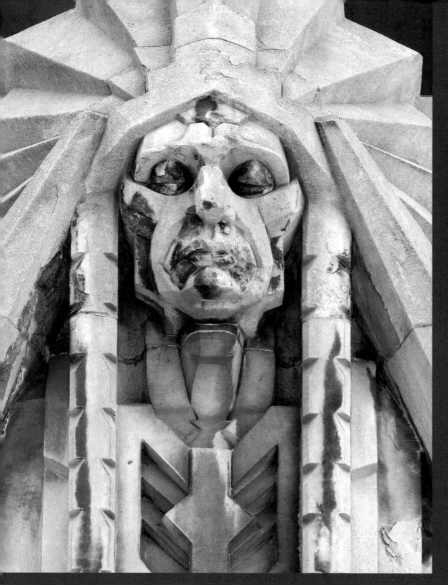

Left: Relief carving of a Native American, affectionately known as "Big Chief Penobscot," over the main entrance.

Below: Gold-painted cast-iron flag-pole mount.

Facing page: Relief figures representing commerce, prosperity, and industry from the Congress Street façade. Drawings of these figures were featured in Penobscot Building advertising to potential tenants.

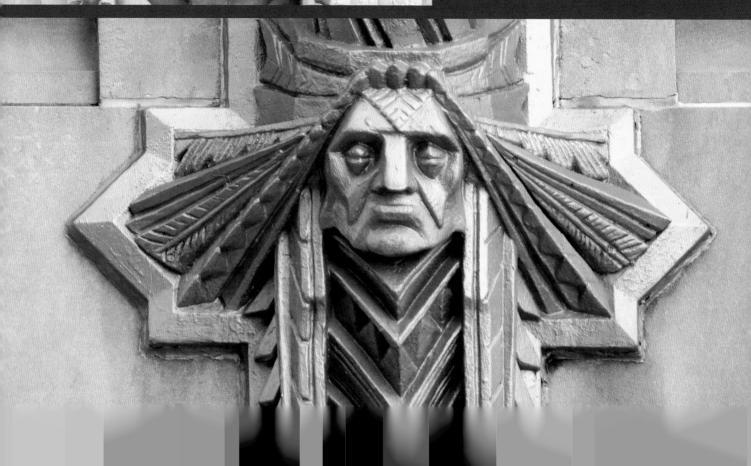

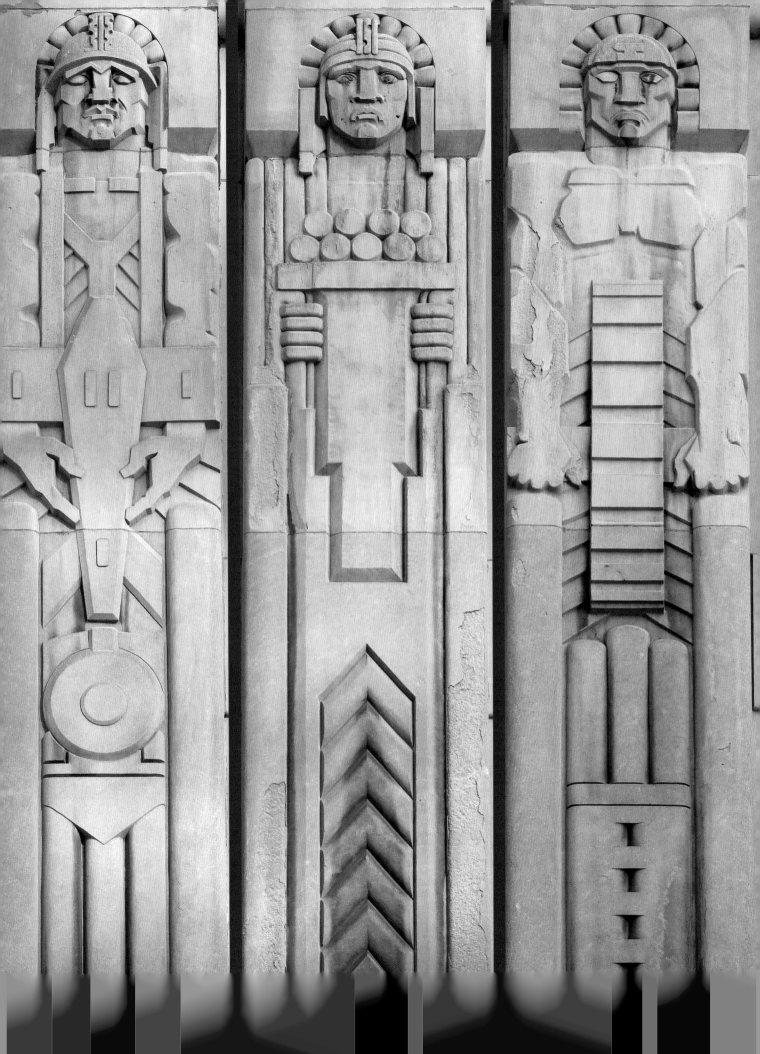

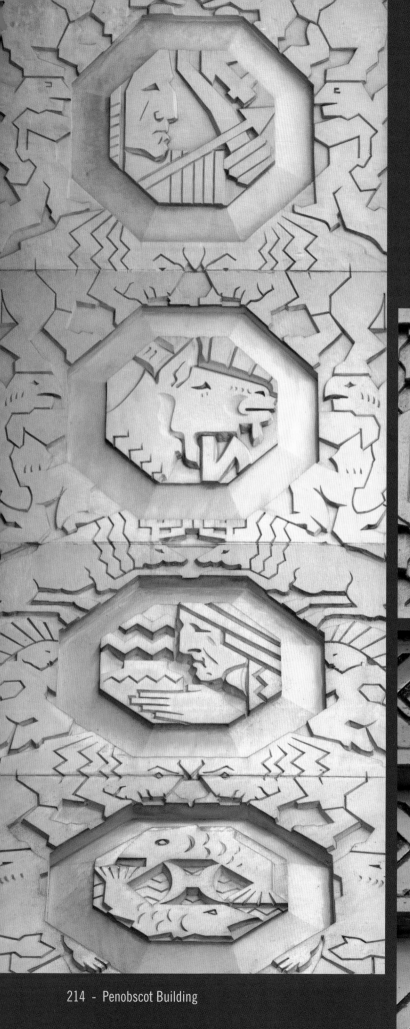

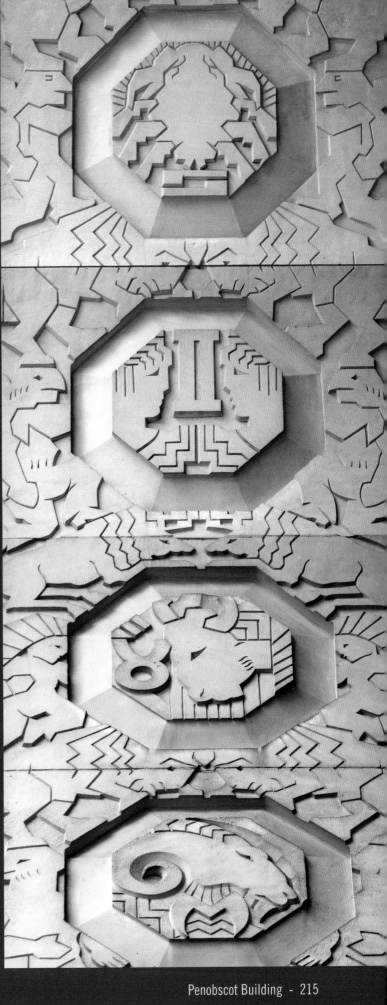

Left and above: Window spandrels with a bull, for financial strength, and an eagle, for vigilance.

Below: Eagle detail from a light fixture over the main entrance.

2727 Second Avenue

Completed: 1929

Architect: Albert Kahn

Sculptor: Corrado Parducci

W HEN THE S. S. Kresge Company, operator of the second-largest variety-store chain in the country, outgrew its Albert Kahn–designed, eighteen-story headquarters at the corner of Adams and Park Avenues in downtown Detroit, it turned again to Mr. Kahn. The new headquarters was built on Second Avenue, next to Cass Park. Charles B. VanDuren, the president of the company, wanted the finest commercial building in the country, a structure that would "be a fitting tribute to the growing understanding and appreciation of the citizens of Detroit of things beautiful."[1]

With land more readily available outside the downtown core, Kahn designed a massive, city-block-sized, E-shaped, four-story building whose long horizontal façade is offset with strong vertical piers that double and get smaller above the belt course and again near the cornice. It is topped with a copper mansard roof that hides the fifth-floor addition of 1966. True to VanDuren's ambition, the building earned a 1931 American Institute of Architects Medal of Honor for its "distinguished design, construction, meticulous quality of materials used, decorating taste and fine appointments."[2]

In 1972, the S. S. Kresge Company left Detroit for a new headquarters in suburban Troy. After an unsuccessful attempt to sell the building, the company donated it to the Detroit Institute of Technology, which closed in 1982. Purchased by Wayne State University, the building became the Metropolitan Center for High Technology in 1985, with a mission to act as an incubator for young high-tech companies. It was rebranded as The Block at Cass Park in 2014.

This building features detailed sculptural Art Deco ornamentation, concentrated in three areas—around the main entrance, on the belt course between the third and fourth floors, and at the cornice of the central pavilion. The cornice features twelve crowned heads in three different alternating styles. These heads are similar to heads found on the Argonaut Building (page 285) and the Maccabees Building (page 182).

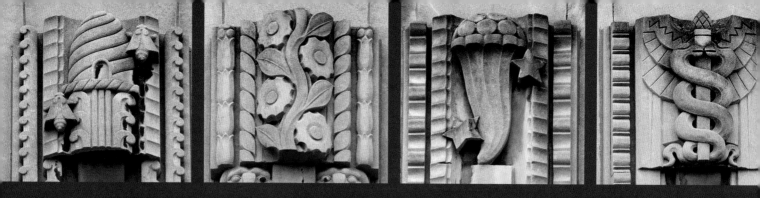

Above: Symbols of industriousness, fertility, wealth, and commerce from the belt course.

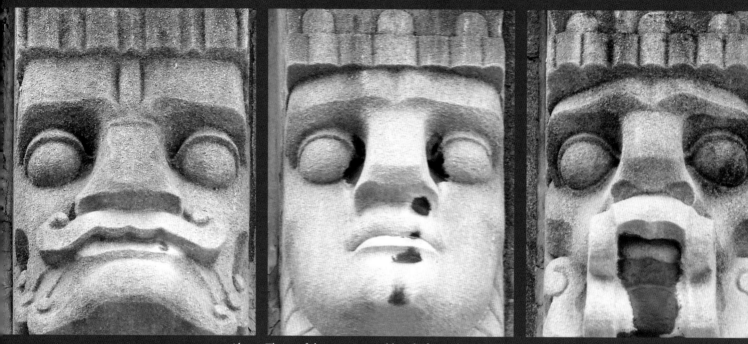

Above: Three of the ornamental heads from the pavilion cornice.
Below: Belt-course allegories for textiles and industry.

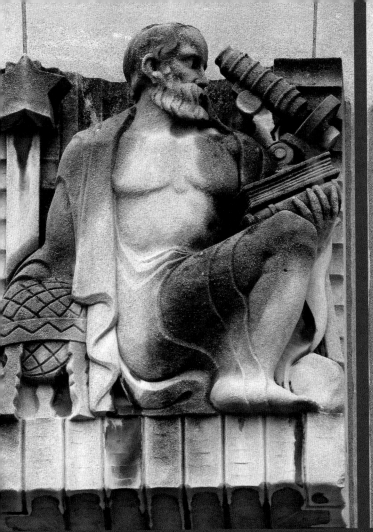

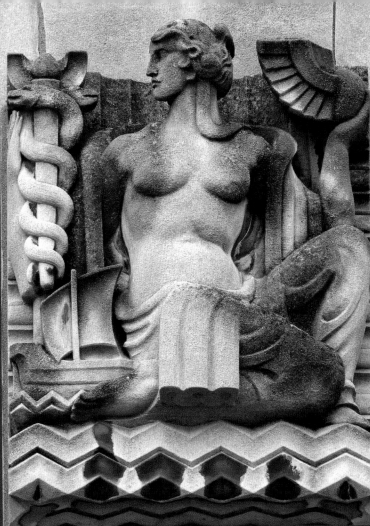

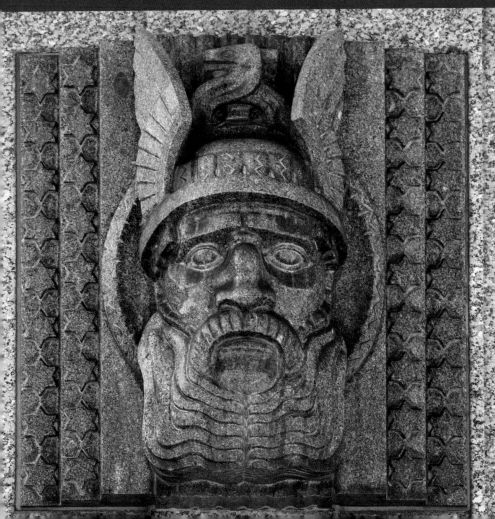

Above: Two more allegorical reliefs from the belt course, this time representing research and commerce.

Left: An unusual bearded Mercury, the Roman god of commerce, over the main entrance. He is typically depicted clean-shaven.

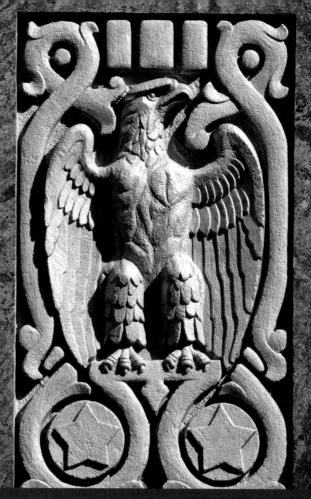

Relief sculptures over the main entrance: an eagle, representing the strength of the U.S. dollar (ironically, the stock market crashed shortly after the building opened); the lion rampant, which symbolizes the security the building offers its occupants; transportation; and flour production, a fitting design for a building named after Detroit's "Flour King."

ACCORDING TO CONTEMPORARY AND modern architectural critics, it is with the David Stott Building that the skyscraper in Detroit achieved its ultimate definition. The Stott was designed to be an homage to Eliel Saarinen's unused plan for the Chicago Tribune Building, making it the closest thing Detroit has to a Saarinen-designed building. It took architects eight years and twenty-two sets of plans to come up with the final design.[1] David Stott, the building's namesake, died ten years before its construction. He had made a fortune milling and selling flour and then went into manufacturing and real estate, and the business was continued by his children.

The first three stories of the slim, thirty-eight-story building are clad in beautiful dark-red granite. The entrance features relief copper and stone lions and eagles and carved reliefs representing transportation and flour production crafted by Corrado Parducci. The floors above are clad in custom-made rose-brown bricks with a protective glazed finish. The cornices on the elegant setbacks that begin at the twenty-third level are carved beige limestone. The cornices and the bricks both get lighter as the building gets taller, further emphasizing its height.

The Stott was the fourth-tallest building in Detroit when completed and was known for its bank of six amazingly fast elevators that could go from ground level to the top floor in less than thirty-five seconds, at a speed of eight hundred feet per minute, equaling the fastest elevators in the world.[2]

The fortunes of this building named for Detroit's "Flour King" repeatedly rose and fell over the years. It was completed on the eve of the Great Depression with much fanfare but soon went into bankruptcy. It remained closed throughout most of the 1930s, the catalyst for a Stott-family legal battle over blame. The courts eventually ruled that many wise investors failed to foresee the coming economic collapse, and there was no blame to be assigned. The Stott rebounded in the post–World War II boom and became home to many of Detroit's leading legal and architectural firms. Local radiophiles remember it as the home of the groundbreaking progressive/album-rock station WABX FM.

Like most downtown buildings, it began a slow decline in the late '60s and was down to two tenants in February 2015, when it suffered a new indignity. Ninth-floor pipes burst in the record-breaking winter cold, and water flowed unchecked for over twenty-four hours, flooding all three basements and the first four floors with more than two million gallons.[3] It took days to pump out the water, and it was feared that the icicle-bedecked building might be a total loss. Fortunately, due to its solid construction, the building survived.

The David Stott Building's fortunes rose again when it was purchased by Dan Gilbert's Bedrock real estate firm in 2015. Renovation and restoration has been proceeding since, and it is expected that the Stott will be restored to its former glory by the end of 2018.

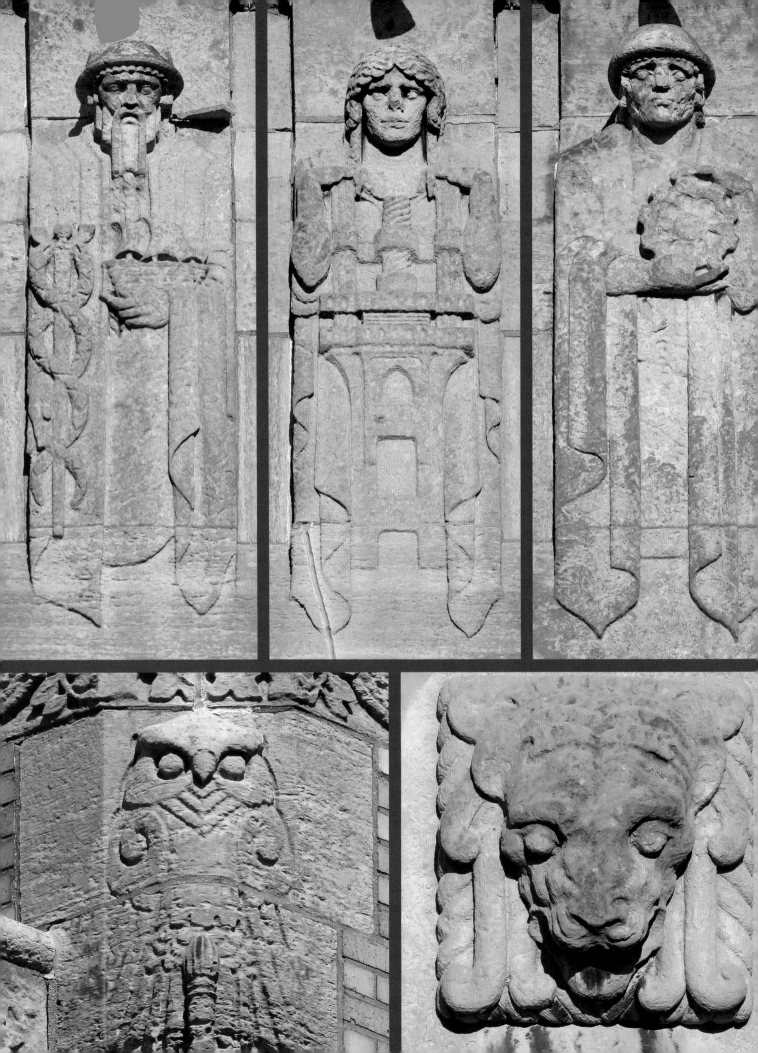

THIS MUSTARD-COLORED BRICK AND sandstone edifice on the north side of Jefferson Avenue stands out in the morning sun. It is a five-story Art Deco office and industrial building erected by the Detroit Press Company, which went out of business a few years after the building opened. The three central piers of the building's straightforward design are topped with figures chiseled out of the large sandstone blocks of the cornice. Carved in high relief at the top with garments in low relief that blend back into the stone, they represent commerce, printing, and industry. The figures were probably the work of Corrado Parducci, given the timing and their stylistic similarity to Parducci's work on several Detroit buildings, especially the Penobscot Building (page 210) and the Guardian Building (page 228).

The design of the structure is reminiscent of Albert Kahn's 1916 Detroit News Building (page 78), right down the imposing corner pylons topped with owls, representing knowledge and wisdom. This is not surprising since both buildings were intended to house printing plants and offices. The building is also guarded by three stylized lions in the stone belt course between the second and third floors.

For most of the building's existence, it was home to Ross Roy, the third-largest advertising agency in Detroit, and was known as the Ross Roy Building.

Ross Roy was a very successful Wisconsin car salesman when he came to Detroit in 1926 to found his agency, with the Dodge Brothers as his major client. When the Chrysler Corporation bought Dodge two years later, they stayed with Ross Roy, and the agency grew and prospered, eventually outgrowing these quarters.

By 1987, Ross Roy had $416 million in worldwide billings and over five hundred employees. It took over the George Harrison Phelps Building (page 289) next door in 1972 and so many others up and down the street that company executives referred to Jefferson Avenue as the "Ross Roy Monopoly board."[1] Ross Roy, wanting to seem "modern and powerful" and believing its fifty-eight-year-old headquarters building, which now housed less than two-thirds of its employees, "had been sending out the wrong message for years,"[2] left Detroit. It built a modern, 211,000-square-foot headquarters in Bloomfield Hills, donating the Detroit Press Building to the University of Detroit.

Now known as University Square, this building has provided space for many university and public-service agencies over the years, including the Child Care Coordinating Council, AIDS Partnership Michigan, and the University Psychiatric Center.

DETROIT PRESS BUILDING

250 West Larned Street

Completed: 1929

Architect: Hans Gehrke

Sculptor: Unknown

IN 1927, THE CITY of Detroit needed a new Fire Department Headquarters. The old one, built to house horse-drawn fire-fighting equipment in 1888, had become inadequate. Ironically, the Fire Department Headquarters had become a fire hazard, due to its lack of suitability for housing modern gasoline-powered fire trucks. There was just one problem. Mayor John W. Smith and the City Council were locked in a power struggle over where the new headquarters should be built.

Mayor Smith wanted to build the new headquarters at Gratiot Avenue and Mullett Street, as part of a new "Utility Center" that would include the County Jail and a new Water Board building. The council wanted to tear down the old headquarters and build the new one at the same site, claiming that the mayor was trying to disrupt its plans for a new Civic Center at the foot of Woodward Avenue. The Fire Department, caught in the middle, was ready to endorse either plan, as long as it got the new building it so desperately needed.

In the end, the City Council prevailed, and a new five-story, state-of-the-art Fire Department Headquarters was built at the corner of Larned and Wayne Streets. This portion of Wayne later became part of Washington Boulevard.

The building's architect, Hans Gehrke, who designed many fire houses throughout the city, gave the headquarters a solid, monumental feel. The façade is made of dark-red brick with terra-cotta trim and cornices. It is adorned with symbolic sculpture that includes angels with fire axes over doorways and fire-chief heads at each pilaster capital. Everything is designed to give the citizens of Detroit, a city completely destroyed by fire in 1805, confidence in their fire department's ability to provide safety and protection.

The building was sold by the city in 2013 after the Fire Department moved to the new Detroit Public Safety Headquarters on Third Street. It has since been converted into the one-hundred-room Foundation Hotel, which opened in 2017.

As part of the conversion, the façade was cleaned of almost ninety years of soot and grime, presenting a unique opportunity to see the terra-cotta ornaments as they looked when the building was brand new, next to photos of how they looked just before the restoration, as shown in the photographs in this chapter.

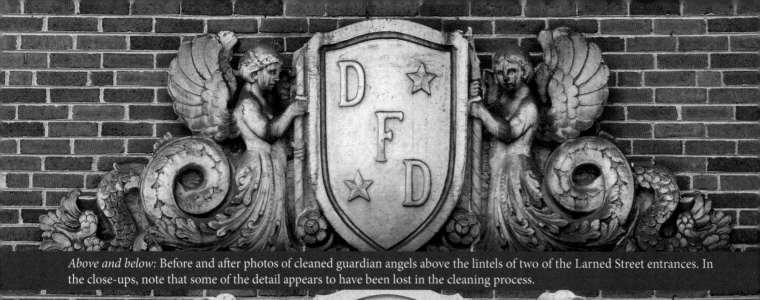

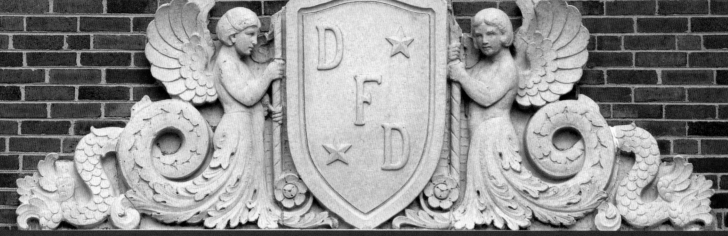

Above and below: Before and after photos of cleaned guardian angels above the lintels of two of the Larned Street entrances. In the close-ups, note that some of the detail appears to have been lost in the cleaning process.

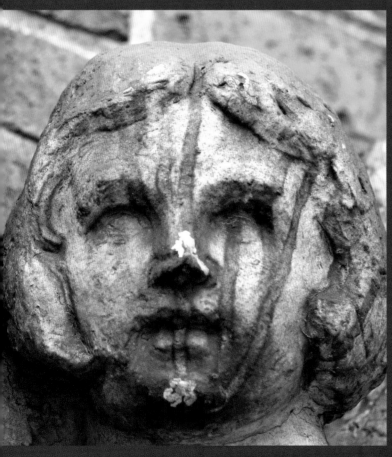

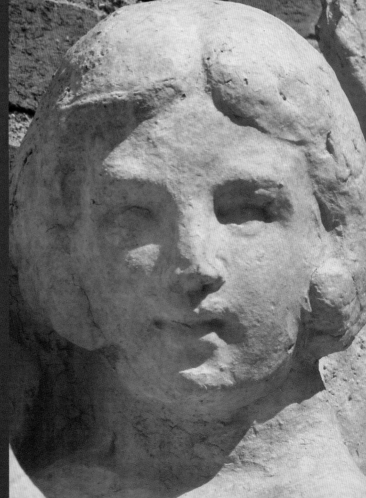

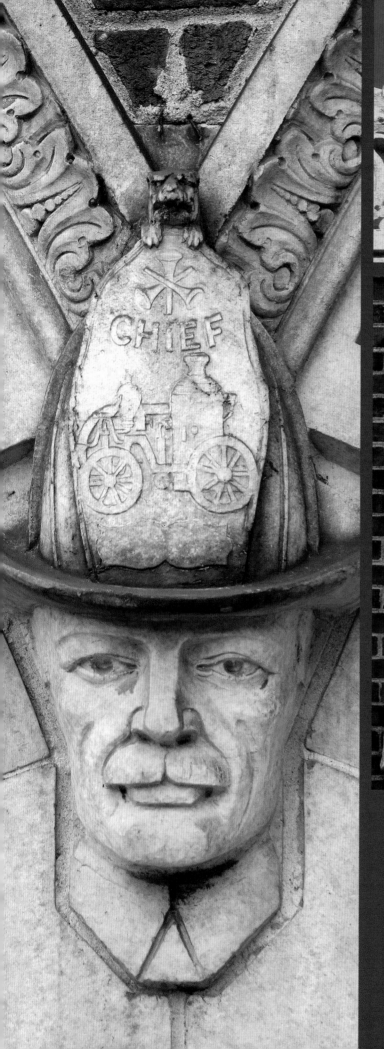

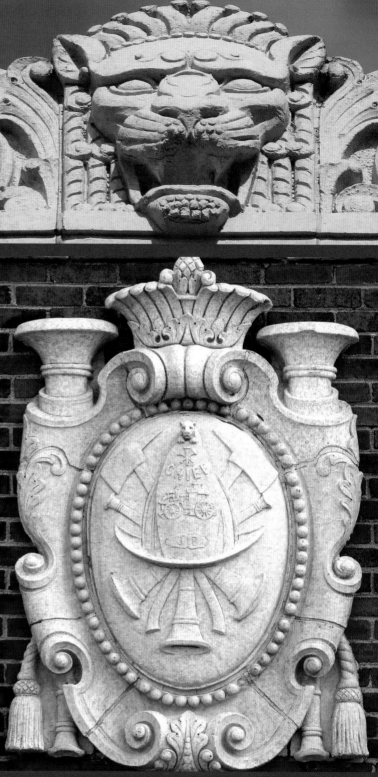

Top right: A restored lion from the cornice.

Above: A restored cartouche featuring a chief's helmet, fire axes, and trumpets, from the west façade.

Left: One of the fire-chief heads that terminate the arches between the large doors. This picture was taken before the head was cleaned.

500 Griswold Street

Completed: 1929

Architect: Wirt C. Rowland (Smith, Hinchman & Grylls)

Sculptors: Corrado Parducci, Peter Bernasconi (carver)

Mosaics: Mary Chase Perry Stratton

THE GUARDIAN BUILDING IS Wirt Rowland's wondrously unique masterpiece. Called the Union Trust Building when it opened in 1929, the overall impression it gave earned it the title "The Cathedral of Finance." This was the culmination of Rowland's skyscraper design evolution, the third of his Griswold Street buildings, each separated by only a few hundred feet of sidewalk. They all opened within four years of each other from 1925 to 1929.

The most striking aspect of the Guardian Building is the use of color, about which Rowland commented, "We no longer live in a leisurely age. . . . What we see we must see quickly in passing, and the impression must be immediate, strong, and complete. Color has this vital power."[1] In a 1975 interview, the sculptor Corrado Parducci commented that Rowland was "revolutionary in his ideas and effort. . . . You take the color he used in the Guardian, that was—Architects didn't use color!"[2]

Instead of using traditional materials such as granite or limestone, the main portion of the exterior is sheathed in nearly two million specially formulated red-orange "Guardian Bricks." The Guardian Building remains the tallest brick building in the world.[3] The building also has ornate patterned bands of green, gold, orange, and tan glazed tiles between the street-level stonework and the brick sheathing. The upper reaches are adorned with oversized designs also executed in colorfully glazed terra-cotta.

The Griswold Street entrance is protected by a carved lion flanked with eagles and two large figures representing financial safety and security. It also has a massive half dome featuring a mosaic figure of a winged aviator, symbolizing progress. The dome was covered in the 1950s to accommodate air-conditioning units but has since been restored.

Although everything about the building was designed to promote the financial power of the Union Trust Company, it opened just six months before the stock market crashed in 1929. The Union Trust Company failed and was reorganized as the Union Guardian Trust Company. The building was home to the U.S. Department of Defense during World War II and Michigan Consolidated Gas Company in the '80s and was then purchased by Wayne County for its administrative offices. It is currently owned and operated by the Sterling Group. The ornate interior has endured ill-advised renovations over the years but has been lovingly restored to its former glory. No sightseeing visit to Detroit is complete without a tour.

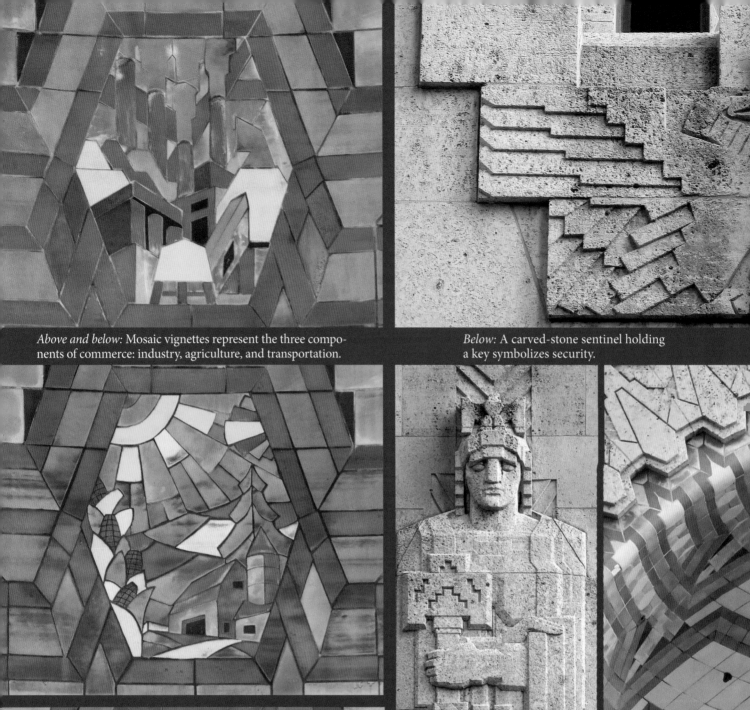

Above and below: Mosaic vignettes represent the three components of commerce: industry, agriculture, and transportation.

Below: A carved-stone sentinel holding a key symbolizes security.

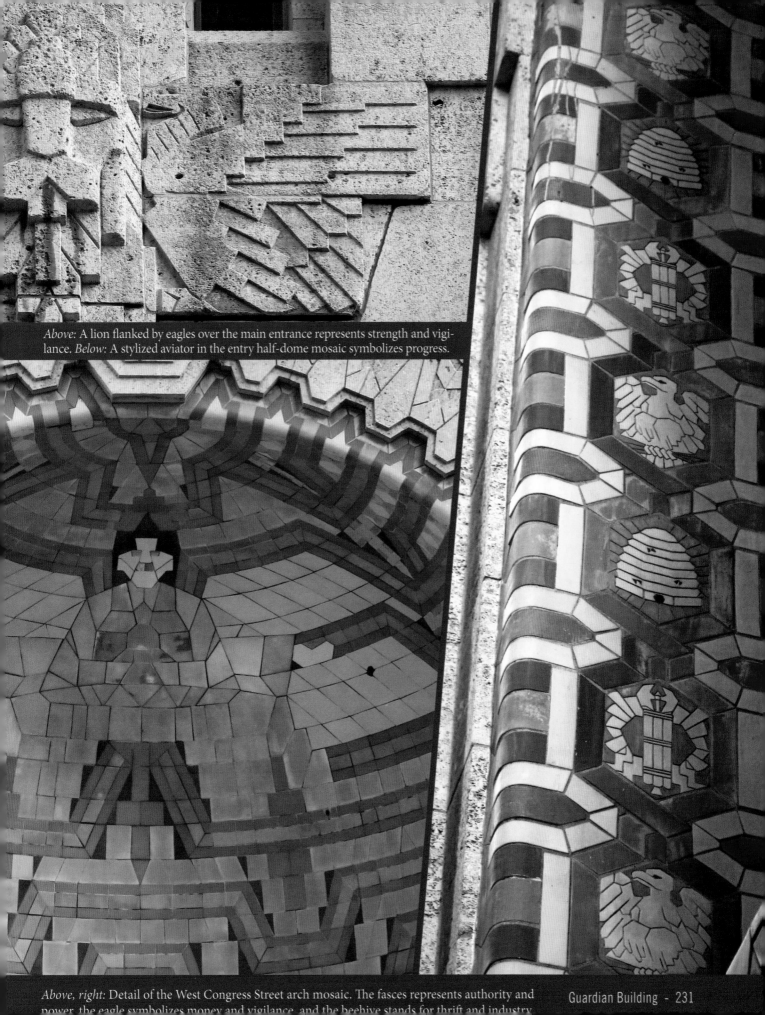

Above: A lion flanked by eagles over the main entrance represents strength and vigilance. *Below:* A stylized aviator in the entry half-dome mosaic symbolizes progress.

Above, right: Detail of the West Congress Street arch mosaic. The fasces represents authority and power, the eagle symbolizes money and vigilance, and the beehive stands for thrift and industry.

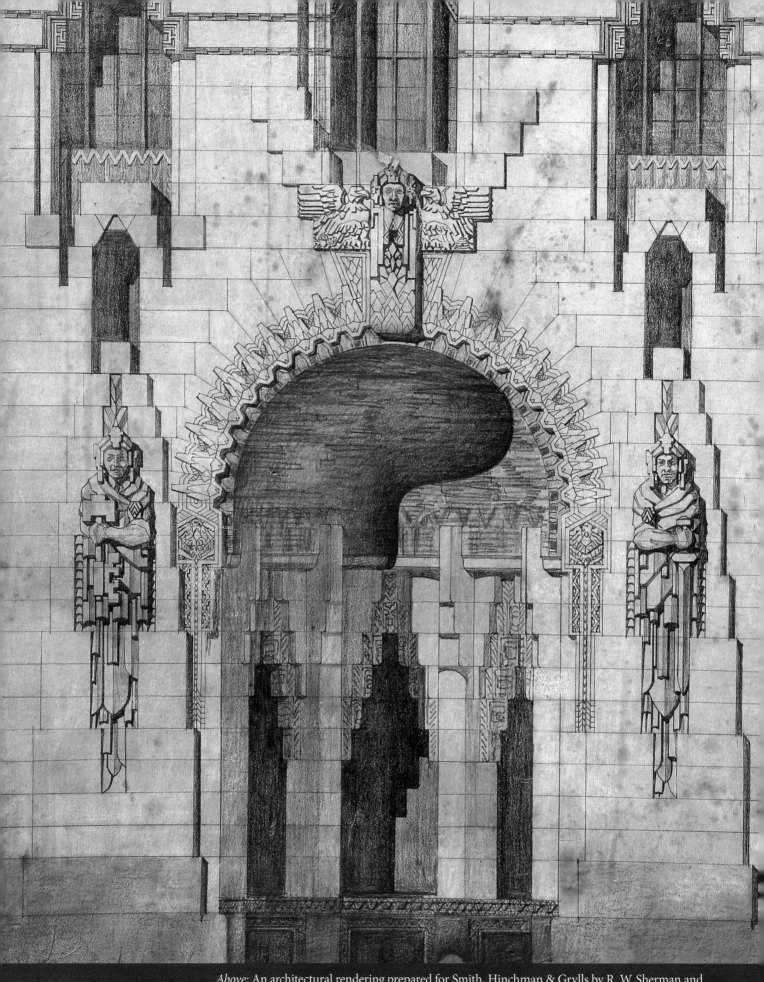

Above: An architectural rendering prepared for Smith, Hinchman & Grylls by R. W. Sherman and C. E. Blessed. It is interesting to compare it with the finished sculpture on the building (*facing page*). Rendering from the personal collection of Martin and Sharon Scott.

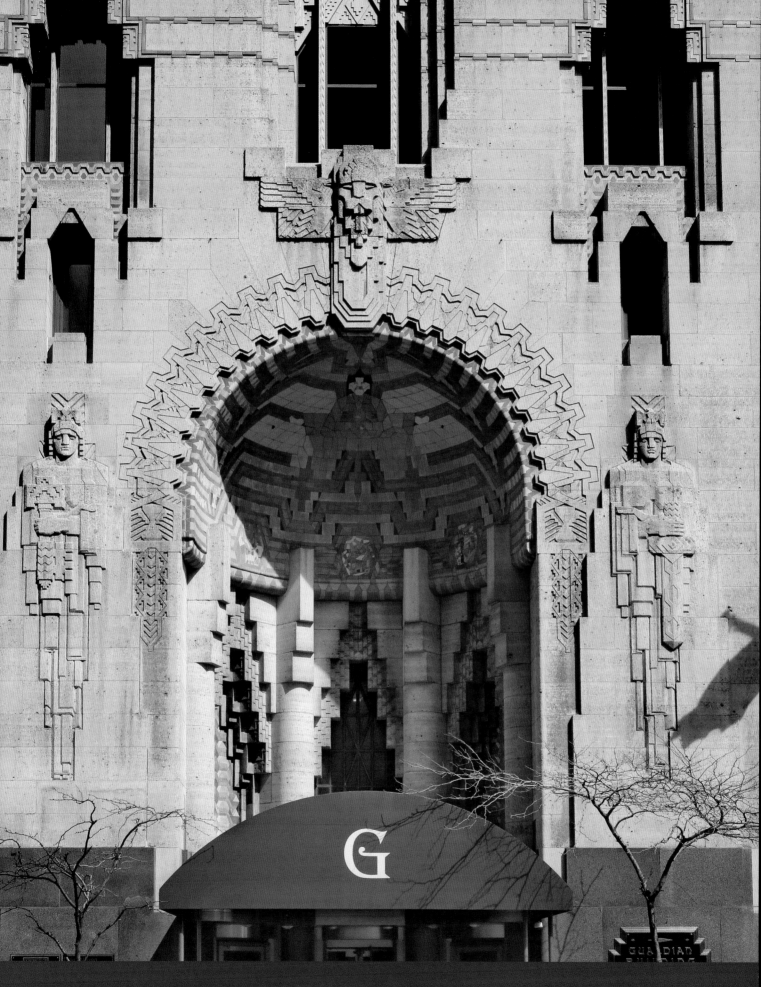

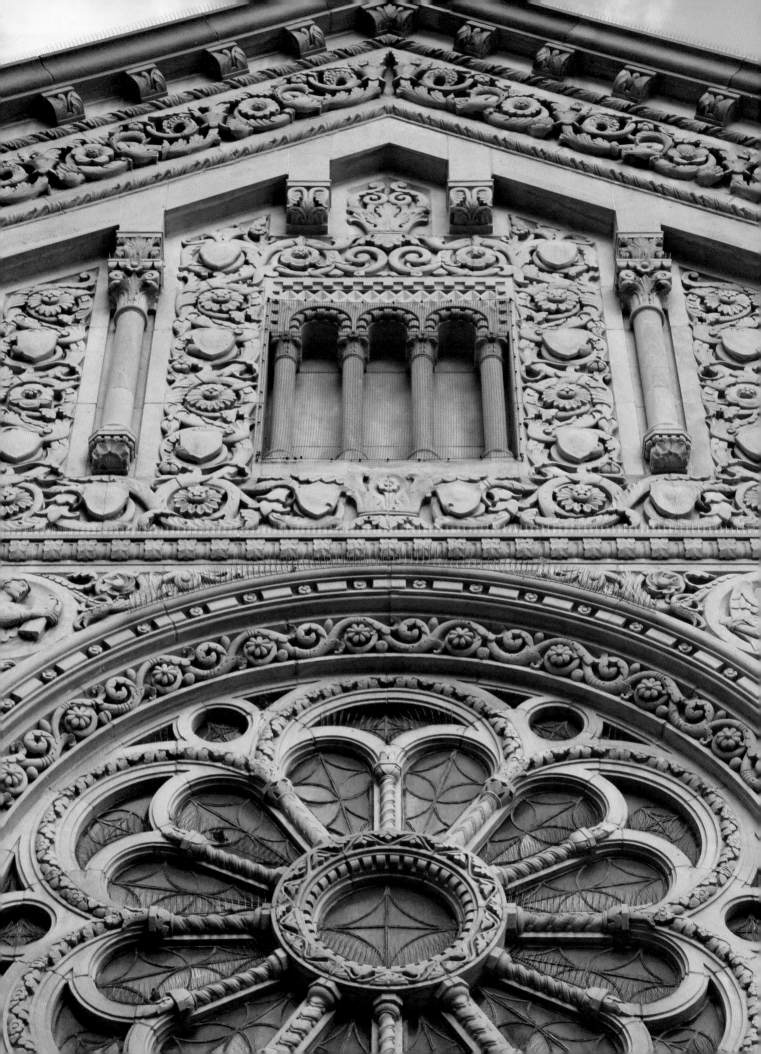

1230 Washington Boulevard

Completed: 1930

Architect: Walter R. Meier (Donaldson & Meier)

Sculptors: Samuel Cashwan (twelve apostles), Corrado Parducci (façade and doors), Peter Bernasconi (carving)

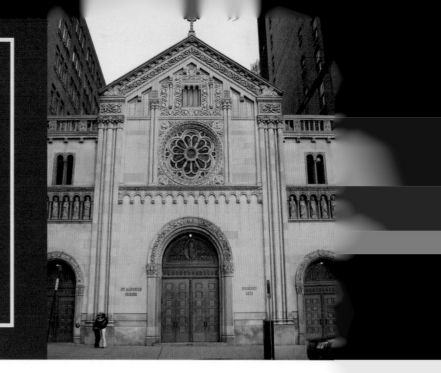

S T. ALOYSIUS ROMAN CATHOLIC Church is unique among Detroit churches in several ways. Its ornate front façade is sandwiched between two buildings, one of the few Detroit churches to share common walls with its neighbors, giving it a truly urban feel. Its three entrances have solid bronze doors with sculpted tympana that gleam in the late-afternoon sun. Known as "Everybody's Church," it draws its membership from throughout the city and beyond, its location around the corner from the Book-Cadillac Hotel bringing it visitors from all over the world. But its most unique feature cannot be seen from outside.

In 1929, the original church building, built in 1860, had been outgrown. With building space limited by the seventy-two-by-one-hundred-foot lot and a need for far more seating than the 728 allowed in the old church, Monsignor John M. Doyle was inspired by a visit to the Cathedral of Milan in Italy. This cathedral has a large opening in the main floor that allows visitors to view the relics of Saint Charles Borromeo in the crypt below.

Doyle shared his inspiration with the architect Walter Meier, who created a three-level church. A large semicircular "well" in the main floor allows everybody seated on the lower level to see the priest and the main altar. Along with the balcony above and perfectly designed sight lines, there was now room for twenty-one hundred people. Meier felt it was the most satisfying of all his endeavors in church architecture. To honor his work, Meier was chosen to be the first layperson to receive Holy Communion in the new building.

The Italian/French Romanesque façade of the church features a bounty of beautifully sculpted ornamentation. Niches above the side doors contain statues of the twelve apostles, and the doors themselves are solid bronze, with intricate tympana that portray all three aspects of the Trinity. The arches around the doors are intricately carved, as is the setting of the rose window above the main entrance. Angels stand at each corner of the roof, turning away from the mortal world to face the main entrance. Altogether, the façade of "St. Al's," as it is affectionately known, is a veritable "sermon in stone."

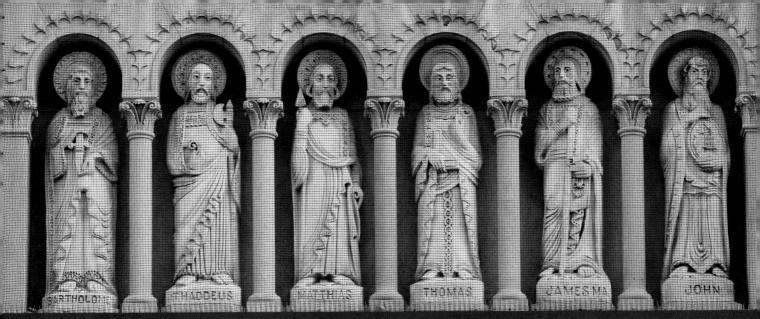

BARTHOLOME THADDEUS ATTHIAS THOMAS JAMES MA JOHN

Below: Saint Bartholomew stands behind a pigeon-proof screen (*left*). A detail of Saint Matthew (*right*) with the screen digitally removed.

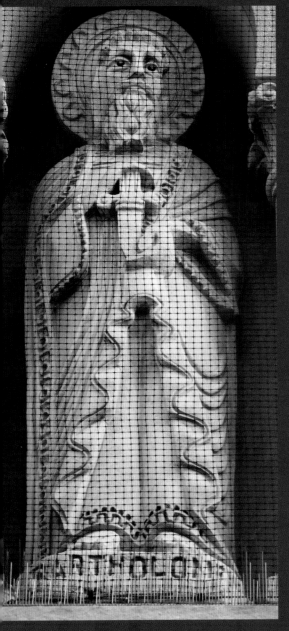

BARTHOLOMEW

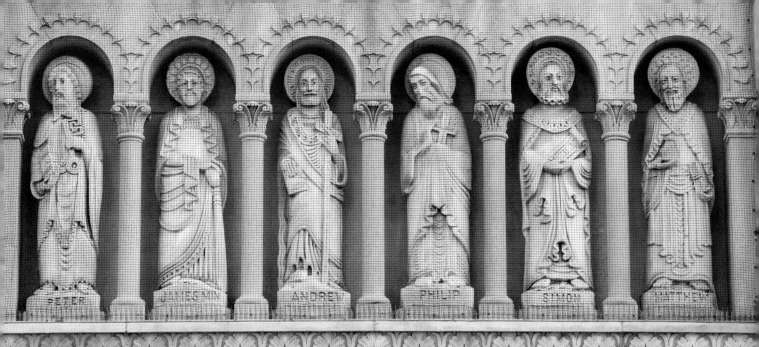

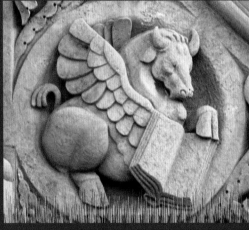

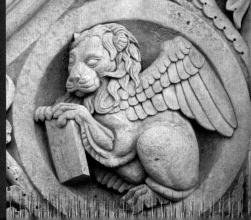

Above: The twelve apostles, most holding symbols of their martyrdom, stand in their niches above each side door.

Far left: A rooftop angel points to a scroll of Divine Law.

Left: Symbols of three of the Evangelists: the eagle of Saint John, the ox of Saint Luke, and the lion of Saint Mark.

IN PRINCIPIO CREAVIT DEUS CAELUM ET TERRAM

OCCISUS · ES · ET · REDEMISTI · NOS · DEO · IN · SANGUINE · TUO

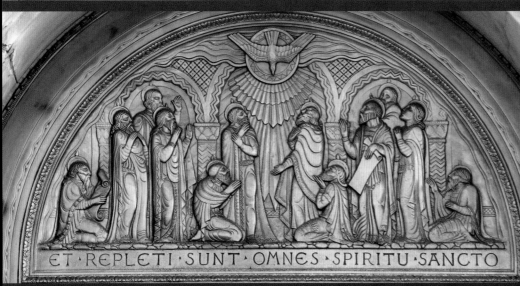

ET · REPLETI · SUNT · OMNES · SPIRITU · SANCTO

Above: The Assumption of the Virgin Mary from between the two center doors.

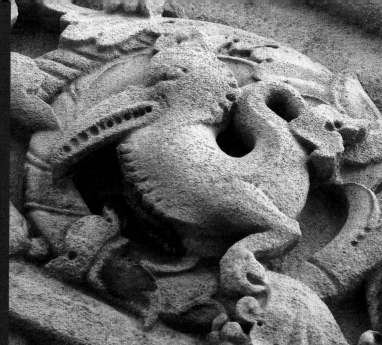

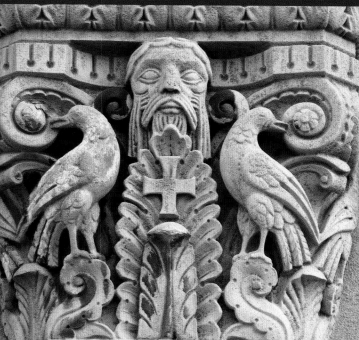

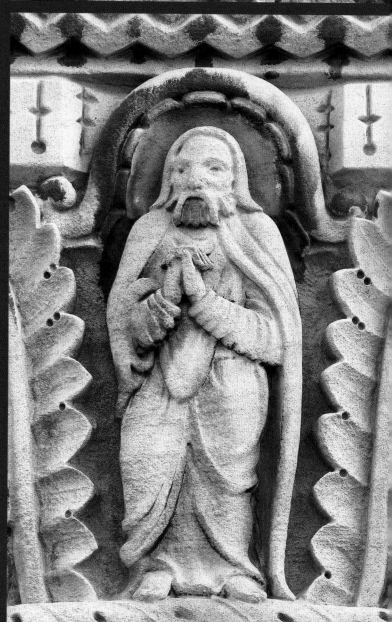

Facing page, far left: The tympana above each of the three bronze doors, depicting the Creation, the Crucifixion, and the Pentecost, respectively, as well as a detail of the frieze beneath the center tympanum, depicting devotional worshipers.

This page, top row: Two fantastic creatures from the doorway arches.

Above and right: Church patriarchs from two of the doorway arch capitals.

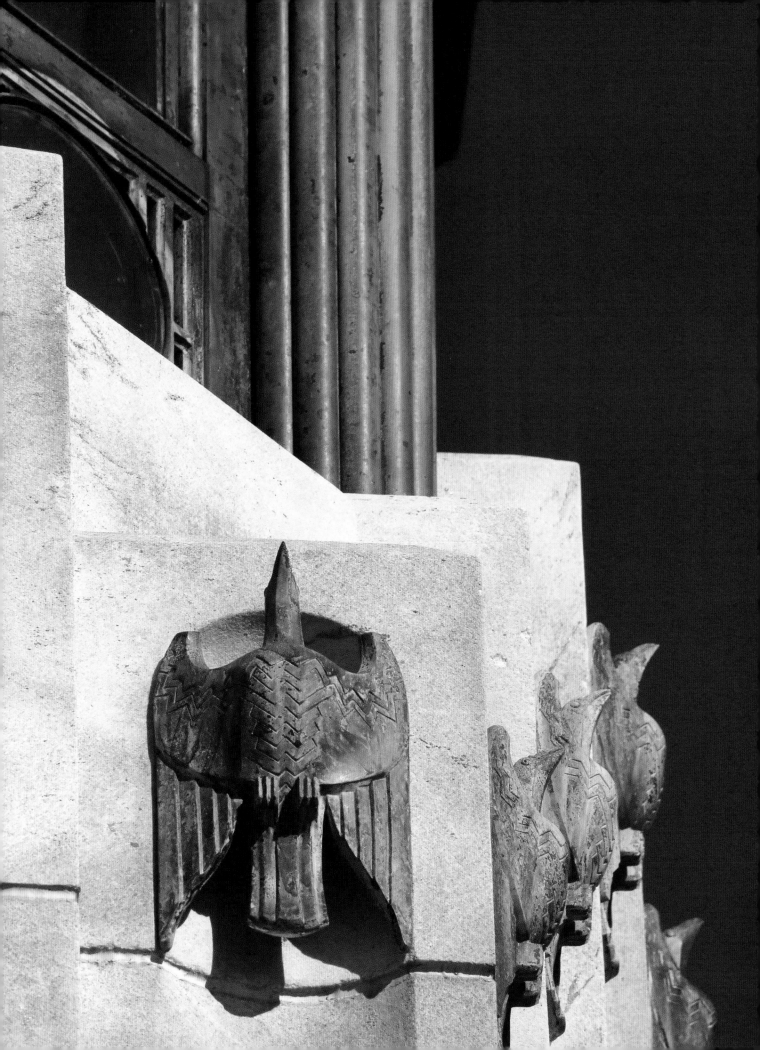

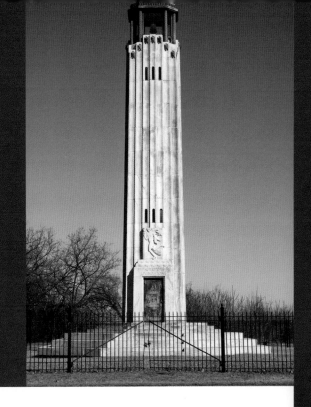

Eastern tip of Belle Isle

Completed: 1930

Architects: Géza Maróti, Albert Kahn

Sculptor: Géza Maróti

E VEN AMONG THE MANY unique structures on Belle Isle, the William Livingstone Memorial Light shines as truly special. It is the only marble lighthouse in North America and the only Art Deco lighthouse in the United States. At the time of its construction, because of the volume of shipping traffic on the Detroit River, it was claimed that it would "serve as a beacon to more ships than any other lighthouse in the world."[1]

Built to honor William "Sailor Bill" Livingstone and erected with $100,000 in funds raised by the Lake Carriers Association, this unique structure is a fitting tribute to the man whose life had a major influence on Great Lakes shipping. The president of the Lake Carriers Association from 1902 until his death in 1925, Livingstone promoted many advances including the creation of deep-water channels in the St. Mary's River, Lake St. Clair, and the lower Detroit River. He was also a prominent advocate for the construction of the Soo Locks.

According to contemporary newspaper reports, the design of the lighthouse structure was a collaboration of the Hungarian sculptor Géza Maróti and the famed Detroit architect Albert Kahn.[2] Maróti was invited by Eliel Saarinen to come to George Booth's Cranbrook Educational Community and create ornamentation for the boys' school. Booth

was very pleased with Maróti's work and probably introduced him to his good friend Albert Kahn. Professor Maróti was a strong proponent of the Arts and Crafts movement, and the Livingstone Light epitomized his belief that sculpture should serve to humanize a building and function as an integral part of the design.[3]

The fifty-eight-foot shaft of the lighthouse is a marvel in white Georgian marble, with elegant flutes topped with soaring bronze eagles that emphasize the building's height. The bronze lantern room holds an eighty-six-hundred-candlepower light that is visible for up to fifteen miles.[4]

There is a large relief sculpture over the west door and an ornate inscription on the opposite side honoring Livingstone. A large bronze medallion with a profile portrait of Livingstone that was mounted above the inscription disappeared long ago, probably lost to vandals or scrappers.

Built on land added to the eastern tip of Belle Isle via landfill, the William Livingstone Memorial Light is not directly accessible by car. Visitors need to park in a small lot on Lakeside Drive, just before Blue Heron Lagoon, and walk the remaining distance to the lighthouse, which stands behind a low hill and is just barely visible from the road.

WILLIAM LIVINGSTONE

NAVIGAT

·THIS·LIGHT·HOUSE·
·IS·ERECTED·BY·THE·
·LAKE·CARRIERS·ASSOCIATION·
·AND·CITIZENS·OF·DETROIT·
·TO·HONOR·THE·MEMORY·OF·
·WILLIAM·LIVINGSTONE·
✳·PRESIDENT·✳
·LAKE·CARRIERS·ASSOCIATION·
✳·1902–1925·✳
·AND·THROUGHOUT·HIS·ACTIVE·LIFE·
·ONE·OF·THE·MOST·PROMINENT·
·AND·PUBLIC·SPIRITED·CITIZENS·OF·
✳·DETROIT·✳
✳·1844–1925·✳

Above: The memorial inscription on the east (water-facing) side.

Facing page: A relief over the west door represents humanity moving in harmony with the elements.

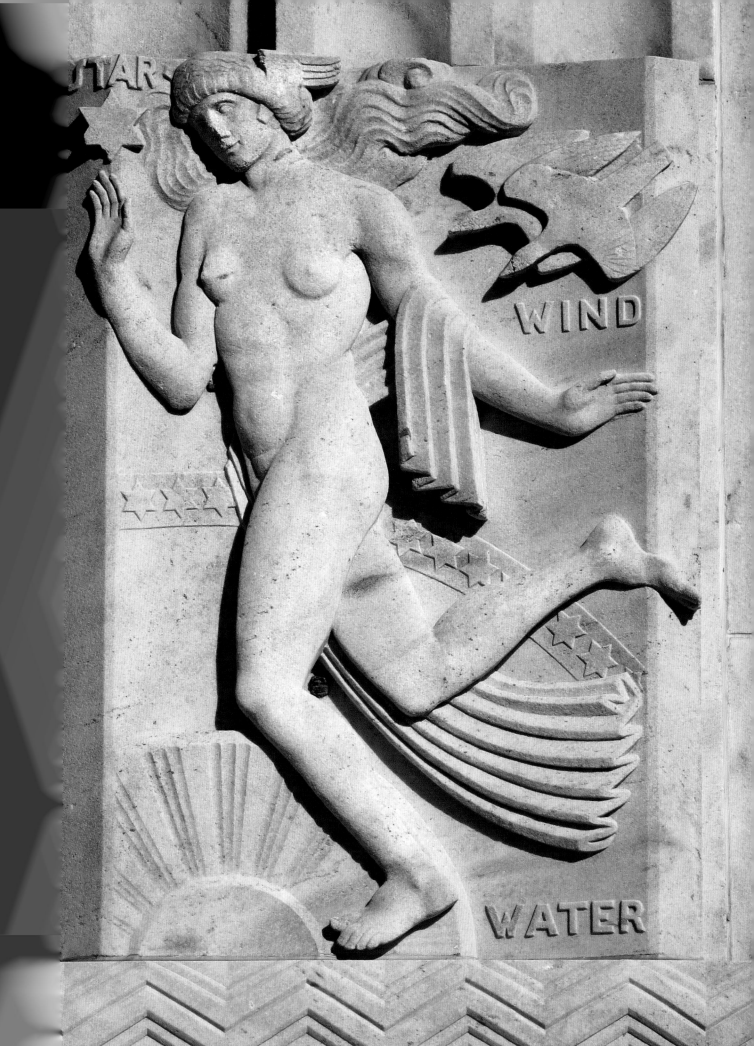

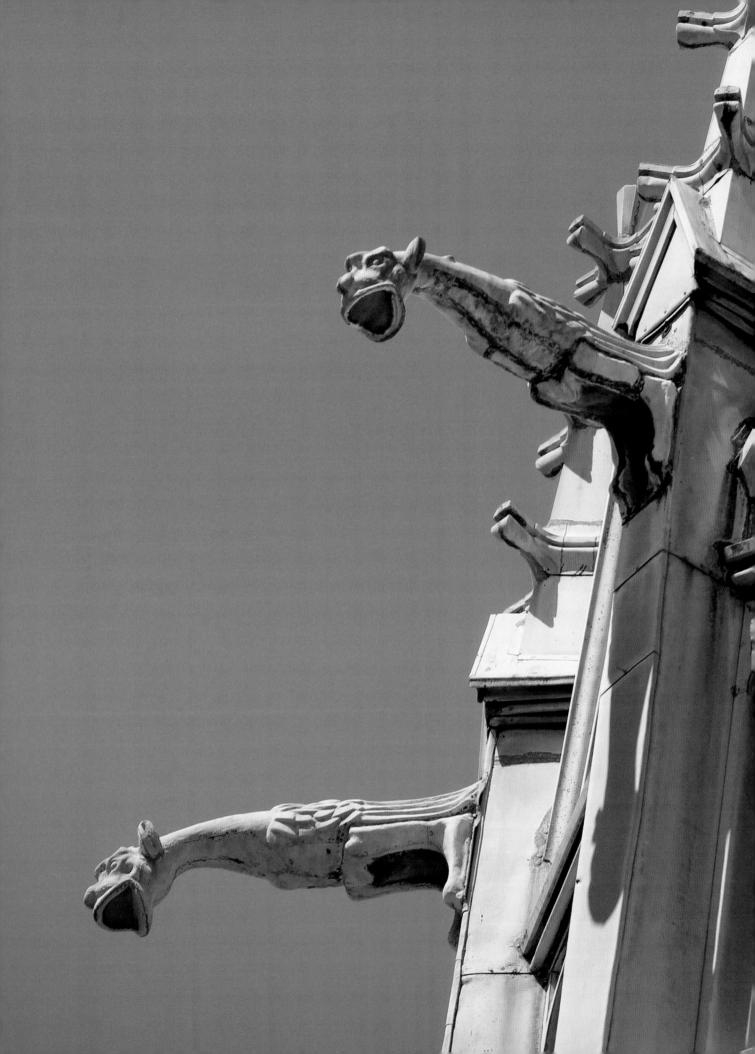

9844 Woodward Avenue

Completed: 1930; front towers added: 1951

Architects: Henry A. Walsh (building),
George and Gerald Diehl (towers)

Sculptor: Corrado Parducci

Begun in 1913, the Cathedral of the Most Blessed Sacrament took thirty-eight years to build. The first mass was celebrated there on August 12, 1915, after the exterior stonework and roof were completed, but the church was not dedicated until Thanksgiving Day 1930, when Bishop Michael Gallagher "solemnly dedicated the structure, finished except for the towers, to the glory of God and the service of His church."[1] The parish had run out of money for building, and it was not until 1951 that the twin 136-foot towers in the original plans were completed. By that time, the church architect, Henry Walsh, was in declining health, and the final work was handled by the father and son architects George and Gerald Diehl.

The church was designated the cathedral of the Detroit Diocese by Pope Pius XI in 1938. It was visited by Pope John Paul II in 1987, and in 2016, it was the site of the Detroit hockey legend Gordie Howe's funeral. An extensive $15 million renovation that included a new roof and cleaning of the exterior was completed in 2003.

The cathedral is a beautiful example of English Gothic architecture with strong French and Norman influences. It would not look out of place in twelfth-century England, although Corrado Parducci's sculptures definitely show the Art Deco influence of the 1920s and '30s. Most of the sculpture is concentrated on the front façade, but there are some wonderful gargoyles on the elegant lead-clad flèche (tower) over the crossing of the nave and the transept, as seen in the photograph on the facing page.

There are four pairs of beautifully carved oak doors on the front of the building. Each set of doors has a theme, with five symbols on each door, for a total of forty carved symbols. The themes include the Saints, the Virtues, the Trinity, and the Rosary.

Right: An angel marks where the cornice of the roof was before the towers were completed.

Below, left: Christ as the Good Shepherd stands in a niche located in the screen between the two towers.

Below, right: Saint Peter stands between the main doors, holding the Key to the Kingdom of Heaven and a scroll declaring, "thou hast the words of eternal life."

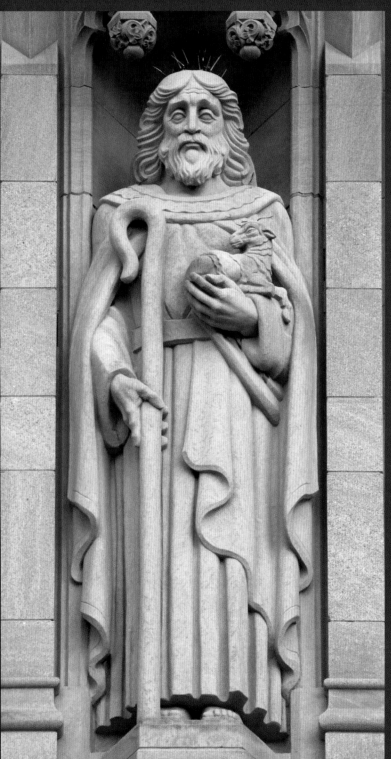

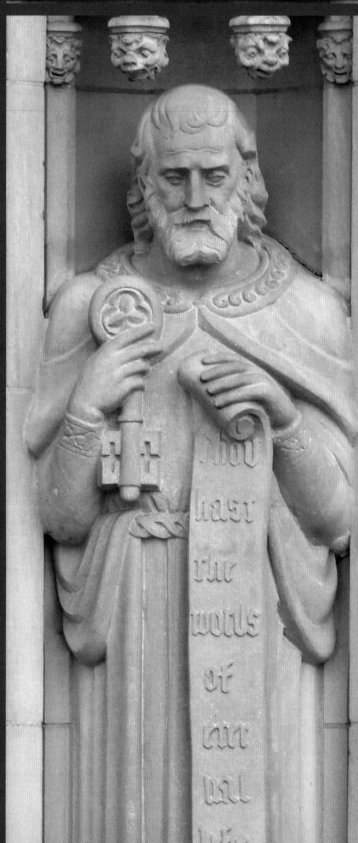

Left: One of seven shields above the main entrance. The bee represents chastity and fecundity and is a symbol of the Virgin Mary.

Below: Portraits of Saint Margaret Mary and Saint Paschal Baylon. They hold representations of their holy visions, Margaret with the heart of Christ burning with his love of humankind and Paschal with the Eucharist.

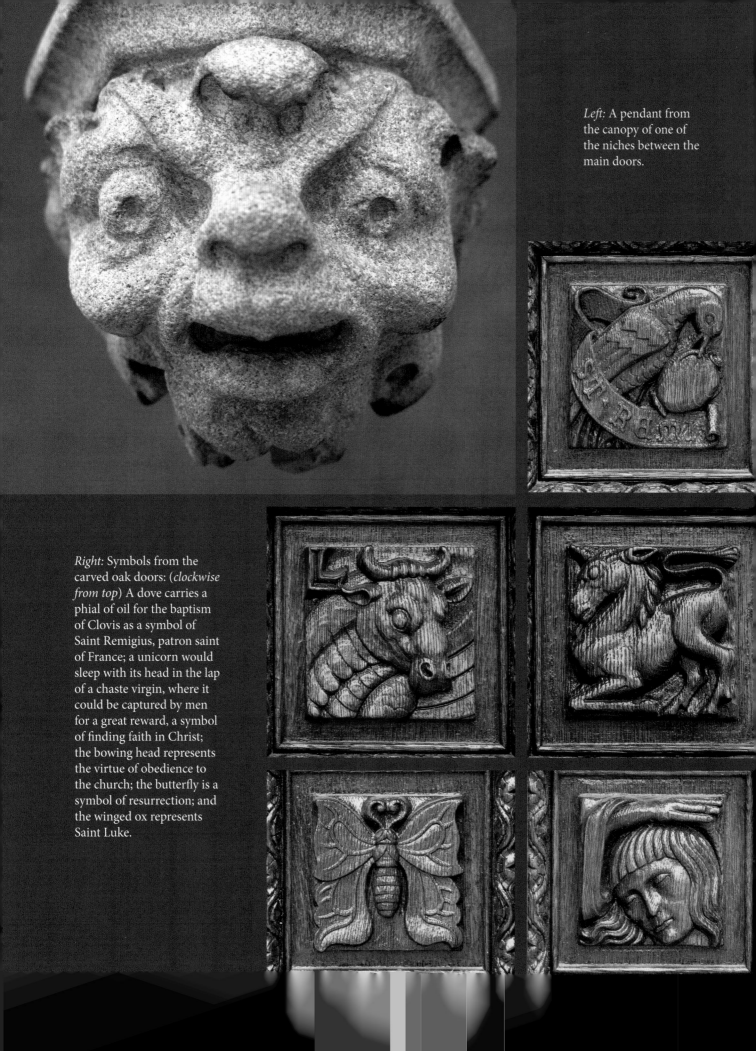

Left: A pendant from the canopy of one of the niches between the main doors.

Right: Symbols from the carved oak doors: (*clockwise from top*) A dove carries a phial of oil for the baptism of Clovis as a symbol of Saint Remigius, patron saint of France; a unicorn would sleep with its head in the lap of a chaste virgin, where it could be captured by men for a great reward, a symbol of finding faith in Christ; the bowing head represents the virtue of obedience to the church; the butterfly is a symbol of resurrection; and the winged ox represents Saint Luke.

Above: Two of the seven shields above the main entrance. The sun over the water symbolizes the Creation, and the doves eating grapes represent Communion.

Right: One of the praying angels from the bases of each of the entrance arches.

(St. Charles Lwanga Parish)

1400 Stoepel Street

Completed: 1931

Architect: Antonio DiNardo

Sculptor: Attributed to Corrado Parducci

WITH ROUND ARCHES, OFFSET tower, and outdoor pulpit, St. Cecilia Roman Catholic Church is a beautiful example of early twentieth-century Romanesque church architecture. A statue of the church's namesake stands in an attic niche on a field of star-shaped flowers over an elaborate rose window. An arched colonnade decorates the façade between the rose window and the intricately carved entrance. A notable feature of the recessed entrance is the unique faces that top two out of three of the Corinthian pilasters on either side of the doorway.

The tower is square at ground level, but near the top, four of the corners are flattened to make it octagonal. Four guardian angels, the work of Corrado Parducci,[1] stand in the spaces created, keeping a watchful eye over the surrounding community. Parducci's angels, as well as the rest of the ornamentation, are all true to the Romanesque theme of the architecture but with a definite Art Deco influence.

St. Cecilia Church is historic for more than just its architecture. In 1968, in an effort to reflect the makeup of the congregation, then-pastor Father Raymond Ellis commissioned a new fresco for the apse that depicted Jesus as a black man, surrounded by ethnically diverse angels. Painted by the church member and artist Devon Cunningham, this work was featured on the cover of *Ebony* magazine and put St. Cecilia Church squarely at the center of a national discussion regarding Jesus's ethnicity.[2]

The church is also historic among basketball fans, or rather, its gym across Chalfonte Street to the north is. During the 1967 Detroit Riot, St. Cecilia School's athletic director, Sam Washington Sr., opened up the gym so his son and other neighborhood kids had a place to go during the unrest. This was the start of the legendary Ceciliaville basketball program. During the 1970s and '80s, "the Saint," as the gym was known, was the place to prove yourself as a basketball player, not just for Detroit but for the entire state of Michigan and a good part of the Midwest. Local high school, college, and professional talent all played there in various summer leagues, including Dave Bing, Magic Johnson, George Gervin, Earl Cureton, Chris Webber, and Jalen Rose, just to name a few.

In 2013, due to decreasing membership and a shortage of priests, St. Cecilia Parish was merged with nearby St. Leo Parish to become St. Charles Lwanga Parish. Named for a nineteenth-century Ugandan Christian martyred for his faith, the combined parish offers services at both churches.

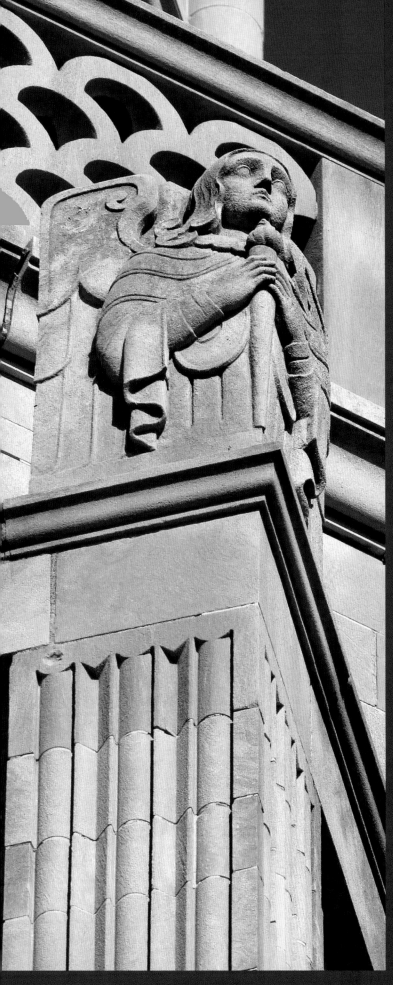

Left: One of four angels from the tower.

Above, this page and facing: Pilaster capitals feature unique faces, pairs of nightingales, and unusual bird-like creatures.

Right: A child representing innocence and the openness to accept the word of God from the entrance frieze to the left of the doorway.

Facing page, far right: An icon of the church's namesake, Saint Cecilia. As the patron saint of music, she is usually depicted holding organ pipes, as shown here, or a violin.

Below: Detail of one of the pilaster-capital faces.

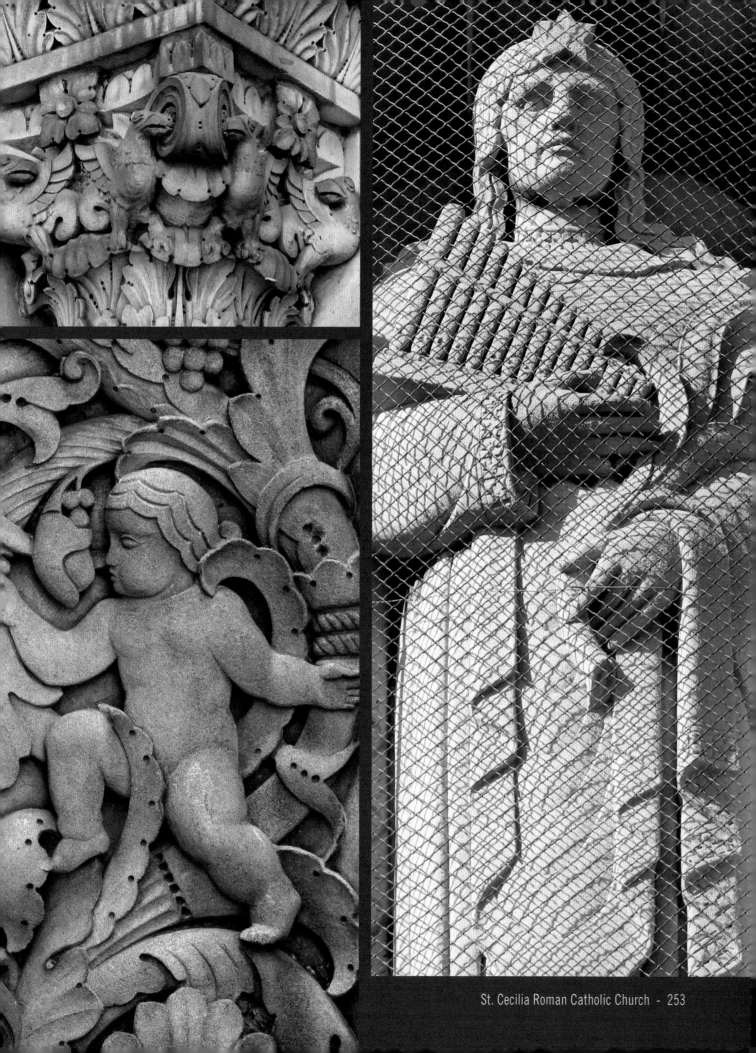

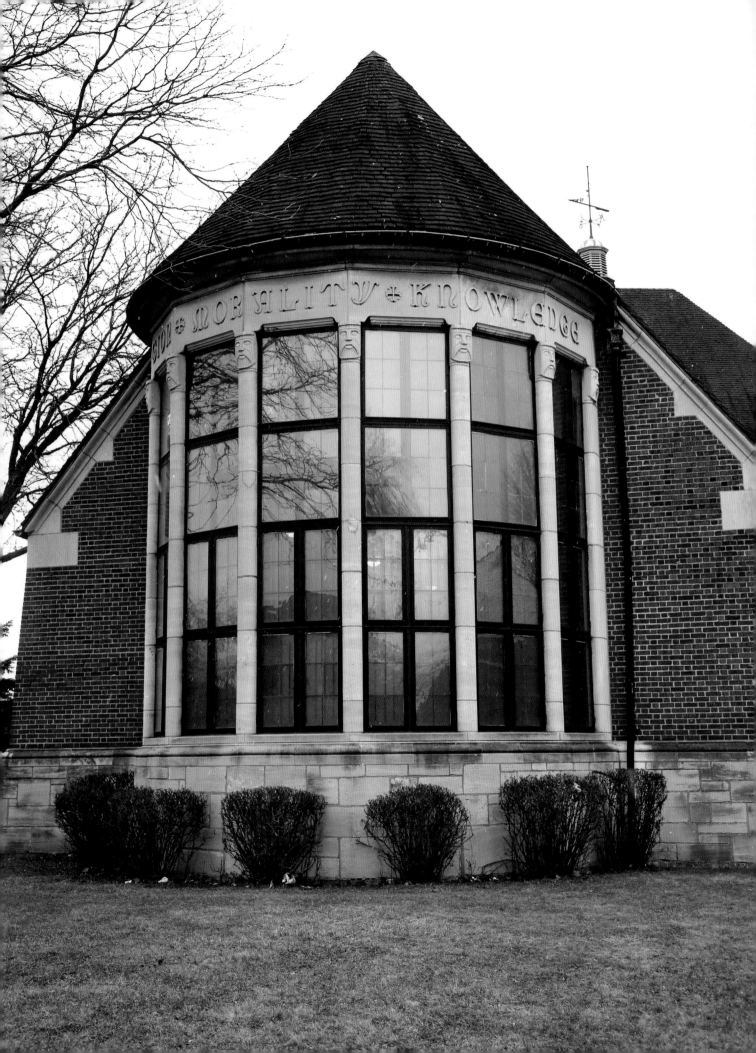

1765 Oakman Boulevard

Completed: 1931

Architect: Marcus R. Burrowes
(Burrowes and Eurich)

Sculptor: Unknown

THE FRANCIS PARKMAN BRANCH Library was designed by the Detroit architect Marcus R. Burrowes in the English Revival/Tudor style for which he was known. Burrowes also designed many large houses in Detroit and the Grosse Pointes, as well as several other libraries, including the Duffield and Richard branches in the Detroit system and the Birmingham and Redford libraries.

The Parkman Branch features a row of nine expressively whimsical faces over the Oakman Boulevard entrance, which must have been very entertaining to the many children who have visited this neighborhood library through the years. The Tudor design is carried through the interior, which has a church-like feeling, given the stone arches and vaulted ceilings with stone lion heads above the circulation desk and dark intricately carved wooden hammer beams in the main reading room. On the basis of the date of construction, stylistic elements, and the fact that Burrowes worked for and with Albert Kahn at various points in his career, it seems likely that the ornamentation was created by Corrado Parducci, but no documentation has been found.

This building is also noted as the home to the Mary Conover Room for Boys and Girls, dedicated "in recognition of the faithful and valuable services rendered by Miss Mary E. Conover, the first children's librarian in the Detroit system, and one of the

primary movers in the development of library work with children."[1] It features a large stained-glass window dedicated to the woman who helped establish one of the first children's rooms at a major public U.S. library, organized special services for children, worked closely with the public schools, and founded the Detroit Story Tellers' League in 1912. Conover put in forty years of service with the Detroit Public Library, starting as a temporary assistant in 1894 and retiring in 1934.[2]

The eighteenth (and largest) branch in the Detroit Public Library system, the Parkman was planned as a regional branch, a new concept in municipal libraries that was first tried in Chicago. The idea was to build self-contained branches at the edges of the city that relied less on the main library for books and services.[3]

This library was named after Francis Parkman, a historian from Boston, Massachusetts. His eight-volume history of the struggle between England and France for control of North America was once recognized as the definitive story of Colonial America. Recent scholarship has brought many of his assertions into question, but he was recognized as the preeminent American historian of his time.

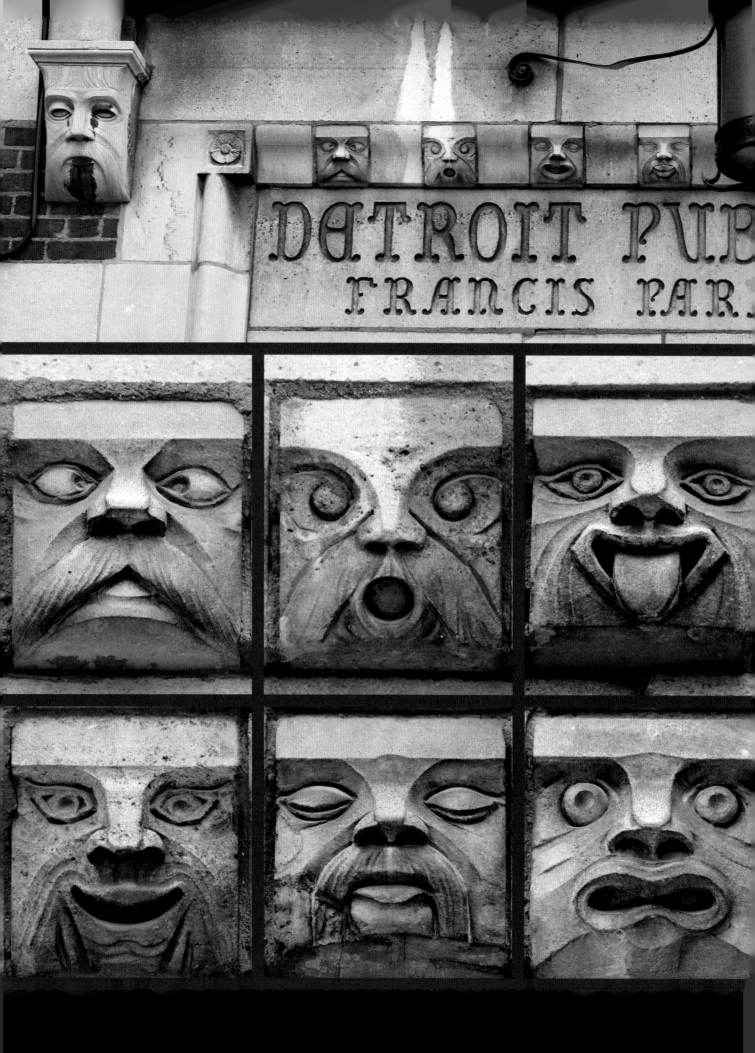

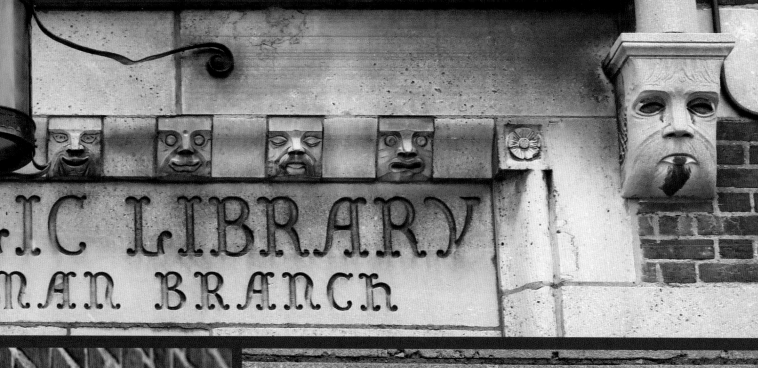

IC LIBRARY
man BRANCH

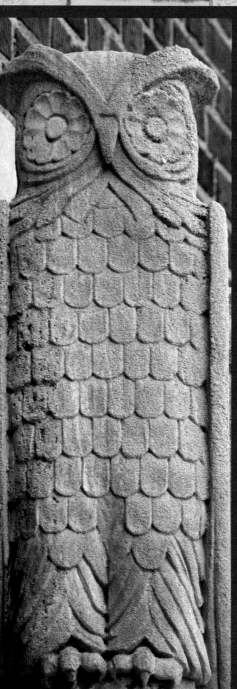

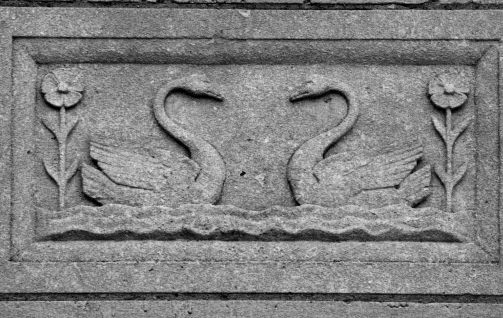

Top: A row of silly faces greets children and
other visitors from above the main entrance.

Facing page: A closer look at six of the faces.

Above: A pair of swans from a panel near the
north doors.

Left: One of the owls that guard the cornice of
the Oakman Boulevard oriel.

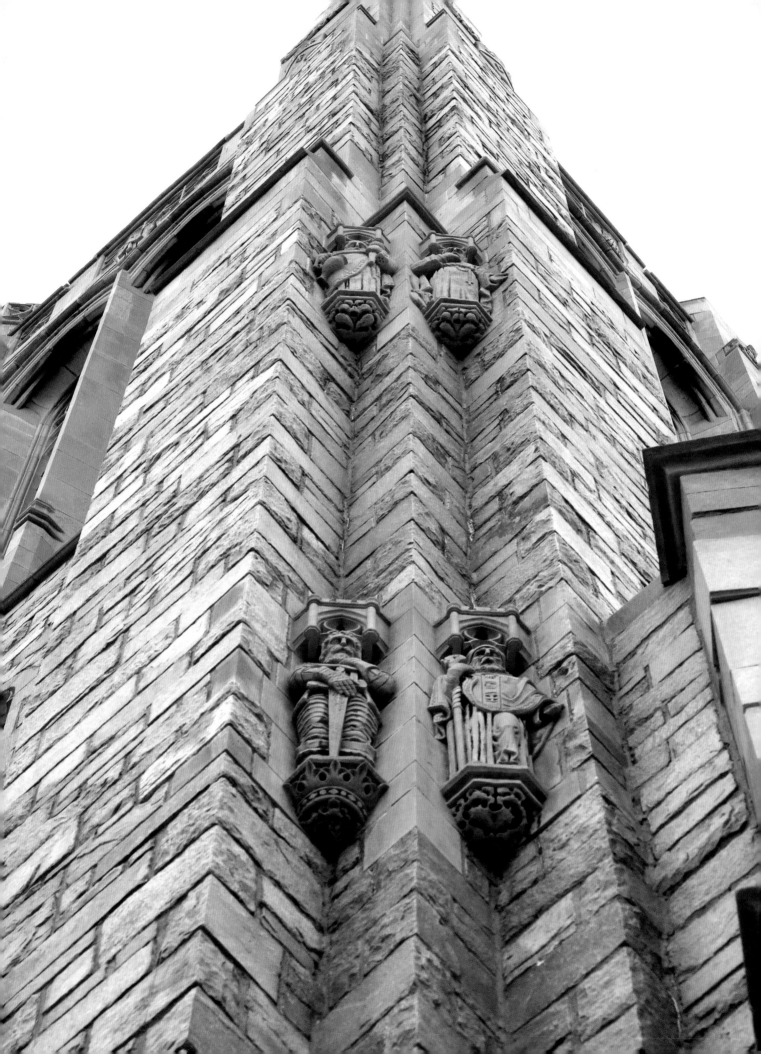

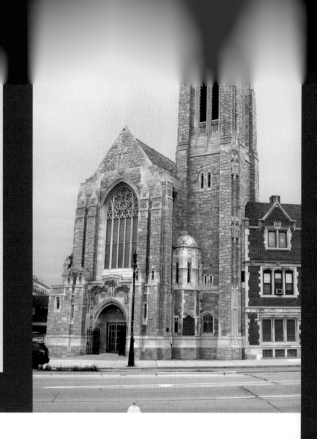

1335 Gratiot Avenue

Completed: 1931

Architects: William E. N. Hunter, Don W. Hunter, Lewis Simpson

Sculptors: Corrado Parducci, Peter Bernasconi (carver)

HISTORIC TRINITY LUTHERAN CHURCH was built with funds donated by the tobacco magnate Charles Gauss and his wife, Margaret, as a thank-you to God, "for the recovery of his daughter's health and in memory of the spiritual ministrations and Christian fellowship extended him when he came to Detroit years ago as a penniless lad of 16."[1] The Gausses, in consultation with architectural ecclesiastical experts including Rev. Dr. Gilbert Theodore Otte (Trinity's head pastor, 1928–83), Rev. F. R. Webber of Cleveland (an expert in iconography), and others, achieved their goal of building the finest liturgical architectural church in Detroit.

The church was built in a sixteenth-century pier-and-clerestory Gothic style with Plymouth seam-face granite walls, Indiana limestone trim, and a slate roof. An exterior cleaning and restoration was completed in the summer of 2000, and the effect of the colors of the varicolored granite contrasting with the pale limestone trim is very impressive.

The building features abundant sculptural ornamentation on the Gratiot Avenue façade, but one of the most striking decorative elements cannot be seen from Gratiot. The short tower on the west wall of the building features a heroic sculpture of Martin Luther. Between the windows on this wall are the initials and symbols of martyrs and confessors of the faith and the dates of their deaths.

The piers on either side of the front door have niches with lead statues of the four Evangelists. Lead was used for these statues as a test by the architect to see if they would hold up better over time than stone. Within the doorway arch are bas-reliefs of the Prodigal Son, the Woman of Canaan, and an early Christian congregation. A relief of Aaron, Moses, and Hur praying for Israel's victory as well as sculptures of Isaiah and Saint Paul are above the arch.

Four portraits of historic "Fighters for the Faith" are carved in niches on the corner of the bell tower. They include Gideon, Saint Boniface, King Gustavus Adolphus of Sweden, and Saint Athanasius.

The inside of the church is richly decorated with over 300 figures from the Bible and Christian history, including 60 in stone, 65 in wood, 140 in stained glass, 9 in metals, and 34 paintings. It is also home to the Dau Library, where much of the research for this book took place.

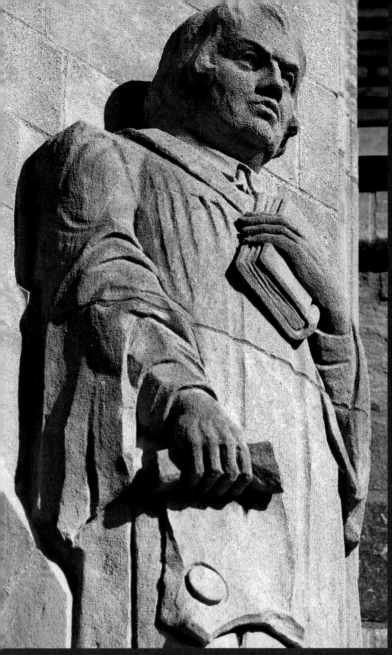

Above: Martin Luther holds his Ninety-Five Theses while preparing to throw his papal bull of excommunication into the flames at Leipzig.

Below: Wartburg Castle, where Luther translated the Bible.

Facing page, top right: A Pelican tears her breast open to feed her children with her blood, bringing them back to life, a powerful symbol of Christianity.

Facing page, bottom right: Over the main-entrance arch, Aaron, Moses, and Hur pray for the victory of Israel.

Right: King Gustavus Adolphus of Sweden, leader of European Protestants during the Thirty Years' War, and Saint Athanasius, bishop of Alexandria and defender of the Trinity against the Arian Heresy.

Below: Lead statues of Saint John and Saint Luke.

Bottom right: Early Christians enter their church, blessed by the gilded hand of God.

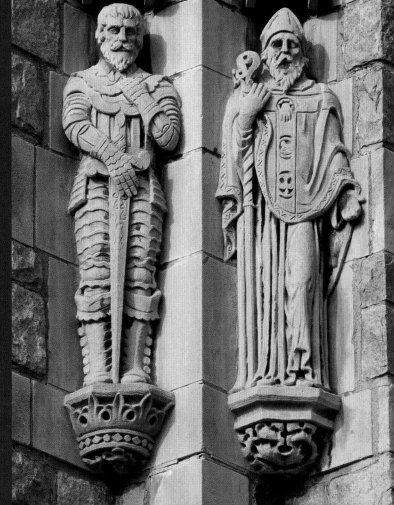

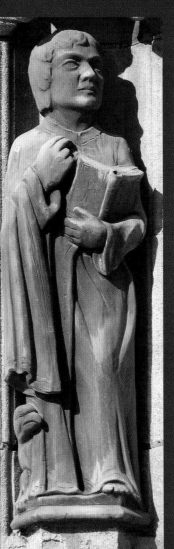

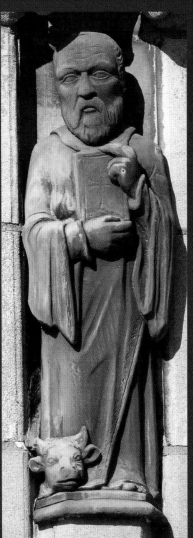

Historic Trinity Lutheran Church - 261

THE LAND ON WHICH the Downtown Library was built has a storied and historic past. The first Detroit City Jail was built here in 1817, and this jail is remembered, among other things, as the site of the Blackburn Rescue and Riots.

Thornton and Ruthie (Lucie) Blackburn escaped slavery in Kentucky and had been living in Detroit for two years when they were arrested, tried, and convicted under the Fugitive Slave Act in 1833. Civil unrest ensued, and the Blackburns were helped to escape and flee to Canada. They were aided by activists who later founded the Second Baptist Church Underground Railroad Station in Detroit. British officials refused extradition of the couple, and this led to the establishment of Canada as the terminus of the Underground Railroad.[1]

The City Jail was also the site of an 1835 jail-break in which all of the inmates escaped, as well as more civil unrest in 1840 over the arrest of an escaped slave named Henry, and the last public execution in Detroit, when Stephen G. Simmons was hanged for killing his pregnant wife in a drunken rage.[2] The jail was razed in 1848, replaced by a new building a few blocks away, and the site became a city park.

In 1872, the library board was given a lease on the land, and after some legal wrangling over the site and considerable controversy over plans that some people found extravagant, Detroit's first purpose-built library was dedicated in 1877. It was a beautiful building inside and out, but it was quickly outgrown by the rapidly expanding city, despite additions in 1885 and 1886. It was replaced by the current Main Library (page 84) in 1921 but continued on as the Center Park Branch Library until 1931, when it was deemed outdated, torn down, and replaced with the building we see on the site today.

Designed in a classically based Art Deco style, the library features inscriptions just below the cornice, including "The Fountain of Wisdom Flows through Books" and "The Wealth of the Mind Is the Only Wealth." There are also Corrado Parducci–designed allegories of printing and publishing and of research and writing as well as winged representations of commerce and the arts, all featuring the clean lines and angular rhythmic shapes characteristic of Art Deco design.

This building closed in 1998 to prepare for the implosion of the nearby Hudson's Building. It was expected to reopen in 1999, but it stayed closed until the end of 2003. During this time, it underwent extensive remodeling, much of which was paid for by a donation from the Skillman Foundation, leading to the branch being renamed as the Rose and Robert Skillman Branch of the Detroit Public Library. The library was closed again in January 2018, following a burst water pipe, which caused some damage to the building and its collections. Current expectations are that the building will not remain closed for very long.

The Skillman Library houses the National Automotive History Collection, "the nation's premier public automotive archive documenting the history and development of the automobile,"[3] and is also home to the *History of Detroit Renaissance* mural, painted by Kwasi Asante in 1981.

A historic statue of Abraham Lincoln, created by Alfonso Pelzer, stands in Library Park, just north of the building. Given to Henry Leland, the president of the Lincoln Motor Company, in 1915, it was donated to the city in 1957. The original statue was made of two-ounce sheet bronze and was twice damaged by vandals rocking it from its pedestal, once in 1969 and again in 1997. It was replaced with a more durable bronze casting, and the original was restored and is now in the Burton Reading Room at the Main Library.

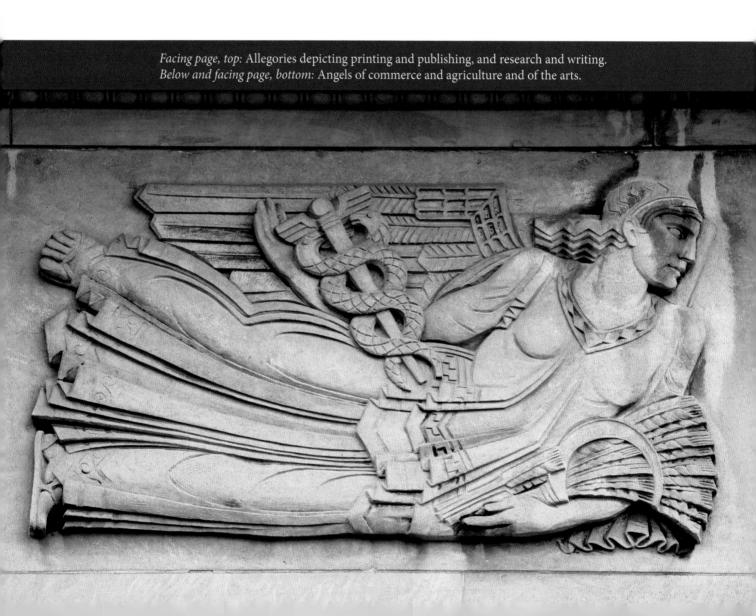

Facing page, top: Allegories depicting printing and publishing, and research and writing.
Below and facing page, bottom: Angels of commerce and agriculture and of the arts.

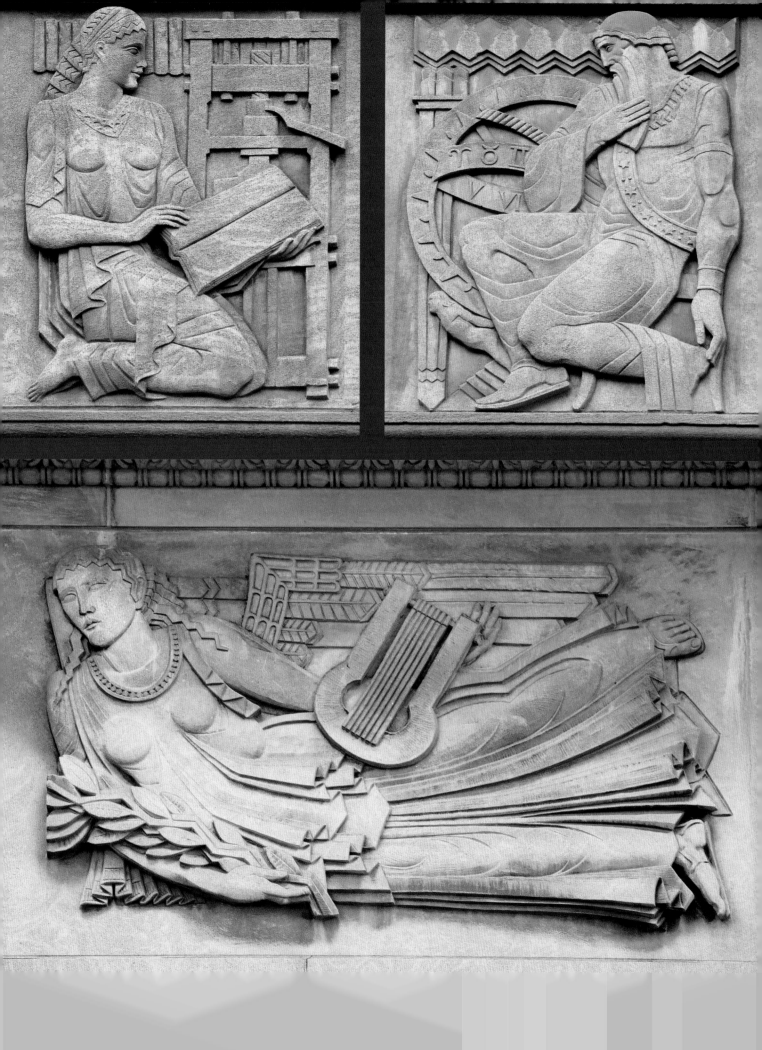

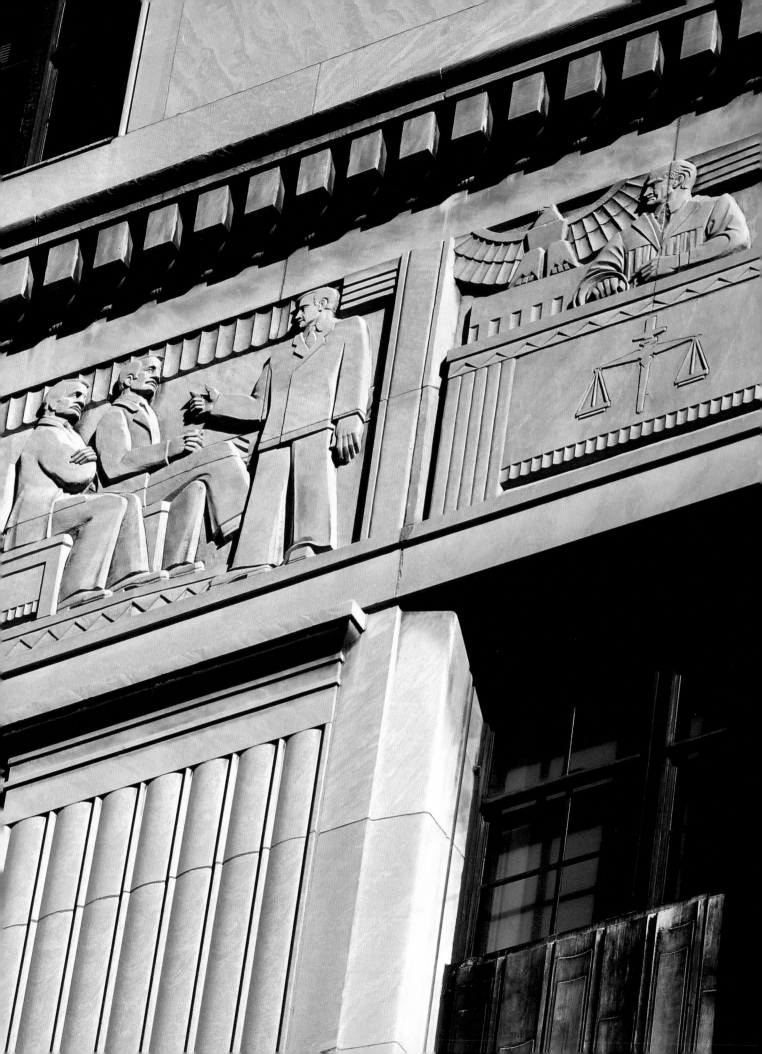

(Theodore J. Levin U.S. Courthouse)

231 West Lafayette Boulevard

Completed: 1934

Architect: Robert O. Derrick

Sculptor: Corrado Parducci

THE OLD POST OFFICE and Federal Building was completed in 1897, when the population of Detroit was around 280,000. By 1930, Detroit's population had grown to over one and a half million, and the grand old Romanesque Revival castle, thought to be extravagantly oversized when built, was woefully inadequate. The federal government's plan was to build a new office building nearby to relieve some of the pressure and then possibly to update the existing structure. Detroit would have none of that.

A delegation of politicians and prominent businessmen went to Washington, DC, to convince Secretary of the Treasury Andrew W. Mellon that instead of a "makeshift" solution, Detroit needed and deserved a completely new structure, large enough to provide room for all federal departments under one roof.[1] After a few months of discussion, the decision was made, and Robert O. Derrick, best known for designing the Henry Ford Museum, was hired to draw up plans.

The grand Old Federal Building would be torn down, and in its place, Derrick promised "a structure of great utility to the city and state, and one of which the citizens will always be proud, because of its architectural beauty."[2] He created a solid, ten-story Art Moderne / Art Deco block of a building, whose stern governmental presence is somewhat relieved by Corrado Parducci's elegant friezes representing various government activities. Ornamentation also includes carvings of the official seals of many of the forty-four different government departments that originally occupied the building.

Seven of the courtrooms in the building are historic, including the "Million Dollar Courtroom," the only part of the Old Federal Building that was preserved. Built to impress all those who entered its confines with the power and glory of justice, the courtroom features walls of solid marble from all around the United States, inset medallions of Mexican onyx, friezes featuring thirty-six unique lion heads topping each wall, and intricately carved wood throughout, including a judge's bench of East Indian mahogany.[3] Before the old building was razed, the courtroom was "painstakingly taken apart, the various sections photographed, lettered, numbered and stored in 150 barrels in the temporary Post office headquarters. Blueprints of the old room and its decorations and friezes were drawn up and [were] used in the reassembly."[4]

Today, the building provides courtrooms, chambers, and offices for the United States District Court for the Eastern District of Michigan and supporting federal agencies. It is currently in the midst of a four-year, $140 million renovation.

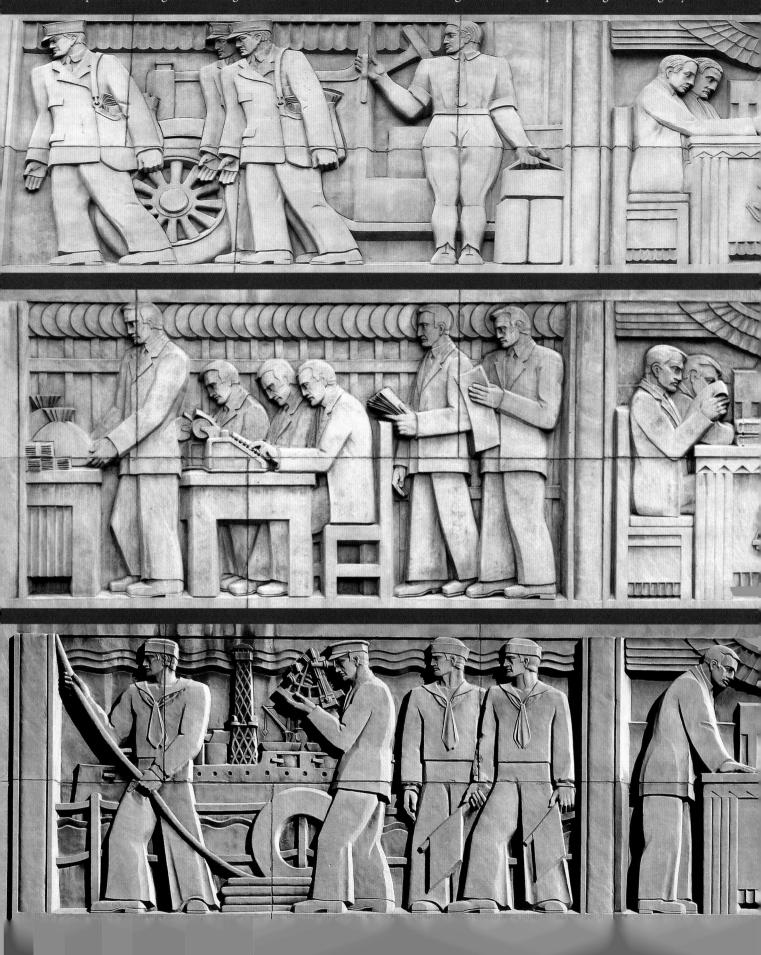

Below: Three of the eight elaborate friezes at each of the building's corners between the sixth and seventh floors. They show activities of the Postal Service, the Treasury, and the Navy. The model for the Postal Service frieze was cast backward, as shown by the uniform coats in the left panel buttoning on the wrong side and the Postal Service seal and the eagle in the middle panel facing the wrong way.

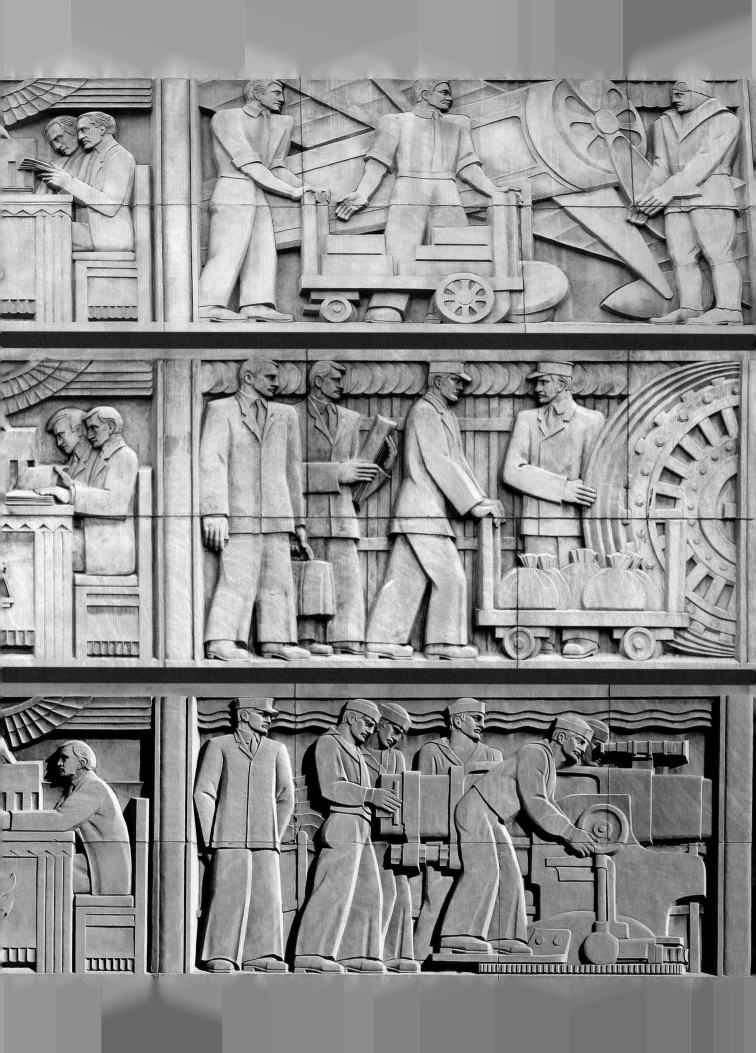

Top row: Brass light fixtures from the ceiling and walls of the north entrance portico. A man sowing seeds represents agriculture, a blindfolded woman holding scales symbolizes impartial justice, a female warrior with shield and sword stands for homeland defense, and the Roman god Mercury with his winged helmet and caduceus is an often-used symbol of commerce.

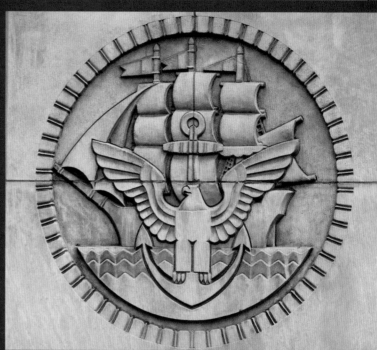

Middle row: Seals of the Postal Service (facing the right way), the Army, the Department of Commerce, and the Navy.

Bottom row: A medallion depicting a personification of Liberty and one of the large eagles that surmount the pillars and pilasters of the north and south porticos.

MAYAN REVIVAL ARCHITECTURE WAS popular in Detroit starting in the mid-1920s and continuing on into the '30s, as exemplified by the Fisher Theatre (page 198) and the Vanity Ballroom, both of which opened in 1929. Some commercial retail buildings followed this trend, most notably buildings occupied around 1935–36 by neighborhood branches of the D. J. Healy Shops.

Daniel J. Healy was an innovative retailer who came to Detroit from Ireland by way of Toronto. In 1882, at age nineteen, Healy and his partner, Mary Kennedy, opened a small (eight feet wide) ostrich-plume cleaning and curling shop on Woodward Avenue. Healy and Kennedy later married and had eight children together. When ostrich plumes fell out of style, they turned to selling perfume, art, and accessories, eventually adding men's and women's fashions and home furnishings.

The D. J. Healy Shops was a department store with a difference. It was run, as the name implies, like a collection of shops under one roof. The main store was a six-story building at 1426 Woodward Avenue. Healy's was one of the first department stores to open branches in Detroit neighborhoods and the near suburbs, with up to nine different locations open at one time. Several of these branches were in buildings featuring intricate brickwork and elaborate Mayan Revival sculpture.

One of the branch stores opened in 1940 on 14400 East Jefferson Avenue at Chalmers Street.[1] Most of the brickwork is still intact, although the molded-concrete heads along the cornice have deteriorated, as the far-left picture on the facing page shows. This edifice has most recently housed a building-supply and hardware store.

The D. J. Healy Shops branch that opened in 1936 at the corner of McNichols Road and San Juan Street[2] had similar brickwork and some of the same ornate trim, but what is really striking about this building is the colorful pressed-concrete Mayan faces over the entrance and along the roof line. A detail image is on the right side of the facing page. As the picture at the top of this page shows, this building is now a liquor and grocery store.

There are three other buildings similar to this one around Detroit. One, apparently abandoned, is on McNichols just east of Second Avenue. Another is in southwest Detroit at 7649 Vernor Highway, just east of Central Avenue, and houses a market and a hair salon. The third is at 10654 Grand River, not too far from Southfield Road. The faces on the Grand River building are different, but much of the ornamentation is the same. Unfortunately, the colorful pressed concrete has been painted over in white and blue. This building is currently home to a florist, a small Baptist church, and a salon.

BEAVER

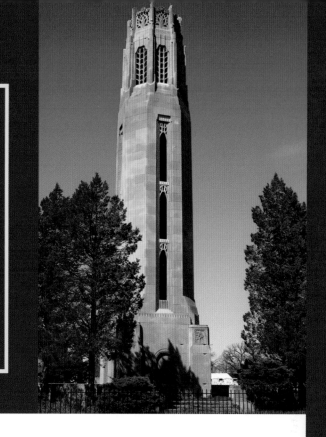

Belle Isle, just west of Conservatory grounds

Completed: 1940

Architect: Clarence E. Day (Harley, Ellington & Day)

Sculptors: Charles Beaver Edwards (Nancy Brown portrait), unknown (stonework)

THE STORY OF THE Nancy Brown Peace Carillon is actually the story of two very interesting people. The first person is the tower's namesake. Nancy Brown was a pseudonym for the author of the extremely popular column "Experience," published in the *Detroit News* from 1919 to 1942. Her true identity was kept a closely guarded secret, although it was said that she liked to mingle anonymously with the crowds that attended the parties and religious services she promoted. And these were very large crowds indeed, with thirty thousand to fifty thousand or more people attending sunrise religious services on Belle Isle or stopping by the Detroit Institute of Arts to see an art show she mentioned in her column.

The idea to erect a Peace Carillon dedicated to Nancy Brown came from her readers and was entirely paid for through their donations, at no expense to the city of Detroit. It was at the tower's dedication, during the seventh annual Sunrise Service, attended by more than fifty thousand of her readers, that Nancy Brown's true identity was finally revealed to her adoring public. She spoke to the crowd that day, thanking them for all they had done to make the Peace Carillon possible.

Annie Louise "Nancy" Brown was born in Perry, Maine, on December 11, 1870. She graduated from Mount Holyoke College in 1892 and taught school in Vermont, Connecticut, and Mount Clemens, Michigan. While living in Mount Clemens, she met and married James Edward Leslie and moved with him to Pittsburgh, Pennsylvania. Leslie died in 1817, and Brown eventually moved back to Michigan. She applied for work at the *Detroit News* when the paper happened to be looking for someone to write a "women's column," and the rest is history.

A special surprise awaited Brown at the tower's dedication ceremony. Bronze doors donated by the *Detroit News* were unveiled, and in the center of one was a portrait created by the second person mentioned at the beginning of this chapter, the Detroit sculptor Charles Beaver Edwards.

Born in 1900, Edwards grew up in Detroit studying art and music, and it seemed at one point that he might pursue a career as a violinist. He chose sculpture instead, and it was while attending art school in Paris that he was inspired by the sight of disfigured World War I veterans hiding their faces with veils to use his artistic talent to create restorative prosthetics.

Edwards was a prolific artist and member of the Scarab Club, where he had a studio for many years. He is not primarily remembered as an architectural sculptor, although he was at one time associated

with Detroit Decorator Supply Company. He regularly entered Scarab Club shows, and his work was well known in the artistic community. Several of his larger bronzes can be seen today at White Chapel Cemetery in Troy.

Edwards also taught for many years at Wayne University (now Wayne State University), first teaching sculpture at the College of Mortuary Science and later teaching restorative prosthetics at the medical school. Edwards was especially busy during and after World War II and was very well known in Detroit and nationally for his work creating artificial limbs, especially hands. It can even be said that he wrote the book on the subject: *Beyond Plastic Surgery*, published by Wayne State University Press in 1972. Edwards retired from teaching in 1975 and died in 1986.

It is not known who created the rest of the sculpture on the carillon. There are wonderful Art Deco flourishes at the top of the Neo-Gothic tower, as well as a series of eight relief panels depicting peaceful pursuits at the four corners of the base. At least there were eight originally. One has been missing for many years and remains unaccounted for. There are also two inscribed quotations. The first, from Abraham Lincoln, is located over the west door and reads, "A just and lasting peace among ourselves and with all nations." The other, "As on the Sea of Galilee the Christ is whispering peace," is from the Quaker poet John Greenleaf Whittier and is located over the east door.

The carillon mechanism stopped working in 1970, after the stained-glass windows protecting it from the elements were broken by vandals, and it fell victim to neglect and pigeon damage. Fortunately, a new mechanism was installed in 1977, and the chimes still ring out today. The immediate grounds of the tower, protected like the Livingstone Light (page 240) by a wrought-iron fence of more recent vintage, are overgrown and in need of restoration.

Facing page: A pigeon stands in for a dove of peace atop the carillon dedicated to *Detroit News* columnist Nancy Brown.

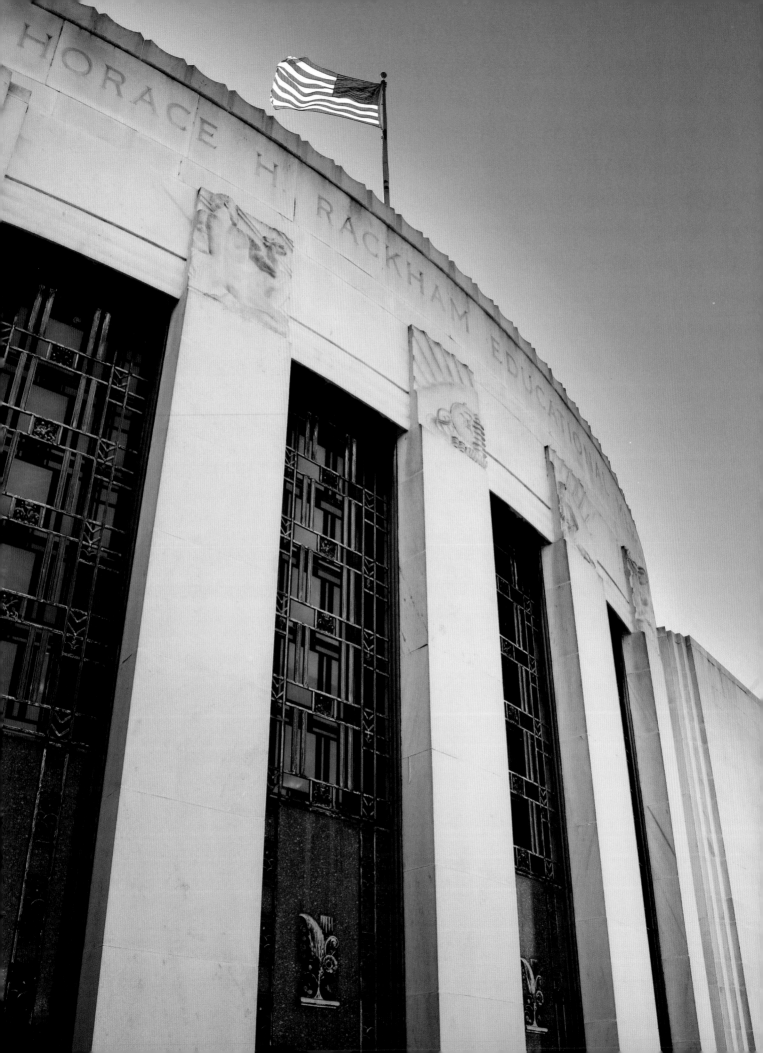

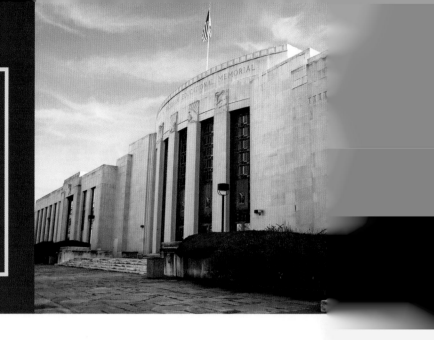

106 Farnsworth Street

Completed: 1941

Architect: Harley, Ellington & Day

Sculptor: Marshall Fredericks

THE HORACE H. RACKHAM Educational Memorial is a testament to, among other things, good fortune and vision: the good fortune of living near young Henry Ford and the vision to ignore those who warned against investing in something as "frivolous" as the horseless carriage.

Horace H. Rackham was a hard-working young lawyer who grew up poor on a Macomb County farm. In 1903, he sold property and borrowed funds to purchase $5,000 worth of stock (one hundred shares) in his neighbor Henry Ford's new motor-car company. Sixteen years later, that investment had paid off to the tune of approximately $16.5 million, the equivalent of about $240 million in 2018 dollars.

Rackham soon retired from practicing law and spent the rest of his life working to find worthwhile ways to give away his fortune. He donated property and time to help found the Detroit Zoo, gave generously to the University of Michigan, provided unsecured loans to students in need, and donated regularly to charities, always on condition of anonymity. He invested conservatively and so was mostly unaffected by the crash of 1929. When he died in 1933, he left more than $20 million to establish a foundation to benefit humankind.[1]

The Horace H. Rackham Educational Memorial was built with funding from that foundation to house the Engineering Society of Detroit and the University of Michigan Extension Service. Each had its own section of the building, joined in the middle by a shared one-thousand-seat auditorium. Both the Engineering Society and the University of Michigan eventually left, and the building is now leased to Wayne State University.

The long, low, white marble building across Farnsworth Street from the Detroit Institute of Arts features an integrated program of architectural sculpture created by Marshall M. Fredericks. He is best known for his *Spirit of Detroit* statue outside the Coleman A. Young Municipal Center, but his sculptures can also be found locally at the Detroit Zoo, Belle Isle, the Cranbrook Educational Community in Bloomfield Hills, and elsewhere throughout the area.

Fredericks was born in Rock Island, Illinois, in 1908 and grew up in Cleveland, Ohio, where he graduated from the Cleveland School of Art in 1930. He studied in Sweden with Carl Milles and traveled extensively in Europe and North Africa. Fredericks returned to the United States in 1932 to teach with Carl Milles at Cranbrook, leaving to enlist in the armed forces in 1942. After the war, he worked continuously. It was said in his obituary that he worked in his Royal Oak studio through the week before his death on April 4, 1998.[2] Fredericks left a legacy that includes works in more than 150 locations in seventeen states and eight countries, as well as a museum dedicated to his art at Saginaw Valley State University. His work is known for its spiritual intensity as well as its whimsical good humor.

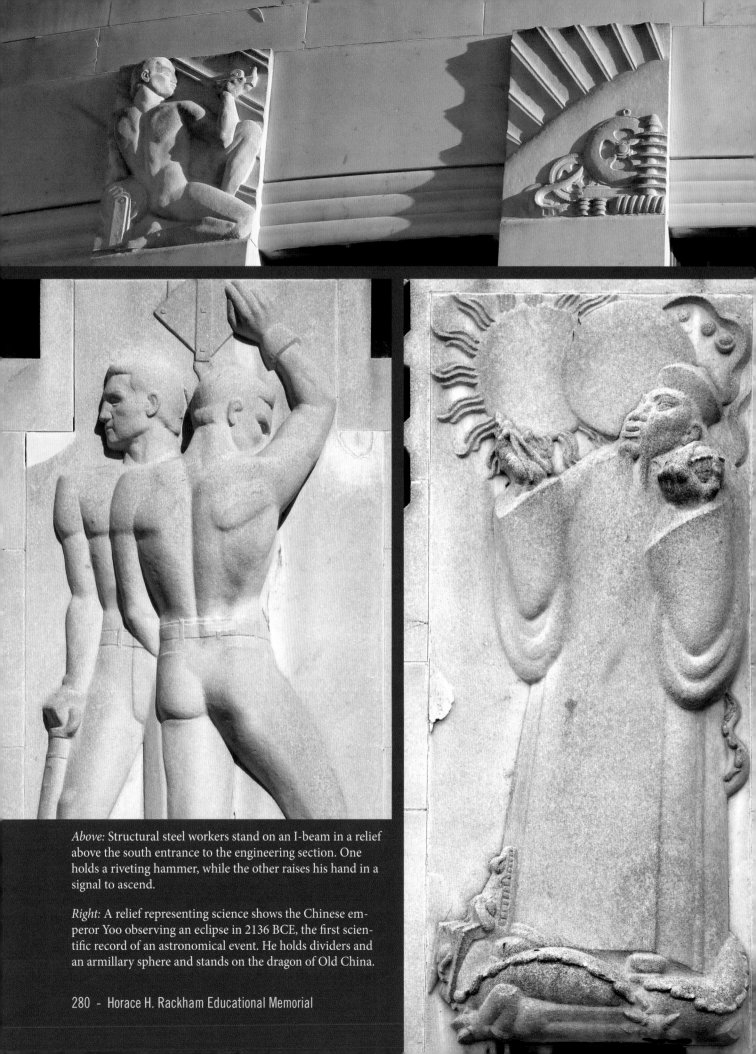

Above: Structural steel workers stand on an I-beam in a relief above the south entrance to the engineering section. One holds a riveting hammer, while the other raises his hand in a signal to ascend.

Right: A relief representing science shows the Chinese emperor Yoo observing an eclipse in 2136 BCE, the first scientific record of an astronomical event. He holds dividers and an armillary sphere and stands on the dragon of Old China.

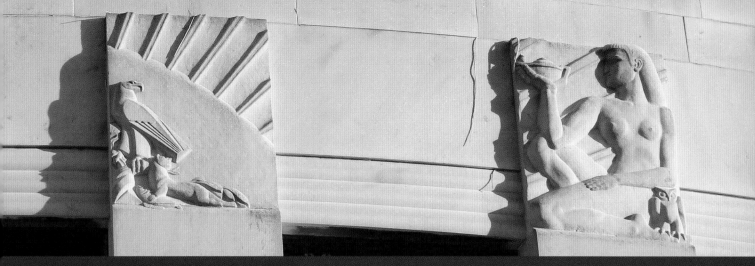

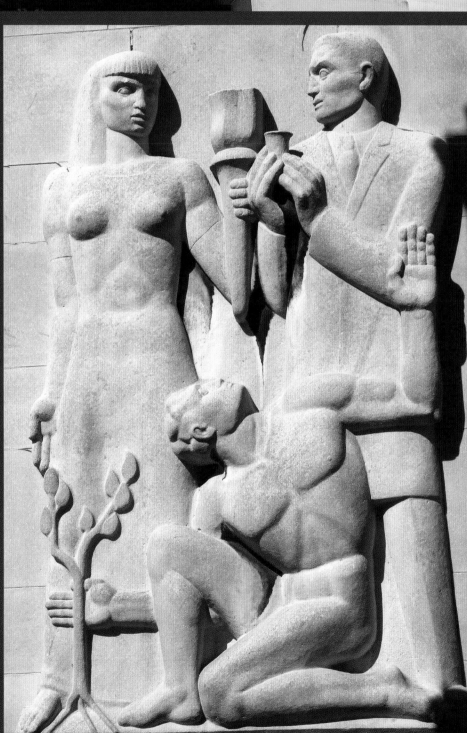

Above, this page and facing: Sculptures at the heads of the pylons that divide the façade of the central auditorium. The relief at the far left shows a figure representing engineering. The calipers in his left hand and the dynamo at lower left represent precision and power. In the next panel, technological objects emerge from the sun. The third panel shows natural forms of life and experience, and the far right panel shows education accompanied by the owl of wisdom, holding high the lamp of knowledge. All four panels are visually united by the rays of the sun of universal knowledge.

Right: This sculpture can only be seen from the top level of the parking structure built next to the south wall of the Rackham building. The foreground figure represents humankind, grasping the tree of life in one hand while the other reaches for knowledge. Figures representing education and science stand behind him.

Below: "Education," from the north entrance to the west wing of the building.

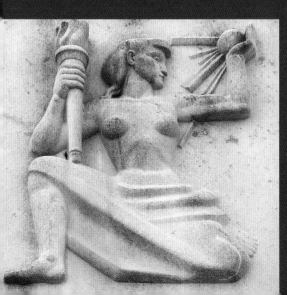

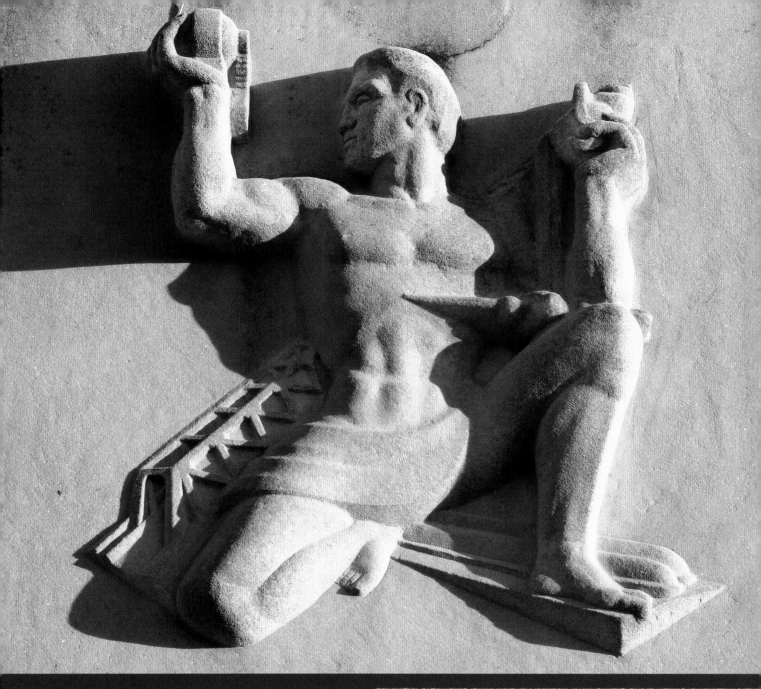

Above: This figure of engineering is reminiscent of Marshall Fredericks's most famous local sculpture, *The Spirit of Detroit*. He represents every branch of engineering, holding aloft a dynamo in his right hand and a symbol of metallurgy in his left. The design also includes an airplane, a streamlined train, and a trestle bridge.

Right: A bronze relief near the door to the east wing of the building represents precision automotive engineering.

Facing page: This relief symbolizes the ancient dream of flight, made possible through modern aeronautical engineering. Another sculpture that is rarely seen by the general public, it is located above a door that can only be reached through the parking structure.

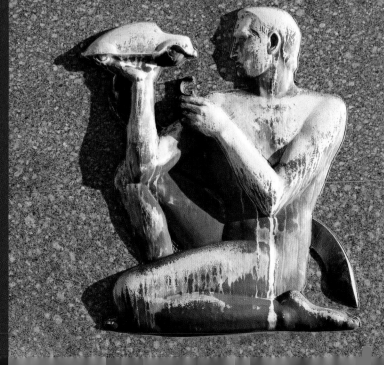

B ESIDES THE ARCHITECTURAL SCULPTURE on the buildings already featured in this book, there are hundreds of faces, figures, angels, and demons watching over the people of the city of Detroit. Some are hidden in nooks and crannies, some are high above street level, some are small and easily missed, and some are right in plain sight but generally ignored by the people who pass them on a daily basis, but all of them have their own purpose and personality.

In an effort to be as comprehensive as possible, the following pages show sculpture from throughout the city, taken from buildings that were not featured elsewhere in this book. Most come from structures that do not have much in the way of architectural sculpture on them or from buildings that do not have much variation in the sculpture they do have.

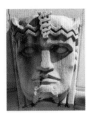

The Albert (Griswold Building), 1929

1214 Griswold Street. Architect: Albert Kahn. Sculptor: Attributed to Corrado Parducci.

Archdiocese of Detroit Chancery, New (Chamber of Commerce Building, Detroit Savings Bank), 1895

The tympanum over the Gratiot Avenue entrance to the Archdiocese of Detroit Chancery holds a fiberglass sculpture created in 2016. In it, the Christ child stands on a Bible, while his grandmother Saint Anne, patron saint of Detroit, and his mother, Mary, look on. Mary, in her role as "the new Eve," has her foot on a serpent. A trillium on Jesus's chest and apple branches above represent Michigan. The features of the angels reflect African American ethnicity, in recognition of the majority population of Detroit.

1212 Griswold Street. Architect: Spier & Rohns. Sculptors: Sergei Mitrofanov, Michael Kapetan.

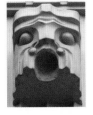

Argonaut Building (A. Alfred Taubman Center for Design Education), 1930

This building was built to house General Motors Corporation Laboratories, which had outgrown its space in the recently completed annex to the General Motors headquarters building across the street. It was donated by General Motors to the College for Creative Studies in 2007.

485 West Milwaukee Avenue. Architect: Albert Kahn. Sculptor: Attributed to Corrado Parducci.

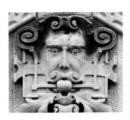

Blenheim Building, 1909

An unusual face meets the gaze of all who enter the Blenheim Building. There is not a lot of information available about this building, and there have been some questions about its date of construction and original purpose. This is possibly settled by a classified ad in the September 5, 1909, *Detroit Free Press* touting new downtown apartments in the Blenheim at the corner of Park and Columbia Streets.

2218 Park Avenue. Architect: Unknown. Sculptor: Unknown.

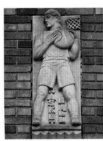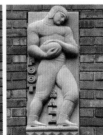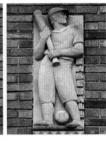

Blessed Sacrament Center, circa 1930

These athletic figures are from the Blessed Sacrament Center, a parish hall built behind the Cathedral of the Most Blessed Sacrament on Woodward Avenue.

150 Belmont Street. Architect: Unknown. Sculptor: Attributed to Corrado Parducci.

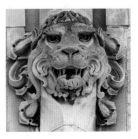

Boulevard Temple Methodist Episcopal Church/School/ Apartments, 1926

2567 West Grand Boulevard. Architect: Ivan Dise. Sculptor: Unknown.

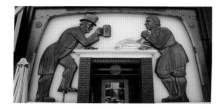

Brass Rail Restaurant, 1937

These figures, carved by Joachim Jungwirth, currently adorn the front of Kruse and Muer on Main, in Rochester, Michigan, but they were created for the Brass Rail Restaurant in downtown Detroit.

116 Michigan Avenue, Detroit (now at 327 South Main Street, Rochester). Architect: Ted Rogvoy. Sculptor: Joachim Jungwirth.

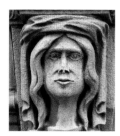

Carlton Plaza Hotel, 1924

The Carlton Plaza Hotel was one of the foremost performance venues for African American Detroiters to see jazz greats during the 1920s and '30s. This sculpture disappeared from the building in the 1990s but was sold back to the new owners when the building was redeveloped as condominiums in 2005.

2915 John R Street. Architect: Louis Kamper. Sculptor: Unknown.

La Casa de la Habana

This is one of several lion mosaics at La Casa de la Habana.

1502 Randolph Street. Architect: Unknown. Artist: Unknown.

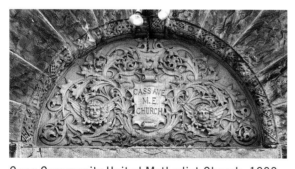

Cass Community United Methodist Church, 1892

The tympanum of this tower doorway is intricately decorated in a style very similar to the sculptor Alfred F. Nygard's work on Wayne State University's Old Main (page 46), a few blocks to the north.

3901 Cass Avenue. Architect: Malcomson & Higginbotham. Sculptor: Unknown.

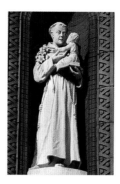

Cathedral of St. Anthony, Ecumenical Catholic Church of Christ (St. Anthony Roman Catholic Church), 1902

Saint Anthony holds the infant Christ and a book of Psalms. The book was stolen from him and then returned. Saint Anthony is the patron saint of lost articles.

5247 Sheridan Street. Architect: Donaldson & Meier. Sculptor: Unknown.

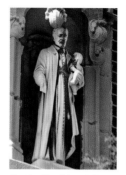 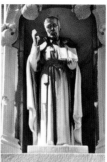

Catholic Charities Building (Westminster Presbyterian Church), 1920

This building has two niches that hold saints representative of the charitable mission of those who work inside. On one side stands Saint Vincent de Paul, patron saint of charities and the poor. The other niche holds Saint Camillus, patron of the sick, doctors, nurses, and hospitals.

9851 Hamilton Avenue. Architect: George M. Lindsey Company. Sculptor: Unknown.

 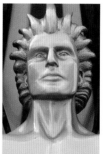

Centaur Bar (Iodent Building), 1923

This is a modern example of sculpture on a building representing the business inside. Built as offices and later purchased by the Iodent Chemical Company, this building once housed a toothpaste factory.

2233 Park Avenue. Architect: Unknown. Sculptor: Unknown.

Charles H. Wright Museum of African American History, 1997

This stylized African mask graces the entrance to the third home of the Museum of African American History. Founded by Dr. Charles H. Wright, a Detroit obstetrician and gynecologist, in 1965, the museum is home to over thirty-five thousand artifacts and archival materials. These materials include the Blanche Coggin Underground Railroad Collection, the Harriet Tubman Museum Collection, the Coleman A. Young Collection, and the Sheffield Collection

315 East Warren Avenue. Architect: Sims-Varner & Associates. Sculptor: Richard Bennett.

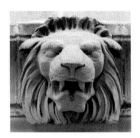

Comerica Bank (Detroit Trust Company Building), 1915

201 West Fort Street. Architect: Albert Kahn. Sculptor: Unknown.

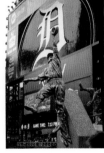

Comerica Park, 2000

2100 Woodward Avenue. Architect: Populous (formerly HOK Sport). Sculptors: Michael Keropian (tiger statues), Julia Rotblatt Amrany and Omri Amrany with cosculptors Gary Tillery and Lou Cella (Walk of Fame player statues)

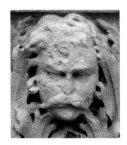

The Coronado Apartments, 1894

3751–73 Second Avenue. Architect: William S. Joy. Sculptor: Unknown (similar to the work of Alfred F. Nygard).

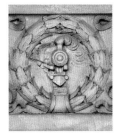

CPA Building, 1923

This locomotive is found above the entrance to the CPA Building. What does a train have to do with CPAs? Well in this case, CPA stands for Conductors Protective Association, a sort of trade union for railroad conductors.

2238 Michigan Avenue. Architect: Elvin E. Harley. Sculptor: Unknown.

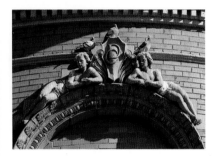

Detroit Club, 1891

Pigeons can be a problem, something that shows up especially well on the red terra-cotta figures over this Detroit Club window.

712 Cass Avenue. Architect: Wilson Eyre Jr. Sculptor: Unknown.

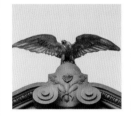

Detroit Cornice & Slate Co., 1897

When Tibble & Sielaff moved its architectural ornamentation business to the top two floors of the Detroit Cornice & Slate Co., Louis Sielaff felt something was missing from the building. He created this eagle to top it off.

733 St. Antoine Street. Architect: Harry J. Rill. Sculptor: Louis Sielaff.

Detroit Historical Museum, 1951

The shield in Corrado Parducci's unique stainless-steel sculpture over the Woodward Avenue entrance to the Detroit Historical Museum features symbols representing the three countries that have held dominion over Detroit. The fleur-de-lis represents France, the lion Great Britain, and the stars the United States. The beavers represent Michigan.

5401 Woodward Avenue. Architect: William E. Kapp. Sculptor: Corrado Parducci.

Detroit Opera House, 1922

Griffin-like creatures adorn the Detroit Opera House, originally the Capitol Theater, a palatial vaudeville and movie house known for its perfect acoustics. Fittingly, its design was inspired by the great opera houses of Europe.

1526 Broadway. Architect: C. Howard Crane. Sculptor: Unknown.

Detroit Opera House Parking Structure, circa 1981
1426 Broadway. Sculptor: Unknown.

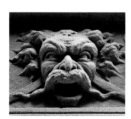

Detroit Savings Bank (Archdiocese of Detroit Chancery, Chamber of Commerce Building), 1895
1212 Griswold Street. Architect: Spier & Rohns. Sculptor: Unknown.

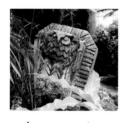

Detroit Times Building, 1929–78

This owl is from the home of Detroit's other, mostly forgotten, great daily newspaper, the *Detroit Times*. Saved from destruction when the building was torn down in 1978, this sculpture was given to the Belle Isle Conservatory a few years ago by someone who felt that he had held onto it long enough and wanted to see this piece of the past displayed in another of Albert Kahn's buildings. It can be found in the Conservatory fernery.

1370 Cass Avenue. Architect: Albert Kahn. Sculptor: Corrado Parducci.

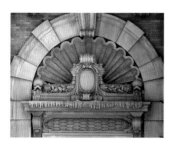

Detroit Waterworks Pumping Station, 1908

Due to security concerns, the Detroit Waterworks facility on East Jefferson Avenue, once home to the immensely popular and scenic Waterworks Park (see Hurlbut Gate, page 40), is fenced off, and the public is not allowed on the grounds. Therefore, this building can only be seen from a distance. The sculpture on this building is reminiscent of work attributed to Joachim Jungwirth on the Belle Isle Aquarium (page 68).

East Jefferson Avenue and Marquette Drive. Architect: Field, Hinchman & Smith. Sculptor: Unknown.

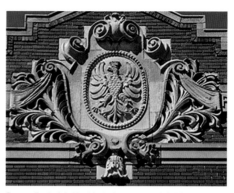

Dom Polski (Polish House), 1913

This cornice ornament on the Dom Polski, a Polish community center, is much more prominent than the actual name of the building is.

2279 East Forest Avenue. Architect: Joseph G. Kastler. Sculptor: Unknown.

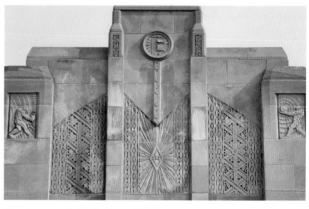

Electrograph Building, 1930

This building, originally built for the Electrograph Company, a direct-mail advertising and printing firm, is currently the home of Latino Family Services.

3815 Fort Street. Architect: Unknown. Sculptor: Attributed to Corrado Parducci.

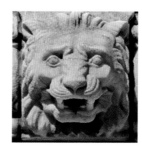

Federal Reserve Building, 1927
160 West Fort Street. Architect: Graham, Anderson, Probst & White. Sculptor: Unknown.

The Fillmore (Palms Theatre, State Theatre), 1925

A repeating design of rams and eagles decorates a belt course between the third and fourth floors.

2215 Woodward Avenue. Architect: C. Howard Crane. Sculptor: Unknown.

Film Exchange Building, 1926

Unfortunately, one of the heads is missing from this pair of figures over the entrance to the Film Exchange Building, but the coils of film, sprockets, and movie projector clearly reflect the building's function as a film clearinghouse for Detroit's multitude of movie theaters.

2310 Cass Avenue. Architect: C. Howard Crane. Sculptor: Unknown.

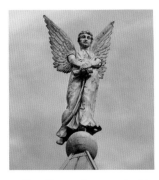

First Congregational Church, 1891

The Archangel Uriel brings wisdom, as represented by the scroll he holds, to the city of Detroit. He stands atop the 120-foot tower of this onetime stop on the Underground Railroad.

33 East Forest Avenue. Architect: John Lyman Faxon. Sculptor: Unknown.

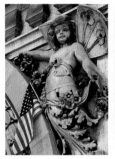
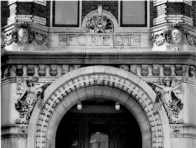

Forest Arms Apartments, 1905

Lovely young fairies with butterfly wings adorn the entrance to the recently restored Forest Arms Apartments.

4625 Second Avenue. Architect: Unknown. Sculptor: Unknown.

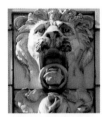

Fowler Building, 1911

This building was once the home of Kline's Department Stores.

1225 Woodward Avenue. Architect: Donaldson & Meier. Sculptor: Unknown.

Fox Theater, 1928

C. Howard Crane built 250 theaters in North America, including 62 in Detroit, but the Fox is considered his masterpiece. Among its most notable exterior features are the many griffins that adorn its doors and windows.

2111 Woodward Avenue. Architect: C. Howard Crane. Sculptor: Unknown.

George Harrison Phelps Building, 1926

This town crier spends much of the year hidden by ivy leaves, which were mostly gone when this late-autumn photo was taken. This building was erected to house an advertising agency and radio station.

2761 East Jefferson Avenue. Architect: William Kapp (Smith, Hinchman & Grylls). Sculptor: Corrado Parducci.

Gesu Roman Catholic Church, Rectory, and Parish Offices, 1950

This relief represents Saint Ignatius Loyola, founder of the Society of Jesus, also known as the Jesuits. The letters "AMDG" stand for "Ad maiorem Dei gloriam" (To the greater glory of God), the Jesuit motto. Gesu Parish was established and built by Jesuit priests, including its founding pastor, Rev. John P. McNichols, for whom the city renamed Six Mile Road.

17180 Oak Drive. Architect: George F. Diehl. Sculptor: Corrado Parducci.

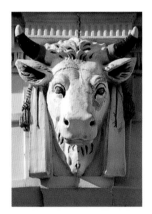

Grand Park Centre (Michigan Mutual Building), 1922

This building was originally home to the Stroh Brewing Company headquarters.

28 West Adams Street. Architect: Paul Kamper. Sculptor: Unknown.

Gratiot Central Market, 1915

The south façade of the Gratiot Central Market is the last remaining part of the original two-story building, which has sustained substantial fire damage over the years. This cow is from an entrance-arch keystone.

1429 Gratiot Avenue. Architect: Smith, Hinchman & Grylls. Sculptor: Unknown.

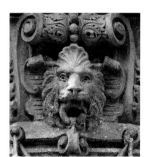

Harmonie Club, 1895

This building was designed to be the home of the Harmonie Society, a German singing and social club.

267 East Grand River Avenue. Architect: Richard E. Raseman. Sculptor: Unknown.

Hellenic Museum of Michigan (Robert Pauli Scherer House), 1912

Dragons guard the door to the Hellenic Museum of Michigan, originally built as a residence. It was the home of Robert Pauli Scherer, inventor of the rotary die encapsulation machine, which revolutionized the production of soft gelatin capsules and thereby the pharmaceutical industry.

67 Kirby Street. Architect: Unknown. Sculptor: Unknown.

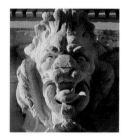

Heyn's Bazaar, 1919
1241 Woodward Avenue. Architect: Albert Kahn. Sculptor: Unknown.

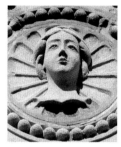 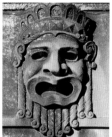

The Hibbard Apartments, 1924
8909 East Jefferson Avenue. Architect: Robert O. Derrick. Sculptor: Unknown.

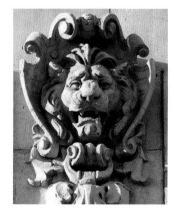

Himelhoch Brothers Building, 1901

Once the home of Himelhoch's Department store, this building has entrances on both Woodward Avenue and Washington Boulevard so people can enter it from either of what were once Detroit's two main shopping thoroughfares.

1545 Woodward Avenue. Architect: Donaldson & Meier. Sculptor: Unknown.

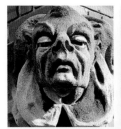
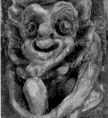
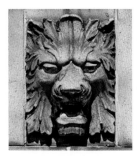

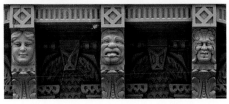

Indian Village Residences, circa 1900–1910

Many historic homes in Detroit's Indian Village feature interesting architectural sculpture. The examples shown here are from the Frederick T. DuCharme House at 982 Burns Avenue, built in 1907 by H. J. Maxwell Grylls; the Arthur M. Buhl House at 1116 Iroquois Avenue, built in 1909 by John Scott & Company; and the Wayland D. Stearns House at 1039 Seminole Street, built in 1902 by Stratton & Baldwin.

Architects: Various. Sculptors: Unknown.

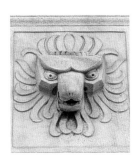

Industrial/retail building, 1946

This unique lion guards a building that once housed the Society of St. Vincent DePaul and has most recently been the home of an exercise studio.

2929 East Grand Boulevard. Architect: Unknown. Sculptor: Unknown.

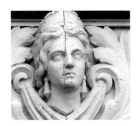

The Inn on Ferry Street, circa 1890

Part of a group of historic Victorian homes that together have been converted to a unique hotel called The Inn on Ferry Street.

110 Ferry Street. Architect: Unknown. Sculptor: Unknown.

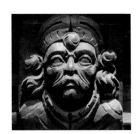

Joseph R. McLaughlin House (J. L. Hudson House), 1899

121 East Boston Boulevard. Architects: Nettleton & Kahn (original structure), Hinchman & Grylls (1911 alterations for J. L. Hudson). Sculptor: Unknown.

Kean Apartments, 1931

A fierce wolf guards the entrance to the Kean Apartments, while a flock of somewhat cartoonish crowned eagles watch over the building's upper reaches.

8925 East Jefferson Avenue. Architect: Charles Noble. Sculptor: Unknown.

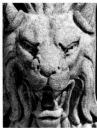

Loyal Order of Moose Lodge, 1922

2215 Cass Avenue. Architect: Baxter, O'Dell & Halpin. Sculptor: Unknown.

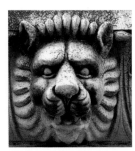
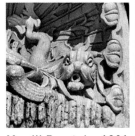

Merrill Fountain, 1901

Originally placed in front of the old Detroit Opera House on Campus Martius, this fountain was moved to Palmer Park in 1925 and has since been vandalized and fallen into disrepair.

Palmer Park, Second Avenue and Merrill Plaissance Street. Architects: John Carrère and Thomas Hastings. Sculptor: Unknown.

Michelson-Young House (Motown Mansion), 1917

Built by the lumber baron Nels Michelson, this opulent residence was owned for many years by Berry Gordy, hence the name "Motown Mansion."

918 West Boston Boulevard. Architect: Unknown. Sculptor: Unknown.

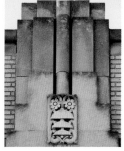

Michigan Bell Telephone Exchange Building, 1927

Art Moderne cornice and doorway ornaments adorn the Michigan Bell Telephone Exchange Building.

52 Selden Street. Architect: Smith, Hinchman & Grylls. Sculptor: Unknown.

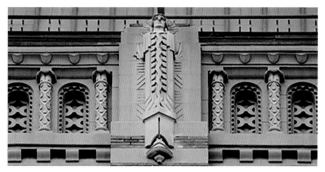

Michigan Bell Telephone Headquarters, 1919 (first seven stories) and 1927 (twelve-story addition)

This is one of ten identical figures along the colonnaded cornice of the Michigan Bell Telephone Headquarters. Note the bell below the pedestal.

1365 Cass Street. Architect: Smith, Hinchman & Grylls (1919 building), Wirt C. Rowland (1927 addition). Sculptor: Unknown.

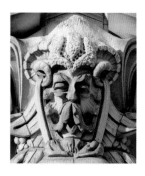

Michigan Central Railroad Station, 1913

Closed in 1988, this abandoned train station has long been a symbol of Detroit's decline. Over the years, plans have surfaced to revive the building, possibly as a casino or a new police headquarters, but none have come to fruition until the Ford Motor Company purchased the building in 2018 to redevelop as the anchor for their new Corktown autonomous vehicle campus. The interior has been a setting for action movies such as *Batman v. Superman: Dawn of Justice*.

2001 Fifteenth Street. Architects: Warren & Wetmore, Reed & Stem. Sculptor: Unknown.

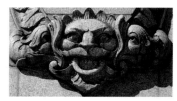

Michigan Theatre, 1926

The Michigan Theatre was acclaimed as one of the most beautiful theaters in the city when it opened. It was built on the site where Henry Ford assembled his first automobile. In 1977, most of the interior walls were torn out, and the building was converted into a parking structure. Many of the theater's architectural ornaments remain, making it one of the most interesting places to park in the city.

238 Bagley Street. Architects: Cornelius W. Rapp and George L. Rapp. Sculptor: Unknown.

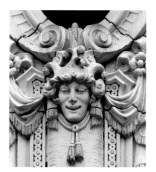

National Theatre, 1911

This was the only freestanding theater building designed by Albert Kahn. The site where this building stands is slated for new development, but it has been reported that the façade of the theater may be preserved.

118 Monroe Street. Architect: Albert Kahn. Sculptor: Unknown.

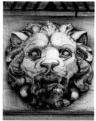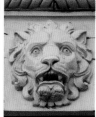

Old Penobscot Building, 1905

These lions (one of which has been cleaned) are from the first of three downtown Detroit buildings to bear the name "Penobscot," all of which are still standing.

131 West Fort Street. Architect: Donaldson & Meier. Sculptor: Unknown.

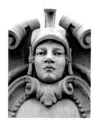

Orchestra Hall, 1919

Built in just six months, this theater is renowned for its flawless acoustics. It almost fell to the wrecking ball in 1970, but it was saved and restored to its former glory. The Detroit Symphony Orchestra left after the 1939 season but returned in 1989.

3711 Woodward Avenue. Architect: C. Howard Crane. Sculptor: Unknown.

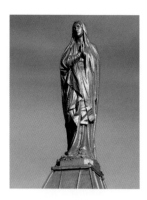

Our Lady of the Rosary Roman Catholic Church, 1896

The Virgin Mary stands atop the tower of Our Lady of the Rosary Roman Catholic Church, clearly visible to drivers on nearby I-94.

5930 Woodward Avenue. Architect: Malcomson & Higginbotham. Sculptor: École de Beaux-Arts, Paris.

Our Lady Queen of Angels Roman Catholic Church, 1952
4200 Martin Street. Architect: Unknown. Sculptor: Attributed to Corrado Parducci.

Our Lady Queen of Heaven Roman Catholic Church, 1959 (bell tower and baptistry, 1963)
8200 Rolyat Street. Architect: Unknown. Sculptor: Attributed to Corrado Parducci.

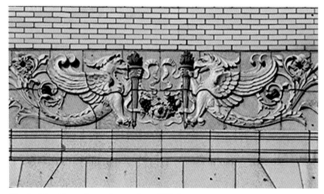

Park Shelton Apartments, 1926

A pair of odd griffin-like creatures are part of the colorful band of ornamentation just below the cornice of the Park Shelton Apartments.

15 East Kirby Street. Architect: Weston & Ellington. Sculptor: Attributed to Corrado Parducci.

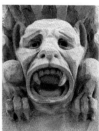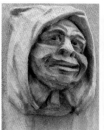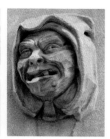

Pochelon Building, 1923

This structure was built by Albert Pochelon to house his floral business. Pochelon was one of the founders of the Florists' Telegraph Delivery Association, better known today as Florists' Transworld Delivery, or FTD. At this writing, the building is said to be scheduled for demolition to make way for new development.

815 Bates Street. Architect: Mildner & Eisen. Sculptor: Unknown.

Redeemer Presbyterian Church (Sweet Home Missionary Baptist Church), 1924–2016

This church was demolished in 2016 shortly after this picture was taken, despite last-ditch efforts to have it recognized as a historical landmark. In 1969, Redeemer Presbyterian was seized by members of the National Black Economic Development Conference as part of a bid to win $500 million in reparations from U.S. churches and synagogues.

2764 West Grand Boulevard. Architect: George D. Mason & Company. Sculptor: Unknown.

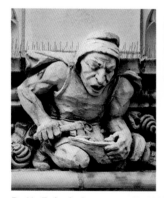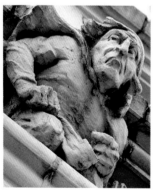

R. H. Fyfe & Company Building, 1919

Cobbler elves adorn this ten-story building that was at one time known as the world's largest shoe store. It is now an apartment building.

10 West Adams Street. Architect: Smith, Hinchman & Grylls. Sculptor: Unknown.

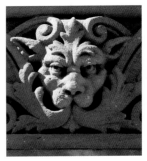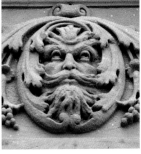

R. H. Traver Building, 1890

This building was originally home to a men's clothing store.

1211 Woodward Avenue. Architect: Gordon W. Lloyd. Sculptor: Unknown.

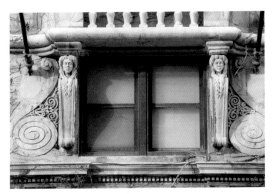

Royal Palm Hotel, 1925

Unique consoles support the balcony above these windows over the entrance to the hotel.

2305 Park Avenue. Architect: Louis Kamper. Sculptor: Unknown.

St. Andrew's Hall, 1908

This building was never a church, as is sometimes thought. It was built as a meeting place for the St. Andrew's Scottish Society of Detroit. This shield over the door shows Saint Andrew with the instrument of his martyrdom; he was crucified on an X-shaped cross. The thistles are a symbol of Scotland. The building is now a popular music venue.

431 East Congress Street. Architect: Unknown. Sculptor: Unknown.

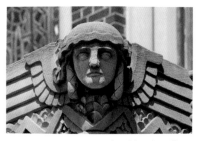

St. Augustine and St. Monica Roman Catholic Church (St. Catherine Roman Catholic Church), 1919

4151 Seminole Street. Architect: Unknown. Sculptor: Attributed to Corrado Parducci.

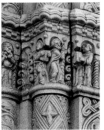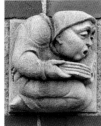

St. Brigid Roman Catholic Church (High Praise Cathedral of Faith), 1949

St. Brigid Parish lost about five hundred homes when the portion of I-96 that runs through Detroit was built in the 1970s. The parish closed in 1989.

8700 Schoolcraft Road. Architect: Diehl & Diehl. Sculptor: Attributed to Corrado Parducci.

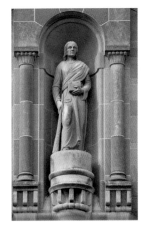

St. Jude Roman Catholic Church, 1942

Saint Jude Thaddaeus was an apostle and epistle writer. In one hand, he holds a club, symbol of his martyrdom, and in the other hand, he holds a copy of his epistle. He is the patron saint of lost causes and the impossible.

15889 Seven Mile East. Architect: Arthur DesRosiers. Sculptor: Attributed to Corrado Parducci.

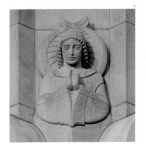

St. Lazarus Serbian Orthodox Church Ravanica, 1967

4575 Outer Drive. Architect: Harold H. Fisher. Sculptor: Unknown.

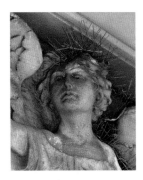

St. Leo Roman Catholic Church, 1908

Along with St. Cecilia Roman Catholic Church (page 250), St. Leo's is now part of the St. Charles Lwanga Parish.

4860 Fifteenth Street. Architect: Harry J. Rill. Sculptor: Unknown.

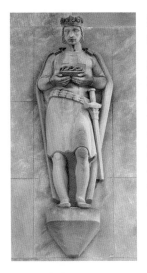

St. Louis the King Roman Catholic Church, 1959

Saint Louis IX, king of France, led two Crusades, hence the Crusader's cross on his tunic and the sword at his belt. He holds Christ's crown of thorns, which he brought to France from Constantinople. He is the patron saint of the French monarchy and hairdressers.

18891 St. Louis Avenue. Architect: Donaldson & Meier. Sculptor: Attributed to Corrado Parducci.

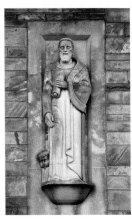

St. Matthew Roman Catholic Church, 1955

6021 Whittier Avenue. Architect: Donaldson & Meier. Sculptor: Attributed to Corrado Parducci.

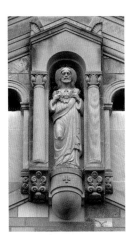

St. Peter Claver Roman Catholic Church (Precious Blood Roman Catholic Church), circa 1950

This icon of Jesus wears a crown of pigeon-repelling thorns. He indicates his sacred heart, encircled with a crown of thorns and burning with the divine fire of his love for humankind.

13305 Grove Street. Architect: Maguolo & Quick. Sculptor: Corrado Parducci.

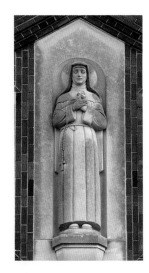

St. Rita Roman Catholic Church (The Promise Land Church), 1954

Saint Rita is the patron saint of difficult marriages and parenthood. She is typically depicted as shown here, wearing a nun's habit and holding a crucifix, a symbol of her devotion to the Passion of Christ.

1044 East State Fair Avenue. Architect: Donaldson & Meier. Sculptor: Attributed to Corrado Parducci.

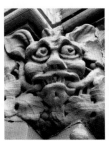 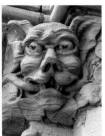

Ste. Anne de Detroit Roman Catholic Church, 1887

These are two of the four unique faces that guard the northeast and northwest doors of Ste. Anne de Detroit Church. It was founded by Antoine de la Mothe Cadillac a day or two after he landed here to establish a fur-trading outpost in 1701, making it one of the oldest continuously operating Catholic parishes in the United States. This is the parish's eighth church building.

1000 Ste. Anne Street. Architect: Leon Coquard. Sculptor: Unknown.

 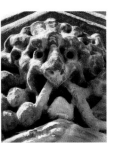

SS. Peter and Paul Academy (St. Patrick Senior Center), 1892

This building served as a grade school and girls' high school from the time it was built until it closed in 1969. It reopened as a senior center in 1972.

64 Parsons Street. Architect: Leon Coquard. Sculptor: Unknown.

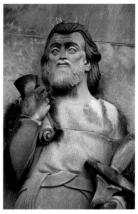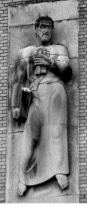

SS. Peter and Paul Roman Catholic Church, 1959

Not to be confused with SS. Peter and Paul Jesuit Church on Jefferson Avenue near downtown, this church is located on the city's far west side.

7685 Grandville Avenue. Architect: Donaldson & Meier. Sculptor: Attributed to Corrado Parducci.

Scarab Club, 1928

The Scarab Club is one of Detroit's oldest arts organizations. High above its entrance flies this colorful scarab beetle, a symbol of rebirth and renewal, beautifully rendered in Pewabic tile.

217 Farnsworth Street. Architect: Lancelot Sukert. Designer: William Buck Stratton. Sculptor: Horace F. Colby.

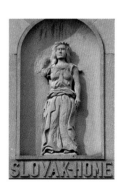

Slovak Home, circa 1923

A possible homage to the Statue of Liberty stands in a niche on the old Slovak Home, a community center for Slovakian immigrants. Her right arm is missing, either damaged or intentionally removed, but it appears that she could have been holding aloft a torch.

7151 Strong Street. Architect: P. R. Rosello. Sculptor: Unknown.

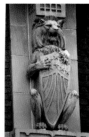

Stuber-Stone & Company Building, 1916

This is one of six identical lions found just below the cornice of the building, which originally served as a dealership for Columbia Motors Company vehicles. In 1997, the building was converted to loft apartments.

4221–29 Cass Avenue. Architect: David M. Simmons. Sculptor: Unknown.

Sweetest Heart of Mary Roman Catholic Church, 1893

A praying Mary is surrounded by lightbulbs. It has recently been reported that church officials have asked the Detroit Historic Commission for permission to remove the church's twin spires, as they are in dangerously bad condition and too costly to repair.

4440 Russell Street. Architect: Spier & Rohns. Sculptor: Unknown.

Temple of Odd Fellows, 1874

This is one of several highly decorated window hood moldings on the building, which was built to house an international philanthropic fraternity.

1211 Randolph Street. Architect: Unknown. Sculptor: Unknown.

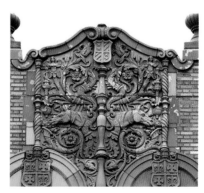

Thomas M. Cooley High School, 1928

Named after a Michigan Supreme Court chief justice, this unique Mediterranean Revival school features many interesting sculptural flourishes based on Italian Renaissance motifs.

15055 Hubbell Avenue. Architect: Donaldson & Meier. Sculptor: Unknown.

United Artists Theatre, 1928

Tragedy and comedy masks adorn this once-opulent theater. One of the few theaters of its time designed exclusively for showing movies, the United Artists Theatre was part of a chain built for the studio founded by Mary Pickford, Charlie Chaplin, Douglas Fairbanks Sr., and D. W. Griffith.

150 Bagley Street. Architect: C. Howard Crane. Sculptor: Unknown.

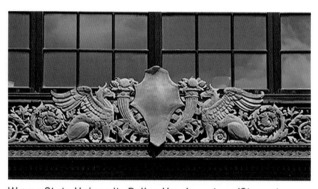

Wayne State University Police Headquarters (Stewart-Warner Speedometer Corporation Building), 1924

Look closely at this bronze ornament over the entrance to the building, and you can see squirrels peeking out of the griffins' curled tails.

6050 Cass Avenue. Architect: Albert Kahn. Sculptor: Unknown.

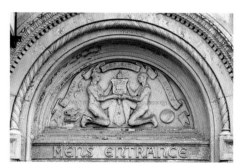

West Side YMCA, 1927

This tympanum is located over the men's entrance to the building.

1601 Clark Avenue. Architect: Malcomson & Higginbotham. Sculptor: Unknown.

W. G. Arthur Reid Residence, circa 1923

A whimsical cat over a window on this residence in the Arden Park Historic District.

311 Arden Park Boulevard. Architect: Unknown. Sculptor: Unknown.

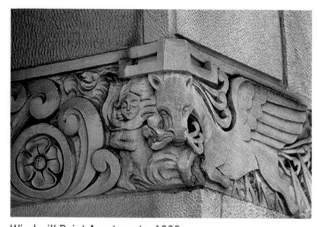

Windmill Point Apartments, 1929

A Pegasus and friend adorn the entrance to this building.

943 Alter Road. Architect: Unknown. Sculptor: Unknown.

The Woman's Hospital, 1922

A stork-riding baby appears over the main entrance of this building.

Hancock between Brush and St. Antoine Streets. Architect: Albert Kahn. Sculptor: Unknown.

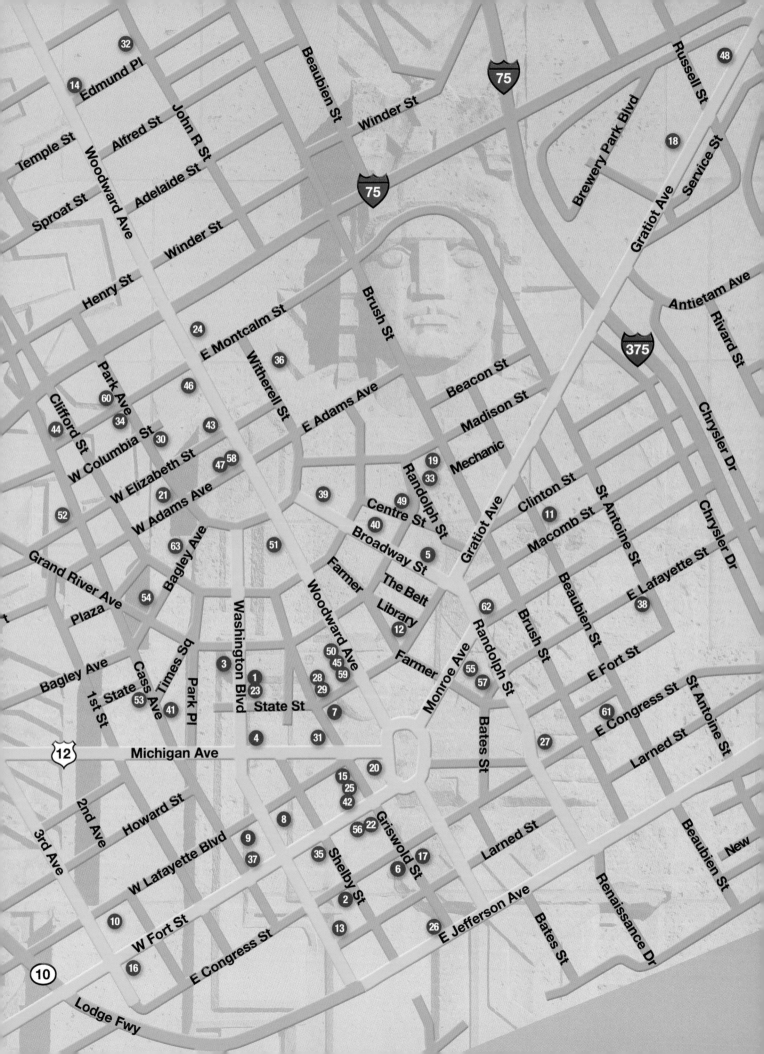

← Downtown Detroit Buildings

Buildings are listed in alphabetical order, followed by address and page number. Buildings that are featured in the book are marked with red dots, and other buildings that appear in appendix A are marked with brown dots.

Featured Buildings

1. **Archdiocese of Detroit Chancery Building, Old**
 1234 Washington Avenue, 112

2. **Bankers Trust Company Building**
 205 West Congress Street, 142

3. **Book Building and Tower**
 1249 Washington Boulevard, 162

4. **Book-Cadillac Hotel**
 1114 Washington Boulevard, 114

5. **Broadway Exchange Building**
 1342–46 Broadway, 168

6. **Buhl Building**
 533 Griswold Street, 148

7. **David Stott Building**
 1150 Griswold Street, 220

8. **Detroit Federal Building and U.S. Courthouse**
 231 West Lafayette Boulevard, 266

9. **Detroit Free Press Building**
 321 West Lafayette Boulevard, 115

10. **Detroit News Building**
 615 West Lafayette Boulevard, 78

11. **Detroit Police Headquarters**
 1300 Beaubien Street, 98

12. **Detroit Public Library, Downtown (Skillman) Branch**
 121 Gratiot Avenue, 262

13. **Fire Department Headquarters**
 250 West Larned Street, 224

14. **First Presbyterian Church**
 2930 Woodward Avenue, 22

15. **First State Bank Building**
 751 Griswold Street, 124

16. **Fort Street Presbyterian Church and Church House**
 631 West Fort Street, 2

17. **Guardian Building**
 500 Griswold Street, 228

18. **Historic Trinity Lutheran Church**
 1335 Gratiot Avenue, 258

19. **Music Hall**
 350 Madison Street, 208

20. **Old City Hall (demolished)**
 755 Woodward Avenue, 12

21. **Park Avenue Building**
 2011 Park Avenue, 94

22. **Penobscot Building**
 645 Griswold Street, 210

23. **St. Aloysius Roman Catholic Church**
 1230 Washington Boulevard, 234

24. **St. John's Episcopal Church**
 2326 Woodward Avenue, 6

25. **Security Trust Building**
 735 Griswold Street, 128

26. **Standard Federal Savings & Loan**
 1 Griswold Street, 190

27. **Wayne County Building**
 600 Randolph Street, 60

Other Buildings

28. **The Albert (Griswold Building)**
 1214 Griswold Street, 285

29. **Archdiocese of Detroit Chancery Building, New (Detroit Savings Bank)**
 1212 Griswold Street, 284

30. **Blenheim Building**
 2218 Park Avenue, 285

31. **Brass Rail Restaurant (original location)**
 116 Michigan Avenue, 286

32. **Carlton Plaza Hotel**
 2915 John R Street, 286

33. **La Casa de la Cabana**
 1502 Randolph Street, 286

34. **Centaur Bar**
 2233 Park Avenue, 286

35. **Comerica Bank (Detroit Trust Company Building)**
 201 West Fort Street, 287

36. **Comerica Park**
 2100 Woodward Avenue, 287

37. **Detroit Club**
 712 Cass Avenue, 287

38. **Detroit Cornice & Slate Co.**
 733 St. Antoine Street, 287

39. **Detroit Opera House**
 1526 Broadway, 288

40. **Detroit Opera House Parking Structure**
 1426 Broadway, 288

41. **Detroit Times Building (demolished)**
 1370 Cass Avenue, 288

42. **Federal Reserve Building**
 160 West Fort Street, 288

43. **The Fillmore (Palms Theatre, State Theatre)**
 2215 Woodward Avenue, 289

44. **Film Exchange Building**
 2310 Cass Avenue, 289

45. **Fowler Building**
 1225 Woodward Avenue, 289

46. **Fox Theatre**
 2111 Woodward Avenue, 289

47. **Grand Park Centre**
 28 West Adams Street, 290

48. **Gratiot Central Market**
 1429 Gratiot Avenue, 290

49. **Harmonie Club**
 267 East Grand River Avenue, 290

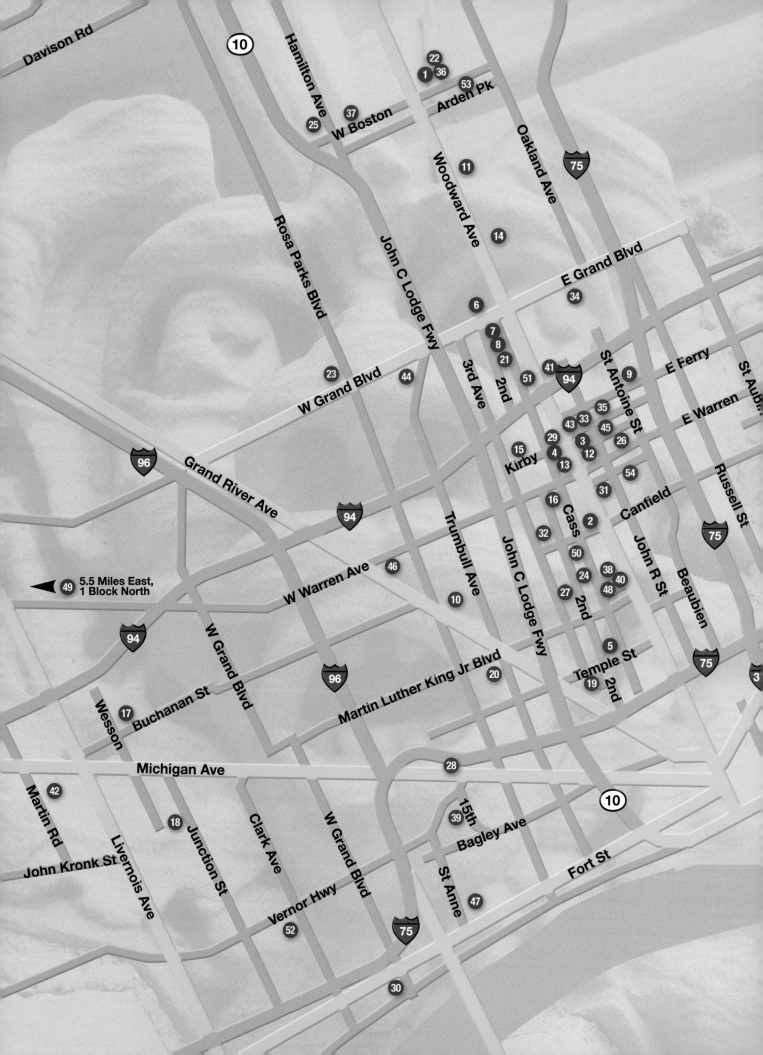

50. **Heyn's Bazaar**
1241 Woodward Avenue, 290

51. **Himelhoch Brothers Building**
1545 Woodward Avenue, 290

52. **Loyal Order of Moose Lodge**
2215 Cass Avenue, 291

53. **Michigan Bell Telephone Headquarters**
1365 Cass Street, 292

54. **Michigan Theatre**
238 Bagley Avenue, 292

55. **National Theatre**
118 Monroe Street, 292

56. **Old Penobscot Building**
131 West Fort Street, 292

57. **Pochelon Building**
815 Bates Street, 293

58. **R. H. Fyfe & Company Building**
10 West Adams Street, 293

59. **R. H. Traver Building**
1211 Woodward Avenue, 294

60. **Royal Palm Hotel**
2305 Park Avenue, 293

61. **St. Andrew's Hall**
431 East Congress Street, 294

62. **Temple of Odd Fellows**
1211 Randolph Street, 296

63. **United Artists Theatre**
150 Bagley Avenue, 297

Midtown, New Center, and Southwest Buildings

Buildings are listed in alphabetical order, followed by address and page number. Buildings that are featured in the book are marked with red dots, and other buildings that appear in appendix A are marked with brown dots.

Featured Buildings

1. **Cathedral of the Most Blessed Sacrament**
9844 Woodward Avenue, 244

2. **David Whitney Jr. House**
4424 Woodward Avenue, 38

3. **Detroit Institute of Arts**
5200 Woodward Avenue, 176

4. **Detroit Main Library**
5201 Woodward Avenue, 84

5. **Detroit Masonic Temple**
500 Temple Street, 154

6. **Fisher Building**
3011 West Grand Boulevard, 198

7. **General Motors Building**
3044 West Grand Boulevard, 104

8. **General Motors Corporation Laboratories**
Milwaukee Avenue (behind General Motors Building), 110

9. **George W. Balch School**
5536 St. Antoine Street, 90

10. **Grand River Avenue Police Station and Barn**
4150 Grand River Avenue, 58

11. **Historic Little Rock Missionary Baptist Church (Central Woodward Christian Church)**
9000 Woodward Avenue, 194

12. **Horace H. Rackham Educational Memorial**
106 Farnsworth Street, 278

13. **Maccabees Building**
5057 Woodward Avenue, 182

14. **Metropolitan United Methodist Church**
8000 Woodward Avenue, 172

15. **Old City Hall Statues**
In front of WSU Faculty/Administration Building, 656 West Kirby Street, 12

16. **Old Main (Detroit Central High School)**
4841 Cass Avenue, 46

17. **St. Francis D'Assisi Roman Catholic Church**
4500 Wesson Street, 72

18. **St. Hedwig Roman Catholic Church**
3245 Junction Street, 74

19. **S. S. Kresge Headquarters**
2727 Second Avenue, 216

20. **Trinity Episcopal Church**
1519 Martin Luther King Jr. Boulevard, 28

Other Buildings

21. **Argonaut Building**
485 West Milwaukee Avenue, 285

22. **Blessed Sacrament Center**
150 Belmont Street, 285

23. **Boulevard Temple Methodist Episcopal Church/School/Apartments**
2567 West Grand Boulevard, 285

24. **Cass Community United Methodist Church**
3901 Cass Avenue, 286

25. **Catholic Charities Building**
9851 Hamilton Avenue, 286

26. **Charles H. Wright Museum of African American History**
315 East Warren Avenue, 287

27. **The Coronado Apartments**
3751–73 Second Avenue, 287

28. **CPA Building**
2238 Michigan Avenue, 287

29. **Detroit Historical Museum**
5401 Woodward Avenue, 287

30. **Electrograph Building**
3815 Fort Street, 288

31. **First Congregational Church**
33 East Forest Avenue, 289

32. **Forest Arms Apartments**
4625 Second Avenue, 289

33. **Hellenic Museum of Michigan**
67 Kirby Street, 290

34. **Industrial/retail building**
2929 East Grand Boulevard, 291

35. **The Inn on Ferry Street**
110 Ferry Street, 291

36. **Joseph R. McLaughlin House**
121 East Boston Boulevard, 291

37. **Michelson-Young House**
918 West Boston Boulevard, 291

38. **Michigan Bell Telephone Exchange Building**
52 Selden Street, 292

39. **Michigan Central Railroad Station**
2001 Fifteenth Street, 292

40. **Orchestra Hall**
3711 Woodward Avenue, 292

41. **Our Lady of the Rosary Roman Catholic Church**
5930 Woodward Avenue, 293

42. **Our Lady Queen of Angels Roman Catholic Church**
4200 Martin Street, 293

43. **Park Shelton Apartments**
15 East Kirby Street, 293

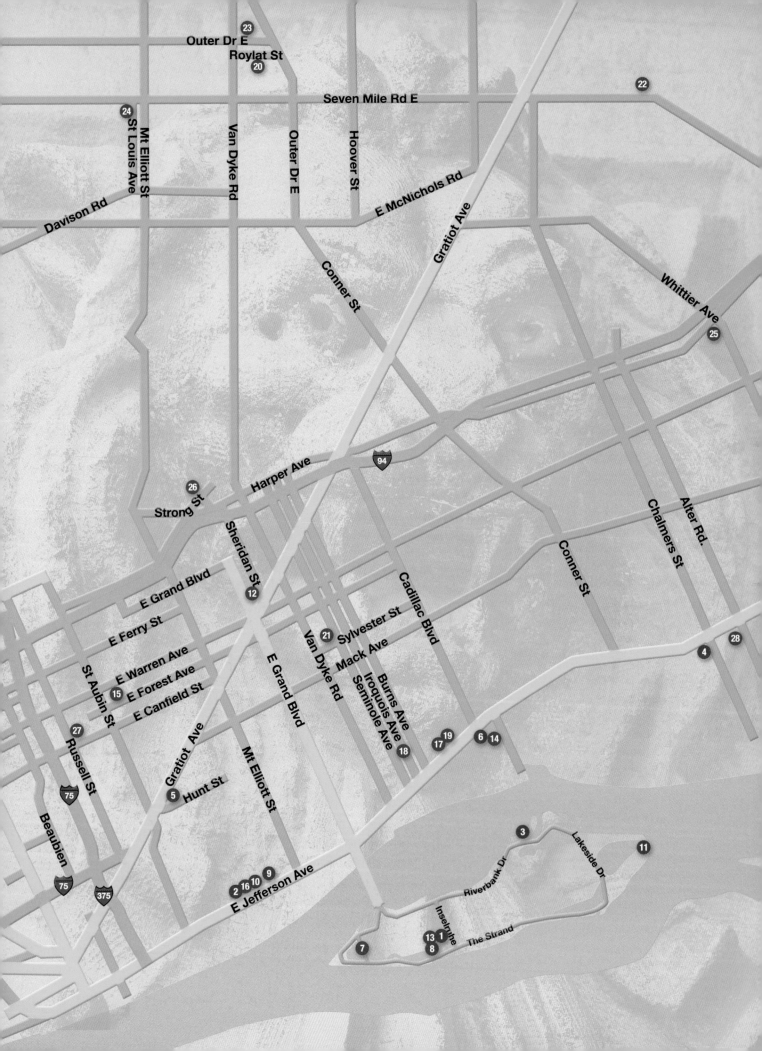

44. **Redeemer Presbyterian Church (Sweet Home Missionary Baptist Church) (demolished)**
 2764 West Grand Boulevard, 293

45. **Scarab Club**
 217 Farnsworth Street, 296

46. **St. Leo Roman Catholic Church**
 4860 Fifteenth Street, 295

47. **Ste. Anne de Detroit Roman Catholic Church**
 1000 Ste. Anne Street, 295

48. **SS. Peter and Paul Academy**
 64 Parsons Street, 295

49. **SS. Peter and Paul Roman Catholic Church**
 7685 Grandville Avenue, 296

50. **Stuber-Stone & Company Building**
 4221–29 Cass Avenue, 296

51. **Wayne State University Police Headquarters**
 6050 Cass Avenue, 297

52. **West Side YMCA**
 1601 Clark Avenue, 297

53. **W. G. Arthur Reid Residence**
 311 Arden Park Boulevard, 297

54. **The Woman's Hospital**
 Hancock between Brush and St. Antoine Streets, 297

← Belle Isle and East Side Buildings

Buildings are listed in alphabetical order, followed by address and page number. Buildings that are featured in the book are marked with red dots, and other buildings that appear in appendix A are marked with brown dots.

Featured Buildings

1. **Belle Isle Aquarium**
 900 Inselruhe Avenue, 68

2. **Detroit Press Building**
 2751 East Jefferson Avenue, 222

3. **Detroit Yacht Club**
 1 Riverbank Drive, 92

4. **D. J. Healy Shops' Neighborhood Store, East**
 14400 East Jefferson Avenue, 272

5. **Hunt Street (Third Precinct) Police Station**
 2200 Hunt Street, 54

6. **Hurlbut Memorial Gate**
 East Jefferson Avenue at Cadillac Boulevard, 40

7. **James Scott Memorial Fountain**
 Sunset Drive, western end of Belle Isle, 134

8. **Nancy Brown Peace Carillon**
 Belle Isle, just west of Conservatory grounds, 274

9. **The Players Theatre**
 3321 East Jefferson Avenue, 152

10. **William H. Wells House**
 2931 East Jefferson Avenue, 18

11. **William Livingstone Memorial Light**
 Eastern tip of Belle Isle, 240

Other Buildings

12. **Cathedral of St. Anthony, Ecumenical Catholic Church of Christ**
 5247 Sheridan Street, 286

13. **Detroit Times Building (owl sculpture)**
 Inside Anna Scripps Whitcomb Conservatory, 900 Inselruhe Avenue, 288

14. **Detroit Waterworks Pumping Station**
 East Jefferson Avenue at Marquette Drive, 288

15. **Dom Polski (Polish House)**
 2279 East Forest Avenue, 288

16. **George Harrison Phelps Building**
 2761 East Jefferson Avenue, 289

17. **The Hibbard Apartments**
 8909 East Jefferson Avenue, 290

18. **Indian Village Residences**
 982 Burns Avenue, 1039 Seminole Street, 1116 Iroquois Avenue, 291

19. **Kean Apartments**
 8925 East Jefferson Avenue, 291

20. **Our Lady Queen of Heaven Roman Catholic Church**
 8200 Roylat Street, 293

21. **St. Augustine and St. Monica Roman Catholic Church**
 4151 Seminole Street, 294

22. **St. Jude Roman Catholic Church**
 15889 Seven Mile East, 294

23. **St. Lazarus Serbian Orthodox Church Ravanica**
 4575 Outer Drive, 294

24. **St. Louis the King Roman Catholic Church**
 18891 St. Louis Avenue, 295

25. **St. Matthew Roman Catholic Church**
 6021 Whittier Avenue, 295

26. **Slovak Home**
 7151 Strong Street, 296

27. **Sweetest Heart of Mary Roman Catholic Church**
 4440 Russell Street, 296

28. **Windmill Point Apartments**
 943 Alter Road, 297

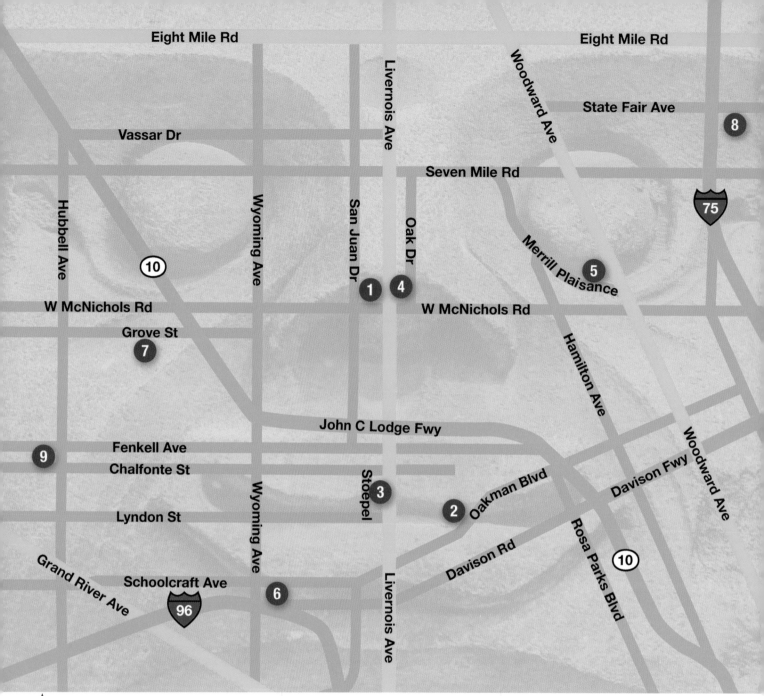

North and Northwest Buildings

Buildings are listed in alphabetical order, followed by address and page number. Buildings that are featured in the book are marked with red dots, and other buildings that appear in appendix A are marked with brown dots.

Featured Buildings

1. D. J. Healy Shops' Neighborhood Stores, West
 7436 McNichols Road, 272

2. Detroit Public Library, Francis Parkman Branch
 1765 Oakman Boulevard, 254

3. St. Cecilia Roman Catholic Church
 1400 Stoepel Street, 250

Other Buildings

4. Gesu Roman Catholic Church
 17180 Oak Drive, 290

5. Merrill Fountain
 Palmer Park, Second Avenue and Merrill Plaissance Street, 291

6. St. Brigid Roman Catholic Church
 8700 Schoolcraft Road, 294

7. St. Peter Claver Roman Catholic Church
 13305 Grove Street, 295

8. St. Rita Roman Catholic Church
 1044 East State Fair Avenue, 295

9. Thomas M. Cooley High School
 15055 Hubbell Avenue, 296

Their Buildings

Adams, Herbert
James Scott Memorial Fountain, 134

Amrany, Julia Rotblatt
Comerica Park, 287

Amrany, Omri
Comerica Park, 287

Beil, Carl
Detroit Institute of Arts, 176

Bennett, Richard
Charles H. Wright Museum of African
American History, 287

Bernasconi, Peter
Guardian Building, 288
Historic Trinity Lutheran Church, 258
St. Aloysius Roman Catholic Church,
234

Cashwan, Samuel
St. Aloysius Roman Catholic Church,
234

Cella, Lou
Comerica Park, 287

Colby, Horace F.
Scarab Club, 296

Coysevox, Antoine
Detroit Institute of Arts, 176

Cull, Hubert
Trinity Episcopal Church, 28

DiLorenzo, Anthony
Fisher Building, 198
General Motors Building, 104

Donaldson, John M.
Old City Hall, 12

Donatello
Detroit Institute of Arts, 176

Donnelly, John
Detroit Main Library, 84
General Motors Building, 104

École de Beaux-Arts
Our Lady of the Rosary Roman Catholic
Church, 293

Edwards, Charles Beaver
Nancy Brown Peace Carillon, 274

Fredericks, Marshall
Horace H. Rackham Educational Me-
morial, 278

Friedlander, Leo
Detroit Masonic Temple, 154

Gehrke, Bill
Detroit Masonic Temple, 154

Gerlach, Bruce
Belle Isle Aquarium, 68

Grandelis, C.
Detroit Main Library, 84

Hermant, Leon
Detroit Institute of Arts, 176

Hoepfner, Oswald
Detroit Main Library, 84
General Motors Building, 104
James Scott Memorial Fountain, 134

Jungwirth, Joachim
Belle Isle Aquarium (attributed), 68
Brass Rail Restaurant, 286
Detroit News Building (attributed), 78
Hurlbut Memorial Gate, 40

Kapetan, Michael
Archdiocese of Detroit Chancery Build-
ing, New, 284

Keropian, Michael
Comerica Park, 287

Krakow, Richard H., Sr.
Hurlbut Memorial Gate, 40
Wayne County Building, 60

Magnier, Philippe
Detroit Institute of Arts, 176

Maróti, Géza
Fisher Building, 198
William Livingstone Memorial Light,
240

Melchers, Julius
Old City Hall, 12

Michelangelo
Detroit Institute of Arts, 176

Mitrofanov, Sergei
Archdiocese of Detroit Chancery Build-
ing, New, 284

Nygard, Alfred F.
Old Main, 46

Parducci, Corrado

The Albert (attributed), 285

Archdiocese of Detroit Chancery Building, 112

Argonaut Building (attributed), 285

Bankers Trust Company Building, 142

Blessed Sacrament Center (attributed), 285

Book Tower (attributed), 162

Buhl Building, 148

Cathedral of the Most Blessed Sacrament, 244

David Stott Building, 220

Detroit Federal Building and U.S. Courthouse, 266

Detroit Historical Museum, 287

Detroit Press Building (attributed), 222

Detroit Public Library, Downtown (Skillman) Branch, 262

Detroit Times Building, 288

Electrograph Building (attributed), 288

First State Bank Building, 124

Fisher Building, 198

General Motors Building, 104

George Harrison Phelps Building, 289

Gesu Roman Catholic Church, Rectory and Parish Office (attributed), 290

Guardian Building, 228

Historic Trinity Lutheran Church, 258

Maccabees Building, 182

Music Hall, 208

Our Lady Queen of Angels Roman Catholic Church (attributed), 293

Our Lady Queen of Heaven Roman Catholic Church (attributed), 293

Park Shelton Apartments (attributed), 293

Penobscot Building, 210

The Players Theatre, 152

St. Aloysius Roman Catholic Church, 234

St. Augustine and St. Monica Roman Catholic Church (St. Catherine Roman Catholic Church) (attributed), 294

St. Brigid Roman Catholic Church (attributed), 294

St. Cecilia Roman Catholic Church (attributed), 250

St. Jude Roman Catholic Church (attributed), 294

St. Louis the King Roman Catholic Church (attributed), 295

St. Matthew Roman Catholic Church (attributed), 295

St. Peter Claver Roman Catholic Church, 295

St. Rita Roman Catholic Church (attributed), 295

SS. Peter and Paul Roman Catholic Church, 296

Security Trust Building, 128

S. S. Kresge Headquarters, 216

Standard Federal Savings & Loan, 190

Reuther, Richard G.

Hurlbut Memorial Gate, 40

Trinity Episcopal Church, 28

Wayne County Building, 60

Rhind, John Massey

Wayne County Building, 60

Ricci, Ulysses

Detroit Free Press Building, 115

Fisher Building, 198

General Motors Building, 104

General Motors Corporation Laboratories, 110

State Savings, x

Rodin, Auguste

Detroit Institute of Arts, 176

Schweikart, Walter

St. John's Episcopal Church, 6

Sielaff, Louis

Book-Cadillac Hotel, 114

Detroit Cornice & Slate Co., 287

James Scott Memorial Fountain, 134

Steinman, Henry

Detroit Masonic Temple, 154

Stratton, Mary Chase Perry

Detroit Main Library, 84

Guardian Building, 228

Stratton, William Buck

Scarab Club, 296

Tibble, Thomas

Book-Cadillac Hotel, 114

Tillery, Gary

Comerica Park, 287

Wagner, Edward Q.

First Presbyterian Church, 22

Trinity Episcopal Church, 28

Wayne County Building, 60

Unknown

The buildings listed below are those for which I was unable to find enough information to definitively determine the sculptor who worked on them or even make an attribution. If you can provide this information or know where it can be found, please contact me through my website, www.GuardiansOfDetroit.com.

Blenheim Building, 285

Boulevard Temple Methodist Episcopal Church/School/Apartments, 285

Book Building, 162

Broadway Exchange Building, 168

Carlton Plaza Hotel, 286

La Casa de la Habana, 286

Cass Community United Methodist Church, 286

Cathedral of St. Anthony, Ecumenical Catholic Church of Christ, 286

Catholic Charities Building, 286

Centaur Bar, 286

Comerica Bank (Detroit Trust Company Building), 287

The Coronado Apartments, 287

CPA Building, 287

David Whitney Jr. House, 38

Detroit Club, 287

Detroit News Building, 78

Detroit Opera House, 288

Detroit Opera House Parking Structure, 288

Detroit Police Headquarters, 98

Detroit Public Library, Francis Parkman Branch, 254

Detroit Waterworks Pumping Station, 288

Detroit Yacht Club, 92

D. J. Healy Shops' Neighborhood Stores, 272

Dom Polski (Polish House), 288

Federal Reserve Building, 288

The Fillmore, 289

Film Exchange Building, 289

Fire Department Headquarters, 224

First Congregational Church, 289

Forest Arms Apartments, 289

Fort Street Presbyterian Church, 2

Fowler Building, 289

Fox Theatre, 289

George W. Balch School, 90

Grand River Police Station, 58

Grand Park Centre, 290

Gratiot Central Market, 290

Harmonie Club, 290

Hellenic Museum of Michigan, 290

Heyn's Bazaar, 290

The Hibbard Apartments, 290

Himelhoch Brothers Bulding, 290

Historic Little Rock Missionary Baptist Church, 194

Hunt Street (Third Precinct) Police Station, 54

Indian Village Residences, 291

Industrial/Retail Building, 291

The Inn on Ferry Street, 291

Joseph R. McLaughlin House, 291

Kean Apartments, 291

Loyal Order of Moose Lodge, 291

Merrill Fountain, 291

Metropolitan United Methodist Church, 172

Michelson-Young House, 291

Michigan Bell Telephone Exchange, 292

Michigan Bell Telephone Headquarters, 292

Michigan Central Railroad Station, 292

Michigan Theatre, 292

Nancy Brown Peace Carillon, 274

National Theatre, 292

Old Penobscot Building, 292

Orchestra Hall, 292

Park Avenue Building, 94

Pochelon Building, 293

R. H. Fyfe & Company Building, 293

R. H. Traver Building, 294

Redeemer Presbyterian Church, 293

Royal Palm Hotel, 294

St. Andrew's Hall, 294

St. Francis D'Assisi Roman Catholic Church, 72

St. Hedwig Roman Catholic Church, 74

St. Lazarus Serbian Orthodox Church Ravanica, 294

St. Leo Roman Catholic Church, 295

Ste. Anne de Detroit Roman Catholic Church, 295

SS. Peter and Paul Academy, 295

Slovak Home, 296

Stuber-Stone & Company Building, 296

Sweetest Heart of Mary Roman Catholic Church, 296

Temple of Odd Fellows, 296

Thomas M. Cooley High School, 296

United Artists Theatre, 297

Wayne State University Police Headquarters, 297

West Side YMCA, 297

W. G. Arthur Reid Residence, 297

William H. Wells House, 18

Windmill Point Apartments, 297

The Woman's Hospital, 297

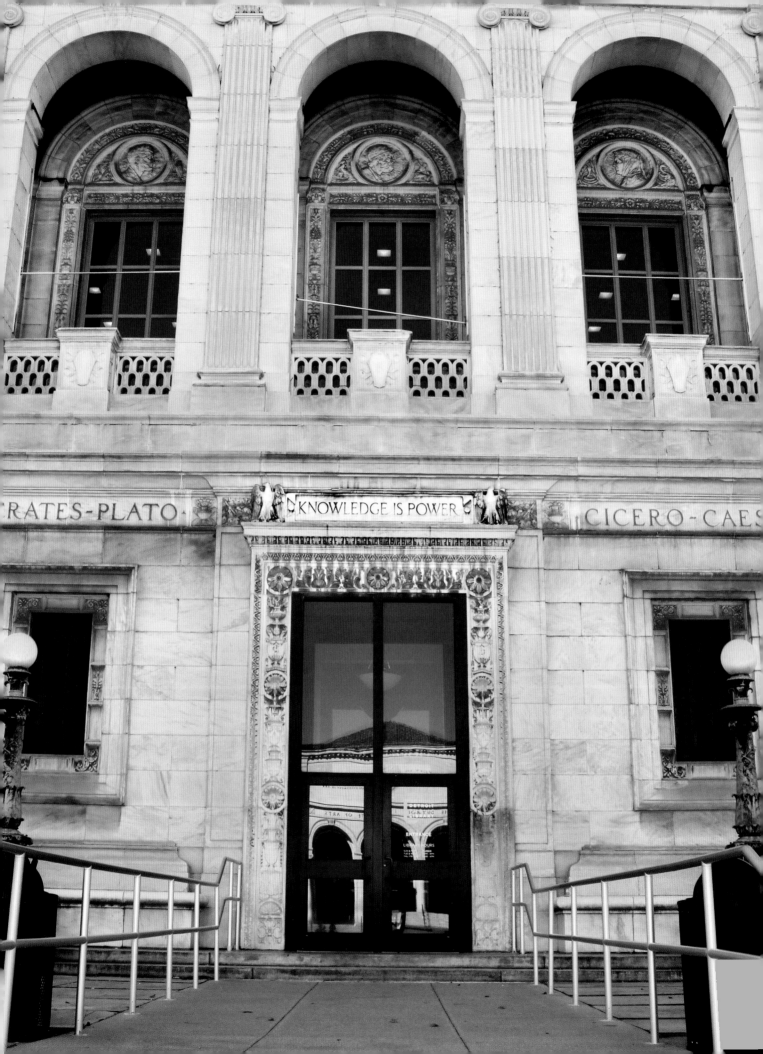

Preface

1. Population figures: Peter Gavrilovich and Bill McGraw, *The Detroit Almanac: 300 Years of Life in the Motor City* (Detroit: Detroit Free Press, 2006), 289.

St. John's Episcopal Church

1. Rev. Canon Irwin C. Johnson, George W. Stark, Charles E. Gringer, and Ralph J. Burton, *St. John's Centennial Book, 1858–1958* (Detroit: St. John's Church of Detroit, 1958), 15.
2. Advertisement: Walter Schweikart Stone Cutter and Carver, *Detroit Free Press*, May 14, 1861, 3.
3. "Legal Matters: Still Undismayed," *Detroit Free Press*, July 20, 1867, 1.
4. "Walter Schweikart at Rest in Elmwood," *Detroit Free Press*, May 7, 1904, 10.
5. Advertisement: Walter Schweikart Stone Cutter and Carver.

Old City Hall

1. "The New City Hall: A Tour From Basement to Cupola," *Detroit Free Press*, July 4, 1871, 1.
2. W. Hawkins Ferry, *The Buildings of Detroit: A History*, rev ed. (Detroit: Wayne State University Press, 1980), 78.
3. "Just Missed Fame and Fortune—Yet Won't Be Downed: Edward Q. Wagner, Detroit Painter and Sculptor, Compelled by Failing Health to Sacrifice the Ambition of a Lifetime, Still Works On—and Smiles!," *Detroit Free Press*, September 25, 1921, magazine sec., 3.
4. Don Schram, "Council Votes to Raze City Hall: Objectors Plan Fight in Court; Also Study Move for Test at Polls," *Detroit Free Press*, January 18, 1961, 1.

William H. Wells House

1. "Death Came to His Relief: Attorney William H. Wells Passed Away at Oak Grove," *Detroit Free Press*, June 30, 1904, 5.
2. "Fencing de Tuscans Meet in Divorce Duel: War on the Home Front," *Detroit Free Press*, October 31, 1943, 1.

First Presbyterian Church

1. Robert B. Ross and George B. Catlin, *Landmarks of Wayne County and Detroit, Part II* (Detroit: Detroit Evening News Association, 1898), 280.

Trinity Episcopal Church

1. James E. Scripps, *Descriptive Account of the New Edifice Erected for Trinity Church, Detroit* (Detroit: Ladies' Aid Society of Trinity Church, 1892), 3.
2. Scripps, *Descriptive Account*, 8.
3. Scripps, *Descriptive Account*, 7.
4. Bob Smith, interview by author, April 30, 2016, Detroit, MI.

David Whitney Jr. House

1. "New Residence of David Whitney, Jr.," The Architects, *Detroit Free Press*, June 16, 1889, 22.
2. "An American Palace: New Residence of Mr. David Whitney, Jr.," *Detroit Free Press*, February 4, 1894, 19.
3. "An American Palace."
4. "Lumbering in the Past," *Detroit Free Press*, June 25, 1891, 4.
5. "David Whitney Is Dead: Well-Known Capitalist Passed Away Last Night," *Detroit Free Press*, November 29, 1900, 1.

Hurlbut Memorial Gate

1. "Object to the Rewarding of a Contract," *Detroit Free Press*, September 1, 1893, 6.
2. "Funeral Planned for Carver of Huge Stove on Jefferson," *Detroit Free Press*, September 23, 1940, 5.

Old Main

1. Don Creecy, "Central High, Granddaddy of 'Em All," *Detroit Sunday Times*, April 6, 1958, Folder 9, Box 5, Detroit Board of Education / Detroit Public Schools Collection, University Archives, Walter P. Reuther Library, Wayne State University, Detroit, MI.
2. "Detroit Public Schools Trace 125 Years of Progress," *Detroit Historical Society Bulletin* 24, no. 4 (1968): 11.
3. "Golden Key: Open Sesame of the New Central High School," *Detroit Free Press*, January 14, 1897, 1.
4. Patricia Bartowski, "Old Main Retrospective," *Wayne State Magazine*, Winter 1997, 9, Folder 9, Box 5, Detroit Board of Education / Detroit Public Schools Collection.
5. "Golden Key."
6. Bartowski, "Old Main Retrospective."
7. "The New High!: Declared to Be One of the Finest Schools

in the Country," *Detroit Free Press*, September 6, 1896, 24.

Hunt Street (Third Precinct) Police Station

1. "New Police Station: That for the East Side Nearly Completed," *Detroit Free Press*, May 1, 1897, 10.
2. Detroit Police Department, under the direction of James Couzens, *Story of the Detroit Police Department, 1916–17: A History in the Making by the Men on the Job* (Detroit: Inland, 1917), 141.
3. "New Police Station."
4. Picture caption, *Architecture and Building* 27, no. 24 (1897): 13.

Grand River Avenue Police Station and Barn

1. "Will of the People," *Detroit Free Press*, April 6, 1897, 1.

Wayne County Building

1. J. Walker McSpadden, *Famous Sculptors of America* (New York: Dodd, Mead, 1925), 251.
2. "Sayings and Doings," *Detroit Free Press*, January 8, 1902, 5.
3. "Beautiful Bronzes to Be Placed at the Base of the Wayne County Building Tower," *Detroit Free Press*, March 14, 1903, 1.
4. "Wayne County's Bronze Horses May Go to War: Into the Melting Pot?," *Detroit Free Press*, August 20, 1942, 2.
5. Louis Cook, "A Brave Soul Comes to Charioteers' Rescue," *Detroit Free Press*, May 14, 1979, 14.

Belle Isle Aquarium

1. "News of the Architects: The Belle Isle Aquarium Competition," *Detroit Free Press*, October 14, 1900, pt. 3, 10.
2. Detroit Zoological Society, *Official Catalog of the Detroit Aquarium* (Detroit, 1911).
3. "City Sells Turtle for $25, Quits Buying Salt Water," *Detroit Free Press*, March 3, 1932, 4.
4. Mark Beltaire, "The Town Crier," *Detroit Free Press*, July 28, 1972, 3.
5. Emelia Askari, "Rare Fish Are Kept Alive and Swimming: Aquarium Awarded for Saving a Species," *Detroit Free Press*, October 6, 1998, 11.

Detroit News Building

1. Lee A. White, *The Detroit News: Eighteen Hundred and Seventy-Three–Nineteen Hundred and Seventeen—A Record of Progress* (Detroit: Evening News Association, 1918), 26.
2. White, *Detroit News*, 26.
3. White, *Detroit News*, 16.

4. University of Manchester Library, "Aldus Manutius," in *Pioneers of Print*, accessed April 19, 2018, www.library.manchester.ac.uk/firstimpressions/Pioneers-of-Print/Aldus-Manutius.
5. "News Plans Addition to Present Building: Cost of Project Estimated at $2,750,000; Construction Will Start in Spring and Be Finished in Nine Months," *Detroit News*, March 7, 1930, 1.
6. Matt Helms, "New Stories at 615 W. Lafayette: Redone News Building Keeps Historic Flair," *Detroit Free Press*, March 31, 2017, 4A.

Detroit Main Library

1. W. Francklyn Paris, *The House That Love Built: An Italian Renaissance Temple to Arts and Letters* (New York: Haddon, 1925), 1.

George W. Balch School

1. "First Contract for Telephone Made by George W. Balch: Enterprising Detroiter, Who Died Monday, Appreciated Invention of Bell and Succeeded in Establishing Initial Telephonic Communication in This City," *Detroit Free Press*, March 4, 1908, 12.
2. "Balch Honored by School Men: Is Lauded at Exercises Opening Educational Building Bearing His Name," *Detroit Free Press*, February 25, 1922, 18.
3. Ray Strickland, *An Honor and an Ornament: Public School Buildings in Michigan* (Detroit: Inland, 2003), 26.
4. "Building Program—Construction of Eight Additions and Three New Buildings Started," Detroit Educational Bulletin 4, no. 2 (1920): 4, Folder 3, Box 85, Detroit Board of Education / Detroit Public Schools Collection, University Archives, Walter P. Reuther Library, Wayne State University, Detroit, MI.
5. "Recent Developments in Detroit School System," Architectural Forum 37, no. 2 (1922): 63.

Detroit Yacht Club

1. "Detroit Yacht Club Is First to Give Out Plans: Warm Weather Sets the Tars to Thinking of What the Season Shall Bring Forth—Largest Fleet on the Great Lakes," *Detroit Free Press*, April 7, 1912, 22.
2. "Finest Yacht Club Home Is Opened Here: 5,000 Attend Dedication of New Building; Will Be Open All Year," *Detroit Free Press*, May 31, 1923, 1.

Park Avenue Building

1. "Another Big Public Market," *National Provisioner* 63 (October 9, 1920): 40.

2. Preservation Detroit is Detroit's oldest and most accomplished preservation organization, working to preserve and revitalize Detroit's architectural and cultural heritage since 1975. See PreservationDetroit.org.

3. Paul Beshori, "Abandoned Park Avenue Building Suddenly Faces Demolition," *Curbed Detroit*, August 15, 2014, https://detroit.curbed.com/2014/8/15/10059884/abandoned-park-avenue-building-suddenly-faces-demolition.

Detroit Police Headquarters

1. "Inches Finds City's Police Rank High: Returns with Kahn from Inspection Trip," *Detroit Free Press*, September 13, 1919, 11.

2. Corrado Parducci, oral history interview by Dennis Barrie, March 17, 1975, 14, 18, Archives of American Art, Smithsonian Institution, Washington, DC.

3. Plans of First Precinct Police Station, Sheets 13 and 19, Folder 6, Drawer 29, Albert Kahn Papers, Bentley Historical Museum, University of Michigan, Ann Arbor, MI.

4. Paul Beshori, "Bing Decides Old Police HQ Should Probably Be Demolished," *Curbed Detroit*, July 1, 2013, https://detroit.curbed.com/2013/7/1/10224780/bing-decides-old-police-hq-should-probably-be-demolished.

5. J. C. Reindl, "Legendary Detroit Police HQ Set to Get a Gilbert Revamp," *Detroit Free Press*, February 9, 2018, 1, 16.

General Motors Building

1. George W. Stark, "Town Talk: Zimmerman and 'His' GM Building," *Detroit News*, August 7, 1953, 30.

2. Albert Kahn, "A Problem in Design: General Motors Bldg Not Mere Construction Job," *Detroit News*, April 4, 1922, Automobile sec., 10.

Archdiocese of Detroit Chancery Building

1. "Diocese Plans New Rectory: Modern Office Building Will Replace Historic St. Aloysius," *Detroit Free Press*, November 23, 1923, 5.

2. Rev. John M. Doyle, *St. Aloysius Church: The Old and the New* (Detroit: Archdiocese of Detroit, 1935), 7–8.

3. "Diocese Plans New Rectory."

4. Doyle, *St. Aloysius Church*, 12.

Book-Cadillac Hotel

1. According to the Westin Book Cadillac guest services manager, David Wilte. He says the story was confirmed by Louis Kamper's granddaughter.

Detroit Free Press Building

1. "Free Press Will Have New Home and World Peer in News Plants," *Detroit Realtor*, July 1924, 12.

2. John Gallagher, "New Chapter for Free Press Building: Gilbert Plans Ambitious Mixed-Use Site of Office Space, Retail and Residential Units," *Detroit Free Press*, January 24, 2017, 1A.

First State Bank Building

1. Corrado Parducci, oral history interview by Dennis Barrie, March 17, 1975, 7, Archives of American Art, Smithsonian Institution, Washington, DC.

2. Parducci interview, 11.

3. Elaine Latzman Moon, "Carved into Detroit's Heart, Parducci's Work Is Unsigned and You'll Have to Look Up to See It," *Detroit Free Press*, March 14, 1976, magazine sec., 18.

Security Trust Building

1. John Woerpel, "Wrecker . . . Spare That Building," *Detroit Free Press*, May 29, 1965, 14-A.

2. Woerpel, "Wrecker."

3. Nicole Rupersburg, "Security Trust Lofts, Detroit's Newest Housing Development, Ready to Start Leasing," Model D, May 21, 2013, www.modeldmedia.com/devnews/security-trustloftsnowleasing.aspx.

James Scott Memorial Fountain

1. "Died Scott," *Detroit Free Press*, March 6, 1910, 24.

2. "To Hold Scott Funeral Today," *Detroit Free Press*, March 7, 1910, 4.

3. "Many Citizens for Scott Gift: Some Oppose Acceptance of Fountain at Hearing before Council Committee," *Detroit Free Press*, December 13, 1910, 2.

4. Peter Gavrilovich and Bill McGraw, *The Detroit Almanac: 300 Years of Life in the Motor City* (Detroit: Detroit Free Press, 2006), 470.

5. "Many Citizens for Scott Gift."

Buhl Building

1. "Symbols Tell Story of Historic Past, and Future of Building," *Detroit Free Press*, May 3, 1925, Buhl sec., 4.

The Players Theatre

1. Marijean Levering, *Detroit on Stage: The Players Club, 1910–2005* (Detroit: Wayne State University Press, 2007), 47.

2. Michigan Registered Historic Site Marker, Players Theatre,

over door at east end of south façade, Registered State Site No. 70, Michigan History Division, Department of State.

Detroit Masonic Temple

1. "$7,000,000 Detroit Masonic Temple Ready for Opening: Believed Largest of Its Kind in the World: Will House 31 Bodies of the Craft," *Christian Science Monitor*, February 19, 1926, clipping, Burton Historical Collection, Detroit Public Library, Detroit, MI.
2. "Frank E. Fisher" (obituary), *Detroit Free Press*, May 1, 1940, 20.

Book Building and Tower

1. Geraldine Strozier, "St. Aloysius: World's Very Much in Evidence at the Downtown Detroit Parish," *Detroit Free Press*, June 24, 1975, 1-C.
2. Dan Austin, "Gilbert: Book Tower to Be Game Changer: He Buys Long-Vacant Skyscraper, Plans Mixed-Use Development for It," *Detroit Free Press*, August 29, 2015, 7A.

Metropolitan United Methodist Church

1. William Kellon Quick, *Directory of Metropolitan United Methodist Church* (Detroit: Metropolitan United Methodist Church, 1992), 8.

Detroit Institute of Arts

1. William C. Richards, "Art Institute, Begun in 1924, Is Dedicated: Thousands Throng Halls of Auditorium," *Detroit Free Press*, October 8, 1927, 1.
2. Theo B. White, *Paul Philippe Cret: Architect and Teacher* (Philadelphia: Art Alliance, 1973), 33.
3. William H. Peck, *The Detroit Institute of Arts: A Brief History* (Detroit: Wayne State University Press, 1991), 66.
4. C. C. Zantzinger to Clyde H. Burroughs, November 20, 1924, 2, The Building/Paul Philippe Cret Papers 1919–1946, Detroit Institute of Arts Research Library & Archives, Detroit Institute of Arts, Detroit, MI.
5. *Bulletin of the Detroit Institute of Arts* 9, no. 1 (1927): 167.
6. Clyde H. Burroughs, "The New Home of the Detroit Institute of Arts," *American Magazine of Art* 18, no. 10 (1927): 549.

Maccabees Building

1. "Ground Broken by Maccabees: Work Started on 14-Story Building at Putnam and Woodward," *Detroit Free Press*, December 30, 1925, 7.
2. "Rites Are Held by Maccabees: Delegates from U.S., Canada Present at Dedication of Building Here," *Detroit Free*

Press, July 24, 1927, 7.
3. "Ground Broken by Maccabees."
4. "Maccabees Hit by City Council: New Temple, Already Underway, Must Be Moved to Permit Widening Edict," *Detroit Free Press*, June 20, 1926, pt. 5, 2.
5. "Orders Condemnation of Maccabees Temple: City Plan Commission Recommends New Structure Be Moved Back," *Detroit Free Press*, June 16, 1926, 4.
6. "Plan to Widen Woodward Unique," *Detroit Free Press*, August 25, 1926, 2.
7. *Conference of the Building Planning Service Committee of the National Association of Building Owners and Managers, in Regard to the Proposed New Maccabees Building to Be Erected at Woodward Avenue and Putnam Street, Detroit Michigan, Thursday and Friday, July 8 and 9, 1925* (Detroit: Mack & Orth Bookbinders, 1925), 23–24, Kahn Library/Archive, Lawrence Technological University, Southfield, MI.
8. *Conference of the Building Planning Service Committee.*
9. "Would Fire Hangar Job Architect," *Detroit Free Press*, January 18, 1929, 1.

Standard Federal Savings & Loan

1. "The Billion Dollar Story of Standard Federal Savings," advertising supplement to *Detroit Free Press*, January 6, 1974, 3.
2. *Souvenir Album of Catholic Churches and Institutions in and around Detroit* (Detroit, 1910), 5, Burton Historical Collection, Detroit Public Library, Detroit, MI.

Historic Little Rock Missionary Baptist Church

1. Bureau of History, Michigan Department of State Inventory Form, Michigan Historical Commission Meeting, April 22, 1993, Dau Library, Historic Trinity Lutheran Church, Detroit, MI.
2. "United Churches Hear Farewell," *Detroit Free Press*, January 1, 1927, 10.
3. "New Christian Church Ready: Central-Woodward Sanctuary to Be Occupied Tomorrow; Dedication Oct. 14," *Detroit Free Press*, September 29, 1928, 8.
4. City of Detroit City Council Historic Designation Board, *Proposed Little Rock Church Historic District Final Report, 1992*, 4, Dau Library, Historic Trinity Lutheran Church, Detroit, MI.
5. Harold Schauchern, "X-Ways Prove a Lifeline for Central Church," *Detroit News*, June 7, 1958.
6. Hiley H. Ward, "89-Year-Old Restores Lost Medieval Art," *Detroit Free Press*, December 3, 1960, 8.

7. Elaine Latzman Moon, "Carved into Detroit's Heart, Parducci's Art Is Unsigned and You'll Have to Look Up to See It," *Detroit Free Press*, March 14, 1976, magazine sec., 18.

Fisher Building

1. New Center Development Corporation, "The Fisher Building," 1928, 3, Burton Historical Collection, Detroit Public Library, Detroit, MI.
2. "Work Starts on New Fisher Building," *Detroiter*, August 29, 1927, clipping, Burton Historical Collection, Detroit Public Library, Detroit, MI.
3. "The Fisher Building: New Center of Detroit," *Michigan Manufacturer and Financial Record Supplement* 42, no. 17 (1928): 30.
4. "Fisher Building: New Center of Detroit," 38.
5. Corrado Parducci, oral history interview by Dennis Barrie, March 17, 1975, 21, Archives of American Art, Smithsonian Institution, Washington, DC.
6. "Fisher Building: New Center of Detroit," 69.
7. "New Mayan Art Temple Ready: Brilliant Premiere Scheduled for Friday of 'World's Perfect Theater,'" *Detroit Free Press*, November 11, 1928, pt. 4, 57.

Music Hall

1. "Plan for New Theater Here: New Detroit to Give Way to Playhouse Financed by Mrs. Alfred G. Wilson," *Detroit Free Press*, June 3, 1928, 1.
2. "Music Hall Gets New Life," *Detroit Free Press*, February 9, 1973, 4.
3. Steven Advokat, "Music Hall Dances to Economic Recovery," *Detroit Free Press*, October 23, 1983, F-1.

S. S. Kresge Headquarters

1. "Kresge Plans New Building," *Detroit News*, February 10, 1929, clipping, Burton Historical Collection, Detroit Public Library, Detroit, MI.
2. Sales brochure, S. S. Kresge Company, April 1979, Burton Historical Collection, Detroit Public Library, Detroit, MI.

David Stott Building

1. Dan Austin, "David Stott Building," HistoricDetroit.org, accessed April 26, 2016, www.historicdetroit.org/building/david-stott-building/.
2. "Elevator Service Sets Speed Marks: Those in New Stott Building Capable of 800 Feet per Minute," *Detroit Free Press*, June 16, 1929, sec. 6, 10.
3. Nathan Bomey, "Burst Pipe Floods Four Floors of the David Stott Building," *Detroit Free Press*, February 25,

2015, www.freep.com/story/news/local/michigan/detroit/2015/02/25/burst-pipe-freeze-david-stott/23984393/.

Detroit Press Building

1. Rick Ratliff, "Ross Roy: Advertising Giant Builds for the Future," *Detroit Free Press*, August 10, 1987, 1C.
2. Ratliff, "Ross Roy."

Guardian Building

1. David Coulter, "Honors for Guardian of Rich Architectural Heritage," *Monitor*, May 5, 1994, 5.
2. Corrado Parducci, oral history interview by Dennis Barrie, March 17, 1975, 35, Archives of American Art, Smithsonian Institution, Washington, DC.
3. Marge Colborn, "A New Lease on Life: Restoration Aims to Protect Guardian's Heritage," *Detroit News*, November 11, 1986, 3C.

William Livingstone Memorial Light

1. William Livingstone Lighthouse, picture caption, Gravure Supplement, *Detroit Free Press*, October 26, 1930, 1.
2. "William Livingstone Monument Designed: Memorial Lighthouse Will Be Constructed at East End of Belle Isle," *Detroit Free Press*, October 30, 1928, 7.
3. Robert Justin Clark and Andrea P. A. Belloli, *Design in America: The Cranbrook Vision* (New York: Harry N. Abrams, Detroit Institute of Arts, Metropolitan Museum of Art, 1983), 238.
4. William Livingstone Lighthouse, picture caption.

Cathedral of the Most Blessed Sacrament

1. Archdiocese of Detroit, *Guide to the Cathedral of the Most Blessed Sacrament* (Ann Arbor: Edward Brothers, 1958), 3.

St. Cecilia Roman Catholic Church

1. Herman Wise, "Artist's Work Is Widespread: Born in Italy, He Has Become Renowned as Sculptor and Modeler," *Detroit Free Press*, May 10, 1931, 18.
2. Alex Poinsett, "The Quest for a Black Christ: Radical Clerics Reject 'Honkey Christ' Created by American Culture-Religion," *Ebony*, March 1969, 171.

Detroit Public Library, Francis Parkman Branch

1. *The Mary Conover Room of the Detroit Public Library*, brochure, Burton Historical Collection, Detroit Public Library, Detroit, MI.
2. Frank B. Woodford, *Parnassus on Main Street: A History of the Detroit Public Library* (Detroit: Wayne State University

Press, 1965), 231.

3. Woodford, *Parnassus on Main Street*, 205–6.

Historic Trinity Lutheran Church

1. "Trinity's New Church Ready: Edifice of First Lutheran Congregation to Be Dedicated Sunday," *Detroit News*, February 14, 1931, clipping, Burton Historical Collection, Detroit Public Library, Detroit, MI.

Detroit Public Library, Downtown (Skillman) Branch

1. U.S. National Park Service, National Underground Railroad Network to Freedom, 1, Burton Historical Collection, Detroit Public Library, Detroit, MI.

2. George Bulanda, "Spine-Tingling: Check Out Library Ghosts," *Hour Detroit* 10, no. 3 (2005): 40.

3. Detroit Public Library website, www.detroitpubliclibrary.org/branch/national-automotive-history-collection, accessed August 15, 2017.

Detroit Federal Building and U.S. Courthouse

1. "Board Appeals to Washington: Commerce Committee Leaves for Capital to Petition for New Federal Building Here," *Detroit Free Press*, December 12, 1929, 22.

2. "Derrick Is Appointed Postoffice Architect: Ford Museum Builder Will Design New Federal Building Here," *Detroit*

Free Press, August 20, 1930, 1.

3. Sherman R. Miller, "Judge to Take Court Room with Him When He Moves: Famous Chamber, with Marble Walls and Symbolic Friezes Is Being Reassembled," *Detroit Free Press*, September 24, 1933, 2.

4. Miller, "Judge to Take Court Room."

D. J. Healy Shops' Neighborhood Stores

1. "Modern Store Opens Its Doors," *Detroit Free Press*, September 22, 1940, 5.

2. "D. J. Healy Shops Announce the Opening of a New D. J. Healy Neighborhood Shop in the University District—Advertisement," *Detroit Free Press*, March 10, 1936, 10.

Horace H. Rackham Educational Memorial

1. "Rackham Will Give Millions to Fellow Men: Fund to Help Charity, Learning and Other Public Causes," *Detroit Free Press*, June 23, 1933, 1.

2. Patricia Montermurri, "Sculptor Was Local; Images Were Global: 1908–1998 Marshall Fredericks," *Detroit Free Press*, April 6, 1998, 12.

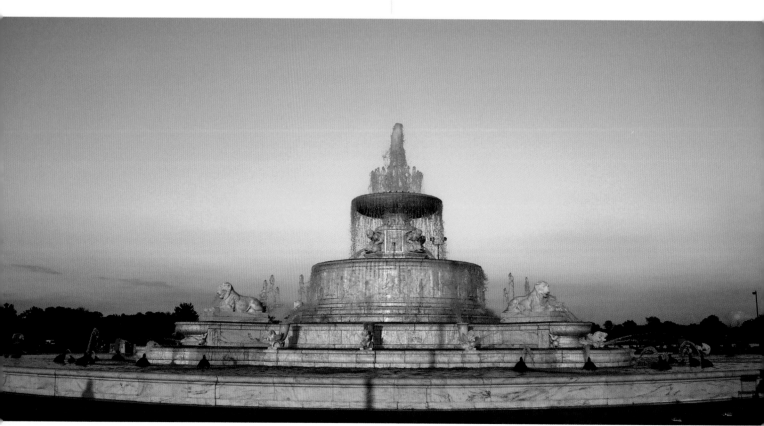

Austin, Dan. *Forgotten Landmarks of Detroit*. Charleston, SC: History Press, 2012.

———. *Lost Detroit: Stories Behind the Motor City's Majestic Ruins*. Charleston, SC: History Press, 2010.

Bragg, Amy Elliott. *Hidden History of Detroit*. Charleston, SC: History Press, 2011.

———. *The Night Train*. http://nighttraintodetroit.com. A blog about preautomotive Detroit history.

Burton, Clarence M. *History of the City of Detroit, Michigan, 1701–1922*. Chicago: S. J. Clarke, 1922.

Catallo, Cara. *Pewabic Pottery: A History Handcrafted in Detroit*. Charleston, SC: History Press, 2017.

Ching, Francis D. K. *A Visual Dictionary of Architecture*. New York: Wiley, 1995.

Collum, Marla O., Barbara E. Krueger, and Dorothy Kostuch. *Detroit's Historic Places of Worship*. Detroit: Wayne State University Press, 2012.

Craven, Wayne. *Sculpture in America*. New York: Thomas Y. Crowell, 1968.

Eckert, Kathryn Bishop. *Buildings of Michigan*. New York: Oxford University Press, 1993.

Evans, E. D. *Animal Symbolism in Ecclesiastical Architecture*. London: Forgotten Books, 2012. A reproduction of the 1917 work published by Holt, New York.

Ferry, W. Hawkins. *The Buildings of Detroit: A History*. Rev. ed. Detroit: Wayne State University Press, 1980.

"Fisher Building, The: New Center of Detroit." Special issue, *Michigan Manufacturer and Financial Record* 42, no. 17 (1928).

Gavrilovich, Peter, and Bill McGraw. *The Detroit Almanac: 300 Years of Life in the Motor City*. Detroit: Detroit Free Press, 2006.

Gibson, Arthur Hopkin. *A Biographical Dictionary of Artists Native to or Active in Michigan 1701–1900*. Detroit: Wayne State University Press, 1975.

Godzak, Roman. *Catholic Churches of Detroit*. Charleston, SC: Arcadia, 2004.

Harris, Cyril M. *Illustrated Dictionary of Historic Architecture*. New York: Dover, 1983. An unabridged republication of the 1977 edition of the work originally published by McGraw-Hill, New York, under the title *Historic Architecture Sourcebook*.

Hill, Eric J., and John Gallagher. *AIA Detroit: The American Institute of Architects Guide to Detroit Architecture*. Detroit: Wayne State University Press, 2003.

HistoricDetroit.org. A nonprofit website founded by Dan Austin and dedicated to sharing stories and pictures of Detroit's historic places.

Hoak, Edward Warren, and Willis Humphrey Church. *Masterpieces of American Architecture: Museums, Libraries, Churches and Other Public Buildings*. New York: Dover, 2002. An unabridged republication of the work originally published in 1930 by Charles Scribner's Sons, New York, under the title *Masterpieces of American Architecture in the United States: Memorials, Museums, Libraries, Churches, Public Buildings, Hotels and Office Buildings*.

Hodges, Michael. *Building the Modern World: Albert Kahn in Detroit*. Detroit: Wayne State University Press, 2018.

McNamara, Denis R. *Catholic Church Architecture and the Spirit of the Liturgy*. Chicago: Hillebrand Books, 2009.

McSpadden, J. Walker. *Famous Sculptors of America*. New York: Dodd, Mead, 1925.

Nawrocki, Dennis Alan. *Art in Detroit Public Places*. 3rd ed. Detroit: Wayne State University Press, 2008.

Parducci, Corrado. Oral history interview by Dennis Barrie, March 17, 1975. Archives of American Art, Smithsonian Institution, Washington, DC.

Paris, W. Francklyn. *The House That Love Built: An Italian Renaissance Temple to Arts and Letters*. New York: Haddon, 1925.

Parker, John Henry. *A Concise Dictionary of Architectural Terms*. New York: Dover, 2004. An unabridged republication of the 1910 (12th) edition of the work originally published in 1846 by James Parker, Oxford (UK), under the title *A Concise Glossary of Terms Used in Grecian, Roman, Italian, and Gothic Architecture*.

Peck, William H. *The Detroit Institute of Arts: A Brief History*. Detroit: Wayne State University Press, 1991.

Ross, Robert B., and George B. Catlin. *Landmarks of Wayne County and Detroit*. Detroit: Evening News Association, 1898.

Scripps, James E. *Descriptive Account of the New Edifice Erected for Trinity Church, Detroit*. Detroit: Ladies' Aid Society of Trinity Church, 1892.

Smith, Michael G. *Designing Detroit: Wirt Rowland and the Rise of Modern American Architecture*. Detroit: Wayne State University Press, 2017.

Stemp, Richard. *The Secret Language of Churches and Cathedrals: Decoding the Symbolism of Christianity's Holy Buildings*. London: Duncan Baird, 2010.

White, Lee A. *The Detroit News: Eighteen Hundred and Seventy-Three–Nineteen Hundred and Seventeen—A Record of Progress*. Detroit: Evening News Association, 1918.

Woodford, Frank B. *Parnassus on Main Street: A History of the Detroit Public Library*. Detroit: Wayne State University Press, 1965.

Archival Sources

Albert Kahn Collection, Lawrence Technological University, Southfield, MI

Bentley Historical Library, University of Michigan, Ann Arbor, MI

Burton Historical Collection, Detroit Public Library, Detroit, MI

Dau Library and Archive, Historic Trinity Lutheran Church, Detroit, MI

Detroit Institute of Arts Research Library and Archives, Detroit, MI

Detroit Police Museum, Detroit Public Safety Headquarters, Detroit, MI

First Presbyterian Church Archive, Detroit Ecumenical Seminary, Detroit, MI

Historical Society of Michigan Archive, Clinton Township Public Library, Clinton Township, MI

Preservation Detroit Archive, Wayne State University, Detroit, MI

Walter P. Reuther Library, Wayne State University, Detroit, MI